Archaism,
Modernism,
and the Art of
Paul Manship

American Studies Series
William H. Goetzmann, Editor

Archaism, Modernism, and the Art of Paul Manship

by
Susan Rather

University of Texas Press
Austin

Copyright © 1993
by the University of
Texas Press
All rights reserved
Printed in the
United States of
America
First edition, 1993

Requests for permission to reproduce material
from this work should be sent to Permissions,
University of Texas Press,
Box 7819, Austin, TX 78713-7819.

ⓧ The paper used in this publication meets the
minimum requirements of American National
Standard for Information Sciences—
Permanence of Paper for Printed Library
Materials, ANSI Z39.48-1984.

Library of Congress Cataloging-in-Publication Data

Rather, Susan.
 Archaism, modernism, and the art of Paul Manship /
by Susan Rather. — 1st ed.
 p. cm. — (American studies series)
 Includes bibliographical references and index.
 ISBN 0-292-76035-3
 1. Manship, Paul, 1885–1966—Criticism and
interpretation.
 I. Title. II. Series.
 NB237.M3R37 1993
 730'.92—dc20 92-14217
 CIP

For my parents

Contents

Illustrations ix

Acknowledgments xiii

Introduction 1

1 The American Academy in Rome
and the Formation of Manship's Archaism 9

2 The Archaeological Background 40

3 Archaism as Modernism:
Content and Technique 51

4 *Centaur and Dryad*:
Manship's Art in Context 76

5 Archaism from Other Places
and in Other Modes 107

6 Archaism during the 1920s and 1930s:
Decorative and Monumental 132

7 Archaism and the Critics:
Disenchantment 164

Appendix:
"The Decorative Value of Greek Sculpture" 183

Notes 191

Bibliography of Works Cited 237

Index 259

1. Paul Manship, *Wrestlers,* 1908
2. Auguste Rodin, *Crouching Woman,* 1880–1882
3. "Art Works That Won Prizes for the Makers," newspaper clipping showing Manship's *Rest after Toil,* 1909
4. World's Columbian Exposition, Chicago, 1893
5. Paul Manship, *End of Day,* 1909
6. Constantin Meunier, *Stevedore,* 1885
7. Villa Mirafiori, Rome
8. Group of Academy Fellows, ca. 1909
9. Scrapbook page with snapshots of Academy Fellows, ca. 1909
10. Studio building, Villa Mirafiori, Rome, ca. 1909
11. Paul Manship in his studio at the American Academy in Rome, 1909 [1910]
12. Paul Manship, *Wood Nymph's Dance,* 1910
13. Paul Manship, *Duck Girl,* 1910
14. "*Narcissus,*" fourth century B.C. (?)
15. Ivan Meštrović, *Caryatid,* 1911
16. Paul Manship, *Mask of Silenus,* 1912
17. Paul Manship, *Greek Vase* (drawing of a black-figure vase in the National Museum, Athens), 22 April 1912
18. Paul Manship, *Frieze Detail from the Treasury of the Siphnians,* Delphi, 1912
19. Ascribed by Pausanias to Praxiteles, Hermes with the Infant Dionysus, ca. 340 B.C.
20. Centaur with Lapith Woman, from the west pediment, Temple of Zeus, Olympia, ca. 471–457 B.C.
21. Charioteer, from the Sanctuary of Apollo, Delphi, ca. 470 B.C.
22. Kore 594, ca. 500 B.C.
23. Athena (as restored by Thorwaldsen), from the west pediment, Temple of Aphaia, Aegina, ca. 510 B.C.
24. Bertel Thorwaldsen, *Self-Portrait,* 1839 (posthumous marble, H. W. Bissen, 1859)
25. Perseus Killing Medusa, metope from Temple C at Selinus, ca. 550 B.C.

26. Kleobis and Biton, from the Sanctuary of Apollo, Delphi, ca. 580 B.C.

27. Raoul Verlet, sculptor, and Henri Deglane, architect, *Monument à Guy de Maupassant*, 1897

28. View of the *Dewey Arch*, Fifth Avenue at Madison Square Park, New York City, 1899

29. Herakles subduing the Cretan Bull, from the Temple of Zeus, Olympia, ca. 471–457 B.C.

30. Aristide Maillol, *Desire*, 1905–1908

31. Aristide Maillol, *Flora, Nude*, 1910

32. Statue dedicated to Hera by Cheramyes, from the Heraion, Samos, ca. 560 B.C.

33. André Derain, *Crouching Figure*, 1907

34. Auguste Rodin, *Caryatid*, called *Crouching Woman*, 1886

35. Jean-Baptiste Carpeaux, *The Dance*, 1865–1869

36. Antoine Bourdelle, *The Dance*, bas-relief for Théâtre des Champs-Elysées, 1912

37. Karl Bitter, sketch for left relief panel, *Carl Schurz Monument*, ca. 1910

38. Karl Bitter, left relief panel, *Carl Schurz Monument*, 1909–1913

39. Constantin Brancusi, *Double Caryatid*, ca. 1908

40. Constantin Brancusi, *Mlle Pogany*, 1913

41. Paul Manship, *Centaur and Dryad*, 1912–1913

42. Esquiline Venus, ca. 50 B.C.

43. Paul Manship, *Centaur and Dryad*, detail, 1912–1913

44. Head of a Satyr, antefix from a temple in Gela, early fifth century B.C.

45. Douris, Psykter with Sileni Frolicking around Dionysus, 500–480 B.C.

46. Franz von Stuck, *Mounted Amazon*, 1897

47. Daniel Chester French, *Wisdom*, 1898–1900

48. Karl Bitter, model for western pediment, Wisconsin State Capitol, Madison, 1906–1911

49. Paul Manship, *Playfulness*, 1912

50. Hermon Atkins MacNeil, *Into the Unknown*, ca. 1912

51. Jo Davidson, *Torso*, ca. 1912

52. Henri Matisse, *The Back, I*, 1909, cast ca. 1954–1955

53. Constantin Brancusi, *Sleeping Muse*, 1909–1911

54. Constantin Brancusi, *Torso*, 1908

55. Paul Manship, *Indian Hunter* and *Pronghorn Antelope*, 1914

56. Ruth St. Denis and native Hindus in *Radha*, ca. 1908

57. Paul Manship, *Infant Hercules Fountain*, 1914

58. Yakṣī from Tadpatri Temple, Madras, sixteenth century

59. Sarnath, Lion Capital, third century B.C.

60. Paul Manship, *Dancer and Gazelles,* 1916
61. Goddess from Tamilnadu, India, thirteenth century
62. Jacques Lipchitz, *Woman and Gazelles,* 1911–1912
63. Nāyikā with Deer, Punjab Hills, Guler, 1750–1775
64. Isadora Duncan dancing in ancient Athenian theater, in a photograph by her brother Raymond Duncan, ca. 1903
65. Antoine Bourdelle, Sketch of Isadora Duncan dancing, 1911
66. Vaslav Nijinsky and the original cast of *L'Après-midi d'un faune,* photographed on the stage of the Théâtre du Châtelet, Paris, May 1912
67. Leon Bakst, Costume design for a satyr in *Cléopâtre,* 1910
68. Paul Manship, *Salome,* 1915
69. Maud Allan as Salome, ca. 1908
70. Gaston Lachaise, *Dancing Woman,* ca. 1915
71. John Gregory, *Venus and Her Attendant Nymphs,* ca. 1917
72. John Gregory, *The East—Pursuit of Wisdom,* pediment for the Philadelphia Museum of Art, begun 1925
73. Leo Friedlander, *Mother and Infant Hercules,* 1916
74. Leo Friedlander, *Monument to the Volunteers of a National War,* ca. 1916
75. Augustus Saint-Gaudens, *General William Tecumseh Sherman Monument,* 1903, Grand Army Plaza, New York
76. Bruno Schmitz, architect, and Franz Metzner, sculptor, *Völkerschlacht Monument,* Leipzig, 1905–1913
77. Bruno Schmitz, architect, and Franz Metzner, sculptor, interior of *Völkerschlacht Monument,* Leipzig, 1905–1913
78. J. Milton Dyer, First National Bank, Cleveland, Ohio, 1908
79. Karl Bitter, *Knowledge,* eastern relief panel, First National Bank, Cleveland, Ohio, 1908
80. Franz Metzner, plaster models for facade reliefs, Haus Rheingold Restaurant, Berlin, 1906
81. Karl Bitter, *Thomas Lowry Monument,* Minneapolis, 1911–1915
82. Karl Bitter, *Planting,* left relief panel (detail), *Thomas Lowry Monument*
83. Karl Bitter, *Vintage,* right relief panel (detail), *Thomas Lowry Monument*
84. Betram Grosvenor Goodhue, Nebraska State Capitol, Lincoln, 1920–1932
85. Lee Lawrie, *Wisdom* and *Justice,* east portal of the Nebraska State Capitol, Lincoln
86. André Ventre and Henry Favier, Porte d'Honneur, Exposition Internationale des Arts Décoratifs et Industriels Modernes, Paris, 1925
87. Hotel d'un Riche Collectionneur (Ruhlmann pavilion), Pierre Patout,

architect; Exposition Internationale des Arts Décoratifs et Industriels Modernes, Paris, 1925

88. René Chambellan, in collaboration with Jacques Delamarre, *Endurance;* bronze plaque and radiator grille, Chanin Building, New York, 1927–1929

89. Paul Manship, *Air,* relief for American Telephone and Telegraph Building, New York, 1914

90. Bedroom, Paul Manship residence, East 72nd Street, New York City

91. Paul Manship, *Paul J. Rainey Memorial Gateway,* 1926–1934

92. Paul Manship, *Europa and the Bull,* 1924

93. Paul Manship, *The Flight of Europa,* 1925

94. Paul Manship, *Diana* 1925

95. Paul Manship, *Actaeon,* 1925

96. Paul Manship, *Pauline Frances,* 1914

97. Gaston Lachaise, *Standing Woman (Elevation),* 1912–1927

98. Gaston Lachaise, *American Telephone and Telegraph Figure,* 1921–1923

My interest in archaism began ten years ago, when, having completed a master's thesis on Greek archaic sculpture, I contemplated a return to the field of American art, which I had entered graduate school intending to pursue. I remember sitting in the office of my thesis adviser, Steve Crawford, wondering over the apparent diversion; it was he who suggested I investigate the art of Paul Manship as a way to continue and build on my interest in archaic sculpture. I eventually did just that in a doctoral dissertation directed by Wayne Craven. Roberta Tarbell, as an outside reader, provided enthusiastic guidance all along the way.

The present book bears little resemblance to that initial exploration of Manship and archaism. Manship remains the central figure, but my purpose has changed. This study argues for archaism as a modernist mode of representation in early-twentieth-century sculpture and then traces its assimilation to the academy and popular culture. Among my colleagues at the University of Texas at Austin, Anthony Alofsin, John Clarke, Emily Cutrer, Linda Henderson, Jeff Meikle, and John Robertson read the dissertation and made useful suggestions for its revision, which they will discern here. I especially thank Emily Cutrer for encouraging me to explore the popular and commercial contexts of archaism. Bill Goetzmann, of course, read the work as well and did me the honor of seeking its inclusion in his American Studies series. During the several years of reworking and expansion, his encouragement of the project never faltered, and for that I sincerely thank him.

My substantial rethinking of the enterprise began with a happy coincidence: my offering of a graduate seminar on archaism and the arrival of Richard Shiff as director of the newly formed Center for the Study of Modernism at the University of Texas. I sat in on

his graduate seminar on Tuesday evenings and found that in my own class on Wednesday mornings I could not talk about archaism in the same way. My students mounted their own challenges, for which I must thank them, but my greatest intellectual debt is to Richard Shiff, whose seminar discussions provoked me to reconceive the relationship of archaism to modernism. My colleague Charles Edwards responded helpfully to numerous queries on ancient art, while Peg Delamater reviewed the section of my manuscript on archaism and the art of India and directed me to several pertinent sources I had overlooked. At the final stage of preparation, Paul Staiti read the manuscript in its entirety; his perfectly balanced enthusiasm and judicious criticism spurred a particular adjustment that considerably strengthened the overall book.

The Smithsonian Institution and the University of Texas at Austin provided funding that enabled me to conduct the research for this study. At the Smithsonian, I thank especially Lois Fink, curator of research at the National Museum of American Art, and Arthur Breton of the Archives of American Art, who allowed me to examine the papers of the American Academy in Rome concurrently with his efforts to prepare them for cataloguing. J. A. Hastings provided especially generous assistance in obtaining photographs. John and Margaret Manship aided me in various ways, but I am particularly grateful for their warm support. I have been most fortunate to have the Library of Congress for a hometown library and have benefited from the assistance of many librarians there, not the least my stepmother, Lucia Rather. My father, John Rather, in years past my sternest writing master (though one whose criticism I always sought), will, I hope, find pleasure in this book.

Bob Leach did not live to share my excitement at the conceptual opening up of this project, but—irrepressibly high spirited and my most stalwart supporter—he would have been the most enthusiastic of all.

Archaism,
Modernism,
and the Art of
Paul Manship

In February 1913, American sculptor Paul Manship made his professional debut at the annual exhibition of the Architectural League of New York. Two and a half weeks later, the notorious International Exhibition of Modern Art, better known as the Armory Show, opened across town. The latter event has long been credited with dealing the final blow to the dominance of the artistic academy, with which Manship himself was to become closely identified; nevertheless, between the world wars, Manship ranked as the most visible and sought-after sculptor in America.

In retrospect, the coincidence of the Armory Show and Manship's appearance was propitious for the young sculptor. At the Armory, the full force of modern European art confronted startled visitors, who, for the most part, left baffled and antagonized. By contrast, the Architectural League exhibits offered the warm reassurance of familiar artistic styles, techniques, and subjects. Manship's ten entries, in their consummate craftsmanship and playful mythological themes, posed no exception. But why did he survive and flourish, when other academics did not?

Manship's success seems to lie in the way his work negotiated the distance between tradition and modernity, for there is no question that critics found his early work intriguingly—that is, acceptably—fresh and modern. The distinction belonged essentially to Manship's style. Purged of the tactile naturalism familiar to a generation schooled in French ways, his sculpture featured crisply articulated forms, taut, polished surfaces, and rhythmic contours—characteristics that aligned Manship's work visually with that of more patently modern European sculptors represented at the Armory, including Maillol, Brancusi, and Archipenko. To be sure, Manship's figures were anatomically more naturalistic; and yet the sculptor

contradicted that quality with stylized, linear incisions marking hair, drapery, and other details. The obvious derivation of this treatment from Greek archaic art, which Manship had only recently discovered, immediately earned for his sculpture the label "archaistic."

From a late-twentieth-century vantage point, Manship seems to have little in common with the international vanguard of the second decade. The facts of a career that ended only with the sculptor's death in 1966 merely confirm our image of Manship as an arch-conservative, squarely—and futilely—opposed to the rising tide of modernism, which effectively snuffed out his fame by the early 1940s. He seems the relic of some distant artistic past, the more so because the past was integral to his vision. Archaic Greece, medieval Europe, India—all went into the melting pot of Manship's art to emerge, stunningly recast, in his graceful and guileless, yet paradoxically sophisticated, statuettes.

Closer examination of the discourse and practice of early-twentieth-century sculpture reveals that, at the outset of his career, Manship shared more with the European vanguard than later generations—and even members of his own generation—liked to admit. He was only one among many artists who, exhausted by the accumulated weight of the Renaissance tradition, cleaved to the fresh and (in their eyes) uncomplicated forms of archaic art as a powerful visual alternative to the rhetorical excesses of late-nineteenth-century art. The terms "archaic" and, occasionally, "primitive" appear frequently in the writings of Manship and his contemporaries to designate a wide range of artifacts that shared a stylized, nonnaturalistic language of form and real or perceived connection to later developments in Western art.

Perhaps the best way to begin to understand archaism is by assessing its difference from the much better known phenomenon of modern primitivism. Characterizations of archaism have indeed often occurred in the context of—and as a foil to—studies of primitivism; it seems only fitting therefore to start from the point of view of archaism.

The Greek word *arche* means "beginning" or "origin." The adjective archaic, according to standard dictionary definitions, identifies something as "of, relating to, or characteristic of an earlier or more primitive time."[1] Such definitions, necessarily encompassing, do not associate the archaic with any specific style; rather, they emphasize chronological relativity in situating it within an implied sequence of styles. Archaic objects of art are those "belonging to an early conventional stage, but of too advanced a style to be called primitive"; at the same time, something that is archaic has not yet attained classical equilibrium.[2]

Within Western culture, the classical moment had long been identified with the arts of ancient Greece and Rome and the Italian Renaissance, the academically endorsed highest achievements in Western civilization and the

most worthy models for study by artists. But there were alternatives. Beginning in the late eighteenth century, several groups of artists—including the French Barbus, German Nazarenes, Italian Purists, and English Pre-Raphaelites—rejected those classical exempla for models in Etruscan and early Greek art (especially vase painting), trecento and quattrocento Italian art, and early Netherlandish painting. In contrast to the sophisticated naturalism and illusionism that had dominated Western art since the fifteenth century, such art appeared, and was referred to as, "primitive." The modern artists understood this primitivism in a positive sense: they identified the absence of technical virtuosity with an expressive directness unmediated by training and convention, and they interpreted a resultant formal awkwardness as the sign of sincerity. Taken together, these qualities seemed to express a purity and simplicity that had been lost in a corrupted modern world. At the same time, the seminal relationship that these "primitive" stages of art bore to the classical moments that followed contributed to their attractiveness. The primitive works, in effect, revealed the vital origins of Western cultural traditions long since debased. Modern idealization of these earlier stages necessarily shaped modern perception of earlier art. Thus, romanticized ideas about late medieval purity of faith predisposed the Nazarenes, a group of German artists who resided in Rome during the 1810s, to see purity of style in the primitive art of the late medieval period—or to define purity in terms of what they saw. The idea of the primitive united works varying widely in appearance and contributed to a perception of their formal affinity.

By the end of the nineteenth century, an expanded category of the primitive encompassed the art of Egypt, Romanesque Europe, and Byzantium, as well as Persia, India, and Cambodia. The non-Western cultures in the latter group, however alien to the "civilized" West, had undeniably attained great achievements in the past, as their complex monuments of architecture and sculpture attested. The perception that they had declined from greatness made their art all the more appealing to Westerners, whose own civilization seemed inexorably to be advancing, just as many were beginning to wonder how long that advance could last and what toll it would exact.

These models gradually lost their identification as "primitive" after around 1900, when artifacts from the even more primitive cultures of Africa and Oceania began to attract the attention of Western artists. The same designation could not serve both; whereas an evolutionary model suited the cultures with which primitivism had previously been identified, that model was not adaptable for the alien societies and seemingly incomprehensible aesthetics of African and Oceanic art. Even so, this "new" primitive art did not always escape such classification and, when seen within a general system of artistic progression, was invariably assigned the most re-

mote chronological position. Thus, Manship spoke of the "Greek primitives" early in his career, but later used the term "primitive" in reference to African and Pacific Island art, placing them "further back" on the artistic time line.[3] Such assumptions of chronological priority frequently corresponded to a belief in the relative inferiority of primitive art, but the mistake was common even among its admirers. Guillaume Apollinaire, for example, postulated historical continuity between African and Greek art. No champion of the latter, Apollinaire sought to demonstrate the ultimate authority of African art, suggesting that the Greeks had been indirectly (through the Egyptians) influenced by "Negro fetishes."[4] Only gradually did Westerners come to understand that the African and Oceanic art they admired was often of quite recent date. More slowly still came acceptance of the complete dissimilarity between these societies and Western cultures, and the recognition that the primitive societies could not be judged as formative or degenerate according to European standards. As later scholars hastened to point out, the modern fascination with primitive art reveals nothing about the cultures in question, but potentially a great deal about the Western society that lionized them.[5]

The indeterminate historical position of African and Oceanic art did not trouble twentieth-century artists. Unlike the art identified as primitive in the nineteenth century, which had been valued in part for its compatibility and recognizable relationship with later Western art, the African and Oceanic works evoked interest precisely for the qualities that distinguished them from, and contradicted, the broader European tradition. A truly primitive art did not follow conventions—at any rate not those nurtured in an archaic stage and brought to fruition at a later time. From a Western vantage point, the primitive existed in a state of stylistic anarchy. To artists such as Picasso, that condition was desirable and, in embracing the primitive, they proclaimed active defiance of the most hallowed Western stylistic and iconographic traditions. Modern artists were also attracted by the aura of mystery that surrounded primitive artifacts, the origins and functions of which were largely unknown to them. Such works seemed to exist outside of time or, alternatively, to exist in an eternal present.

By the second decade of the twentieth century, the works previously designated as primitive had been gathered under the aegis of the archaic, and modern archaism began to take shape as a reactionary force. For those attracted to archaic art, the history of a work—its place in the past and, especially, the relation of that past to the present—emerged as central to its meaning and attractiveness. In the face of the apparently crumbling traditions of Western art, modern archaism became an attempt to preserve those traditions at their purest visual and technical levels.

The relationship of archaic art and tradition was underscored in a 1930 article on art criticism terminology, coauthored by Duncan Phillips, the

noted American collector of modern art, and Charles Law Watkins. Phillips and Watkins suggested that the term "archaic" "is applicable to any youthful, vigorous art which is self reliant and not too cultivated and which springs spontaneously and with the utmost sincerity from the aspiring inner life of a civilization *still on the upward climb to the heights of a great ideal and a distinctive aesthetic style.*"[6] They identified as the hallmarks of archaic style sound structure, emphasis on essentials, and simplicity and attributed the vitality of archaic art to the artist's quest for form. But the authors added that this quest occurred within the bounds of rules and conventions. By their definition, archaic art is essentially traditional and "unquestionably implies Authority and a Collective Ideal hostile to individualistic experiment and innovation." Thus, there would seem to be an inconsistency in the "aesthetic archaism" that Phillips and Watkins attributed to so many modernists (a term they applied to nonconformist, anti-academics of any time). And yet, they perceived that the modernists' search for fundamentals led them to embrace simplicity and structural integrity— "qualities [that] form the very foundations of the archaic edifice." Although Phillips and Watkins associated archaic art predominantly with sculpture and architecture, they identified Cézanne as a "*modernist* painter who is typically archaic."[7]

Phillips and Watkins took care to distinguish between the archaic and the archaistic, rather pejoratively deeming the latter a romantic, exotic, and antiquarian phenomenon. Robert Goldwater elaborated this theme in *Primitivism in Modern Painting* (1938), the first thorough study of the subject. Goldwater regarded primitivism and archaism as aspects of romanticism and recognized their mutual effort "to infuse new life into art by breaking away from the current and accepted formulas" and "to renew the *essentials* of art."[8] But he considered archaism's sources in the less-developed, but essentially familiar, stages of a shared cultural tradition to be an important difference from primitivism's embrace of the exotic other:

> Archaism strives for a clear-cut formal restatement of its own art which it tries to renew by means of an elimination of later features, retaining only those elements of style characteristic of an earlier art. But because of its knowledge of later developments (to which indirect reference is not only inevitable but necessary for the archaistic ideal), it cannot help giving to those early elements an extreme precision and a calculated refinement which results in a coldness and formalism not found in the work imitated, and in a substitution of knowing restraint for a sincere naïveté.[9]

Goldwater also found the intensity of feeling in both romanticism and primitivism alien to archaism. The content conveyed by archaistic form, in his opinion, has "only an intellectualized, or an arbitrary meaning; intellectualized because it belongs to a taught tradition, arbitrary because it no

longer has an immediate emotional meaning and is significant only in fitting into a preconceived, artificially limited ideal."[10]

Goldwater's definition of archaism as calculated and correct fails to explain the phenomenon I will be describing in this book. His version of archaism must be seen as a foil to his emphasis on the originality of modern primitivism, which he sought to validate.[11] This aim accounts for the omission of sculpture from his initial study; that is, Goldwater detected in modern sculpture evidence of more direct formal borrowing from primitive art than in painting, and this undermined his claims for the originality of the modernist version of primitivism. He located the problem in the sculptor's medium: quite simply, the modern sculptor, inspired by the primarily three-dimensional primitive objects, had less room for experimentation than did the painter who worked in a more abstract, pictorial language. Goldwater later revised his book to include sculpture, but he did not fundamentally reconsider the relationship of modern primitivism to its sources.

The organizers of the Museum of Modern Art's 1984 exhibition on primitivism in modern art intended their show and its accompanying catalogue as a corrective to Goldwater. They highlighted visual correspondences between modern art, including many works of sculpture, and objects from primitive cultures. And yet, while acknowledging instances of direct borrowing from the primitive, curator William Rubin chose to emphasize what he termed the "elective affinity" of modern artists for the primitive; that is, they were drawn to primitive art only when readied by their own artistic explorations.[12] Thus, he argued, visual correspondences between primitive and modern works do not betray academic imitation but constitute profound correspondences at the level of conceptual form. This stance, as critics of the exhibition and catalogue quickly pointed out, served to protect the ideological purity of modernism by identifying it with original and creative, rather than appropriative, acts.[13]

Like Goldwater, Rubin excluded archaic art from the primitivist equation, even though he acknowledged that as late as 1907 "the sense of the Primitive still revolved around Archaic Art."[14] In the category of the archaic, he included the art of "court cultures"—Maya, Toltec, Aztec, Inca, Cambodian, and Egyptian—describing this art as static, hieratic, and "plastically inert" by comparison with primitive art.[15] Rubin associated such formal qualities, manifested above all in monumental architecture and sculpture, with the "high degree of both specialization and social, economic, and political hierarchization" in the so-called court cultures.[16] Yve-Alain Bois, in a review of the primitivism show, suggested that Rubin in this way disguised an aesthetic preference as a sociological polarization; but the distinction may be useful in characterizing the increasing split between archaism and primitivism.[17] Primitivism earned its modernist authority in

part because primitive objects were believed created in individualistic, anarchic societies, in which the maker enjoyed and exercised complete freedom of expression. Archaic artists, on the other hand, belonged to organized societies, and this membership tempered their art; the conventions of archaic style betrayed a restraining social presence which modernists condemned. Precisely the same reading, on the other hand, converted archaism into an appropriate mode for public sculpture and fostered its rapid assimilation by academic sculptors in Europe and America during the second decade of the twentieth century.

The appeal of the archaic was not felt in America until about 1910, but quickly gained strength, due in large measure to Manship. The year of his professional debut—1913—might be taken as both a symbolic end and a beginning for archaism. As an expression of the avant-garde, archaism was largely finished, superseded by the more radical forms of modernism that so scandalized the American public at the Armory Show. But as an approach capable of mediating between modern art (with which it shared some formal characteristics) and academic art (with which it shared an acknowledged basis in the past), archaism was poised for widespread popularity. This it achieved in the sculpture of Paul Manship.

This study aims to elucidate the relationship between archaism and modernism and to chronicle the transformation of archaism from a modernist to an academic mode. Although Manship serves as the central figure, I have not attempted to outline his entire career or even to describe all that he did within the period of time that interests me—that is, from about 1900 to 1930. Monographs by John Manship, the artist's son, and Harry Rand, both published in 1989, perform this task admirably.[18] My examination of Manship concentrates on his study at the American Academy in Rome, on his response to Greek archaic art and to seemingly related non-Western models, and on the critical success and failure of his archaism. Manship's visibility and readily identifiable style, together with his evident impact on a generation of younger American sculptors, encourage the presumption that he was a representative archaist, but I will not make that claim. Archaism appeared in various guises as style, technique, and content—unified by some manner of reference to archaic art—and few artists practiced it consistently. Manship's sustained engagement with archaism was therefore relatively unusual, but that very condition makes his career an appropriate armature for more comprehensive study of archaism.

To that end, this book, although focused on American sculpture, will not ignore the international climate of creativity in which archaism emerged. The regard that modern artists held for archaic sculpture followed nearly a century of accelerating discoveries of, and scholarly interest in, early Greek art; these endeavors receive due recognition here. Developments in France, the international fount of modernism at the turn of the

century, necessarily have an important role to play; thus, Auguste Rodin, Aristide Maillol, Maurice Denis, André Derain, and Antoine Bourdelle figure with other French artists in this study. German sculptors and, especially, theorists—Adolf von Hildebrand, Emmanuel Löwy, Wilhelm Worringer—appear in this narrative as well. I will articulate some of their ideas in discussion of Karl Bitter, a sculptor born and trained in Austria who became a prominent player in American art and the first in this country to engage in serious experiment with archaism. And, in a highly selective look at nonsculptural archaism, a portion of one chapter considers the art of dance. Pioneer "modern" dancers Isadora Duncan and Ruth St. Denis, and Vaslav Nijinsky, the unconventional genius of the Ballets Russes, drew upon some of the same archaic sources as sculptors—and with mutual acknowledgment of their shared concern to develop a heightened expressiveness of the body.

Modern archaism was a much richer, more complex, and widely experienced phenomenon than heretofore acknowledged. From early in the twentieth century until the 1930s, artists in both Europe and America felt the appeal of archaic art and created from its distinctive formal and technical conventions an equally distinctive set of responses to a changing modern world. The career of Paul Manship offers both an entry to and an exit from the study of twentieth-century archaism. A modernist agenda illuminates his early experiments with archaism, whereas his later practice seems staunchly academic. Significantly, Manship's art actually changed very little during this time; instead, the transformation took place in the critical perception of archaism, as what once had been associated with the avantgarde was "repackaged" for popular audiences, and the modern became merely modernistic.

The American
Academy
in Rome
and the
Formation
of Manship's
Archaism

The word that might best describe Manship's path to archaism is *drift;* he drifted into it by a combination of genuinely fortuitous factors. After a period of apprenticeships and formal artistic training from 1905 to 1909, Manship won a fellowship to the American Academy in Rome (AAR). There, between 1909 and 1912, he gradually worked his way toward archaism. Manship did not go to Rome to study ancient art or because he believed in the American Academy—he really knew very little about either—and yet he found himself in a school environment that not only encouraged him to learn from ancient art but, in effect, paid him to do so, not the least by funding his travel throughout the Mediterranean.

Had Manship begun his fellowship even one or two years earlier, his experience might have been quite different. Still a young institution, younger even than Manship, the Academy floundered along in its own way—though certainly not because the founders lacked vision, even if that vision might have appeared questionable. Instead, with financial, official, and other problems that changed but never quite seemed solved, the Academy itself changed from year to year. Its complicated history during Manship's tenure contributed in subtle ways to his archaism. The development of that archaism, as outlined in this chapter, will not seem purposeful because it was not. Manship had no theory, not unusual in a relatively young man; he was a blank slate, but not an unprepared one, impressionable and extremely receptive. During Manship's third and final year in Europe, his diverse impressions began to cohere and a more sophisticated and deliberate artist emerged, poised for the success that indeed became his.

Manship began his education as a sculptor in

Fig. 1. Paul Manship,
WRESTLERS, 1908.
Bronze, 12⅞ in. high.
National Museum
of American Art,
Smithsonian Institution,
bequest of Paul Manship.

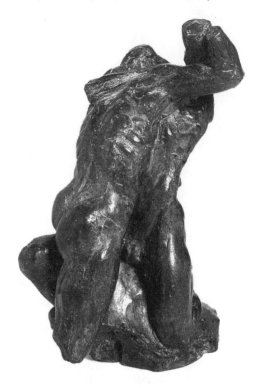

New York in 1905, after several years' experience as a commercial artist in his native Minnesota. Between 1905 and 1907, he served an apprenticeship with Solon Borglum, a well-established sculptor known chiefly for the expressive treatment of western American themes.[1] During this period, Manship advanced from near ignorance about the practice of sculpture to a state of tolerable accomplishment. He studied dissection, anatomy, and modeling; he participated in his first exhibition, at the National Academy of Design (NAD) in 1907; he received his first review; and he was continually exposed to the art and business of a successful sculptor, an opportunity unavailable to the usual art school student.[2]

By the autumn of 1907, Manship had moved to Philadelphia for study at the Pennsylvania Academy of the Fine Arts (PAFA), the nation's oldest and most prestigious art school.[3] He enrolled in life drawing with the noted painter William Merritt Chase; the "Head Class" taught by portraitists Chase, William Sergeant Kendall, and Cecilia Beaux; and life modeling with Charles Grafly, the sculptor whose reputation attracted Manship to the Academy.[4] A pair of wrestlers dated 1908, Manship's earliest surviving effort to sculpt the human figure, exhibit a lively, textural modeling that strikes a surprising note when compared with the smooth, glossy-surfaced

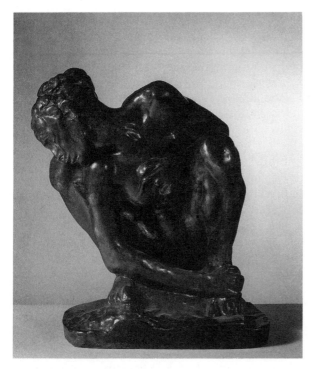

Fig. 2. Auguste Rodin,
CROUCHING WOMAN,
1880–1882.
Bronze, 12⅜ in. high.
Hirshhorn Museum and
Sculpture Garden,
Smithsonian Institution, gift
of Joseph H. Hirshhorn,
1966. Photo, Lee Stalsworth.

works of the sculptor's maturity (M7; fig. 1).[5] Manship's use of the partial figure (both wrestlers are cropped at the knees and elbows)—an expressively modern approach to figuration—seems equally alien in the context of his life's work. When the device appears in his much later *Briseis* of 1950 (M513), the proportions and smooth marble surface evoke ancient sculpture. *Wrestlers,* on the other hand, calls to mind work by the most famous modern sculptor of the day, Auguste Rodin. Rejecting pallid academic naturalism in a sustained quest for formal and emotional expressiveness, Rodin fully exploited the plasticity of the modeler's clay and unhesitatingly violated and exaggerated anatomy (fig. 2). The French-trained Borglum and Grafly undoubtedly fostered Manship's respect for Rodin; indeed, Manship later recalled wanting very much to go to Paris because "Rodin was the great teacher, the inspiring direction which young sculptors decided to follow."[6] The coincidence of roughly modeled surfaces and truncated limbs in the *Wrestlers* presents the clearest evidence that he was once under the great sculptor's spell.

After one academic year at the PAFA, Manship returned to New York, where he joined the studio of Isidore Konti. Born and trained in Vienna, Konti alone among Manship's teachers did not study in Paris, and his

work exhibits little of the tactilely expressive modeling identified with French practice. But it was compositionally dynamic, with complex, broken contours and active, spiraling figures—a rococo exuberance that Konti's American contemporaries recognized as Germanic but did not always approve. Some ten years earlier, for example, the predominantly French-trained members of the National Sculpture Society (NSS) had rallied against a proposed memorial fountain to Heinrich Heine, to be designed by Berlin sculptor Ernst Herter for the city of New York. In a public statement, NSS spokesman Frederick Ruckstull paraphrased a German architect's dismissive comment that Herter's fountain was "but a pretty porcelain design in a rococo style" and he added: "the French say that rococo means bad taste in art and architecture, and the English define it as florid, grotesque, fantastic, decayed art. The fountain lacks dignity and majesty. It is a gingerbread affair."[7] By 1908, however, a significant number of German and Austrian sculptors had emigrated to the United States and become prominent members of the sculptural community. Konti, well established among them, regularly earned high praise as "a decorative artist of unusual versatility . . . who has an instinct for decoration and a lively delight in the pure expression of line and form."[8] Konti, in other words, excelled at the type of lighthearted, fanciful subjects that Manship himself would later favor, and he exposed his pupil to a style and a sensibility quite distinct from those of the young sculptor's previous teachers.

Konti's distance from French sculptural practice has particular importance to Manship's development. Evidence suggests that he discouraged Manship's attraction to Rodin, while he very likely encouraged his pupil's entry in the competition for the sculpture fellowship to the American Academy in Rome.[9] The Academy faced an uphill battle for recognition against the much stronger reputation of Parisian training, but Konti, having spent his own final student years in Rome, had no reason to dissuade his pupil from doing the same. He would even have known something about the Academy (at a time when few artists did) because he had shared a New York studio with newly returned sculpture fellow Hermon Atkins MacNeil in 1900 and, in 1901, traveled to Rome with the then-current sculpture fellow, Charles Keck. Finally, through Karl Bitter, a fellow juror for the Architectural League's February 1909 exhibition, Konti may have been aware that the Academy's sculpture committee—on which Bitter served—was frustrated in its efforts to find a suitable candidate for the Rome prize. He knew just the man.

Manship's association with the American Academy—the single most important factor in the development of his archaism—began when he made formal application to compete for the "Prize of Rome" on 31 March 1909.[10] The relief he completed in the final stage of the competition, on the prescribed subject "Rest after Toil," is known only through a newspaper

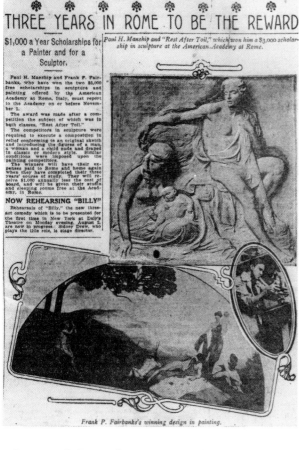

ART WORKS THAT WON PRIZES FOR THE MAKERS
❀ ❀ ❀ ❀ ❀ ❀ ❀ ❀
THREE YEARS IN ROME TO BE THE REWARD

$1,000 a Year Scholarships for a Painter and for a Sculptor.

Paul H. Manship and "Rest After Toil," which won him a $3,000 scholarship in sculpture at the American Academy at Rome.

Paul H. Manship and Frank P. Fairbanks, who have won the two $3,000 free scholarships in sculpture and painting offered by the American Academy at Rome, Italy, must report to the Academy on or before November 1.

The award was made after a competition the subject of which was in both classes, "Rest After Toil."

The competitors in sculpture were required to execute a composition in relief conforming to an original sketch and introducing the figures of a man, a woman and a child nude and draped in classic or modern style. Similar conditions were imposed upon the painting competitors.

The winners will have their expenses paid to Rome and home again when they have completed their three years' course of study. They will receive $1,000 annually less the cost of board, and will be given their studio and sleeping rooms free at the Academy, in Rome.

NOW REHEARSING "BILLY"

Rehearsals of "Billy," the new three-act comedy which is to be presented for the first time in New York at Daly's Theatre on Monday evening, August 2, are now in progress. Sidney Drew, who plays the title role, is stage director.

Frank P. Fairbanks's winning design in painting.

Fig. 3. "Art Works That Won Prizes for the Makers," newspaper clipping showing Manship's REST AFTER TOIL (destroyed by the artist), 1909. American Academy in Rome Papers, Archives of American Art, Smithsonian Institution.

photograph (M13; fig. 3).[11] Created under Konti's aegis, though not of course his immediate direction, *Rest after Toil* reveals the impact of Konti's graceful sculpture on his pupil's art. Without sacrificing plasticity, Manship deftly linked the figures across the surface of his relief by sweeping arcs of anatomy and drapery. The work is an essay in curves, eddying outward from the infant's chubby head through the enfolding protection of the mother's supple body to the man's more open, but still sheltering, posture. For the twenty-three-year-old sculptor, it was a more than creditable effort. Manship's entry obviously pleased the 1909 sculpture committee members: sculptors Karl Bitter, Herbert Adams, and Daniel Chester French (as chair); and painters Edwin Howland Blashfield and Frederic Crowninshield (soon thereafter appointed director of the Academy). They voted unanimously to award Manship the three-year fellowship to Rome.

A young artist in 1909 might well have questioned the value of this prize, for the American artist's city of choice was typically Paris. Indeed, Manship himself once admitted: "When I won the scholarship at the American Academy, I had no particular desire to go to Rome, having always looked upon Paris as the art Mecca." [12] Rome had experienced its heyday with American artists some half century earlier. In the 1850s and 1860s, sculptors, especially, had flocked to the Eternal City, where they found inspiring surroundings, an inexpensive lifestyle, abundant supply of labor and materials, and congenial fellowship with other artists in the quarter around the Piazza di Spagna. [13] By 1875, however, Paris had emerged as the vital center of European art. It offered academies and ateliers, in which the aspiring artist could seek instruction; a well-established Salon, in which to exhibit; and a lively artistic community, alert to innovation in both practice and theory. One artist, writing in 1887, credited America's artistic advancement to the influence of the Ecole des Beaux-Arts in particular and noted: "It used to be the thing for young fellows to come to Italy (Florence and Rome) but it's a singular fact that they have never since been heard of unless it be poor Hart, but what is he to St. Gaudens who went to the Beaux arts." [14]

Although by the early twentieth century, the Ecole's pedagogical domination had decreased somewhat, it remained an important ingredient in an increasingly rich artistic milieu. In the words of critic Charles Caffin: "The Institute and the Ecole des Beaux Arts perpetuate a standard, characterized by technical perfection and elegance of style, while the tendency to academic narrowness is offset by the influence of independent sculptors; for there is not a thought-wave in modern art that does not emanate from or finally reach Paris. It is the world's clearinghouse of artistic currency." [15] By 1900, the preeminence of Paris was firmly established. Young artists considered a sojourn in that city as de rigueur, whereas to go to Rome meant condemning oneself to an artistic backwater. As one artist intoned, with specific reference to the American Academy: "I pity any artist doomed to Rome for three years. Art is certainly dead there and you might as well bury him as to let him go to Rome." [16]

In selecting Rome as the site for the American Academy, the institution's founders did not propose (at least not openly) that young artists turn their backs on Paris. Most of the original organizers—including architects Charles Follen McKim and Richard H. Hunt, painters John La Farge and Francis Millet, and sculptor Augustus Saint-Gaudens—had studied in the French capital themselves and respected its superiority as a center for instruction. But they did not regard art education as their primary mission; rather, they hoped to impart the values of collaboration that had so ignited them in planning and constructing Chicago's magnificent White City: the fairgrounds for the World's Columbian Exposition of 1893 (fig. 4). The

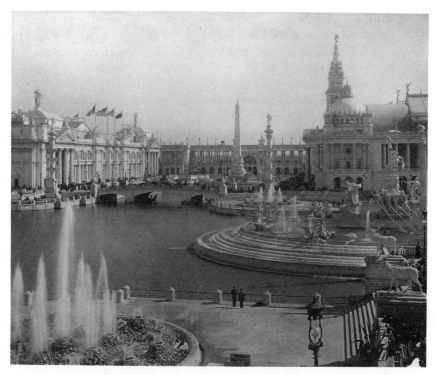

Fig. 4. World's Columbian Exposition, Chicago, 1893 (demolished). Avery Architectural and Fine Arts Library, Columbia University in the City of New York.

experience of designing that vast, but temporary, scenic display evoked for McKim and his colleagues a splendid vision of permanent White Cities, American cities made beautiful through the cooperative efforts of artists. In an age of increasing urban growth, and its manifold attendant problems, the vision was a seductive one indeed.

Rome, more than Paris, was a city that might inspire by its example. The Academy's founders observed that even the French implicitly acknowledged Rome's status by sending the nation's best art students there at government expense. For those winners of the Prix de Rome, the highest honor at the Ecole des Beaux-Arts, four years at the august Académie de France in the Villa Medici provided a final polishing; it taught them to value artistic community and exposed them to the accumulated grandeur of the greatest art of the past.[17] The prestige of this institution and its alumni, and their role in France's artistic development (at least historically), was undeniable—and irresistible to the founders of the American Academy. In their minds, for American art and architecture to secure international respect, a national institution for the arts would have to be formed in Rome, a place where America's most gifted young artists could

complete their education. With no less than the nation's artistic prestige riding on the endeavor, the fledgling Academy opened its doors in November 1894.[18]

The primary role of the Academy, as envisioned by its founders, would be to provide an education in *taste* through constant exposure to the great monuments of the past. McKim referred to the Academy as "a School of Contact and Research (not of original design)."[19] Although at first the founders disagreed over the extent of supervision fellows (all male during the Academy's early years) should have, the Academy never functioned as a school per se, having no formal program of instruction; indeed, the Academy's leaders conceded that "Paris, Munich, or London . . . may be better places for art students and architects when studying for their professions."[20] They required elected fellows to be fully trained and left them free to pursue their own work, without guidance from a professor. The Academy modeled its program after that of the French school, as the founders openly acknowledged in a general circular of 1907: "In making the rules for the government of the Academy the incorporators have followed closely in the footsteps of the Academy of France in Rome, which, from long experience and devotion to art, stands unrivalled in the world."[21] By following the French Academy's example, the Americans hoped to duplicate its success and to gain for their nation a comparable, and eventually superior, position on the world's artistic stage.[22]

Instead, for the first two decades of its existence, the American Academy experienced serious problems—most stemming from financial instability—that threatened its continued existence. Academy fellowships, for instance, lacked supporting funds. Until 1907, other institutions provided stipends through such fellowships as the McKim (Columbia) and Appleton (Harvard) for architects; the Lazarus (Metropolitan Museum) for painters; and the Rinehart (Peabody Institute) for sculptors.[23] This seemingly unexceptionable arrangement became so problematic that a former director advanced the opinion that "to receive holders of scholarships not depending on the Academy is worse than to have no scholars at all."[24] The Academy expected fellows to reside in Rome for at least half of their term but had no administrative leverage over men funded from outside sources—and many of those men had little desire to remain in Rome. Paris simply lured them away. Italy might have "more architectural precedent to the square inch . . . than to the square mile in France," but, according to one professor of architecture at the Massachusetts Institute of Technology, it lacked the pedagogical advantages of Paris: "The trouble has been that the stronger the student we send forth, the more he wants to go where the strong men are and he steers for the Beaux Arts—he is sure to feel that here is the only place to study method and that it is his one opportunity, while style is a personal matter which he will pick up later by himself."[25]

At issue was the very nature of the Academy's role: was it to be little more than a convenient *pied-à-terre* for the traveling artist, or should it play an active role in molding his tastes and interests? The Academy's founders clearly envisioned the latter.

By 1906, the establishment of a stable group of Academy fellows loomed as a matter of vital priority.[26] Director George Breck warned executive secretary Francis Millet: "Our hold on the students now affiliated with the Academy is slight; . . . We have no control over any students except our own and we have none of our own! . . . We need to inculcate the love for Italy. Paris is the loadstone that attracts."[27] In response to his plea, the Academy dug into its recently acquired endowment funds and, in late 1906, appointed three men to fellowships.

Architect Harry Warren was a known quantity, having already spent two years in Rome as an Appleton scholar, but the other fellows proved far from the model academicians the trustees had sought. Italy "bewildered and upset" sculptor Charles Harvey, plucked from his position as a studio assistant to Saint-Gaudens, and left painter Barry Faulkner indifferent.[28] At the end of their tenure, in 1909, the newly installed director, Frederic Crowninshield, advised withholding their final allowances on the grounds that "neither of them has heeded in the least the rules of the Academy."[29] Although the second group of fellows, whose terms began in January 1908, proved more satisfactory in the long run, the selection process did not meet official expectations. Competitions held in the United States and Paris (on the theory that more experienced students congregated there) yielded no painter worthy of the appointment, and officials again directly appointed the sculptor, Sherry Fry.[30] The alarming fact was that sufficiently qualified artists, regardless of their place of residence, did not respond to the call for applicants.

Competitions for the year 1909 began in mid-1908 and, by late autumn, resulted in the selection of architect Ernest Williams. Only a few artists applied for the painting and sculpture positions, all judged insufficiently well trained to receive fellowships.[31] This time, the officials were determined to follow established procedures and, in February 1909, restaged the competition. Among eighteen painting applicants, ten gained admission to the preliminaries and four to the finals before Frank Fairbanks emerged the winner. Five sculptors applied, four competed in the preliminaries, and two in the finals. The prize, as we have seen, was awarded to Manship.

Manship began his fellowship during a time of considerable turmoil at the Academy. McKim's death in September 1909 had deprived the institution of its guiding spirit, even though by that time the capable and dedicated Millet had in large measure assumed the major administrative burdens. A change in leadership occurred in Rome as well, at a level experienced more directly by the fellows, with the inauguration of Frederic

Crowninshield as director in October 1909. That same month, the Academy received through bequest a villa on the Janiculum Hill, renewing a long-standing debate as to what constituted suitable quarters for the institution. Finally, and partly in anticipation of a move, the Academy reestablished association with the American School of Classical Studies, an uneasy earlier partner. Disagreement with the trustees over the latter two issues would eventually drive Crowninshield from the directorship, even before the end of Manship's three-year term. Closer examination of some of these matters must be interwoven with the few known facts relating specifically to Manship's work and study in Rome if the conditions under which his archaistic style developed are to be understood fully.

Manship departed the United States aboard the *Lusitania* in early October 1909 and traveled for a month before reporting to Rome.[32] Naturally, he went to Paris, which he pronounced "a wonderful city! One that is finished and polished—brilliant yet showing a deep strata of degeneracy" (though he did not articulate what he meant by that).[33] At the Louvre Manship confessed to spending "most of the time with the pictures." Among the ancient sculptures, his preferences were conventional and do not anticipate his later interest in archaic art; he particularly liked "the beautiful Venus de Milo" and the "grand yet refined" Victory of Samothrace: "She appeals more deeply to my imagination than the Venus— more to my aesthetic sense." Manship also took the opportunity to see work by some of the modern masters. He found Rodin disappointing, but much admired the work of Constantin Meunier, which he saw in Belgium but undoubtedly knew already from the many published tributes that appeared after Meunier's death in 1905.[34] Meunier's close identification with themes of labor must have interested the young American, who had earlier exhibited the sculpture of animal labor entitled *Pulling*. In one of his first Roman works, *End of Day* (1909; M10; fig. 5), Manship continued the labor theme, combining the paired horses from *Pulling* (now at rest) with the figure of a weary man, whose accentuated contrapposto visually recalls Meunier's well-known *Stevedore,* though expressing fatigue rather than the latter's braggadocio (fig 6).[35]

On November 1, Manship reported to the Academy, housed since 1907 in the seventy-room Villa Mirafiori, located on the Via Nomentana in a new suburb of Rome and a full two-and-a-half miles from the city's center (fig. 7). Manship's arrival followed by only one month that of Crowninshield, the Academy's new director, to whom the trustees looked to stamp out "discontent and insubordination" among the fellows. In particular, they charged his regime with correcting a situation that appalled official visitors to the Academy, including Millet, who exclaimed in 1908: "No one really takes advantage of their surroundings. They sit in bare studios

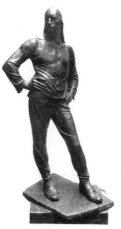

Fig. 5. Paul Manship, END OF DAY, 1909. Terracotta, 8¹³⁄₁₆ in. high.
National Museum of American Art, Smithsonian Institution,
gift of Paul Manship.

Fig. 6. Constantin Meunier,
STEVEDORE, 1885.
Bronze, 19 in. high.
Museum of Fine Arts,
Antwerp.

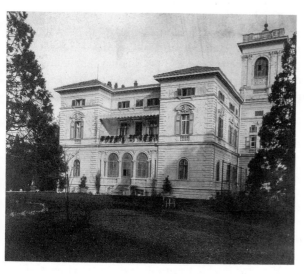

Fig. 7. Villa Mirafiori,
Rome. American Academy
in Rome Papers, Archives
of American Art,
Smithsonian Institution.

Fig. 8. Group of Academy
Fellows, ca. 1909. American
Academy in Rome Papers,
Archives of American Art,
Smithsonian Institution.

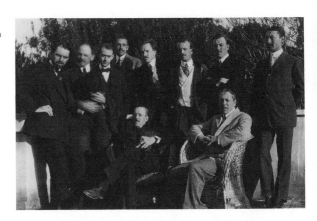

and try to be original!! Wow! it makes me sick."[36] A year later, one officer
heartily agreed: "I do hope that, as you say he will, Crowninshield will
insist upon the outside work of the students, and will make them under-
stand that what they are expected to do is to study on the spot the works
of the past, whether of architecture, painting, or sculpture. . . . What are
they there for?"[37] Such official frustrations highlight how dramatically
conceptions of artistic creativity had changed in a generation. The Acade-
my's founders stood firmly behind tradition and endorsed close study of
past art as a necessary path to achievement and originality. The fellows im-
plicitly rejected this idea; in modernist terms, the pursuit of originality
required them to do precisely what Millet so passionately decried: to "sit
in bare studios and try to be original," that is, to seek inspiration from
within themselves.

From an official point of view, at any rate, the students wasted a lot of
time (figs. 8, 9).[38] The first Academy fellows, in whom the trustees had
placed so much hope, attracted particular criticism for resisting not only
Rome, but also contact with each other. As Crowninshield reported, they
"apparently have done pretty much what they please"; but he pointedly
added: "When a man has a studio from 2 to 3 miles from the villa—being
visible only in the evening, and then not seen unless summoned—*que vou-
lez vous?*"[39] The insufficiency of studios to accommodate all the fellows at
the Villa left the previous director unable to monitor their activities and
inhibited the development of a sense of artistic community. Such were the
perceived dangers of this situation that Millet had warned, in 1908: "The
only thing that will save us is studios in the villa grounds. . . . The men
lose all the advantage of intimate association with each other by being so
far away."[40] Thus, by the spring of 1909, a garage/stable on the property

Fig. 9. Scrapbook page with snapshots of Academy Fellows, ca. 1909. American Academy in Rome Papers, Archives of American Art, Smithsonian Institution.

had been converted into three studios of "a good average Roman size, larger than those of the French Academy, larger than . . . most young artists of New York could afford in a city like New York" (fig. 10).[41] Two were reserved for painters and one for a sculptor, with Manship its first occupant (fig. 11).

Fewer than two weeks after his arrival in Rome, Manship reported, with some sense of exasperation: "I am finally getting settled down to work. I have had considerable difficulty in getting my studio into workable condition, it being newly constructed."[42] The possibility of a commission for a monument to the late governor of Minnesota, John A. Johnson, preoccupied Manship during his first few months in Rome, and the difficulties he encountered in working on it proved the trustees' wisdom in building studios on the villa grounds. As Manship explained to Konti:

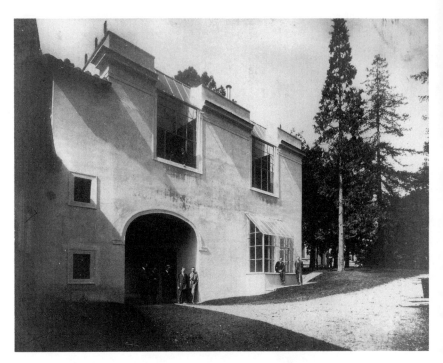

Fig. 10. Studio building, Villa Mirafiori, Rome, ca. 1909. American Academy in Rome Papers, Archives of American Art, Smithsonian Institution.

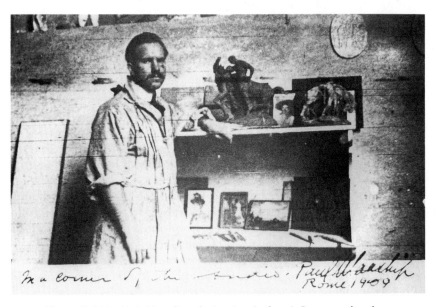

Fig. 11. Paul Manship in his studio at the American Academy in Rome, 1909 [1910]. Photo courtesy of the Minnesota Museum of Art.

"Mr. Crowninshield's studio is just above mine and he is liable to drop in at any minute. . . . But just today a friend has offered me the use of his studio on Via Margutta in the mornings & I shall quickly get it done & have no fear of being caught."[43] At the same time, Manship acknowledged that such professional gratification as would accompany success in the Johnson competition could come only at the cost of his fellowship, and that, he recognized, would be dear:

I seem to have every prospect of an assured future, if I conclude meritori-ously this scholarship, from the patronage of those prominent men who are back of this academy. This is more evident to me each day. If I should give it up I fear that I shall be in a less favorable position than if I had never entered it. To win this competition . . . would give me great satisfaction of the sort which early opportunity to construct a public monument presents—I should be able to make some money out of it. . . . But is it worth the prospects which are balanced in the other hand? In three years here I shall undoubtedly do much and gain a thorough training for the large work which the future may present. It might be that at no other time shall I have the opportunity to thus equip myself and I am just at the age when it will do me most good.[44]

Manship's overoptimism regarding his chances for the commission may owe something to his status as a native Minnesotan and his fortuitous re-cruitment, while on a brief visit to Saint Paul in 1909, to take a death mask of the governor.[45] Surely he would have flinched to know of the letter to Solon Borglum (a competitor) stating: "The commission has been both-ered somewhat by what might be classed as amateurs, people of the state who feel qualified to do the work."[46] Manship's hubris, if somewhat unap-pealing, is that of a young man basking in a recent success—receipt of the Rome prize—whereas his calculations, however mercenary, would only have pleased the Academy's officers, had they been privy to his letter. Full of what might be generously interpreted as anticipatory gratitude, Man-ship reaches the "right" conclusion—stay—apparently confirming both Crowninshield's efficacy as director and his own mettle. Indeed, as one of the first fellows to take advantage of all that the Academy and the city of Rome could offer, he was a young man in whom the trustees could rejoice.

Manship's receptivity to Rome, and thus his fulfillment of official expec-tations, must in large measure have arisen of his own curiosity. Again, to judge from the lamentations of the Academy's officers, the institution had proved singularly unsuccessful in forcing enlightenment on the fellows. The Academy's goals simply did not translate into a specific and easily fol-lowed procedure. It was simple enough to recommend that the fellows gain a rudimentary knowledge of Italian prior to departure and that sculp-tors and painters familiarize themselves with the basic elements of archi-tecture, but what program were they to follow in Rome?

Above all, the Academy expected its fellows to immerse themselves in their surroundings; indeed, to encourage that activity lay at the heart of the institution's mission, according to its vice-president: "The Academy should devote much time to the development of the beneficiaries' faculty for observation, to the expansion of his mental horizon, to his historical knowledge of the work of the Masters; for example, as to *why* certain construction, and designs in painting and sculpture, were selected for adaptation to certain places, etc., etc. In other words, to turn out thinking men as well as skillful ones."[47] But the Academy hindered its cause in failing to communicate its basic mission to the fellows. On his visit to Rome in March 1910, Frank Miles Day, though pleasantly surprised to find the fellows "a serious body of men, and rather more mature than [he] had expected them to be," received the decided impression that they "had not attained altogether a clear conception of the reasons for the founding of the Academy, or perhaps just what it stood for." He undertook to enlighten them, dwelling "particularly on the relationship of the three arts" and reading over "the whole of our rules relating to the curriculum."[48] What he meant by "rules" is unclear, since (according to a circular dated 1910) the Academy had "no staff of instructors and does not aim to teach technique, method or processes." In all likelihood Day emphasized the importance of observation and research over the production of original works, but he might further have reminded the fellows of the mandatory projects and travel associated with each year of study.

For the sculpture fellow, the first year required a relief with at least two figures; the second year, a single figure in the round of nearly life size; and, the third, a large sculpture in the round of no fewer than two figures, nude or partly draped. French pensioners followed the same program, with the addition of a fourth year in Rome, during which they translated the previous year's work into marble. Collaborative projects—assigned annually to teams comprising an architect, a sculptor, and a painter of different fellowship years—supplemented individual work at the Academy. Finally, the fellows followed loosely outlined travel itineraries, generally confined to central Italy in the first year, but expanded to other parts of Europe in the second, and—of great and lasting significance for Manship—Greece in the third.

For his first-year project, Manship created a life-sized relief of a centaur and a nymph dancing, known only through photographs (M14; fig. 12).[49] Its dynamic composition features a nymph balanced tiptoe on one foot as she dances away from the centaur, a crossed configuration reminiscent of Greek metopes.[50] However, the exuberant theme and mood and the full, smoothly modeled figures (in very high relief) more strongly evoke the joyous bacchanals of French rococo-revivalists Carrier-Belleuse or Clésin-

Fig. 12. Paul Manship,
WOOD NYMPH'S DANCE,
1910. Plaster, life size
(destroyed by the artist).
Photo courtesy of
John Manship.

ger, or the more immediate precedent of Manship's teacher Konti. Meta-phorically, the lighthearted subject reveals a newly confident sculptor, one who has left behind the artistic struggles that were expressed thematically—as well as being evident artistically—in such early works as *Pulling, Wrestlers, Rest after Toil,* and *End of Day.* Manship's *Wood Nymph's Dance* represents a significant break from his more prosaic themes of labor and inaugurates his love affair with playful subjects from antiquity.

Manship had certainly started to look closely at, and take inspiration from, ancient art. As he wrote to Konti: "My relief is coming along so-so. I sometimes get very discouraged but when I go & study the antique at the galleries I am much encouraged & come home and tear the thing down & sail into it anew."[51] Manship's correspondence documents repeated visits to the Capitoline Museum, where the collections particularly impressed him, but such mention of specific museums or works occurs only rarely. Nevertheless, the decisive change in Manship's style by the end of his fellowship testifies to his newfound allegiance to the art of antiquity.

By the spring of 1910, Manship had decided to elaborate his relief to make a fountain with accessory groups, but, by the fall, he had reworked the piece yet again.[52] In the aftermath of a summer's travel (probably con-

centrated in Italy), he felt able to approach it "with a fresh eye" and reported that "many things have been changed & corrected. I sincerely hope to get something out of it that shall be a credit to me."[53] With the freedom permitted by his fellowship, Manship tended to rework his compositions repeatedly. The first-year relief had "undergone many changes—good, bad, or indifferent," when finally, in the fall of 1910, he wrote: "I am going to have the damn thing cast [in plaster] in a few days & get rid of it."[54]

By that time, Manship had started work on his second year's project, the life-sized *Duck Girl* (M16; fig. 13), for which he won the Widener Prize at the Pennsylvania Academy of the Fine Arts in 1914. He was especially pleased with his model and delighted that she posed well, having dismissed a previous model because "when she wasn't resting she was complaining of the pose." He added: "that is all right when it comes to learning Italian, but I want to work."[55] Its naturalism notwithstanding, Manship clearly based the *Duck Girl* on an elegant Hellenistic bronze of a youth, long identified as Narcissus, from the Museo Nazionale in Naples (fig. 14).[56] The museum considered the *"Narcissus,"* found in a Pompeian house in 1862, a gem of its superb ancient bronze collection, and reproductions of the work found their way into numerous Victorian parlors.[57] In the broader cultural context, therefore, Manship's admiration for the sculpture seems unexceptional, but at this point in his career, the debt is a matter of note; prior to this time he had not drawn heavily on ancient art. Manship had been spared academic study from casts by his apprenticeships, the first of which prepared him sufficiently to bypass that aspect of the PAFA's curriculum. Thus, one writer asserted, Manship escaped stale academicism: "He placed himself in direct contact with the best of the ancient world," having "not previously been controlled by misguided conceptions" of it.[58] In short, the young sculptor approached the art of antiquity with an unusual lack of prejudice; this made possible his receptivity to preclassical art and accounts in part for the vigor of his first archaistic sculptures. By virtue of the ancient source alone, the *Duck Girl* brings us closer to Manship's archaism; however, the source of inspiration is Hellenistic, a relatively dynamic, "baroque" phase of ancient sculpture and thus a logical step from his first-year relief, with its neobaroque antecedents. Manship in fact increased the movement barely suggested in the prototype by transforming the nude youth into a graceful girl wearing a light, swinging chiton.

The *Duck Girl* also signals Manship's discovery of a technique that would serve him well in his later, more stylized, archaizing sculptures: he used the plaster cast, rather than clay, as his working model. Manship explained this method in a paper delivered at the Art Students League in 1915: "It seems to me that the plaster offers decided advantages for manipulation

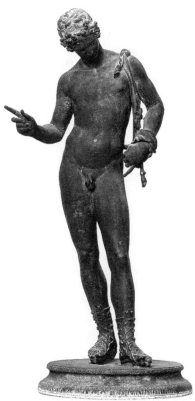

Fig. 13. Paul Manship, DUCK GIRL, 1910. Bronze, 56 in. high. Catalogue and Yearbook of the Architectural League of New York, 1913.

Fig. 14. "NARCISSUS," fourth century B.C.(?). Bronze, 25 in. high. Museo Nazionale, Naples. Photo, Hirmer Verlag, Munich.

over the original clay model. The clay, through its plasticity, serves best for the blocking out of the masses. . . . The next stage, the plaster cast, the ground work or the construction having been built up, one may proceed with this still more or less modelable material, to the refinement in correction of form and delineation of contours and details."[59] Eventually Manship started carving inside the negative plaster mold, a practice that permitted the incision of fine lines for strands of hair and other crisp details distinctive to his style. He brought such details to their fullest clarity by carving also on the fine plaster, positive cast. Using his new method of carving in plaster, Manship made a pedestal for the *Duck Girl,* which he intended as a fountain. This base has one of the artist's most whimsical motifs: a fish and swag alternation, with water for the fountain basin issu-

ing from the fishes' mouths. The plaster helped him to refine the details and, although still "fussing over it a deuce of a lot" as late as the spring of 1912, Manship could take pleasure in "a most complimentary letter" on his work from Daniel Chester French, a recent visitor to the Academy.[60]

By the autumn of 1911, Manship had traveled extensively, studying art throughout Europe.[61] In that year as well, Rome hosted an international exposition, at which—in advance of his first trip to Greece in 1912—Manship would have seen notable examples of archaic sculpture (albeit mostly in the form of casts), including thirteen of the korai excavated from the Acropolis in 1886.[62] He also had the opportunity to review more modern work, since most major countries hosted exhibitions of contemporary art, either in their national pavilions or in the Palazzo delle Belle Arti devoted to that purpose.

The German pavilion, for example, housed sculptures by Franz von Stuck, whose sleek mythological creatures anticipate Manship's archaistic statuettes in both theme and style. Another exhibitor, Adolf von Hildebrand, had attracted international attention as author of the influential book *Das Problem der Form in der bildenden Kunst* (1893; English translation, *The Problem of Form in Painting and Sculpture,* 1907). An outspoken opponent of academic illusionism and Rodinesque impressionism, Hildebrand sought a corrective to the pictorial confusion of contemporary modeled sculpture. He recommended a return to the basic processes of sculpture and specifically to direct carving, a method he believed most productive of unity between artistic conception and representation.[63] Though hardly an intellectual, Manship was not immune to such concerns, as his increasing crispness of style and experiments with carving in plaster suggest. At the exhibition, Hildebrand showed only portraits, these considerably more conservative in appearance than his ideas would suggest; still, as one of Germany's best-known sculptors, he undoubtedly attracted Manship's notice. Another prominent German sculptor, Franz Metzner, exhibited with members of the Vienna Secession in Josef Hoffmann's Austrian pavilion. If Hildebrand's recommended method of direct carving amounted to a technical archaism, Metzner's sculpture manifested a visual archaism, which employed stylization and linearity in the service of architectonic monumentality. He, more directly than Hildebrand, sought inspiration for this endeavor in the art of early Greece and the ancient Near East.[64]

By many accounts, the Exposition's "chief revelation" was the "amazing genius" of the Serbian sculptor Ivan Meštrović.[65] Although he had previously exhibited in Paris (attracting the support of Rodin) and with the Secession in Vienna, Meštrović first attracted international acclaim in Rome, where he showed over seventy works and won first prize for sculpture. Over half of his exhibition comprised the thematically united "Fragments

of the Temple of Kosovo," commemorating the fall of the Serbian empire to the Turks at the battle of Kosovo in 1389.[66] Much of Meštrović's work during this period addressed the cause of Serbian nationalism, and there seems little question that increasing ferment in the Balkan states contributed to the public's interest in his sculpture.[67] But Manship must have found Meštrović's formal evocation of Egyptian, Assyrian, and archaic Greek art equally intriguing.[68] Meštrović frequently used archaic conventions for such details as hair and drapery, as in the marble relief *Dancer,* exhibited in Rome, or the wooden *Caryatid* (fig. 15); Manship would later do the same. However, the Serbian's preference for unusual postures and contortions and his willful distortion of anatomy for formal purposes bespeak a more radical approach to sculpture than Manship favored. Still, the simplification and stylization of natural form in Meštrović's sculpture may well have encouraged Manship's subsequent borrowing from archaic art.

Except for his complaint that the Exposition was "on the whole very poor in modern art," Manship limited his written impressions of the event to comments on the American pavilion.[69] Using characteristically blunt language, he was harsh in condemning both the building, designed by Carrère and Hastings, and the exhibits within: "The Sculpture show at the Amer. pavilion is very rotten with the exceptions of a few works; indeed the whole American show is a sort of a joke and only fit to be in the stinking pavilion that has been built for it; it is indeed a disgrace to the artists of the United States. The house that has been built looks more like a garage than anything else—and in comparison with the pavilions of the other countries is awful. Many people mistake it for a public latrine and only for that reason do they go there."[70] Manship, unfortunately, did not specify which works he found so objectionable among the 176 American sculptures listed in the *Catalogo della Mostra di Belle Arti,* which encompassed exhibits in the Palazzo delle Belle Arti as well as in the individual national pavilions. The comprehensive display included works by such notable sculptors as John Quincy Adams Ward, Augustus Saint-Gaudens, and Daniel Chester French, as well as by Manship's teachers Borglum and Konti.[71]

October 1911 marked the closing of the International Exposition and the beginning of Manship's final year at the Academy. His principal project, a heroic-sized sculpture entitled *Mask of Silenus* (M20; fig. 16), shows a man with a grotesque mask teasing a child. The motif recalls Lysippos's Silenus with a baby, of which a good copy existed in the Vatican, or Praxiteles's well-known Hermes with the infant Dionysus (see fig. 19), a reputed Greek original which Manship studied in Greece in 1912. In the lecture he gave immediately following this trip, Manship confessed that the Hermes had suffered in his estimation by comparison with the preclassical figures from the Temple of Zeus at Olympia, housed at the site in the same museum as

the Hermes. There is no question that his preferences in Greek art shifted radically around this time. Manship drew attention to his new artistic allegiance when he incorporated into his third-year project the decidedly archaic mask that provides the work with its name and narrative focus.[72] This appropriation from archaic art, especially from its more decorative forms (the mask is probably based on a late-sixth-century antefix, an architectural ornament, of which fig. 44 is an example), marks the beginning of Manship's archaistic style, soon to be realized more successfully in statuette form.[73] Indeed, one might say that his exposure to preclassical Greek art unleashed his particular talent for creating playful and decorative statuettes. That, at any rate, was the opinion of Manship's dealer, Martin Birnbaum, who later concluded that Manship "found himself only after he began to appreciate the Greek primitives. He approached the grander and more profound forms of Hellenistic art through the study of those minute fragments which reveal the simpler and lighter phases of the classic spirit. A little head spouting water [that is, an antefix], an intense painting on a vase, a carved intaglio, a precious coin, the exquisite bronze claw of some

Fig. 16. Paul Manship,
MASK OF SILENUS, 1912.
Plaster, over life size
(destroyed by the artist).
Catalogue and Yearbook of
the Architectural League
of New York, 1913.

animal,—these humbler forms helped him to analyze the nobler secrets of the ancients." [74]

Over the course of his third year at the Academy, Manship's respect for ancient art increased dramatically: "Every day I seem to appreciate more and more the beauties of the antique and wonder why no greater sculpture is being made today with that fine inspiration of form and ideality." [75] He had had ample opportunity for study in the museums of Rome, to which he earlier mentioned turning for inspiration, and saw much more during his travels and at the International Exposition. But there was another, less concrete though no less suggestive, stimulus to Manship's fascination with Greek art: the increasing rapprochement, and eventual consolidation, of the American Academy and the American School of Classical Studies in Rome. As a much-debated issue during Manship's tenure, one that concerned the Academy's mission and even its survival, this relationship bears closer investigation.

Established within a year of one another, the two schools considered an early merger and briefly shared quarters in the Casino dell' Aurora on the

Pincian Hill in 1895–1896. At that time, the American School of Architecture (as the Academy was originally called) had three fellows and the School of Classical Studies only two. In November 1895, McKim reported hopefully that "it has already become apparent that their interests are so much in common that mutual benefits accrue from this close association."[76] In Rome, the director of the architecture school, Austin Lord, described a rather different situation. He complained that the vast majority of books in the shared library (one of the perceived "mutual benefits") were both unrelated to architecture and inaccessible because written in Greek and Latin. He should hardly have faulted the archaeologists for the excellence of their library, but any hint of superiority on the other side—an attitude he detected and complained about in the two classics professors—clearly bothered him.[77] The experiment failed and cooperation ended when the School of Classical Studies moved out in 1896.

In 1909, Millet again broached the possibility of joining in "some friendly sort of cooperation" with the School, and a resolution to bring this about gained approval from the Academy's Executive Committee.[78] As he argued to William Rutherford Mead in 1910: "Archaeology is a necessary part of the curriculum of any art school. You must know about the past and if you have not archaeology how can you know about it?"[79] Given the recent difficulties with errant fellows, it is impossible not to interpret the proposed alliance as a way of combating the fellows' stubborn provincialism and expanding their artistic awareness. Thus, painter Edwin Howland Blashfield confessed to Mead that, though he had not always favored amalgamation,

> the experience gained in the judging of competitions and a gradually growing acquaintance with the material from which we recruit our young men has completely changed my opinion.
>
> I now believe that the establishment of all round culture upon the basis of agreement between artists and *scholars* is the only thing that will save American art as applied to public works.[80]

Not everyone maintained a positive attitude toward scholarly pursuits. Director Crowninshield, for one, expressed complete incomprehension as to why the Academy wanted "to tag the lovely, liberal, temperamental arts with an infernal, complicated, pedantic academic which is entirely alien to our mode of thought and action." He pointed out that no precedent existed among Rome's other national institutions (no doubt in appeal to the founders' desire to follow in established footsteps) and argued that continued separation did not prevent cooperation. He added, however, that although the fellows "have the run gratis of the very best lectures imaginable, . . . they want none of them. Occasionally I drive one or two of them

to a discourse. But if any sacrifice of time or strength has to be made in the way of attending these lectures, I am the victim."[81] If anything, Crowninshield's remarks must have given proponents of consolidation, who believed the fine arts fellows ignorant of art history, more reason than ever to support it.

The Academy's most pressing reason to merge with the School involved its financial security and thus its very future. The institutions shared a major benefactor in J. Pierpont Morgan, and consolidation, as Blashfield bluntly stated, was "first and foremost the policy of Mr. Morgan."[82] After the Academy received the Villa Aurelia through bequest in 1909, Morgan secretly began buying adjacent properties on the Janiculum Hill to facilitate not only expansion of the Academy, but also its physical merger with the School. The eventual consolidation agreement of January 1911 undoubtedly proceeded in large measure from the need of both institutions to preserve Morgan's essential role as benefactor. In humorous acknowledgment of his importance, while punning at the expense of the less heavily endowed classical school, Crowninshield's successor dubbed the union of the two schools "a Morganatic Marriage."[83]

Before the merger could proceed, a new director for the combined schools had to be found. Crowninshield was out of the question because he opposed both consolidation and the move to the Villa Aurelia; this unpopular position eventually impelled his resignation as director of the Academy. Gorham Phillips Stevens, an architect with the firm of McKim, Mead, and White, who had an interest in Greek archaeology, took Crowninshield's place in January 1912. At the same time, Millet accepted executive directorship of the soon-to-be-combined institutions; but, in yet another blow to the Academy's stability, he died in the sinking of the *Titanic* in April 1912. His successor (and Morgan's original choice for executive director), head of the classical school Jesse Benedict Carter, faced opposition from artists and classicists alike. The former feared Carter would not be sensitive to art students; the latter complained about his weak standing as an archaeologist. Nevertheless, with the survival of both schools at stake, the officers had to satisfy Morgan and so Carter remained.[84] Legal consolidation finally took place on January 1, 1913, thereafter uniting a School of Fine Arts and a School of Classical Studies under the name American Academy in Rome.

The impending merger fostered a new spirit of cooperation between the artists and the archaeologists. Director Stevens reported accompanying some of the fellows to the classical school library soon after his arrival in January 1912, and he surely encouraged them to attend lectures by the School's director and staff archaeologists, as well as by visiting scholars. In January 1912, for example, Director Carter, a popular speaker, presented a

series of lectures on Greek sculpture in Roman museums.[85] But Academy fellows and personnel of the School had more focused interaction, according to Stevens: "All sorts of interesting things are happening here. [Frederick] Stahr [the Lazarus Fellow] is starting some sketches of Homer reciting poetry to an audience of men and women clad in Mycenaean costumes and in consequence the archaeological school is all stirred up. Van Buren [professor at the School] has been of great help."[86] This report does more than testify to close contact between the artists and archaeologists; it also identifies preclassical art as their object of interest, at just the time when Manship's fascination with the archaic developed. "I am at present quite crazy about the Early Greek Art," he declared to Konti in the spring of 1912.[87] Soon thereafter Manship embarked on his first trip to Greece.

Detailed information about Manship's six-week visit to Greece is not available, but drawings document visits to the major sanctuaries and museums at Athens, Olympia, and Delphi (fig. 17). The Director's Report for 1912–1913 noted that Manship "devoted as much study to architecture and architectural ornament as to sculpture," an observation borne out by full-sized renderings of architectural details from the Parthenon and the Erechtheion in Athens and the Treasury of the Siphnians at Delphi (fig. 18).[88] Manship described the Treasury in an encyclopedia entry he composed many years later:

> With the building of the Siphnian Treasury at Delphi (530 B.C.) sculptural decoration of architecture advanced in originality of conception and freedom of style, though still archaic and not completely liberated from Asiatic traditions. The caryatids which support the entablature of the façade are statues of luxurious rhythms and sensuous forms. The building, although small, is a rare masterpiece of harmonious unity in which sculpture complements the abstract beauty of the architectural proportions. The frieze of the entablature . . . is one of the great sculptural compositions surviving from that age. . . . The design has clarity, spirit and distinction in its ensemble, as well as consummate rendering of detail. The ornamental motifs on the mouldings are carved with the same consideration for beauty of form as the figures themselves.[89]

As his last sentence suggests, Manship attributed the successful integration of the arts on any archaic monument to fundamental affinities of style and approach. He made this quite clear in a lecture entitled "The Decorative Value of Greek Sculpture," presented at the Academy immediately following his return from Greece: "Statues seem drawn with the straight edge of the architect. Architectural details . . . are rendered with the same sensitive & decorative feeling for form that characterizes the sculpture. . . . vases are composed and painted with the same taste, the same drawing, the same fundamental ideas of composition that are the principles of the sister arts."[90]

Fig. 17. Paul Manship, GREEK VASE
(drawing of a black-figure vase
in the National Museum, Athens), 22 April 1912.
Pencil on paper, 8½ × 6 in.
National Museum of American Art,
Smithsonian Institution,
bequest of Paul Manship.

Fig. 18. Paul Manship, FRIEZE DETAIL FROM THE
TREASURY OF THE SIPHNIANS, Delphi, 1912.
Pencil and pale brown wash on cream wove
paper, 8½ × 6¼ in. Bequest of the Estate
of Paul Howard Manship, Collection,
Minnesota Museum of Art, St. Paul, 66.14.152a.
Photo, Shin Koyama, Minneapolis.

Throughout his career, Manship spoke out on the importance of the decorative relationship between painting, sculpture, and architecture, and on the benefits of artistic collaboration. He repeatedly named as one of the greatest advantages of a fellowship at the Academy the opportunity to work in close association with other artists.[91] This association was not only proximate but actual, since the Academy required annual collaborative projects of its fellows. By the same token, Manship believed that the sculptor could contribute much to the effective realization of larger undertakings and should never be satisfied merely to embellish someone else's design. The American Academy's founders set about to promote collaboration among artists and with Manship they succeeded. However, Manship's especially strong response to the "harmonious unity" of early Greek art may have awakened his sensitivity to the interrelationship of the arts even more than did the Academy's teaching.

As Manship traveled in Greece, examples of preclassical sculpture captured his attention most of all. On his return, he praised this art at length

in a lecture that Director Stevens later remembered as "one of the best conferences [Stevens] ever had."[92] Manship's description of his experiences at the museum in Olympia effectively records his shift in allegiance from the acknowledged masterpieces of later periods to earlier Greek art. The Hermes of Praxiteles, a work "considered by many to be the most beautiful marble from ancient times," he found "not all that [he] had expected" (fig. 19). He praised its modeling, spirit, and proportions, its "graceful lines" and "beautifully curved forms," and its excellent preservation.[93] "What more could be said to extol this masterpiece of masterpieces," he asked. Then he admitted: "withal I *was* disappointed, for I had been wrapt in appreciation for those sculptures from the pediments & from the metopes of the Temple of Zeus at Olympia, which are set in the Hall next to it" (fig. 20).[94]

Manship continued by making specific comparisons between the works. He conceded that the earlier figures might be faulted on numerous grounds and that they did not match the Hermes for realism or subtlety of handling; yet he found the "grace & beauty" of Praxiteles's work "soft & effeminate beside these vigorously severe figures of the Zeus temple." Ultimately, he concluded: "The very facility of Praxiteles seems to count against him for his soft flowing forms are lacking in the energy of the cruder expressions of the Early Fifth Century . . . [in which] the impression is one of bold simplicity & vigor." He further noted: "To see these groups alone is worthwhile a trip across the world."[95]

Among other works seen during his tour of Greece and discussed in his lecture, Manship praised the "aristocratic dignity and distinction" of the famous bronze Charioteer at Delphi, whose maker "guided his tool with the precision of a goldsmith" (fig. 21). In Athens, he closely studied the archaic korai excavated from the Acropolis in the 1880s, recording the painted designs still visible on a few of them (fig. 22).[96] He spoke with admiration of "the balance of conservatism which is felt in the early statues in every regard, from expression to the composition of drapery where severity & conventionalizing of form gave dignity & restfulness to the figures."[97]

By and large, popular handbooks of Manship's day did not express the same admiration for early Greek art. In 1904, for example, Russell Sturgis stated: "There is still a whole class of sculpture . . . which is undoubtedly original, and Greek, but not of supreme excellence. This is the archaic."[98] Sturgis included the pedimental groups from the Zeus temple at Olympia in the category of archaic, as did Manship.[99] Manship, well aware that his new artistic allegiance might not be shared, suggested that the appreciation of archaic art requires patience and attentiveness. When one is accustomed to the technical mastery of "the more florid" Hellenistic art, he told his audience, the early works, with their "reposeful beauty," "sometimes do

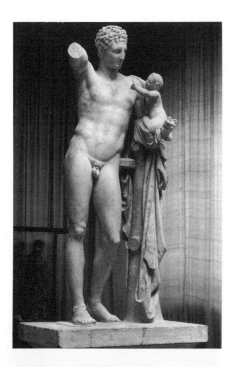

Fig. 19. Ascribed by
Pausanias to Praxiteles,
Hermes with the Infant
Dionysus, ca. 340 B.C.
Marble, 84 in. high.
Museum, Olympia. Photo,
Hirmer Verlag, Munich.

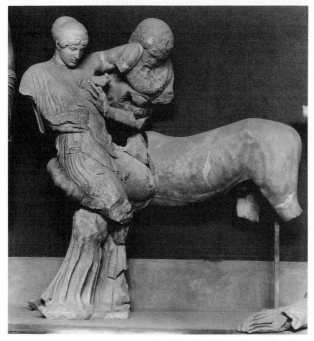

Fig. 20. Centaur with Lapith
Woman, from the west
pediment, Temple of Zeus,
Olympia, ca. 471–457 B.C.
Marble, 92 in. high.
Museum, Olympia. Photo,
Hirmer Verlag, Munich.

Fig. 21. Charioteer, from
the Sanctuary of Apollo,
Delphi, ca. 470 B.C.
Bronze, 70 in. high.
Museum, Delphi.
Photo, Hirmer Verlag,
Munich.

Fig. 22. Kore 594,
ca. 500 B.C.
Marble, 48½ in. high.
Acropolis Museum, Athens.
Photo, DAI Athens, 72/2918.

not at first appeal to us—they may be stiff in pose & expression; the forms are often curiously & unrealistically rendered." But, he submitted, "their appeal is not to our dramatic sense nor is it superficial. It is a deeper chord that is struck & a tone to which we can respond." Manship clearly did respond to that deeper chord. "He who loves beauty for beauty's sake," he concluded, "will ever [go] back to those early works of the primitives."[100]

Thus, Manship's trip to Greece and his exposure to large numbers of archaic works mark a turning point in his career. The experience had an immediate impact on his work, as Mead noted on a visit to Rome: "His love for the Archaic is a consequence of his late visit to Athens, with which he is much impressed."[101]

Manship distinguished himself at the Academy. In the institution's year-end report, Stevens described him as "an enthusiastic lover of the antique, a facile worker and full of energy" and declared: "He . . . will be heard from in the future."[102] Manship had been commended for his work on at least two occasions by Daniel Chester French, America's preeminent sculptor, and by the Academy's president, W. R. Mead. The artist members of

the board delighted in recommending this successfully cultivated academician for work, and the institution's officers and trustees included some of America's wealthiest and most powerful families and influential patrons of the arts, among them the Morgans and the Vanderbilts, Henry Walters, and Henry Clay Frick.[103] Finally, through the Academy's active social schedule (which he often mentioned wearily), Manship gained the social graces necessary to ease his passage through the drawing rooms of the rich, whose favored sculptor he soon became.[104]

Manship returned to America in November 1912, by way of Germany (where the *Duck Girl* was being cast) and London. His sculptures were shipped directly from Rome to the Architectural League of New York, for display with the work of other returning fellows in a special room at the League's annual exhibition. This event brought him immediate acclaim and marks the beginning of his long and successful sculptural career. Perhaps no greater tribute could have been made than the words written by Herbert Adams, president of the National Sculpture Society, after seeing Manship's work: "It is not impossible that this man alone may be worth to American Art all the effort the American Academy in Rome has cost."[105]

Manship's admiration for archaic Greek art might seem from this account to have arisen quite spontaneously, as a natural or inevitable expression of his own personality and as a result of his direct contact with original examples in Greece.[106] Such conclusions have the effect of dismissing the particular historical context in which Manship's interest took shape. They fail to explain why Manship felt compelled, beginning in the last of his three years in Rome, to incorporate references to archaic art in his own work, nor do they probe the purpose and meaning of those references. And if Manship's archaism was truly "natural," then it is unclear why he—as the most visible American practitioner of the style—later attracted such vehemently negative charges to the contrary. All of these issues are critical to understanding the character and significance of archaism, not only in Manship's work but in that of a great many other artists of the period, for he was neither the first nor the last to find vitality in preclassical Greek art and to apply its principles to his own work.

The next chapter offers a foundation for the further exploration of archaism in reviewing the state of knowledge of preclassical art, the most obvious referent for much early-twentieth-century archaism. The more challenging task follows in chapter 3: namely, to identify those aspects of the ancient works that appealed to early modern artists and to consider their impact on modern practice. This examination of the broader context in which archaism came to be seen as a vital means of artistic expression will set the stage for subsequent assessment of the development of Manship's archaism.

2

The Archaeological Background

The nineteenth century was an age of spectacular archaeological discoveries, many of important archaic works. The period also saw established the theory and practice of archaeology as the systematic recovery, description, and classification of antiquities. This increasingly scientific orientation within the discipline had significant ramifications for preclassical archaeology. Most important, the archaeologists' belief in the necessity—and the possibility—of scientific objectivity carried with it acknowledgment of the potential value of any material remains of a civilization. Fragments or objects incompatible with aesthetic sensibilities prevailing at the time of excavation thereby gained some measure of protection from destruction or neglect. Owing to its strangeness, preclassical art required such protection for much of the nineteenth century.[1]

Credit for initiating systematic study of ancient art belongs to German scholars, first and foremost to Johann Joachim Winckelmann, whose monumental *History of Ancient Art* (1764) was unprecedented for its careful analysis of successive stylistic phases in ancient art, and most particularly in sculpture.[2] Written during an eight-year residence in Rome, the *History* elaborated and systematized the commentary on ancient art of Pliny the Elder, Pausanias, and Quintilian, interweaving careful discussion of individual works with the larger story of classical civilizations. The priority of German scholars in classical archaeology and art history unquestionably owed much to the importance of Greek and Latin in their education, and their approach to classical remains reflected a distinctly philological bias. In 1755, for example, with little experience of Greek art beyond coins, gems, and vases, Winckelmann felt sufficiently confident to

identify "noble simplicity and quiet grandeur" as its most distinctive characteristics.[3] He based this assessment on the Laocoon group in particular, noting points of divergence in its appearance from the description of Laocoon's death throes in the Aeneid (II, 213–224). "The pain," Winckelmann wrote, "expresses itself with no sign of rage in his face or in his entire bearing. He emits no terrible screams such as Virgil's Laocoon, for the opening of the mouth does not permit it."[4] Lessing seconded this extraordinary reading of one of the least simple and quiet works of ancient art (although disagreeing with Winckelmann's reasoning) in his essay *Laocoon,* argued on the basis of engravings of the group and literary evidence.[5] In each case, lack of familiarity with the original, the paucity of earlier Greek sculpture with which the group could be compared, and Virgil's observations on Laocoon's greatness of soul shaped the authors' perceptions.

The Laocoon, discovered in 1506 in Rome, belonged to a limited number of ancient works identifiable through literary evidence, including the Cnidian Aphrodite and Apollo Sauroctonos by Praxiteles, the Discobolus of Myron, and the Ganymede of Leochares.[6] All were Roman copies. Indeed, with the exception of vases, small bronzes, coins, and gems, original works of Greek art were almost entirely unknown before the nineteenth century, except to the rare traveler in Greece.[7] Studies of early Greek art therefore suffered on two counts. First, they exhibited a persistent bias toward artists known through ancient writers, who named few sculptors of the archaic period (with whom, even now, little can be associated).[8] Second, and more decisively, few sculptures from that time had been discovered.[9]

As an inevitable result of the great surge of excavations that began in the mid-eighteenth century with Pompeii, large numbers of objects came to light for which no documentary or literary evidence existed. Determination of their historical position thus rested on stylistic analysis and careful notation of the context of a find, a matter of the utmost importance, as Rhys Carpenter so succinctly observed: "The moment of excavation is unique; it represents for most objects a translation from an undisturbed (but hitherto invisible) historical setting to a visible (but historically irrelevant) environment."[10] When careful documentation of context exists, close observations of style and comparison with works of known date allow the establishment of relative chronologies. Consideration of these and many other criteria led, by the end of the nineteenth century, to a more authoritative and immensely richer history of ancient art.

The changing perspective and more willing embrace of anonymous works prompted some "discoveries" among objects already in museums, but these had limited instructiveness; as Carpenter noted: "Once an object is out of the earth, cleaned, and put on exhibition in a museum, it becomes sullen and refuses to answer questions."[11] More important, archaeological

excavations throughout the nineteenth century yielded scores of exciting new discoveries. Political factors may initially have stimulated interest in some locations, such as that of the French in Egypt, but as the classical bias of earlier generations gave way, genuine scientific interest prompted an increasingly international and informed professional community to investigate a wide range of ancient sites. For example, excavations beginning in the 1840s revealed the remains of the Assyrian empire, while explorations in the region of the Tigris and Euphrates, later in the century, disclosed the cultures of Sumeria and Babylon. Not only geographical, this scholarly branching out entailed a search of human prehistory, with some of the most notable discoveries occurring in western Europe, such as that of the cave paintings at Altamira in the later 1870s.[12]

Heinrich Schliemann's revelation of the pre-Hellenic civilizations of the eastern Mediterranean (that is, Mycenaean Greece and the pre-Mycenaean Anatolian civilization of Troy II), beginning around 1870, surely qualifies as the century's best-known—and most notorious—achievement. Possessing a dramatic instinct and flair for publicity, Schliemann trumpeted his adventures around the world. During the latter part of 1876, for example, he sent fourteen reports on his excavations at Mycenae to the *Times* (London).[13] But history has not treated him kindly; beginning in Schliemann's own lifetime, scholars questioned the reliability of his findings. Even the temperate Adolf Michaelis—whose early history of archaeology maintains a studied neutrality the author must have thought appropriate to the scientific discipline he celebrated—presents Schliemann as a "dilettante . . . a man who pursues his aim without method or thorough knowledge."[14] Still, there is no question that Schliemann, more than anyone in the nineteenth century, stimulated widespread interest in archaeology.

Criticism of Schliemann's methods must be set in the context of archaeology in the 1870s, for after that time, the discipline gained dramatically in sophistication. Complementing their newfound respect for the potential importance of any discovery, archaeologists sought increasingly to describe and analyze their finds with precision, accuracy, and objectivity. In addition, they adopted systematic excavation procedures, which simultaneously preserved and reconstructed a site. Three particularly important methodological developments were the introduction of accurate stratigraphy, the use of photography for documentary purposes, and the enlistment of architects in recording and restoration efforts. Each of the latter two must have contributed to the popularization of archaeology: photography made the visual evidence available to the wider public, while architects provided a link to artistic circles not normally in contact with the archaeological community. With the Austrian excavations on Samothrace, in 1873 and 1875, and the German excavation of Olympia, beginning in 1875, archaeologists applied the new techniques to the study of entire an-

cient sites. The scientific approach of the Germans and the Austrians, the scope of their operations, and the authoritative publications they subsequently issued had no precedent in the history of Greek archaeology.[15]

Adding to the importance of the Olympia excavations, the German Empire, which sponsored the work, set an international precedent in renouncing any claim of ownership to the finds.[16] These remained at the site in a museum built by Berlin architect Friedrich Adler, who also was directly involved with the excavations. This marks an important shift in attitude regarding the nature and purpose of archaeological excavation. The recovery of isolated treasures—almost invariably so identified on the basis of modern aesthetic values—ceased to be the goal. Rather, with new respect for the integrity of a site, archaeologists used all available means to preserve the most complete possible picture (actually a reconstruction) of its nature and function.

Although the Germans and the Austrians laid the foundation for modern archaeology, other countries soon followed their lead. During the final decades of the century, several nations established institutes or schools of archaeology in Rome and Athens and charged them with overseeing excavations in the ancient sanctuaries at Delos and Delphi (France), Athens and Sparta (Britain), and Argos and Corinth (the United States).[17] In addition to the opening of previously unexplored or underexplored locations, a new era of research, employing modern excavation techniques, was begun at such venerable sites as Pompeii.

The full revelation of preclassical Greek art in excavations at Aegina, Selinus, Delos, Olympia, Athens, and Delphi certainly qualifies among the major developments of nineteenth-century archaeology. This revelation entailed more than just the physical unearthing of objects; with the evidence before them, scholars recognized that archaic art had quite distinctive characteristics, including planarity, frontality, linearity, ornamentality, and stylization.[18] These peculiarities (as measured against the relative naturalism of classical art and the Western tradition since the Renaissance) fascinated archaeologists, art historians, theorists, and artists. Beginning even with Winckelmann—who identified expressive vigor, severity, and hardness with early Greek art—commentators on preclassical art struggled to understand and to explain its appearance and to define its relationship to later traditions.[19] The sheer volume of the archaic material unearthed demanded nothing less.

The late-archaic temple pediments from Aegina—in 1811 the first major discovery of archaic sculpture—constitute a particularly revealing barometer of nineteenth-century sensitivity to preclassical Greek sculpture. Acquired in 1812 by the crown prince of Bavaria, they were restored and reconstructed in Rome by Danish neoclassical sculptor Bertel Thorwaldsen and installed in Munich's Glyptothek, a new museum conceived around

Fig. 23. Athena
(as restored by Thorwaldsen),
from the west pediment,
Temple of Aphaia, Aegina,
ca. 510 B.C.
Marble, 66 in. high.
Glyptothek, Munich.
Photo, Hirmer Verlag,
Munich.

them, in 1828. The figures from Aegina thereby became among the first original Greek sculptures of any date in a European collection (fig. 23).[20] The Aegina sculptures particularly interested contemporary commentators for their relationship to the development of later Greek art. That concern helps to explain why writers focused more on the figures' nonarchaic qualities, especially the naturalism of the bodies (which scholars tended to exaggerate), than on the distinctively archaic characteristics.[21] Thorwaldsen himself, in creating new heads for some of the figures, softened the archaic smile.

Thorwaldsen completed his restoration of the Aegina figures in 1817, and several of his own works from that year, including *Ganymede with the*

Fig. 24. Bertel Thorwaldsen,
SELF–PORTRAIT, 1839
(posthumous marble,
H. W. Bissen, 1859).
Thorvaldsens Museum,
Copenhagen.

Eagle, Mercury, and *Hope,* betray their influence. The *Hope,* judging from its inclusion in Thorwaldsen's full-length self-portrait of 1839, must have had special meaning for the sculptor (fig. 24). A quotation from one of the temple's small figurative acroteria, it refers directly to the Aegina sculptures and therefore also to the responsibility with which Thorwaldsen had been charged in restoring them. The restoration project had at once attested to royal confidence in Thorwaldsen's abilities and permitted a degree of intimacy with ancient art that few sculptors shared. In the 1839 self-portrait, Thorwaldsen gives form to his claim of kinship with the masters of antiquity by representing himself with mallet and chisel in hand leaning on the unfinished *Hope*—a work that was not carved directly (as had been

Fig. 25. Perseus Killing
Medusa, metope from
Temple C at Selinus,
ca. 550 B.C. Limestone,
58 in. high.
Palermo Museum.
Photo, Jeffrey M. Hurwit.

the archaic sculptures), but modeled. Thorwaldsen's flagrant contradiction
of nineteenth-century sculptural practice made a symbolic gesture that his
contemporaries must readily have understood: as a creator in marble,
Thorwaldsen claimed parity with the ancients.[22]

Thorwaldsen's reference to the sculptures from Aegina did not signal his
allegiance to an archaic style. Nor did the discovery and placement in a
European museum of the archaic sculptures from Aegina effect a shift in
taste, which in Thorwaldsen's day was still conditioned by late-eighteenth-
century admiration for Hellenistic and fourth-century sculpture. In that
context, the three mid–sixth century metopes from Temple C at Selinus,
discovered in 1822, must have seemed extraordinarily naïve in their em-
phatic frontality, proportional distortions, and anatomically impossible
poses (fig. 25). As late as 1912, German archaeologist Reinhard Kekulé
characterized these metopes as "almost ludicrously primitive and rude,"
although he suggested that their originally elevated placement within a
strong architectural framework may have contributed to "a less repulsive
effect." Kekulé's emotional language aside, his assessment has some basis;

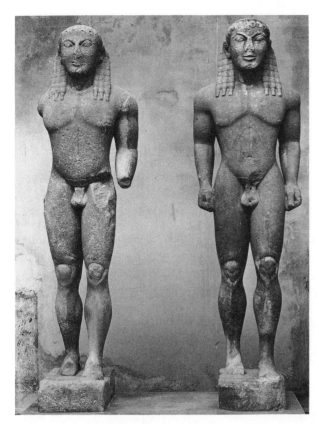

Fig. 26. Kleobis and Biton, from the Sanctuary of Apollo, Delphi, ca. 580 B.C. Marble, each about 77 in. high. Museum, Delphi. Photo, Hirmer Verlag, Munich.

the metopes from Selinus are provincial work and cruder than that of mainland Greece. The tourist reader of Baedecker, in which Kekulé's comments appeared, stood duly forewarned. Yet these are also undeniably potent sculptures, whose expressive ferocity shines through even Kekulé's contempt; "beset by a childish restraint," the metopes from Temple C had, in his opinion, "no other merit than a ruthless and violent distinctness and a grotesque vivacity, entailing the disfigurement of the human form and the entire sacrifice of natural proportion." In the opinion of some modern artists, such qualities constituted merit, as we shall presently see. What seems particularly noteworthy about Kekulé's point of view is that, notwithstanding his distaste, he saw in the metopes "the germ of a mighty future." The perceived prefiguration of greatness in archaic art likewise interested modern practitioners of archaism, even as they celebrated the "grotesque vivacity" that Kekulé decried.[23]

During the last quarter of the nineteenth century, excavations at the major Greek sanctuaries yielded early sculptures of indisputably high quality. At Athens, the systematic uncovering of the Acropolis between 1885 and

1891 revealed remains of the pre-Periclean religious complex, including impressive pedimental sculptures. Archaeologists also recovered approximately thirty marble korai broken up during the Persian invasions of 480 B.C. and buried by the Athenians. Many kouroi, the nude male counterparts of korai, came to light during contemporaneous French excavations at the temple of Apollo Ptoios in Boetia. For power of expression, however, they were eclipsed by the brute intensity of the magnificent, seven-foot-tall pair of early archaic kouroi discovered by the French at Delphi (fig. 26). Such extraordinarily rich finds dramatically increased the number of freestanding marble figures of preclassical date.[24] Finally, in 1896, French excavators at Delphi found the magnificent Charioteer, the first life-sized Greek bronze (and one of preclassical date) preserved in a more than fragmentary state—a fitting culmination to a great century in the history of archaeology (fig. 21).

Outside of archaeological circles, preclassical works attracted relatively little attention. Such works did not become sufficiently familiar or available to prompt their acquisition by public museums or private collectors until fairly late in the nineteenth century; by that time, however, finds made on Greek soil generally remained in that country, not on the usual European itinerary.[25] Publications offered one way to gain an impression of the early works. With so many important discoveries, histories of sculpture compose a significant proportion of the archaeological literature around 1900. In these studies, early Greek sculptures claimed increasing attention and respect; as originals in a field littered with Roman copies, they could hardly be disregarded.

Ernest Gardner's *Handbook of Greek Sculpture* (1895) and *Six Greek Sculptors* (1910) make the point. The earlier study, which ran through several editions, offers a lengthy scholarly overview entitled "The Rise of Greek Sculpture, 600–480 B.C.," whereas the later, more popular, book features unusually thoughtful chapters entitled "Characteristics of Greek Sculpture" and "Early Masterpieces" as a preface to more traditional consideration of known artists of the fifth and fourth centuries B.C.[26] In this opening section, the author (a former director of the British School at Athens) establishes his particular concern: namely, to assess the relative roles of tradition and observation in any work of art. Gardner found the balance to have been perfectly struck in the classical period; prior to that time artists adhered more closely to conventions of representation, whereas subsequently they placed greater weight on individual observation. The relative roles of each, Gardner suggested, are determined less by the artist than by circumstances. But he wondered: "Are we . . . to recognize continuous advance in the freedom and the resources of the art of sculpture? Or should we rather maintain that the earlier sculptors, consciously or unconsciously, adhered to these conventions as the canons and principles of their

art, and that the violation of these canons is not to be regarded as an advance, but as a loss of the finer instinct for what is fitting, and therefore most satisfying to the eye and to the intelligence?"[27] Although Gardner expressed reservation about either point of view in its extreme, his rumination is unquestionably symptomatic of new ways of thinking, not only about archaic sculpture, but about sculpture in general. He makes the leap himself in suggesting that "the danger . . . of a too great freedom from convention, of too exclusive dependence on individual observation . . . is the cause of the chaos which we see in a modern exhibition of sculpture."[28] In something of a paradox, modernist artists of the early twentieth century came to recognize a certain expressive freedom precisely in the conventions of archaic sculpture.

Gardner's interest in the relationship between tradition and observation, as he acknowledged, was stimulated by Emmanuel Löwy's *The Rendering of Nature in Early Greek Art* (1900).[29] Löwy sought to understand why archaic art appears as it does, identifying as its key formal properties the use of a limited number of shapes; stylized, linear forms; the importance of outline and silhouette; lack of interior modeling; representation of the "broadest aspect" of the parts of a figure (for example, a profile nose or frontal eye); avoidance of overlapping; and little or no representation of environment. He argued, with reference to a number of contemporaneous theories about archaic and primitive art, that deliberate intent, convention, repetition, or technical conditions failed to explain the distinctive qualities of archaic work. Instead, Löwy averred, those qualities affirmed the role of memory in artistic creation; the archaic artist reproduced a mental image, not a visual one (that is, one based on the direct observation of nature).[30] The archaic work thus remains independent of the real appearance of objects. Löwy's theories had the potential for broad application; as Meyer Schapiro recognized in his studies of the Romanesque sculpture of Moissac, the term "archaic" can be used "not simply with the literal sense of ancient, primitive, or historically initial and antecedent, but as a designation of a formal character in early arts."[31] Accordingly, the category of the archaic might encompass the diversity of early medieval European and ancient Indian art, as well as the art of preclassical Greece.

Löwy's study, and Gardner's more popularized presentation of his ideas, helped draw attention to the special qualities of archaic sculpture. Although neither book was well illustrated, photographic reproductions became fairly standard in the literature by 1900 and offered readers some opportunity (if decidedly limited in its usefulness) to assess the earlier phases of Greek art.[32] Sculptural casts provided another means of access; the major museums and art schools had substantial collections of casts, but relatively few of archaic sculpture.[33] And although casts may have conveyed a general impression of a work, they did nothing to reveal the subtleties of

its treatment, a matter of ever-increasing concern during the early twentieth century. After his first confrontation with original works in Greece, in 1907, sculptor-painter Maurice Sterne recognized "how anemic [his] conception of ancient Greece had been, based as it was on second rate Hellenistic copies and . . . plaster casts of original sculpture."[34] By "original," Sterne may simply have meant "ancient" since the most frequently cast ancient sculptures were themselves copies (and usually Roman, not Hellenistic, as believed). The quality of nineteenth-century mechanical reproductions (whether in plaster or marble) after ancient sculptures could be abysmal, as James Fenimore Cooper noted after seeing "attenuated Nymphs and Venuses, clumsy Herculeses, hobbledehoy Apollos, and grinning Fauns" at a marble copy shop in Livorno.[35] The revelatory potential of initial confrontation with actual archaic art should not be underestimated, for its attractiveness to modern artists went beyond its abstracted forms. To an equal degree, the expressive vitality of directly carved archaic statuary captivated modern sculptors and shone as a beacon of authenticity amidst the pointed (indirectly carved) marble sculpture of their age.

The regard that modern artists held for archaic sculpture followed nearly a century of accelerating discoveries of, and scholarly interest in, early Greek art. Over the same period of time, aesthetic interest had also been shifting—paralleling the pattern of archaeological discovery—to accommodate modes of artistic expression chronologically, geographically, technically, or stylistically distant from the traditions of Western art since the Renaissance. One phenomenon did not cause the other; they were interdependent. Certainly it would be foolhardy to credit archaeological discoveries with inordinate influence on artistic developments, as sculptor and writer Stanley Casson did in declaring: "archaeology is the enemy of modern art because it always lays down the law and strives to dictate to artists what rules they should follow. . . . [It] can never and should never set the rules for modern art."[36]

Casson's defensiveness undoubtedly arose from the ubiquitousness of archaism among academic sculptors of the day, and his perception was not unique; however, it evades the question of why a modern artist would look to an ancient model. From the beginning of the nineteenth century, important examples of archaic sculpture had been available for study and yet had minimal impact on contemporary art. When, around 1900, artists began to pay close attention to archaic art, they did so because it offered an unexceptionable model to guide them along the path on which they had already embarked.

3

Archaism As Modernism: Content and Technique

Around the turn of the century, the visitor (let us imagine her a woman) to a large sculpture exhibit such as the Paris Salon or a National Sculpture Society showing would not have seen anything that much reminded her of archaic art. Indeed, she might not have thought of art at all in her astonishment at the cast of characters there arrayed. Famous men, voluptuous women, mischievous children, mythical personages, fierce animals: a vast population in stone, bronze, and plaster, the very material of which seemed transformed into flesh and blood. From subjects of high drama to those of meditative calm, they vied for her attention, alternately inspiring, amusing, edifying, frightening, or merely pleasing; their claims might have seemed almost audible, such was the visual cacophony. Yet however overwhelming the high drama and rhetoric in the exhibition space, our visitor (especially if she were from a large city such as Paris or New York) would have been prepared by the monuments and architectural sculpture of the urban environment, for the public arena was the sculptor's chosen theater at the close of the nineteenth century (figs. 27, 28).[1]

To some observers, sculpture's service of visual and thematic realism compromised its artistic status. Baudelaire, earlier in the century, had defined the problem as basic to sculpture, an art form that—owing to its three dimensionality—seemed "as brutal and positive as nature herself." Baudelaire classed sculpture as a "*complementary* art" of little independent expressive force and considered it decidedly inferior to painting in communicating personal sensibility.[2] The idea that an artist committed an unholy sacrifice of self and art to the academic imitation of superficial material appearances emerged as an increasing concern of later-nineteenth-century modernists.[3] Among them,

Fig. 27. Raoul Verlet,
sculptor, and Henri Deglane,
architect, MONUMENT À
GUY DE MAUPASSANT,
1897. Marble.
Paris, Parc Monceau.
Photo, A. Pingeot,
Musée d'Orsay, Paris.

Fig. 28. View of the DEWEY
ARCH, Fifth Avenue at
Madison Square Park,
New York City, 1899
(demolished). Courtesy of
The New-York Historical
Society, New York City.
Photo, George Dodd.

Maurice Denis asserted: "Art is the sanctification of nature. . . . The great art, called decorative, of the Hindus, the Assyrians, the Egyptians, the Greeks, the art of the Middle Ages and the Renaissance, and those works of modern art which are decidedly superior: what are they if not the transformation of vulgar sensations—of natural objects—into sacred, hermetic, imposing icons?"[4]

One need not know precisely which works Denis had in mind to judge that, despite his own activity as a painter, his first four categories evoke sculpture: Indian, Assyrian, Egyptian, Greek. He may well have been thinking of reliefs, the forms of which could easily be viewed pictorially, as if delineated shapes on a painter's canvas. Relative formal abstraction united such work in the minds of late-nineteenth-century artists and scholars and raised intriguing questions. Had the sculptor of a kore, for example, deliberately abstracted from nature or was that effect somehow involuntary? Löwy's definition of archaic art presupposes the latter. Archaic sculptors may have wanted to approximate nature—the gradual development toward naturalism in Egyptian, Greek, and medieval art seemed to suggest that they did—but the dominance of a mental, rather than optical, image defeated their efforts.[5] The result distorted the external appearance of things, perverting one reality in favor of another; that alternative reality, internal to the artist and therefore invisible, assumed concrete form in the archaic work. In that sense, archaic art exemplified nature filtered through a temperament—to paraphrase Emile Zola's famous definition of art—the very prescription Denis and others wrote for modern art, however much they may have objected to Zola's own concern for material objectivity.[6] To those for whom an externalized, "objective" naturalism seemed a dead end, the archaic thus exerted a powerful appeal. Clearly, it could represent human figures and other subjects in recognizable form, yet it appeared to allow internalized forces to dominate, or at least to resist, the demands of a conventional naturalism regarded as having been drained of all expressive force. Archaic sculpture, in particular, emerged as an important model and to none more so than modern sculptors, since their art (as Baudelaire had charged) seemed more closely bound than painting to the material things it might represent.

Among those who sought a balance between observed reality and a personalized sense of the harmony and unity underlying nature was Aristide Maillol. Focusing particularly on the subtleties of the motionless female nude, he created sculptures of magnificent balance, repose, and simplicity; these qualities, along with his figures' architectonic character and clean, rhythmical contours, are points of similarity with severe-style Greek sculpture. Maillol had the opportunity to study such work at the Louvre, which housed two metopes from the Temple of Zeus at Olympia, dis-

Fig. 29. Herakles subduing
the Cretan Bull, from the
Temple of Zeus, Olympia,
ca. 471–457 B.C. Marble,
63 in. high. Louvre,
Paris, and Museum,
Olympia. Photo, Hirmer
Verlag, Munich.

Fig. 30. Aristide Maillol,
DESIRE, 1905–1908. Lead,
47 in. high. Museum
Boymans-van Beuningen,
Rotterdam. © 1992 ARS,
N.Y./SPADEM, Paris.

Fig. 31. Aristide Maillol, FLORA, NUDE, 1910. Bronze, 66 in. high. Fondation Dina Vierny-Musée Maillol, Paris. © 1992 ARS, N.Y./SPADEM, Paris.

covered at the site during a brief period of French excavation in the late 1820s (fig. 29). Visual evidence suggests that the example of the metopes prompted Maillol's relief *Desire* (1905–1908), his experiment in organizing within the confines of a square framework a pair of struggling figures (uncharacteristic in his oeuvre, though not in Greek art) (fig. 30). Prompted by Maillol's relief, among his other works, critic Roger Fry wholeheartedly applauded the manner in which Maillol brought "sculpture back once more to its true fount and origin, its inspiration and its safest haven—to architecture."[7]

Fully aware that the French sculptor had traveled to Greece in 1908, Fry conceded Maillol's debt to preclassical art in observing of *Flora, Nude* (fig. 31): "It would be useless before this to deny that Maillol had seen and loved the sculptures of Olympia, but the archaism is not part of a stylistic *parti pris* so much as the deliberate return to the same principles as inspired that early language."[8] Fry's use of the term "archaism" clearly refers to Maillol's own contribution and not to the sculptures from Olympia, which Fry recognized as post-archaic. In fact, he criticized ancient archaic art (under which he included Egyptian and Assyrian as well as Greek art) and its modern imitators for excessive attention to detail and lack of "plastic unity"—that quality he regarded as an achievement of the classical Greeks

(though anticipated at Olympia) and of Maillol.[9] Yet he found Maillol "no classicist in the old-fashioned way" and praised the sculptor's "simplicity of outlook," "almost rustic ingenuousness," and the "rustic simplicity and bluntness of form" of his sculpture.[10] Such terms evoke archaic, not classical, Greek art. Maillol's archaism, to clarify Fry's view, has, then, less to do with specific borrowing than with an attitude: Maillol's desire to return to sculpture its fundamental artistic integrity—perhaps what Fry had in mind in praising Maillol's figures as "true statues."[11] In that spirit, Maillol himself reportedly admired the Zeus temple sculptures as "an art of synthesis, an art superior to the work of the flesh that we moderns seek."[12] To modern observers, this moment of synthesis seemed more precious for its precariousness; as American sculptor William Zorach wrote of the Olympia figures: "Stone is still sculpture, not anatomy. . . . Simplicity and volume are still valued; but sculpture is becoming a vehicle to tell a story, and not a direct expression of man's soul. . . . Here the Greeks destroyed their Gods by making them in the image of man."[13]

First and foremost, modern archaism constituted a reaction to the pictorial, descriptive, and anecdotal character of much late-nineteenth-century sculpture. It opposed not so much representation per se as representation of a rhetorical and public nature. Rather than communicating a story in as realistic terms as possible, modern sculptors asserted the right to create works for visual interest alone, without regard to purpose, destination, or illusionism. Such emphasis on form facilitated the expression of an artist's thoughts and feelings, without incurring any obligation to render them intelligible to the public. Paradoxically, the elimination of narrative had the potential to heighten psychological immediacy because, in effect, it respected—and therefore privileged, rather than directed—the viewer's response. Consider Rodin before the early archaic "Hera" from Samos in the Louvre (fig. 32): "How young it is, how happy! . . . We have been, we are too anxious, too tormented; but we shall return to that art of good health, it will be the style of the coming centuries."[14] Judith Cladel's report of Rodin's rhapsodic response reveals little more than that the sculptor admired the statue's supple, yet firm, modeling. The grounds for his reading therefore remain far from obvious. Certainly, Rodin's perception of healthiness and joyousness owed nothing to facial expression or to the figure's participation in any narrative (nor is such a reading easily evoked by the goddess Hera, whom the work was long believed to represent). Above all, Rodin's response to the archaic statue was a personal one.

Although the Louvre Hera is headless, the so-called archaic smile that appeared on many other sixth- and early-fifth-century figures undoubtedly had an impact on the way modern viewers interpreted archaic forms. In 1911, French novelist and literary critic André Beaunier made the enigma

Fig. 32. Statue dedicated
to Hera by Cheramyes,
from the Heraion,
Samos, ca. 560 B.C.
Marble, 76 in. high.
Musée du Louvre, Paris.
Photo, Cliché des Musées
Nationaux, Paris.

of the archaic smile the subject of an essay, "Le Sourire d'Athèna," for a book of the same name. A meditation on the author's quest for the spirit of ancient Greece, the essay focuses on the Aegean island of Aegina ("an island encircled by the never-ending smile of waves"), site of a brief cultural efflorescence during the archaic period—in Beaunier's estimation, the supreme moment of Greek artistic perfection.[15] He describes how the sculptures from the Temple of Aphaia captivated him with the strange gaiety and playful grace of the pediment's combatants, who smile even in their mortal struggle.[16] "This smile, which surprises us and radiates spirituality throughout the composition . . . , is ravishing. . . . it captivates us, perhaps because of its mystery but also for its enchanting beauty."[17] Thus, Beaunier finds the smile equally suited to the charming korai, in whose faces he detected gentle, coquettish seduction. The archaic smile, he concludes, expresses a spiritual state: a composed, understated, and perhaps even mockingly ironic acceptance of the powerful mysteries of love and death.

The archaic smile potently symbolized the vitality and "good health" that early-twentieth-century artists read into the rigorously simplified and compact masses of archaic sculpture. After the emotional excesses of late-nineteenth-century sculpture, including that of Rodin, they sought a finer atunement. The simplicity of classical sculptures, a British writer submitted, "is inclusive, not exclusive, . . . if they do not arrest and strike the attention, it is because they disdain to. If a Grecian Aphrodite looks chill and quiet by a piece of sculpture such as Rodin's *Le Baiser,* it is not because the antique is passionless, but that passion unexpressed and only suggested is stronger and more enduring than explicit sensibility."[18] The appeal of archaic sculpture, as Paul Manship stated in his Academy lecture of 1912, "is not to our dramatic sense nor is it superficial. It is deeper chord that is struck & a tone to which we can respond."[19] Archaism in the work of early modern sculptors must be understood as expressing a yearning for emotional, as well as formal, restraint and simplicity. The sculpture does not force a message upon the viewer; it may not even appear to express one. Yet intensity remains: meaning emanates from form.

As nonnarrative representations of the human figure (Jeffrey Hurwit has called the kouros "a kind of all-purpose iconographic blank"), archaic kouroi and korai held a special appeal for modern artists.[20] So too did the Egyptian statues from which the early Greeks derived their formula for the representation of human figures.[21] Jacques Lipchitz recalled having been "very conscious of the examples of Egyptian and archaic Greek sculpture" when, during the 1910s, he began "working toward a kind of simplification that emphasized and clarified the structure, the masses and the planes."[22] Such sculpture had, in his estimation, "many points of rela-

tionship [with modern sculpture] in its accent on simplicity and direct-
ness."[23] André Derain, as well, commented admiringly that Egyptian stat-
ues "have simplicity, dignity, directness, unity; they express emotion as if
by a conventional formula, like writing itself, so direct it is." The statues,
he continued, make "a direct appeal to the instinct" and are "informed
with emotion."[24]

How is it that a conventionalized representation could be seen as so pro-
foundly expressive, even as the source of a work's expressiveness? Here
again, the answer may lie in the association, made by Löwy and others,
between archaizing conventions and inner directives. Wilhelm Worringer
forcefully articulated this relationship in *Abstraction and Empathy* (1908), ar-
guing that abstraction (especially geometric) appears at times of spiritual
unrest and represents a striving for the eternal and absolute.[25] Sculpture
particularly interested Worringer because its inherent three dimensionality
worked against the urge to abstract conceptualization. Thus, he identified
strong stylization, such as appears in archaic Greek statuary, as the pri-
mary evidence for the greater importance, among archaic Greeks, of inter-
nal ideals over external matter. Archaic artists distorted visual reality be-
cause they had to, Worringer and his contemporaries reasoned. Modern
artists, by contrast, had a choice, and in electing archaism, they rejected
academic conventions that had been developed for naturalism, a naturalism
regarded as having lost expressive force.

The very repudiation of naturalism renders the huddled form of Derain's
Crouching Figure (1907) expressive (fig. 33). That quality increases with
Derain's suppression of narrative cues that might permit the attribution of
any specific emotion to the sculpted figure; to a significant extent, how a
viewer reads the work is left open, becomes a matter of personal interpre-
tation. Directness of appeal does not therefore preclude subtlety and psy-
chological nuance. The qualities of simplicity and unity that Derain ad-
mired in Egyptian and early Greek sculpture also inform the *Crouching
Figure,* a work so simplified that it is barely distinguishable from the block
of stone. This was certainly Derain's intent. In calling the viewer's atten-
tion to the material origins of the work and, through its technical crudity,
to the process by which it was made, Derain engaged in another type of
archaism—one that must be understood as a direct challenge to sculptural
tradition since the Renaissance.

That tradition identified artistic genius and creativity with a conceptual
process primarily. To be sure, the viewer's recognition of that quality of
genius depended on successful physical realization of the idea in the work
of art, but skill in handling alone did not certify artistic power. For sculp-
tors, this was especially true; unlike the painter of easel pictures, the sculp-
tor rarely executed the finished work. In the nineteenth century, the pro-

Fig. 33. André Derain,
CROUCHING FIGURE, 1907.
Sandstone, 13 in. high.
Museum of Modern Art,
Vienna. © 1992 ARS,
N.Y./ADAGP, Paris.

cess of sculpture merely began with the artist, who worked the malleable medium of clay to develop a maquette of the proposed composition. Invention was thereby served. Cast in plaster, the small model guided the worker who built a larger, roughly blocked-out clay version around a supporting metal armature. This model underwent further refinement—sometimes by the sculptor, but in larger studios by assistants—until brought to a state of finish. If the sculpture were to be rendered in marble, it would then pass into the hands of an artisan skilled in stonecutting, whose relationship to the artist nineteenth-century sculptor Harriet Hosmer characterized "as that of the mere linguist [that is, translator] to the author who, in another tongue, has given to the world some striking fancy or original thought." [26] Henry Jouin, the primary voice of French academic sculpture during the second half of the nineteenth century, invoked a similar metaphor: "It is not [the workman] who sings; he transcribes. The poem is the work of the artist, the practitioner only apprehends its syntax. An artist with clipped wings, sometimes he manages to touch upon beauty; he knows neither how to embrace it nor how to name it." [27]

Such exalted language aside, the claims are accurate: pointing, an indirect carving method used to transfer the model into stone, is a strictly mechanical procedure. [28] For the completion of a work in bronze, a highly specialized and technical process, the sculptor turned to a professional founder. Again, a plaster model (cast from the artist's clay model) served

as the starting point for the complicated processes of either sand- or lost-wax casting. The rough bronze cast produced by either method could then be chased, finished, and patinated. In this final stage, the sculptor often became involved again, since the color of the patina decisively affected the appearance of the work (as had little else if the casting had been a success).[29]

Both marble and bronze were widely employed during the nineteenth century. Neoclassical sculptors, in particular, prized marble for its evocation of the antique, but its ability to approximate the character of flesh had more enduring appeal. Bronze enjoyed steady gains, in part because the material's tensile strength well suited it to the dynamic subjects that gained popularity later in the century. Concomitantly, sculptors placed new valuation on lively modeling, no longer confined to the initial stage of conception, but intended for translation to the finished work, thereby heightening its movemented quality. More than strength or durability, the molten property of bronze held the key to its popularity; flowing around the artist's model in the mold, it captured the freshness of that model—and therefore also of the artist's conception. The model "must be preserved exactly as his fingers have left it," wrote Lorado Taft of American sculptor Frederick MacMonnies, and for that reason, MacMonnies preferred bronze: "He knows that no other hand would reproduce his touch in marble."[30] With the revival of the highly refined ancient technique of lost-wax casting, in the 1870s, sculptors gained even greater opportunity to leave their mark in the finished work.

It might seem that bronze sculpture foregrounded the artist in a way that marble had not, since the finished work literally preserved the imprint of the sculptor's hand or tool. This was not necessarily the case. However lively the modeling of a sculpture might be, pictorialism and narrative redirected the viewer's focus from how and by whom the work was made to what it depicted. Rodin offers the outstanding exception, although perhaps less because of his technical processes than because his approach to subject matter departed so sharply from that of his contemporaries. American sculptor and art critic Truman Howe Bartlett, in his discussion of Rodin's *Age of Bronze,* sought to explain Rodin's aim: "The sole idea in the sculptor's mind was to make a study of the nude, a good figure, correct in design, concise in style, and firm in modelling—to make a good piece of sculpture. . . . the question of subject is not included. . . . After [the work] is completed it suggests various names and subjects to those who see it, though it is really nothing more nor less than a piece of sculpture—an expression of the sculptor's sense of understanding of the character of his model, and his capacity to reproduce it in clay."[31]

Rodin did not precisely repudiate conventional subjects (though his subjects often proved inventive and unusual); rather, he allowed the formal

Fig. 34. Auguste Rodin,
CARYATID, called CROUCHING
WOMAN, 1886. Marble,
17¾ in. high. Gift of
Julia Isham Taylor,
courtesy Museum of
Fine Arts, Boston.

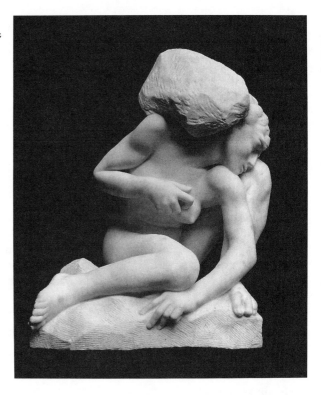

properties of a work to become the vehicle of its content.[32] This held true for works in both marble and bronze. "Rounded, worn, immovable, and heavy like Unhappiness" wrote art critic Gustave Geffroy concerning the stone borne by Rodin's *Caryatid (Crouching Woman)* (fig. 34), whereas poet Rainer Maria Rilke suggested that the same figure "bears its burden as we bear the impossible dreams from which we can find no escape."[33] Such readings were not conditioned by any obvious narrative that the sculpture related, but freely supplied by the viewers in direct response to the work's physical properties—in other words, largely in response to the action upon the material by the sculptor.

But the material Rodin had acted upon was clay, a material fundamentally different from the stone or bronze of a finished work. As already noted, the popularity of bronze arose from its ability to capture the freshness of the sculptor's original model: in a molten and formless state, it physically envelops the model, faithfully reproducing the sculptor's every mark. Yet a finished work in bronze is manifestly hard, nothing like the soft, malleable clay of the model; it is a false index of the artist's original.[34] Marble presents an analogous paradox of a hard material with the capacity

to communicate precisely the opposite quality; according to Jouin: "[Marble] alone has the density of human modeling without hardness. Smooth to the touch like flesh, soft and transparent to the eye, it is marble that, while not being alive, will give in the most perfect way the illusion of life." [35] The sculptor could choose to confront the hardness of marble directly by carving the block (as he or she obviously could not do with bronze), but in practice artists rarely did this. Even Rodin, though he knew the craft intimately and exercised close control over the work in his studio, employed a small army of assistants to execute sculptures having the lifelike quality that was one of the sources of Rodin's own fame.

Rodin's expressive subjects and handling broke away from the moribund academic tradition, but some early-twentieth-century sculptors wondered whether he had gone far enough. They challenged the worth of approximating natural appearances and questioned the equation, established in the Renaissance, between a sculptor's idea and genius, which effectively justified the manufacture of sculpture by hired hands. [36] Of course, few could argue that the torturously kneaded surfaces of Rodin's sculpture did not bear the imprint of his individuality; but was this properly transferable? If sculpture were to express an artist's personal understanding and intuition, such would not be achieved by adapting the creative process of another. Each artist must find his or her own technique.

In the late-nineteenth-century critical discourse, as Richard Shiff has demonstrated, finding appears as the modernist challenge to academic making. Making is self-conscious, deliberate, and learned; finding, by contrast, is intuitive, spontaneous, and personal. The modern artist's paramount concern with his own identity, Shiff explains, impelled his search for a technique that did not appear to be one, "a technique designed to free [the artist] from his culture." This would amount to a procedure for representing "the individual, the real, the particular. . . . such is a *technique of originality,* which, when mastered, assures personal liberation from any technical restriction or convention." [37] For turn-of-the-century sculptors, direct carving was the preeminent technique of originality. It entailed rejection of the predictable, mechanical process of pointing—an indirect method—in favor of unmediated action by the sculptor upon the material.

The most prominent advocate of direct carving around the turn of the century was the German sculptor and theorist Adolf von Hildebrand, author of *The Problem of Form in Painting and Sculpture.* Highly critical of the realistic and pictorial tendencies in modern sculpture, to which he felt artistic values were sacrificed, Hildebrand advocated a return to the basic processes of sculpture. [38] He believed that sculpture had evolved from drawing, first in the form of reliefs, which he characterized as drawings in depth, and then in the round, as reliefs worked through the block. This

explanation is historically incorrect with reference to preclassical Greek sculptors, who worked from outlines on all four sides; however, they did carve directly, without benefit of preliminary models, and their works are dominated by a single point of view.[39] Hildebrand sought to replicate this effect. He contended: "Hewing out of stone frees the figure from the block in such a manner that, although the block disappears materially, it remains, nevertheless, as a unity in our perception because of the fact that prominent parts of the figure combine to form outer planes which still represent the simple block."[40] Because he believed that the necessity of working in the round jeopardized the development of a clear pictorial idea, Hildebrand vehemently opposed the contemporary practice of modeling. In his estimation, direct carving alone permitted the creation of a unified work of sculpture.

Hildebrand also regarded carving as a more natural method than modeling, likening the gradual emergence of a sculpture from the preexisting, positive volume to a natural development in which the form "seems to evolve as something growing."[41] Yet he did not share the desire of later, twentieth-century direct carvers to allow the subject to be determined in the process of carving; rather, he stressed that the artist's conception should be clear from the beginning.[42] Hildebrand considered direct carving a means to the end of restoring pictorial clarity to modern sculpture and credited it with no less than the ability to work an "artistic metamorphosis" in the imagination of the sculptor, whose "ability of conception develops . . . as a result of his mastery over the process of representation."[43]

Hildebrand undoubtedly had Rodin in mind as the most important modern exemplar of the pernicious effects of modeling (although his critique of the French sculptor was not composed until 1917 and remained unpublished during either of their lifetimes).[44] Hildebrand objected strenuously to what he regarded as the falsity of Rodin's technique. "Marble . . . is but a superficial matter for him. He exploits marble by retaining the block in an artificial way that makes no sense to the knowledgeable person. His blocks simply convey an impression of being freely carved. . . . [they] had no real basis in the creative process. . . . they could not have evolved in this manner. . . . His works were only realized in clay and his marbles were fakes stated in an untrue language."[45] But Hildebrand did not limit his criticism to Rodin's technical deceit; the larger issue of pictorial clarity (or its lack) in modern sculpture always remained. Thus, he found appalling Rodin's "inferiority of feeling for architectonic structure" in the *Monument to Victor Hugo* (which he singled out for particular derision) or in Rodin's multifigured works.[46]

Hildebrand's call for the restoration of architectonic monumentality and clarity to sculpture in an age of impressionistic tableaux expressed a wide-

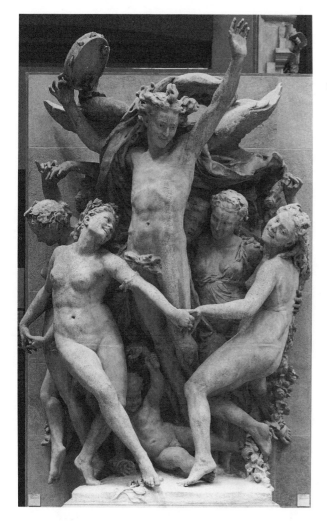

Fig. 35. Jean-Baptiste
Carpeaux, THE DANCE,
1865–1869.
Limestone, 15 ft. high.
Formerly Opéra, Paris;
now Musée d'Orsay, Paris.
Photo, Cliché des Musées
Nationaux, Paris.

spread concern among turn-of-the-century sculptors. The period saw the development of a more formally disciplined sculpture generally, but the renewed interest in relief sculpture, which Löwy had called "the truest exponent" of the laws of art, offers the clearest evidence that sculptors wished to reinstate intellectual control and order as important qualities of their art.[47] Architectural sculpture, in particular, evinces a striking change from its almost autonomous relationship to architecture during the nineteenth century—as in Carpeaux's *The Dance* for the Paris Opéra (fig. 35)— to a more contained linearity in the early twentieth, exemplified by An-

Fig. 36. Antoine Bourdelle,
THE DANCE, bas-relief for
Théâtre des Champs-Elysées,
1912. Bronze, 70 in. high.
Musée Bourdelle, Paris.

toine Bourdelle's reliefs for the Théâtre des Champs-Elysées (1910–1913) (fig. 36).[48]

A longtime assistant to Rodin, Bourdelle reportedly complained that Rodin's monumental effort in relief, the *Gates of Hell,* was "too full of holes."[49] Following the example of the archaic Greeks, Bourdelle sought to bring his own relief sculptures into closer accord with the surrounding architectural framework; even his freestanding sculptures, some scholars argue, imply an architecture.[50] Instead of protruding vigorously from the background, Bourdelle's flattened figures—symbolizing architecture and sculpture, tragedy, comedy, music, and the dance—hug the contours of their square framework, as do the figures in Greek metopes, while insistent linear indications of drapery and hair contribute a crude vigor to their active poses.[51] Contemporary critics recognized a generalized source of inspiration in archaic Greece, but disagreed in their estimations of Bourdelle's success; in 1913, one described the sculptures as "faux grec zigzaguants" (fake Greek zigzags).[52] In evident response to the condemnation of his theater reliefs as archaic, Bourdelle responded testily that he regarded the term as a compliment: "All synthesis is archaism; archaism is the opposite of the word copy; it is the enemy of illusion."[53]

Hildebrand would certainly have agreed and perhaps sympathized with Bourdelle, since critics had been baffled by his archaism. But Hildebrand's early biographer Adolf Heilmeyer, writing in 1902, defended that archaism as integral to the sculptor's purpose: "When we see these works . . . , we are aware that traditional forms are relied upon and that, often, an archaistic style is used, which may sometimes seem strange to us. We should not forget that modern sculpture needs these apprenticeship years if it is to learn technique and to gain a clear sense of design. This can best be achieved by delving deeply into the artistic heritage of our fathers."[54]

Yet Hildebrand's glance was far from a backward one. His insistence on the autonomy of the artist's expression, in particular, strikes a decidedly modern note: "Sculpture and painting do not borrow their poetic force from other arts, nor do they exist merely to illustrate poetic subjects. What the artist has to grapple with is a problem of visual manifestation solely. The subjects which he selects for representation need have neither ethical nor poetic significance. What he does is to give them an esthetic significance which is distinctive and no less valuable."[55] Hildebrand maintained that artists could neither give their subjects esthetic significance nor compellingly evoke nature unless they were sensitive to the subjective impression. Consequently, he despaired of the view that "considers any influence of our interpretative faculty to be a falsification of natural truth."[56] Such an attitude arose, in his opinion, from the fundamental misperception of synonymity between what he termed actual form—the discrete physical identity of a thing—and perceptual form—the "impression" or "effect" arising from the relationship of the object to its environment and to the viewer. "In true Art," Hildebrand argued, "the actual form has its reality only as an effect."[57] This is the vocabulary of late-nineteenth-century modernist criticism. Indeed, the modernist concern to locate the origins of art in both nature and the self resonated in Hildebrand's manifest belief that "works of art will always be combined of these two elements: objective reality and subjective unity; and the manner of their combination is what characterizes artistic individuality."[58]

If direct carving made manifest the modern sculptor's quest for originality and authenticity, it also represented a return to the vital origins of classicism as revealed in archaic sculpture. By the late nineteenth century, most classical and later Greek sculpture, so influential in shaping artistic taste since the Renaissance, had been reattributed as Roman copies of Greek prototypes. In many cases, these sculptures were translations into marble from bronze and thereby situated at a further remove from the originals. By contrast, the archaic sculptures were undeniably authentic; what is more, each one had its origin in the hand of an individual sculptor, who carved directly in the marble, constrained in what he or she could

achieve by the dimensions of the block and by the resistance and tremendous weight of the material. The result revealed its material origins and technical processes; marble sculptures in the round (such as the kouroi and korai) tended to be cubic, closed in form, and stylized. The suppression of pictorialism that I previously identified with modern archaism must be understood within this broader context; it was a means to the sculptor's larger goal of reaffirming the basic principles of the art. In adapting both archaic procedures and formal conventions, modern sculptors raised the banner of authenticity for their own work.

The early-twentieth-century sculptor's concern for the relationship between technique and material and consequent interest in the example of ancient art are well demonstrated by the relief sculpture of Karl Bitter. An Austrian by birth, Bitter became a leader of the National Sculpture Society and one of the foremost sculptors in America before his untimely death in 1915. Well into his career, and notwithstanding his prior conservatism, Bitter in 1902 declared the intent to make his sculpture more "modern."[59] Initially, the art of the Vienna Secession, especially the sculpture of Franz Metzner, influenced the direction of this modernity; but by the end of the decade, Bitter's attention turned to early Greek art.[60] Lured by the "peculiarly beautiful style of Greek archaic sculpture," he traveled to Greece in summer 1910. He found the direct experience of Greek art a revelation, declaring after a visit to the Acropolis Museum: "There are beautiful things there, technically perfect works whose realization one cannot see on a plaster cast. . . . [I] saw in complete reality what I so long believed I knew from pictures."[61]

Bitter's reliefs for the *Carl Schurz Memorial,* completed in the wake of his trip to Greece, were by far the most thoroughly archaistic works of his career. Comparison of a completed panel with its initial conception makes strikingly apparent the effect of Bitter's decision to incorporate archaic conventions. The clay sketch for the left relief panel, which is devoted to the theme of emancipation, shows a compact group of ten black men, women, and children in contemporary clothes and a single American Indian, who look on while a Greek soldier breaks a whip over his knee (fig. 37).[62] In the final version, a female figure in Greek dress leads the American Indian (now a prominent figure), as three Negroid adults (with Egyptian-style garments, headdresses, and hairstyles) watch a militant Athena breaking a chain (fig. 38).[63] The work exhibits many of the characteristics that Löwy identified with archaic art and that Bitter had recently observed at firsthand: the figures are decidedly stylized, clearly outlined, flat surfaced, in composite projection, and evenly distributed across a blank background.[64] These elements made the relief much more legible from a distance; however, the impression of archaic simplicity and clarity is de-

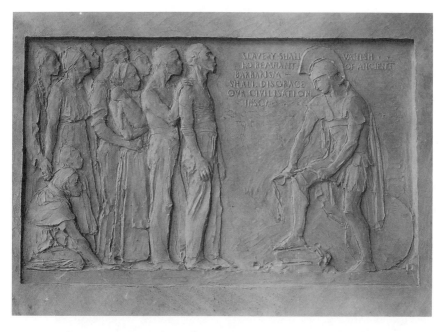

Fig. 37. Karl Bitter, sketch for left relief panel, CARL SCHURZ MONUMENT, ca. 1910.
Clay, approx. 48 in. high. Photo, Peter A. Juley; courtesy James M. Dennis.

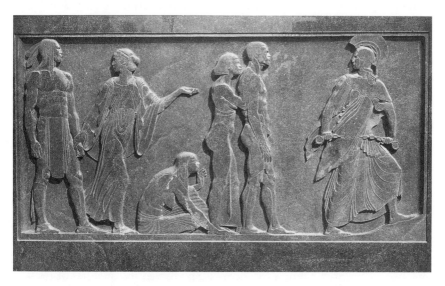

Fig. 38. Karl Bitter, left relief panel, CARL SHURZ MONUMENT, 1909–1913. Granite, 48 in. high.
New York City. Photo, James M. Dennis.

ceptive, since Bitter simultaneously incorporated certain complexities that are quite unarchaic, as we shall see.

Bitter may initially have been attracted to archaic art by its precise shapes, but the influence that archaic sculpture exerted on his technique— or the impression he wished to create of that technique—is equally important. Indeed, this may be the most original aspect of Bitter's archaism. He admired the masterful direct carving of archaic Greek statuary and believed that archaic forms and materials were integrally related. Thus, in his desire to capture the spirit of the archaic for the Schurz reliefs, following his exposure to Greek art, Bitter went beyond mere visual re-creation of Greek forms; he changed his material from marble to granite because, surely, the latter's resistant character seemed better suited to his stylistic purposes.[65] A firm believer in the idea that "the simplicity of the archaistic [that is, archaic] forms is not a product of free will, but of constraint from the material," Bitter maintained: "Tradition produces technique and technique alone renders richer fashioning possible. . . . nothing suddenly appears by itself as a completely perfected form."[66] His material-based conception of the genesis of sculptural style corresponds to mid-nineteenth-century theories most fully articulated by Gottfried Semper in *Der Stil in den technischen und tektonischen Künsten* (1860–1863). A new model, which explained historical change by emphasizing an artist's freedom and creativity, had emerged about 1900. Its primary exponent was Viennese scholar Alois Riegl, who argued that nonnaturalistic art resulted not from technical limitations but from a different will-to-form (*Kunstwollen*).[67] Bitter, who had trained while the older theory was still being expounded, probably kept abreast of the new theoretical debate; indeed, his defensiveness in explaining his position to his regular Viennese correspondent, Hans Kestranek (continuing a conversation the two evidently had in the antiquities collection of an unnamed museum), suggests that it was a topic of discussion more than once.

Notwithstanding his equating of archaic forms and material limitations, Bitter felt no compulsion actually to adopt ancient working methods and carved his reliefs in plasteline, onto which his full-scale drawings had been transferred. Once cast in plaster, the model served as a guide for the final granite versions, which were pointed and carved by the Piccirilli Brothers firm.[68] In spite of this technical deviation from archaic processes, Bitter certainly intended to approximate the appearance of archaic reliefs. Having seen original, directly carved works, he concluded that the resistance of the material significantly affected the aesthetics of archaic sculpture. Bitter probably switched to granite, a material not used by the Greeks, precisely because by twentieth-century standards it conveyed the qualities of resistance and hardness that no longer seemed to be properties of marble.

Bitter's *Schurz Memorial* reliefs do not correspond in appearance or technique to any single phase in the development of ancient relief sculpture. In one sense, they recall ancient Assyrian and Egyptian reliefs, which were barely more than drawings carved into stone. The ancient Near Eastern artists cared little about the representation of space, however, and did not employ foreshortening, such as appears in Bitter's reliefs. Greek artists, on the other hand, were intensely concerned with foreshortening, as revealed by both vase paintings and reliefs of the archaic and classical periods. For the sculptor the challenge was compounded because foreshortening is essentially a pictorial problem, whereas knowing how to treat the planes in a relief is a sculptural problem: to convey the impression of a three-dimensional figure, the height of a relief must diminish gradually toward the background plane. Bitter expressed his understanding of these principles in a lecture he gave in 1914:

> In any frieze, such as that of the Parthenon, the outline is of primary importance. When this is traced upon the marble an assistant can easily sink the background to the required depth, leaving the silhouette in its original height. The master can trace other definite lines within this silhouette onto the marble, and again the assistant can be set to work sinking the planes into the remaining mass to such depth as is directed by the artist, and even that might conceivably be given in precise measurement on the pattern.[69]

In the *Schurz Memorial* reliefs, Bitter did not provide intermediate planes corresponding to those he correctly distinguished in the Parthenon frieze; rather, he distributed flat-surfaced figures in sharp relief across a uniform background plane and created the illusion of depth by incised lines describing the foreshortened poses and garments. The flatness of the Schurz panels, visually reinforced by strong shadows the figures cast, mimics the effect, but not the fact, of archaic reliefs. The Greek relief sculptor worked to maintain the uniformity of the outer plane, but the background plane always remained irregular, not flat, as it is in the Schurz panels. The sophisticated foreshortening exhibited by Bitter's figures (characteristic of classical, rather than archaic, art) did not occur independently of gradual planar recession in the relief sculpture of any ancient culture.[70]

The modernity—and the archaism—of Bitter's panels for the *Schurz Memorial* is thus most fully revealed in his combination of several aspects of ancient art that never coexisted, including perpendicular relief and sophisticated foreshortening. Stylistic commingling is integral to the definition of archaism and results less from an artist's conscious decision than from ignorance of the fine tunings of period style. This is not to imply that irregularities in historical reference indicate a lack of concern for past

styles. To the contrary, archaism depends on the self-conscious use of aspects of an earlier art. Bitter's reliefs therefore fall squarely within a tradition of archaism extending back to ancient times. The Schurz reliefs also comment on styles and techniques prevailing during the late nineteenth and early twentieth centuries. Their flattened aspect and sharp edges deny the volume and mass that are at once essential properties of sculpture and, yet, seemed to contribute to sculpture's debasement by the end of the nineteenth century. The *Schurz Memorial* implicitly criticizes the illusionistic, architecturally weak, modeled sculptural monuments of Bitter's day. A purist might fault these reliefs for their lack of conformity with ancient methods or for technical deceptiveness (although these are aspects of their archaism); however, the effect of the sharp edges visually emphasizes the idea of carving, rather than modeling, as Bitter surely intended.[71]

In the case of cast bronze sculpture, modern archaism necessarily assumed a different form. The personal and singular quality of the directly carved work had no ready translation to a medium that did not involve direct action of the hand on the material and that was potentially reproducible. We have seen that Rodin and other late-nineteenth-century sculptors asserted their creative presence by employing a lively modeling technique—the evidence of their working of the clay—that could be duplicated in the casting process. The end result, which expressed the malleable character of clay, was untrue to the character of bronze, which (though in a molten state during the casting process) is necessarily hard in the finished work. Some modern sculptors working in bronze sought to call attention to the material's "natural" or "authentic" hardness and, consequently, to remove the impression of the hand from the work. This is unexpected. One long-accepted measure of modernism has been the mark that signifies the artist's presence in the work and yet, in the case of bronze sculpture, it may be the absence of the autograph mark that characterizes modernity.

Brancusi's earliest work in stone and bronze suggests the early modern sculptor's investigation of the discrete properties of these materials. Abandoning the "essentially painterly mediums" of clay and plaster (as Sidney Geist has termed them), Brancusi began to carve directly in 1907, inspired by Gauguin's carvings at the Salon d'Automne retrospective of 1906 and perhaps also by Derain's *Crouching Figure,* on view at Kahnweiler's gallery in 1907.[72] In Brancusi's early direct carvings, the roughness, density, and opacity of the material—and the sculptor's struggle to work it—are fully evident (fig. 39). The experimental nature of such works may account in part for their crudity, but it does not explain Brancusi's compulsion to make them. Surely the stylistic and formal archaism represent his exploration of material and technical limits that conventional sculptural procedures had rendered inconsequential. In making emphatic his own labor,

Brancusi's rough, apparently intuitively executed, direct carvings visually reject the idea of the smoothly functioning academic studio, which separated sculptor from finished work by a complicated intermediary process.[73]

Having made the point (if perhaps only for his own benefit), Brancusi was free to pursue other approaches more congenial to his sensibility. The limited number of roughly hewn carvings and the smoothly polished appearance of his stone sculpture beginning around 1910 affirm his distaste for coarseness.[74] Brancusi never abandoned his advocacy of direct carving, which he called "the true path to sculpture," but his nearly interchangeable

use of marble and bronze for most of his career indicates a greater interest in form than in truth to material.[75] The notable exception is the *Kiss,* which was never reproduced in metal, surely because its cubic form so unequivocally evoked a quarried block of stone. The *Kiss* motif may owe its endurance over Brancusi's long career to its radical simplicity and unity, qualities most brilliantly expressed by the taut ovoidal forms of Brancusi's bronze and marble sculptures after about 1910. In these works, the artist suppressed evidence of his touch and of process in favor of gleaming, polished surfaces (whether of marble or bronze) and smooth, continuous forms that seem impersonal by comparison with Rodin's sculpture (fig. 40). Significantly, Brancusi never exploited either material for its imitative qualities, whether of flesh (marble's capacity) or of the sculptor's model (bronze's forte).

Thus far, I have identified archaism with an approach to both subject and technique, and yet the artists considered in this discussion appear to have little in common when it comes to style. Was there an archaistic

style? Too frequently (as in virtually every discussion of Paul Manship) archaism has been seen as little more than an empty stylistic gloss on conventional, academic sculpture—as an insidious modernistic veneer perfectly suited to a shallow, consumer society. The mere presence of explicit thematic or stylistic references to preclassical art does not constitute archaism. Conversely, their absence does not preclude the determination of a work as archaistic. I argue for a broader definition, one that identifies as among the primary characteristics of archaism an artist's deliberate self-consciousness about the materials and processes of art. The emphasis on the medium, whether stone or bronze, works to destroy the academic illusion of transparency, the sense that there could be continuity between a fictive art and the "reality" of life that it attempts to capture. Archaism, in short, privileges qualities of the artistic medium, often to the detriment of naturalistic illusion. Seen in this light, it may be situated fully within the bounds of modernism.

4

Centaur and Dryad: Manship's Art in Context

Manship returned to New York after the completion of his Academy fellowship and just in time to see the exhibition that publicly signaled the arrival of modernism in America: the Armory Show. There is, however, no evidence that he did see it; neither the sculptor's papers nor his art give any indication that the instantly notorious event had any effect on him whatsoever. Of course, Manship must have joined the thousands of curious visitors to the Armory, and he can hardly have been indifferent to a display that ranged from the conservative—especially in submissions by American artists (whom Manship had collectively criticized at the International Exposition in Rome)—to the radically modern. Was he hostile to the predominantly European modernists, like the academic artists with whom he allied professionally? Or had he grounds for sympathy with any of the modern sculptors represented at the Armory? The answer may be "yes" to both questions. The first describes above all a public position, one Manship could hardly avoid in later years as a leader of various conservative artistic organizations, though he did not announce it in his youth. Manship's point of intersection with modernism—his archaism—reveals itself only to more delicate probing and then perhaps only fleetingly; archaism and modernist sculptural practice diverge by the middle of the 1910s. That story will be taken up in chapters 6 and 7. What follows here is a consideration of the early years of Manship's artistic maturity: the character of his sculpture, the response to it, and the creative context in which it appeared. Conservative approbation aside, Manship's art exhibited some unexpected points of congruence with modernism, and these contributed in subtle but important ways to his later success.

Manship made his professional debut in February 1913 at the Twenty-Eighth Annual Exhibition of the conservative Architectural League of New York. From its inception in 1880 and despite its name, the League not only included painters and sculptors among its members but actively cultivated these colleagues whose decorative talents contributed so prominently to the ambitious architectural projects of the period.[1] A similar motivation had prompted the early decision to include painters and sculptors among fellows of the American Academy. The two organizations thus shared a point of view and cooperated to promote it, especially after the election of C. Grant La Farge (the Academy's secretary) to president of the Architectural League in 1908 bolstered the alliance. Beginning in 1910, the League featured a statement on the origins and objectives of the Academy in its combined catalogue-yearbook and presented the work of newly returned fellows in the annual exhibitions.[2] In 1913, Manship showed ten sculptures, including his annual Academy projects, a commemorative medallion, and six statuettes produced chiefly during his final year in Rome. Among them, the *Centaur and Dryad* attracted the most critical attention (M28; fig. 41). Sophisticated yet playful, complex but accessible, this work offers a fitting introduction to Manship's archaistic style and reveals his ability to adapt from a wide range of artistic prototypes to create an appealing work that is quite his own.

The origins of the *Centaur and Dryad* lie in Manship's earliest work at the Academy. His major project of the first year, the large relief of a centaur and a nymph dancing, in effect presents the narrative prelude to the *Centaur and Dryad;* in the later work the centaur captures a fleeing nymph, gripping her firmly beneath the breast with one hand. Scenes on the *Centaur and Dryad's* base, although populated with different mythological characters, suggest earlier stages in the drama: on the primary side, two maenads and two sileni dance; on the reverse, a pair of sileni on goats pursue a maenad. Manship's interest in the erotic capture motif is also evident in several small, expressively modeled maquettes (one on the eccentric theme of a struggling centaur and a mermaid; M9) that appear in photographs of his studio; of these, the nearest antecedent to the *Centaur and Dryad* rests on the shelf to Manship's immediate left in the photographic postcard from 1910 (fig. 11).[3]

In theme and composition, the *Centaur and Dryad* has monumental antecedents in Greek architectural sculpture showing lapith and centaur confrontations—for example, the centaur struggling with a lapith bride from the west pediment of the Temple of Zeus at Olympia.[4] Its earnestness of conflict is not, however, expressed by Manship's leering centaur and the mock horror of his nymph, whose struggles a newspaper critic described as "amusing rather than bestial."[5] The playful spirit of Manship's work finds closer parallel in Greek vase painting and in Pompeian frescoes of

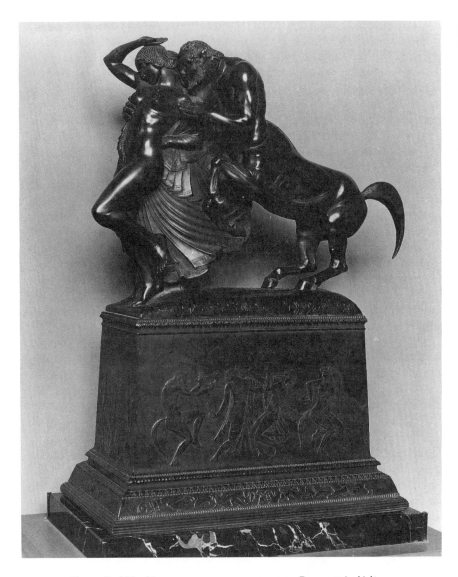

Fig. 41. Paul Manship, CENTAUR AND DRYAD, 1912–1913. Bronze, 29 in. high.
Metropolitan Museum of Art, Amelia B. Lazarus Fund, 1914.

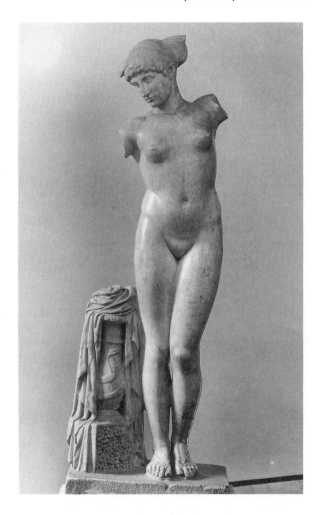

Fig. 42. Esquiline Venus,
ca. 50 B.C. Marble,
61 in. high.
Conservatori Museum,
Rome. Photo, Hirmer
Verlag, Munich.

frolicking satyrs, nymphs, centaurs, and bacchantes, such as Manship must have seen in the Museo Nazionale in Naples.[6] Just as significantly, there is little stylistic affinity between the architectural sculpture from Olympia and the *Centaur and Dryad;* Manship's sculpture is far too stylized and decorative, as befits a table-top statuette, for the early-fifth-century work to have been more than a general source of inspiration.[7]

Individual parts of the statuette suggest other models. The body of the nymph recalls the compact and sensually posed torso of the so-called Esquiline Venus, a classical work as eclectic as Manship's modern sculptures are and, not surprisingly, one that he particularly liked (fig. 42).[8] A characterization of Manship's sculpture, written in 1916, well serves the ancient work: both combine the "clear precision and simple force" of preclassical

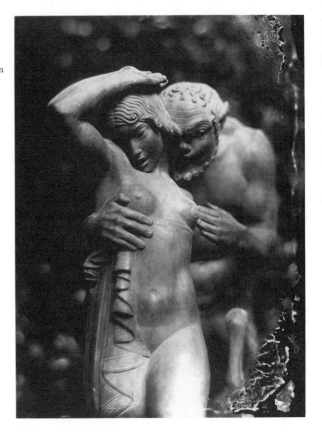

Fig. 43. Paul Manship,
CENTAUR AND DRYAD,
detail, 1912–1913.
Peter A. Juley & Son
Collection, National Museum
of American Art,
Smithsonian Institution.

Greek art with "the grace of the later Greek figures and the anatomical correctness of a still later time."[9] The similarity between the two is most evident when the dryad is seen frontally, a view contrary to the *Centaur and Dryad*'s usual presentation, but one the sculptor must have thought interesting (fig. 43); a photograph of Manship in his New York studio, with his work arranged for a private exhibition in November 1913, reveals that he oriented the *Centaur and Dryad* in a way that compelled attention to the narrow end and direct confrontation with the nymph. On the other hand, only the broad (and best known) view displays the complicated, stylized pattern of the dryad's long garment. This stylization, apparent also in the figures' faces and hair, is the most striking aspect of the statuette and the clear evidence of Manship's newfound infatuation with archaic art. The centaur's head appears based on late-archaic satyr-head antefixes (fig. 44), evoked also in the contemporary *Mask of Silenus*. In ancient times, satyrs were sometimes identified as water demons, hence the choice of a satyr's head for the purpose of draining rainwater from a temple roof.[10] Manship's

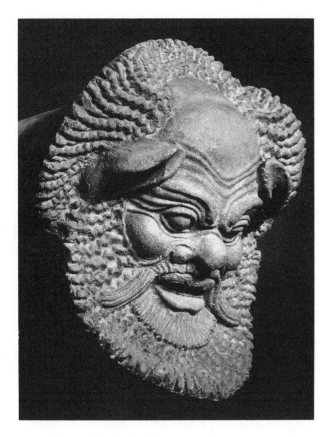

Fig. 44. Head of a Satyr,
antefix from a temple
in Gela,
early fifth century B.C.
Terracotta, 7¾ in. high.
Antiquario, Gela,
Sicily. Photo, Hirmer
Verlag, Munich.

familiarity with such architectural ornaments and understanding of their function is evident from his use of similar grotesques as waterspouts for his *Infant Hercules Fountain* of 1914 at the American Academy in Rome (M55; fig. 57).

The centaur's face also recalls those of satyrs on Greek vases, raising the possibility of a painted source of inspiration for the *Centaur and Dryad*. Certainly, the low relief of the base, where nymphs and satyrs cavort in bacchic merriment, suggests designs found on vases, as well as evoking their occasionally bawdy subjects (fig. 45). A comparison with the principles of design in vase painting can be extended, for although the main group is executed in the round, the primary view is from the side, where the decorative, expressive silhouette (so important to vase painting) is seen to best advantage. Manship believed Greek vase painting to be related to Greek sculpture. "The draftsmen of Greek vases," he later declared, "came close to suggesting the nobility of form and movement of the supreme art of sculpture"—and the same might be said of its relationship to his own

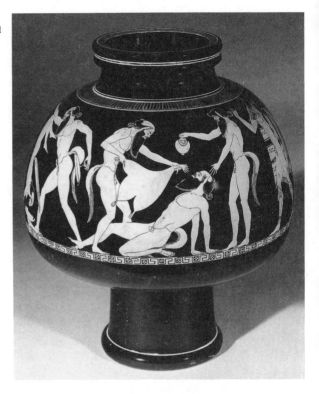

work.[11] The stylized and linear quality of so much of Manship's sculpture has frequently been noted; with specific reference to the *Centaur and Dryad,* one writer remarked that "drapery in a pattern reminiscent of Greek vases is used to fill the space between the two figures."[12] Another critic observed of Manship's work as a whole, "his figures, his draperies, his animals, invariably strike one as being *drawn* rather than modelled. In Manship, the silhouette is triumphant."[13] The artist would not have quarreled with this assessment and once stated: "My attitude toward composition . . . has always been more or less influenced by drawing. That is to say that the linear feeling and the silhouettes and the open spaces between the solids always played an important part in my feeling for composition. . . . The fact that I liked to first draw my compositions whatever they may have been, had an influence to make them . . . two-sided, perhaps considering the front view as being exceedingly important."[14] Manship perceived form in line and outline at least as much as he did in mass.

Although ancient art offered important models for the *Centaur and Dryad,* at least one modern parallel exists in the work of the German symbolist painter and sculptor Franz von Stuck (1863–1928). Stuck's *Mounted Amazon* (fig. 46), in particular, exhibits a sleekness of surface and form

Fig. 46. Franz von Stuck,
MOUNTED AMAZON, 1897.
Bronze, 25 in. high.
The Metropolitan
Museum of Art,
gift of Edward D. Adams,
1927.

similar to that of the *Centaur and Dryad* (and suggests that both sculptors were looking at early-fifth-century Greek animal sculpture).[15] The *Mounted Amazon* was included in a traveling exhibition of contemporary German art that opened at the Metropolitan Museum of Art in January 1909, during Manship's residency in New York.[16] The centaurs, nymphs, and satyrs that dominate Stuck's subject matter led the *New York Times* to dub him a "neo-Greek" German, but the characterization might well be applied to the crispness of form in his sculpture, apparent as well in the work of Stuck's fellow exhibitors Hermann Hahn, Adolf von Hildebrand, Hugo Lederer, and Louis Tuaillon.[17]

Catalogue essayist Paul Clemen identified "striving after greatness of outline" with modern German art, but such emphasis on outline also characterizes Manship's sculpture. At least two of Manship's contemporaries believed that there might be some connection; one thought the *Centaur and Dryad* "a curious note to find in American sculpture, although so frequent in German," while the other—confronted with Manship's *Satyr and Sleeping Nymph* (1912; M22)—remembered "the same topic worked out grotesquely" by Stuck in the 1909 exhibition.[18] Although subject may have been foremost in the minds of these commentators, the frequency of

mythological motifs in American sculpture compels the conclusion that style contributed significantly to the perception of similarity between Manship's art and contemporary German sculpture. The second comment, on the other hand, underscores an essential difference between Manship and Stuck. By comparison with the German artist's vibrantly bestial creatures, especially as represented in his paintings, Manship's pagans seemed curiously chaste, "removed enough from actuality to be pretty and quaint, not revolting"; indeed, they were perceived as "wholesome, untainted by sin, for the primitive world knew neither morality nor immorality"—a romantic distortion characteristic of modern primitivism.[19]

Not everyone concurred on the innocence of Manship's sculptures. A Detroit reviewer complained that the female figures appeared "more animal than human emphasizing the physical rather than the mental traits" and predicted that Manship's subjects were unlikely to appeal to a wide audience because they were "bizarre," "uncultured," and celebrated "the cruder emotions of mankind."[20] This response found its extreme in official censorship of the February 1914 issue of *Metropolitan Magazine* on the grounds that Manship's sculptures, reproduced in that issue, were indecent. *The Wood Nymph's Dance,* said New York postmaster Edward M. Morgan, "is something I would not permit in my family circle," and he declared the *Centaur and Dryad* a "bestial" depiction of "the leering passion of a monster."[21] In fact, Manship's employment of half-human, mythological creatures and narrative context tends to neutralize, rather than enhance, sexuality, as other commentators on his art had recognized. The voices of outrage certainly represented an extreme opinion and, as is so often the case with censorship, may have done Manship more good than harm.

The *Centaur and Dryad* perfectly exemplifies Manship's sculpture in the years following his return from Rome and for which he attracted immediate critical attention. Soon after the Architectural League exhibition opened, the conservative artist and critic Kenyon Cox devoted a column in the *Nation* to the young sculptor. His commentary opens with reserved praise for the work he correctly assumed to be Manship's earliest in the show, the first-year Academy relief (fig. 12), but he added that "the manner shows no particular individuality, and the only thing that distinguishes this production from that of almost any other clever young sculptor is the entire absence of the influence of Rodin." Cox mistakenly believed the *Duck Girl* (fig. 13), created only a year later, to be Manship's most recent work because he saw it as the sculptor's most accomplished performance. While recalling "the best Pompeian bronzes," the *Duck Girl* conveyed to Cox the charm and spirit of the live model: "This is living flesh and tissue, the movement profoundly studied, each bone and muscle and tendon in its place and functioning under the smooth skin. The figure . . . is probably that of some

precocious Italian girl of to-day; the lovely head . . . is apparently a refined portrait. We are as far from the mechanically constructed pseudo-classic ideal as from vulgar realism. . . . It seems to me an original work of true classic inspiration." This praise contrasts with Cox's opinion of the *Mask of Silenus* (fig. 16). He criticized the "archaistic treatment of certain de-tails"—specifically, the mask—as ill-conceived and conspicuous; however, he correctly divined that it was among "the first fruits of Mr. Manship's interest in archaic Greek sculpture and a tentative effort to appropriate its piquancy." [22]

Cox was more forgiving of Manship's archaism in the "almost uni-formly successful and charming" statuettes, including *Centaur and Dryad, Lyric Muse, Playfulness,* and *Little Brother.* Quite in spite of their archaizing details, they seemed to him "full of the direct observation of life and of an essential modernity." He further observed that "to see this archaistic man-ner applied to figures with a quite unarchaic freedom of movement, doing things that no archaic sculptor would have thought of making them do, is oddly exhilarating." Cox perceived these works as at once inspired by the example of antiquity and grounded in direct observation of the present, as fresh in appearance and modern in expression; without doubt, he regarded them as the products of an adventurous and capable young sculptor. Still, he seems not entirely to have approved of their archaism, which he felt com-pelled to justify: "These are minor works with a distinctly sub-humorous intention, and the peculiarity of method seems to me a quite legitimate way of attaining the desired effect." Thus, although Cox recognized the artistic superiority of these works to the *Mask of Silenus,* he considered the statuette a more appropriate vehicle for Manship's archaizing tendencies than large-scale, more public sculptures. [23]

Cox's emphasis on craftsmanship, reverence for accepted artistic models, and belief in tradition epitomize the academic point of view. A prolific writer on matters of art, he articulated that position most cogently in a series of lectures at the Art Institute of Chicago in 1911, published later that year as *The Classic Point of View.* As he defined it:

> The Classic Spirit is the disinterested search for perfection; it is the love of clear-ness and reasonableness and self-control; it is, above all, the love of perma-nence and continuity. It asks of a work, not that it shall be novel or effective, but that it shall be fine and noble. It seeks not merely to express individuality or emotion but to express disciplined emotion and individuality restrained by law. It strives for the essential rather than the accidental, the eternal rather than the momentary—loves impersonality more than personality. [24]

Cox's artistic credo, as he well knew, positioned him squarely against the rising tide of modernism. He decried the modernists' celebration of sub-

jectivity—their insistence on individual authority and self-expression—and was frankly aghast at their embrace of the art of "savage peoples, Hottentots, or Alaskan Indians" as a corrective to naturalism, an "unspeakable" and "hideous" program for which he especially blamed "young Parisian students." [25]

As a product of the American Academy, Manship not only had the right pedigree but demonstrated it in his meticulous craftsmanship and respect for the art of the past—if not always for a canonical model. Cox's faith in Manship would not be betrayed. Manship himself later became a prominent spokesman for academic principles and a firm guardian of the principles for which the Academy stood. In the words of one trustee: "The establishment of the American Academy in Rome is in the interests of the continuance of traditions and in opposition to the tendency of the present age, which is to break off from them entirely. . . . the greatest works have been produced only in strict subordination to the traditions of the past. Nothing . . . is more futile than the deliberate effort to create a new style." [26] To that effort, precisely, modern artists committed themselves. By contrast, Manship remained in acceptable bounds with his borrowings from archaic Greece; indeed, a precedent for his archaism already existed in the work of three of America's most celebrated sculptors: Daniel Chester French, Augustus Saint-Gaudens, and Karl Bitter.

"Modern-archaic": so one writer dubbed French's *Republic,* which presided briefly over the Court of Honor at the World's Columbian Exposition a full twenty years before Manship's Architectural League debut. [27] French must have intended its colossal size and imposing architectonic character to evoke the legendary Athena Parthenos by Phidias (known only through literary descriptions, small-scale and partial copies, and images on coins); that work, although postdating the archaic period, emulated the kore type and, appropriately for a cult statue, retained more of the kore's sober reserve than did other classical statues. French's *Wisdom* (1898–1900; fig. 47) for the Minnesota State Capitol refers more directly to Athena, the Greek goddess of wisdom, by its inclusion of symbolic attributes (the headdress and aegis) associated with Athena and by reference to ancient stylistic conventions for representing her. The official capitol guidebook of 1907 described *Wisdom* as "early Greek in treatment" and pronounced it "the most beautiful" of French's six statues for the building's second-story arcade. [28] "Many changes in art expression have taken place during the last century," the writer observed, "and the dry formulas of classicism are no longer observed. Artists are free to use their taste and judgment, and they may cull from the ages. Mr. French thoroughly understands Greek art, and he adapts it to modern requirements." [29]

Augustus Saint-Gaudens joined French in the early use of archaism, no-

Fig. 47. Daniel Chester
French, WISDOM, 1898–1900.
Minnesota State Capitol.
Minnesota Historical Society.
Photo, A. B. Bogart.

tably in the eight caryatids he executed for John J. Albright between 1906 and 1908.[30] According to the sculptor's son, Saint-Gaudens "wished to create his caryatids as large reposeful women in no way personal and to some extent archaic."[31] The well-known caryatids from the Erechtheion were certainly his models; although dating to the late fifth century, they, like the Athena Parthenos, were based on korai and thus were archaizing in certain details. Saint-Gaudens increased the archaizing effect of his sculptures by changing the element that most clearly indicated the late-fifth-century date for the Erechtheion sculptures: the way they are draped. Garments cling to and reveal the full, womanly figures of the Greek caryatids, whereas on the caryatids by Saint-Gaudens, they hang heavily and in distinctly archaizing fashion.

Although Karl Bitter's archaism was more sustained, and ultimately more sophisticated, than that of Saint-Gaudens and French, his earliest essays in the style are not unlike theirs. A decisively archaizing, allegorical female figure representing Wisconsin is the centerpiece of Bitter's west pediment for George B. Post's Wisconsin State Capitol (fig. 48). Her head appears to be based on archaic Ionic korai, such as were unearthed on the Acropolis in the late 1880s;[32] however, the rigidly symmetrical drapery and, especially, the outstretched arms are uncharacteristic of the archaic period, when the most daring departure from the vestigial block of quarried stone was a doweled-in lower arm extending forward from the waist in a gesture of offering. Paradoxically, the korai exude far greater vitality than Bitter's stiff *Wisconsin*. Archaic sculptors had worked directly in marble and, constrained in some measure by its resistance, had developed subtle strategies for communicating movement. Bitter experienced no comparable technical struggles: his figure was modeled, cast in plaster, and pointed in granite. The end effect belies the means. Although Bitter's concern with archaic processes increased dramatically as he became more aware of archaic work, his knowledge in early 1909, as the dry and lifeless Wisconsin figure reveals, was extremely limited.[33] These works by Bitter, Saint-Gaudens, and French demonstrate a highly selective use of archaism, one reserved for monumental sculpture in stone, which—by virtue of architectural context or allegorical reference—related to rather specific ancient prototypes. Manship, on the other hand, exercised considerably greater freedom in adapting archaic conventions and, for some viewers, their novelty alone signaled modernity.

Manship's modernity received consideration from Charles Caffin, art critic for the *New York American*. Although no radical, Caffin accepted artistic experimentation more readily than did Cox and concerned himself less with protecting an academic status quo. He also decidedly opposed the idea of the American Academy in Rome and expressed this disapproval in

Fig. 48. Karl Bitter, model for western pediment, Wisconsin State Capitol, Madison, 1906–1911. Plaster, 54 in. high. Photo courtesy of James M. Dennis.

no uncertain terms in his review of the League exhibition. "From the standpoint of art Rome is a mausoleum, a sepulchre of dead motives; the live influences are elsewhere," he wrote, adding that the young artist exposed to Rome will feel "the touch of the dead hand" and risk becoming "prematurely an artistic fogy." Nevertheless, Caffin saw distinct promise in Manship's work, noting in connection with the *Centaur and Dryad:* "He is not using the old story merely as subject, but seems to comprehend its emotional significance and, more than that, seems also to feel it in terms of modern experience. Possibly in time he will find a way to express these emotions even more poignantly by associating them with modern forms." Caffin was optimistic that this would come to pass because he perceived in the draperies and heads a "searching after a more abstract treatment of form"; the bodies he dismissed as conventionally modeled and "by comparison commonplace." Significantly then, the archaic-inspired details (though not identified using that term) caught Caffin's attention, along with the work's emotional expressiveness. These factors caused him tentatively to rank Manship among the country's promising young modernists.[34]

Manship's work unquestionably represented something different from other tendencies in American sculpture around 1913, but the degree to which his work appeared modern needs to be evaluated in the broader context of contemporary artistic production. Late-nineteenth- and early-twentieth-century sculpture was dominated by a manner labeled "Beaux-Arts," in reference to the Ecole des Beaux-Arts in Paris, where so many American artists of the period—sculptors, painters, and architects—studied. Beaux-Arts sculpture itself represented a decisive departure from neoclassical practice of the mid–nineteenth century. The neoclassical sculptor typically studied in Italy, usually independent of any modern master; worked in white marble, carved to smooth finish by artisans; and chose morally uplifting ideal subjects, often based on themes or types from classical antiquity or the Bible. After about 1875, however, sculptors abandoned Italy for Paris, where they sought instruction in one of several academies (such as the Beaux-Arts) or in the atelier of a French sculptor. These artists favored bronze as a material because it well preserved the lively modeling that may be considered a hallmark of Beaux-Arts style.

Sculptors also drew upon a broader range of subjects than previously. Although their greatest purpose was still defined in terms of inspiring and edifying the viewer, personifying imagery and abstract types supplanted specifically classical subjects. Such sculpture of lofty ideals and exhaustive allegory demanded an architectural and urban environment and, in preferring this forum, Beaux-Arts sculptors differed little from their predecessors. They were more fortunate, however, for by the 1890s—with the impetus provided by the City Beautiful movement and the construction of

ambitious monuments, memorials, and civic buildings—American sculptors finally gained the public prominence they had so long sought.[35]

The Beaux-Arts approach dominated sculpture and architecture in turn-of-the-century America. Any ambitious artist would have absorbed it at firsthand in France, but the techniques and philosophy were promulgated in the United States as well. In cities throughout the country, and at the world's fairs, Americans had ample opportunity to become familiar with Beaux-Arts design. New Yorkers, especially, were surrounded by examples: the Appellate Court, the Customs House, the Stock Exchange, and the Public Library were among the more important buildings featuring sculptural decoration by such prominent artists as Herbert Adams, Karl Bitter, Paul Wayland Bartlett, Daniel Chester French, and John Quincy Adams Ward. Both the style and the elaborate, allegorical programs developed for these buildings had counterparts in freestanding monuments distributed throughout the city. The *Maine Memorial* offers an example exactly contemporary with the *Centaur and Dryad;* featuring sculptures by Attilio Piccirilli, it allegorized *The Antebellum State of Mind (Courage awaiting the Flight of Peace and Fortitude supporting the feeble)* and *The Post Bellum Idea (Justice receiving back the sword which she has entrusted to the Genius of War, and History recording its deeds).*[36] The Architectural League's exhibition in 1913 featured numerous sculptures of this general type.

Although it might seem inappropriate to compare such large-scale, ambitious, and morally earnest projects with the miniaturistic and playful sculptures of Manship, such work had long represented a pinnacle of achievement to ambitious sculptors. It is not that "serious" sculptors such as French never created purely decorative work, but that they would, under no circumstances, wish to be identified with so frivolous a genre. Nevertheless, the leaders of American sculpture—founders of the National Sculpture Society in 1893—recognized a need to broaden the creative and economic opportunities for members of their profession. One of their objectives was to promote private acquisition of sculpture; however, as of 1893, the Society needed to encourage not only citizens to become consumers, but also sculptors to become producers. Other than portraits, few sculptors of that time made works suited to domestic settings, in scale, subject matter, or cost. Genre sculptor John Rogers had been a notable exception, but more high-minded sculptors scorned his populism and the mass production and commercial marketing of his work.

Some two decades later, genre sculpture constituted a significant percentage of the sculpture exhibits at National Academy of Design exhibitions, one of the regular showplaces for American sculptors. Indeed, later scholars have considered such works, particularly when contemporary and urban in theme, the first real threat to the dominance of Beaux-Arts sculp-

ture.[37] Genre sculpture secured official recognition when the National Academy of Design awarded its Helen Foster Barnett prize for Sculpture (instituted in 1908 and granted to sculptors under thirty-five) to Abastenia Eberle's *Windy Doorstep* in 1910 and Mahonri Young's *Bovet Arthur, a Laborer* in 1911. Even so, such realist themes did not bring genre sculptors the kind of success Manship quickly gained, perhaps because they always threatened to remind comfortably established patrons of economic realities they preferred to ignore.

Private purchasers could certainly find less socially sensitive works of modest scale in an increasing number of exhibitions devoted exclusively to sculpture, especially that intended for individual acquisition; these gradually relieved the lack of exposure from which sculptors so long suffered. Examples include a 1912 exhibition in Boston of garden sculpture and the 1913 showings of small marbles and bronzes at the National Arts Club and small bronzes (including some of Manship's) at New York's Gorham Galleries.[38] By 1915, a Philadelphia newspaper could declare "agreeable ornaments for house and garden" to be "the thing of the hour in American art."[39] In this climate, Manship's attraction and sensitivity to small-scale sculpture worked in his favor, but that factor does not explain his extraordinary success.

Manship's playful themes, so entirely unlike Beaux-Arts bombast or the more prosaic genre subjects, undoubtedly also contributed to the attractiveness of his sculptures. French art historian Paul Vitry, writing in 1927, found the gaiety of Manship's *Playfulness* (M21; fig. 49) and *Little Brother* (M18) a far cry from the "harsh or dolorous themes of motherhood" of nineteenth-century academic sculpture.[40] Manship's arcadian subjects seemed slightly exotic, even a little bit naughty at times, but few audiences would have found them either offensive or unfamiliar; after all, *Playfulness* presented a woman (albeit nude) playing with a baby in a most innocuous fashion, and quasi-mythological, decorative subjects abounded at the National Academy exhibitions. This is apparent even from a sample limited to submissions by recipients of the Barnett Prize for Sculpture. Robert Aitken, who received the award for *The Flame* in 1908, also showed a *Tired Mercury, Dancing Nymph,* and *Bacchante.* In 1909, Chester Beach was honored for his *Young Nymph.* Mahonri Young won for *Bovet Arthur* in 1911, but he showed a *Listening Faun* as well.[41] In this line of succession, Manship's *Centaur and Dryad,* the prizewinner in 1913, seems right at home. But Manship's statuettes did not look like these, or any other, works in the various sculpture exhibits of that time. The key to Manship's impact lies in his archaistic style.

To help them assess this unfamiliar style, writers, not surprisingly, resorted to comparisons. They observed the difference between Manship's

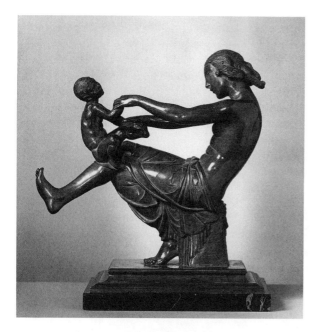

Fig. 49. Paul Manship,
PLAYFULNESS, 1912.
Bronze on marble base,
13⅜ in. high.
National Museum of
American Art,
Smithsonian Institution,
gift of Paul Manship.

smooth-surfaced, crisply detailed sculptures and the expressively modeled works so characteristic of the day; more particularly, they contrasted his work with that of the most prominent representative of sculptural expressionism, Rodin. A. E. Gallatin declared Manship's freedom from the influence of Rodin—"a rock that has shipwrecked many young sculptors"—a considerable virtue.[42] And even if Manship's style risked the danger of hardening into mannerism, Kenyon Cox allowed that "it would, at least, have the merit of being his own mannerism, not that weak reflection of the mannerism of Rodin, which seems to be the stock in trade of most of our young sculptors."[43] The mannerism in question was surely Rodin's modeling style; few American sculptors understood or adopted the French artist's more radical formal devices, such as retention of the block and use of the partial figure.

Hermon Atkins MacNeil's *Into the Unknown,* exhibited as *Inspiration* at the National Academy of Design in 1912, demonstrates the potential for corruption of those innovations (fig. 50). An allegory on the inspiration of the sculptor, thematically echoing Rodin's fascination with the muse, MacNeil's work represents the genius of sculpture, a naturalistic (though winged) female, apparently hewing herself from the rough block of stone to which her face remains attached. The implication that the sculptor—through his muse—cuts stone is misleading and also somewhat ironic, given the academic denial of genius to hired stonecutters.[44] MacNeil's resort to narrative

Fig. 50. Hermon Atkins MacNeil, INTO THE UNKNOWN, ca. 1912. Marble, 61 in. high. Photo courtesy of Brookgreen Gardens, Murrells Inlet, S.C. Gurdon L. Tarbox, Jr., photographer.

excuse for retaining the block is more troublesome; such justification of the Rodinesque device robs it of all potential for expressive modernity. The urge to formal and narrative clarity unquestionably runs counter to the opacity and resistance to legibility of Rodin's sculptures; however, it typifies the approach of the many American sculptors who emulated Rodin in a literally superficial manner, often employing what seems arbitrarily overworked modeling.[45]

Hardly peculiar to Rodin, expressive handling characterizes much turn-of-the-century French and French-inspired sculpture, including that of Manship's teachers Solon Borglum and Charles Grafly. Under their tutelage Manship himself created work with strongly animated surfaces, as in the *Wrestlers* (fig. 1). When Manship abandoned the rough, impressionistic modeling of his student days—the "knarled [*sic*] and knotted force" that Caffin admired in *End of Day*—he therefore separated himself from a large number of his colleagues.[46] Manship's works have expressive contours—indeed, this quality is emphasized—but the line is continuous, not broken.[47]

In the opinion of some writers, Manship's art sacrificed vitality to hardness (that charge appears with explicit comparison with Rodin in one review of Manship's work), but he would not have regarded that as a criticism.[48] Manship felt that stone and bronze should be made to look like the hard materials they were and not like the malleable clay. As he explained in 1914: "When I give a high finish to my work it is because I think beautiful

form must be positive, and not a combination of accidental surfaces—impressionism, you might call it—and that these forms must have a definite relationship to each other and to the lines upon which the composition is built."[49] This emphasis on the hardness of bronze affords an interesting parallel to the direct carver's concern with truth to material. Of course, it might be argued that there was no inherent truthfulness in equating hardness with smoothness and polish, as Manship did, since the ductile character of bronze could replicate any mold; late-nineteenth-century artists wishing to preserve the vitality of their clay sketches in the finished work indeed adopted bronze for precisely that reason. Nor could the sculptor in bronze enjoy the symbiotic relationship with the material in which the direct carver exulted.

In 1913, direct carving was in its infancy, especially in the United States, where scholars associate its beginnings with Robert Laurent, who started carving decorative reliefs in wood in the early teens, apparently without programmatic intent.[50] Yet Chester Beach, a now mostly forgotten sculptor, expressed the aesthetic of direct carving as early as January 1914 in a letter to sculptor Paul Wayland Bartlett:

> With about six of my last works in marble, I have cut directly in the stone, using charcoal to draw on the granite block for guide. This takes time but, this very fact is its merit. I discover the figure that I see in the block and can take advantage of all suggestions the rough stone forms in the process of working. . . . the modeling or building up of clay and the cutting away of stone are so different, as to bear no relation one to the other. In working the stone I find the shadow or hollows must be modeled very different from clay on account of their luminous quality. The cost is more than with the pointing machine and the mistakes are more, but there is always the chance someday of striking a clean sincere bit of marble sculpture and I believe we should all try to get back to the directness of the Greek and Goth and Michelangelo, mallet and chisel in hand.[51]

Beach's technique of drawing on the block and his insistence on the discrete properties of clay and stone suggest familiarity with Hildebrand's ideas. More significant, his characterization of carving as a process of discovery—a link to such later American proponents of direct carving as Laurent, William Zorach, and John Flannagan—expresses a distinctly modern concern with spontaneity, originality, and authenticity.

Beach's early formulation of such ideas and, especially, his academic connections give him considerable prominence here. Beach had a studio in Rome during the period when Manship lived there and, thanks to a letter of introduction from Daniel Chester French, gained social entree to the Academy in late 1910.[52] The following spring he traveled to Florence,

where he saw Michelangelo's recently rediscovered, unfinished slaves for the Tomb of Pope Julius II. They may have stimulated Beach's interest in carving and the aesthetic of non-finito because soon thereafter he penned a cryptic line to his dealer in America: "At present two of [my] marbles are finished, but I hope they will again look unfinished by end of another year."[53] Around the same time, Beach saw the work of Meštrović at the International Exposition in Rome; he found it "very weird but . . . original."[54] Still later in 1911, he declared his intent to go to Greece to study the technical working of Greek marbles.[55] Given that Manship was in contact with Beach throughout this period, saw the unfinished Michelangelo slaves soon after Beach did—noting that "they show the original inspiration of our new school which finds novelty and greatness (?) in half carved stone"—and followed in his footsteps to Greece, it seems likely that they would have discussed technical matters.[56]

It would be inappropriate to force an association between Manship and any of the direct carvers, for theirs was not a method with which he had much sympathy.[57] Manship appreciated the aesthetic of hardness, but preferred to produce it more expediently; the end, as far as he was concerned, justified the means. Manship was simply too deliberate to surrender to the almost mystical process of discovering what Flannagan later called "the image in the rock."[58] Furthermore, wood and stone were not his chosen materials (although he produced numerous works in marble); Manship favored bronze because that material "lends itself to silhouette, to elaboration of detail, and to open spaces and projecting parts"—qualities of greatest importance to his sculptural aesthetic.[59] But he coupled his appreciation for bronze's tensile strength with a respect for its hardness, a quality he viewed as inherent to the material and "fundamentally wrong" to betray.[60] He insisted that "a clay model should ever remain in clay" and, during his second year at the Academy, began to carve in plaster as a way of purging his work of its earlier, thumbed appearance.[61] Manship's emphasis, in word and deed, on the hardness of bronze must be understood as an early challenge to the modeled appearance of contemporary Beaux-Arts sculpture in bronze.

Whether Manship consciously pursued the aesthetic of hardness, or whether it arose from his growing admiration for the smooth surfaces, controlled contours, and crisp details of early Greek art is difficult to say. His friend and fellow sculptor Walker Hancock, at any rate, had "very much the feeling that [Manship's] work began to harden up just before he found the superficial means of treating it like a hard material; the superficial thing in his case being, of course, the archaistic [that is, archaic] Greek primarily."[62] Hancock's use of the word *superficial* suggests that archaic art as such had limited meaning for Manship, but that can hardly be the case,

since the archaic style confirmed the direction of his art at a critical moment. Moreover, Manship's attraction to archaic art and his adaptation of its sharp-edged details in his own work cannot be seen as a matter of desultory antiquarianism or novelty seeking. To the contrary, Manship's archaism was purposeful: he borrowed sharp-edged details of hair and drapery from Greek archaic art because such treatment emphasized the surface and the hardness of his material.

Such stylized details most readily identify Manship's art, prompting for his sculptures the label "archaistic." Not having followed the steps that led Manship to the style, the art-going public in 1913 was quite unprepared for the effect of his work.[63] Commentators repeatedly noted the striking combination of stylized details and naturalistic poses, a quite unarchaic conjunction, but a successful one—particularly compared to Charles Keck's base for a lamppost at the same exhibition, an infelicitous pairing of stylized vegetation and naturalistically rendered children reading books and wearing wrinkled stockings.[64] Quite in spite of their hardness, which might be equated with stiffness, Manship's figures convey an easy naturalism, an unforced grace, which won wide approval in early reviews. Interestingly, critics identified both the absence of naturalism and its presence as the modern notes in Manship's work: one writer discerned "the fusion of a modern naturalism with an antique distinction of style," whereas Caffin identified the archaizing elements as modern.[65] These observers excused Manship's obvious reliance on the past because his archaic prototypes abstracted natural form, giving his work a basis that was acceptable as "modern" rather than unacceptable as an "academic" naturalism.

The degree to which Manship appeared modern in 1913 can be appreciated by considering the extent to which a more truly vanguard American sculpture had developed. Nonobjective sculpture did not appear in America until Max Weber's exploration of basic design principles in such works of 1915 as *Equilibrium* and *Spiral Rhythm*. Within a few years, both John Storrs and Robert Laurent also created abstract sculptures; but, in 1913, Storrs was a pupil of Rodin in Paris, his career just beginning, and Laurent had only recently taken up direct carving. In the American section at the Armory Show, which opened two and a half weeks after the Architectural League exhibition, the most modern sculptures may have been a statuette by Gaston Lachaise (who soon thereafter became an assistant to Manship) and *Lucifer,* a bust by Andrew Dasburg.[66] Lachaise's modernity, rather than being technical or thematic, derives from the sculptor's highly personal interpretation of the female nude, an approach he developed more fully later in the decade. Dasburg's cubistic work, featuring sharp angular planes created by direct carving in plaster, appears visually and technically more radical. Although Manship would never have distorted anatomy as

Fig. 51. Jo Davidson, TORSO,
ca. 1912. Bronze on rock,
22 in. high.
Estate of Jo Davidson,
courtesy of
Conner-Rosenkranz,
New York.
Photo, Scott Bowron,
New York.

Dasburg did in *Lucifer,* he also routinely carved on his plaster models and
for essentially the same reason: it permitted a sharpness of form and detail
that could not be achieved in clay. Otherwise, Rodin's influence prevailed
among the more modern American sculptors, including Robert Aitken
and George Gray Barnard, both of whom exhibited marbles incorporating
roughly worked areas of stone, and Jo Davidson, whose *Torso* combined
an expressively modeled partial figure in bronze with a base of apparently
unshaped stone (fig. 51).[67]

For those Americans not familiar with the European avant-garde, the

Fig. 52. Henri Matisse,
THE BACK, I, 1909,
cast ca. 1954–1955.
Bronze, 74⅜ in. high.
Hirshhorn Museum
and Sculpture Garden,
Smithsonian Institution,
gift of Joseph H. Hirshhorn,
1966. © 1992 Succession
H. Matisse/ARS, N.Y.

Armory Show provided their first exposure. As in the case of the paint-
ings, the European sculptures far outstripped those by Americans in mo-
dernity. Picasso and Matisse, whose paintings appalled American observ-
ers, each showed a single sculpture. Although the vigorously worked
surfaces of these entries may have suggested Rodin to the average viewer,
neither Matisse nor Picasso shared the older sculptor's respect for naturalis-
tic appearances. Picasso's *Woman's Head* (1909), a bronze variant of his cub-
ist experiments from that period, aggressively restructured anatomy; the
head is faceted in such a way that its surface no longer corresponds to the

represented volume.[68] Matisse's monumental relief *The Back*, more naturalistic than his smaller freestanding sculptures of the same period, likewise distorts the anatomy of his subject (fig. 52).[69] Because the ground in a relief is usually read pictorially, the viewer might—by a stretch of the imagination—attribute these distortions to pressure of the figure against a wall, splaying the breast and fingers sidewards. To some extent, Matisse facilitates such a reading by positioning the woman's left hand at the top of the relief in a manner that evokes a model's hand hooked over a panel to support her pose (the abruptly truncated legs, however, resist such rationalization). But even this narrative explanation contains a challenge to tradition because it threatens the accustomed reading of the ground, like the embattled picture plane, as empty space. Matisse's *Back* relief is thus at once opaque in its resistance to spatial penetration and transparent in representing the studio and a process that the expressively worked surfaces—undifferentiated as to figure and ground—continually affirm.[70]

Opposing the expressive facture of Picasso and Matisse's sculpture, Brancusi's five entries exhibit the greater surface refinement and formal reductiveness characteristic of his work. In a way that Picasso did not, Brancusi strove to liberate his heads of women—*Sleeping Muse* (fig. 53), *Muse,* and *Mlle Pogany* (fig. 40)—from anatomy, releasing them to self-sufficiency as objects. This holds true especially for the *Sleeping Muse,* an ovoidal form with the merest hint of facial features, which rests on one side unattached to body or even to a pedestal, a traditional signifier of art. Shown only in plaster at the Armory, these works lacked the visual complexity of their marble or, especially, their bronze versions, which married structure to context in the reflective surfaces.[71] By comparison, the rough, blocky *Kiss,* never translated into bronze, suffered less in its exhibited plaster version, particularly as Brancusi never polished any of the stone versions of that work. Brancusi's fifth entry, the only one in a permanent material, was the remarkable marble *Torso* (1912), lent by the Armory Show's principal organizer, Arthur B. Davies, who had purchased it while scouting works for the exhibition (fig. 54 shows an earlier and slightly smaller version of that work). Less a torso than a single hip, the fragment is naturalistically modeled and yet rendered extremely abstract by its anatomical isolation.

Maillol, the Spaniard Manolo, and Polish artist Elie Nadelman belonged to a contingent of European sculptors pursuing a modern classicism. Nadelman's two entries at the Armory Show did not represent his characteristic manner to best advantage, but after the sculptor's move from Paris to New York in 1914 his style-conscious, modernistic sculptures enjoyed a popularity equal to Manship's. Nadelman did not share Manship's love of the archaic, preferring later Greek art for its "harmony of graceful lines" and "beautifully curved forms," to borrow Manship's characterization of

Fig. 53. Constantin
Brancusi, SLEEPING MUSE,
1909–1911.
Marble, 7 in. high.
Hirshhorn Museum
and Sculpture Garden,
Smithsonian Institution,
gift of Joseph H. Hirshhorn,
1966. Photo, Lee Stalsworth.
© 1992 ARS, N.Y./ADAGP,
New York.

Fig. 54. Constantin
Brancusi, TORSO, 1908.
Marble, 9½ in. high.
Art Museum
of Craiova, Romania.
Photo, The Conway Library,
Courtauld Institute of Art.
© 1992 ARS, N.Y./ADAGP,
Paris.

the fourth-century Hermes of Praxiteles.[72] Among the European sculptors at the Armory Show, only Raymond Duchamp-Villon acknowledged the blunt, taut quality of archaic art (indeed, much more so than did Manship) with his *Torso of a Young Man* (1910), a lunging partial figure that recalls the warriors from the east pediment of the Temple of Aphaia at Aegina. To Walter Pach, who owned the plaster *Torso* in the Armory Show, Duchamp-Villon wrote: "I do not believe that each epoch creates all parts of its aesthetic, but that it finds its roots in the preceding generations which have prepared the way."[73]

Duchamp-Villon's words sound right from an academic standpoint, but to an academic artist his and the other modern European sculptures in the exhibition represented "artistic anarchy."[74] Thus, faced with the horrors of the Armory Show, academics wholeheartedly embraced Manship (who did not exhibit there) as "a young man who has, fortunately, an eye for the art of the past as well as for the nature of all times, and who is not willing to submit himself to the dominating influence of his own time." Cox, who penned those words, identified that "dominating influence" as Rodin's.[75] However little Manship's sculptures conformed in some aspects to established and idealized types, they demonstrated thorough knowledge of antique styles and subjects—and no models were more revered by the academic community. That fact alone ensured Manship's academic stature. In addition, academics recognized in Manship a guardian of time-honored traditions of craftsmanship, so often disregarded by the modernists. Modernism (however one chose to define it) and careful craftsmanship appeared so mutually exclusive that their coincidence in Manship's "extremely 'modern,' and yet thoroughly workmanlike," sculptures seemed promising indeed.[76] Herbert Adams, president of the National Sculpture Society, summed up the academic point of view when he wrote, in 1913:

> Just at present we are suffering so severely from the painful consequence of the "beautiful *morceau*," the "clever sketch," and various forms of eccentricity or ignorance handed out to us as new art, that we need tremendously the influence that Manship has brought to us. I do not refer to the archaic or archaistic spell to be noted in some of his work, but rather to his ability and skill in design and execution. Some of his little bronzes . . . show great technical address, backed by a sound knowledge of form. They are executed with a loving care which means the expenditure of time and thought upon them. . . . Have we in this country ever had such beautiful workmanship backed by artistic knowledge.[77]

Adams's dismissal of Manship's archaism as a "spell" suggests that it contributed little to academic admiration for Manship's work. But the word

implies a temporary condition, and Adams must have expected the archaism to fade; Manship, he concluded, was "a man who, if given a chance to work out his natural bent, may do American art an incalculable good."[78]

The Architectural League exhibition launched Manship's career. Only two months later, one of his colleagues from the Academy, Frank Fairbanks, reported that Manship had "all sorts of work staring him in the face."[79] This contrasted with his own experience: after six months without any prospect of work, Fairbanks was ready to give up mural painting. And yet, so complete had been his indoctrination by the Academy that, instead of faulting it for encouraging him in an obsolete branch of painting, he, in effect, conspired with it to promote an illusion. In concluding a letter to the Academy's director, Fairbanks wrote: "My best to the fellows and the painters might just as well dream on, I was happy while mine lasted. To them please, *I am getting on nicely* (which is true if one doesn't refer to work)."[80]

As a muralist, Fairbanks had the further disadvantage of specializing in a type of painting wholly dependent on patronage. Sculptors had long experience with such reliance, owing to the considerable expense of their materials and studio operations, and their opportunities for commissions had increased substantially with the spread of Beaux-Arts architecture, on which sculptural ornamentation was important. The World's Columbian Exposition served as the proving ground for collaboration between sculptors, architects, and landscape architects, and the City Beautiful movement, also stimulated by the fair, offered extensive opportunities to continue the association. Younger sculptors likewise benefited from the National Sculpture Society's efforts to foster a new, private market for small-scale and garden sculpture; such works might be executed on commission, but often they were not. In creating works independent of destination, sculptors joined easel painters in the modern art marketplace.

Manship, more than any other sculptor of his generation, profited from these new conditions. One writer—perhaps thinking of the linear, decorative character of Manship's archaism—praised him as "the first evidence of a talent that appears to have an instinctive understanding of the relationship of sculpture to architecture."[81] Indeed, his popularity with architects led Herbert Adams to worry that "the architects [might] ruin him by giving him a lot of big work."[82] Among the architects favoring Manship with early commissions were Welles Bosworth—for whose American Telephone and Telegraph Company building in New York the sculptor made panels of the four elements, a decorative frieze, a drinking fountain, a door pull (M40–M46), and bronze floor plaques—and landscape and country house architect Charles Platt. Manship's playful subjects eminently suited garden sculpture, a genre that had been rising steadily in popularity since

the 1890s. Within a few years of his return from Rome, he made monu-
mental vases and griffins for the Charles Schwab estate in Loretto, Penn-
sylvania (M90–M95); a pair of sphinxes for the Samuel Untermyer estate
near Yonkers, New York (M102); and twelve nine-foot herms for Harold
McCormick's Lake Forest, Illinois, property (M61).[83] The ancient Roman
use of herms in the decoration of private gardens undoubtedly prompted
their choice for the Italianate McCormick estate, designed by Charles Platt,
and there Manship's choice of archaism for the herms is historically sound:
Roman sculptors frequently employed an archaistic style in imitation of
korai for female herms, as Manship did for his *Calypso,* whereas Greek
sculptors routinely archaized their herms because they were reluctant to
put a naturalistic head atop anything other than a naturalistic body.[84]

Manship exercised greater creativity with the *Indian Hunter* and *Prong-
horn Antelope,* paired figures that exemplify sculpture suited for the decora-
tion of both the domestic interior and the garden. He designed the original
pair, dated 1914 (M51–M52; fig. 55) and only about twelve inches high,
to occupy preexisting pedestals at either end of an unsatisfactory mantel-
piece in his New York apartment; in that setting, the sculptures worked
together to activate and unify the space.[85] After seeing them in the Na-
tional Academy of Design exhibition in 1914, Herbert Pratt ordered he-
roic-sized versions for the garden of his Glen Cove, Long Island, estate
(M100–M101). The dramatic subject, clarity of design, and relative sim-
plicity of surface and form allowed for successful translation of the *Indian
Hunter* and *Pronghorn Antelope* into the large size, but such was not always
the case. In Manship's best work, there exists a delicate balance between
line and mass, a balance thrown off by enlargement. Crisp lines become
dense and volumes bloated; the sculptures lose the defining snap of the
cleanly incised lines, which both animate the volumes and help to contain
and order them. One may be left, as was Royal Cortissoz, with "the un-
comfortable sense of a statuette magnified."[86]

In part, Manship owed his success in attracting patrons to the American
Academy's network of well-connected architects, sculptors, painters, and
supporters. He also showed aggressively, taking regular part in exhibitions
sponsored by the major artists' organizations; as his popularity grew, mu-
seums, commercial galleries, and private clubs throughout the country
featured his work as well. In 1915, for example, Manship took part in the
annual exhibitions at the National Academy of Design, the Pennsylvania
Academy of the Fine Arts, and the Architectural League, and a large selec-
tion of his works circulated to the St. Botolph Club in Boston, the City
Art Museum in Saint Louis, the Panama-Pacific Exposition in San Fran-
cisco, the Art Institute in Chicago, the Albright Gallery in Buffalo, and
the Museum of Art in Denver. Walker Hancock, just fourteen when he

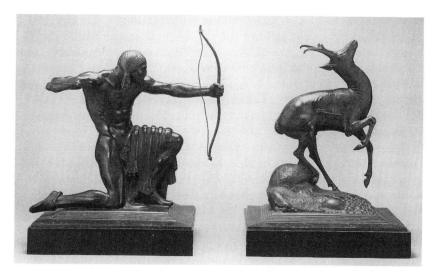

Fig. 55. Paul Manship, INDIAN HUNTER and PRONGHORN ANTELOPE, 1914. Bronze, 14½ and 13⁹⁄₁₆ in. high. National Museum of American Art, Smithsonian Institution, gift of Paul Manship.

saw Manship's exhibition in Saint Louis, years later remembered "the stir that was created by this thing that had never been seen before," the combination of "wonderful realism" and archaism.[87]

With the spread of his fame, Manship's life became increasingly complex and, in 1916, he agreed to be represented by Martin Birnbaum of the Berlin Photographic Company. Among the New York art dealers actively committed to sculpture, Birnbaum remembered being very much "carried away by [his] determination to introduce new talent."[88] In 1913, he approached sculptor Albin Polasek, who had recently returned from the American Academy, about a possible show. He told the artist that at least a year's lead time was necessary to "'prepare the public'" by getting Polasek's name into the press and advised the sculptor to "'produce something different, something that will make people talk!'" One must "'keep the public guessing,'" he advised. Polasek withdrew under this pressure, but noted that Birnbaum was "soon to bring out another sculptor more in sympathy with his ideas."[89] That sculptor must have been Manship, in whom Birnbaum found the sensation—and the commercial success—he so avidly sought.[90] Manship's first solo exhibition, in 1916, prompted "a wild scramble" that resulted in the sale of entire editions of some of his small bronzes. Birnbaum crowingly proclaimed the event a *"succès fou."*[91]

By the mid 1910s, Manship had attained considerable fame. At a time of enormous change in the art world, the reasons for his rapid rise to success

are not difficult to imagine: the combination in Manship's sculpture of naturalism and narrative legibility with archaism simultaneously evoked classicism and modernism—and proved irresistible to a patron class sophisticated enough to know that modern art could not be dismissed but not prepared to cast tradition to the winds. Manship's classicism appeared in his subject matter, ancient sources, and fine craftsmanship; together they connoted history and good taste. His modernism lay in the greater importance of form than subject to the effect of his works and the provocative combination of stylization and naturalism; his conceptualized treatment of form, in particular, signified originality. "Originality and charm": an untenable combination from a radical modernist point of view, this characterization of Manship's sculpture added up to an acceptable modernism for a broader public.[92] For the "diabolically sophisticated" young artist, archaism was the charm, the force behind the "altogether exhilarating sensation" that audiences felt in viewing Manship's work.[93] Manship had little reason to alter the recipe (as he often termed it) that brought his success.[94] He added the spice of India to his artistic mixture, but the basic ingredients of the archaistic style launched with the *Centaur and Dryad* were to change very little.

Preclassical Greek art was a principal ingredient
of modern archaism, but it was not the only one.
Once artists had embraced its decorative and linear
aesthetic, it seemed but a short step to the apprecia-
tion—and appropriation—of other art that had been
overlooked as a result of the nineteenth-century bias
toward naturalism. The desire to break from the
perceived stylistic corruptions and moral ambiguity
of later Western art contributed to an extraordinary
catholicity of taste; works quite unrelated visually
and culturally became linked in the modern artist's
mind and eye by common dissimilarity from turn-
of-the-century academic practice. In this context,
the art of India held an important place. Even
though doctrinally alien to the Judeo-Christian
traditions of the West, the overwhelmingly religious
art of India commanded respect from a range
of critical thinkers who found Western society
spiritually bankrupt. From a more strictly artistic
perspective, it demonstrated that a representational
art could exhibit naturalistic detail without sacrificing
expressive formal conceptualization. Indian art, in
short, was a fertile source of the values that modern
artists, including Manship, associated with archaism.

A broader picture of modern archaism can also be
drawn by appraising its relevance to artists other
than sculptors, who were not alone in seeking such
an alternative to academic art. Indeed, visual,
performing, and literary artists alike joined in the
modern pursuit of purified form and heightened
expressiveness. Although the complete investigation
of archaism in other modes exceeds the scope of
this study, it is appropriate to explore its role in
theatrical dance, for the expressiveness of the human
body that is dance's domain is the province also of
sculpture. This shared concern did not escape early
modern dancers, sculptors, or their critics.

Manship's attraction to Indian art is evident from several sculptures he created within a few years of returning from Rome; although this influence has long been acknowledged, it remains a vaguely defined ingredient in his eclectic mix. Precisely how Manship's interest in the art of India developed, to what examples he may have been exposed, and the context in which this occurred need to be articulated. The sensitivity of his Indian-inspired sculptures suggests a degree of awareness relatively unusual at a time when the expressive power of Indian art was only beginning to be recognized.

The period 1874 to 1927 (each date corresponding to a landmark publication) was marked by intense debate on the subject of Indian art.[1] As in the classical fields, the last quarter of the nineteenth century witnessed tremendous advances in Indian archaeology, accompanied by a significant increase in scholarly publications about India. And yet, however appreciative of certain aspects of Indian artistic production, the major writers (largely Englishmen) exhibited distinct biases: they praised Indian craftsmanship and decorative arts, but saw them as essentially utilitarian and thus inferior to the European fine arts. The well-established high points of Western art, with classical Greece at the apex, remained the standard against which Indian art was frequently compared and found deficient. In 1889, for example, leading Indianist Vincent Smith asserted that "in the expression of human passions and emotions Indian art has completely failed, except during the time when it was held in Graeco-Roman leading strings"—a reference to the so-called Graeco-Buddhist art of Gandhara in northwest India, thought to have absorbed Greek influences from contact with the eastern reaches of Alexander's empire.[2] Thus, Smith simultaneously hailed Gandharan art as India's best and denigrated it as derivative. Without Western presence, he believed, Indian sculpture and painting would not have attained, and could not maintain, the status of a fine art. In the face of such opinions, the richness and diversity of the Indian aesthetic sensibility went underestimated or ignored.

Smith's statement provided fodder for Ernest Binfield Havell, one of the first scholars to seek an understanding of how Indian traditions had shaped the appearance of Indian art. As the director of the Calcutta School of Art from 1896 to 1906 and keeper of the Government Gallery there, Havell initially concentrated on contemporary Indian artistic practice. He instituted a reform in instruction at the Calcutta School, shifting the focus from standard European academic methods (introduced by the British) to indigenous methods and styles, which he believed more appropriate to the Indian context. With the publication of *Indian Sculpture and Painting,* in 1908, Havell emerged as a major polemicist for a new school of scholars determined to vindicate historical Indian art. He quoted the Anglocentric

statement by Smith and, although conceding in a footnote that the remark did not accurately reflect that scholar's point of view in 1908, justified his own distortion on grounds that Smith's words remained "a faithful reflection of the official and unofficial views of Indian art which dominate our whole artistic policy."[3] Havell further criticized scholars who he believed had ignored the spiritual bases of Indian art, which he regarded as critical to understanding its character. Countering another statement by Smith that Indian art "has scarcely, at any time, essayed an attempt to give visible form to any divine ideal," Havell proclaimed it "essentially idealistic, mystic, symbolic, and transcendental," not "merely an imitation . . . of . . . phenomena in Nature, but an interpretation [of] the inner beauty, and meaning of the external facts of Nature."[4] Havell's campaign to replace European standards of judgment with a contextual assessment of Indian art had an explosive effect on the field, one compounded by the similarly revisionist writings of Ananda Coomaraswamy. Open confrontation between the two schools of thought erupted in 1910 and led to the establishment of the India Society by Havell, Coomaraswamy, and others who dedicated themselves to the study of Indian art in its cultural context.[5]

The cause for Indian art attracted the attention of the influential English critic Roger Fry, who became a founding member of the India Society. Although he considered much Indian art—and sculpture in particular—alien and inaccessible, Fry felt that his generation could "no longer hide behind the Elgin marbles and refuse to look" at the new discoveries of non-Western art.[6] Westerners who had learned to accept early Greek, Gothic, and Byzantine art were not, in Fry's view, entirely without preparation for the experience of Eastern art. Indeed, he saw an "essential continuity between the art of the East and early European art" and believed that, in evaluating either, "likeness to natural appearances . . . can no longer be used as the chief criterion of value."[7] Fry believed that exposure to Eastern art could have positive and liberating effects on modern artists by encouraging them to "throw over all the cumbrous machinery of merely curious representation, and . . . [to] seek to portray the essential elements of things."[8] It is a mark of this period that interest in the arts of non-Western cultures so often paralleled a concern for their applicability to contemporary artistic developments. The "primitive" arts emerged from the province of archaeologists and ethnologists to assume simultaneous importance to art historians and artists.

Fry's countryman, calligrapher-turned-sculptor Eric Gill, shared the hope that Indian art might have an invigorating effect on modern artistic practice. Like Fry, he conceded that Indian sculpture must always remain somewhat alien to Westerners, and yet he felt that the modern artist in the grip of empty realism had much to learn from the spirituality of Indian

sculpture and from its seemingly uncomplicated direct processes. Gill articulated these concerns in his introduction to *Viśvakarma,* a serial publication of plates of Indian art assembled by Coomaraswamy, with whom Gill began a long friendship in 1910.[9]

Gill's familiarity with its subject matter and context was not his only reason for identifying Indian art as spiritual; the stylized forms that he, like so many others in this period, equated with a nonworldly reality contributed equally to that conclusion.[10] This quality of abstracted—and hence spiritualized—naturalism linked the art of India in Gill's mind with that of archaic Greece, Byzantium, or medieval Europe and separated them all from the "irreligious gentility and banality of modern European art."[11] "All primitive art, so called, is a combination of the Real and Realism. Such realism as that which in these days goes by the name is merely the more or less complete imitation of appearances and appearances are, by definition, not realities . . . Realism I shall define, then, as the imaging of the essential quality of things."[12] For Gill, Indian art seemed to speak to higher truths, and this he saw as the root of its greatness and power.

Perhaps no exponent of the new attitude toward Indian art had greater impact, certainly not in the United States, than Ananda Kentish Coomaraswamy. Like Havell, Coomaraswamy sympathized with contemporary artists of the Calcutta School and their desire to create a reinvigorated and "honest" modern Indian art by drawing on Indian precedent untainted by Western influence. But he valued the works created in the modern revival of traditional Indian art and techniques less in and of themselves than for the attention they brought to historical Indian art. After the publication in 1908 of his first important work of art history, *Mediaeval Sinhalese Art,* Coomaraswamy devoted his career to the study of India's artistic heritage; the next decade saw his establishment at the forefront of Indian art history scholarship.[13] During that period alone, he completed books on Indian drawings (1910, 1912) and sculpture (1912–1914, with the preface by Eric Gill); Rājput painting (1916); gesture (1917, a translation of a Sanskrit treatise on Indian dance); and a collection of essays entitled *The Dance of Śiva,* his most popular work (1918).[14] In 1917, Coomaraswamy moved to America; having sold his substantial personal collection to the Museum of Fine Arts in Boston, he arrived as curator for its Indian section (the country's first), newly created within the museum's already distinguished Asiatic department. At once a meticulous, philosophically oriented scholar and a self-appointed missionary of Indian culture, Coomaraswamy imposed no restrictions on his own efforts to publicize the art of India. Although already well known to the scholarly community, his influence expanded considerably after this time as he began to organize exhibitions of Indian art, to lecture widely, and to write articles for such popular and accessible magazines as *Vanity Fair.*

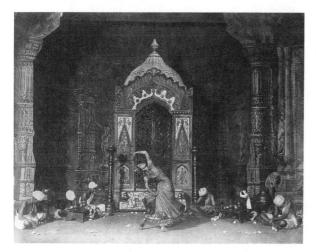

However much American appreciation for Indian art owes to Coomaraswamy, there is no question that, by the mid-teens, interest in India was in the air. The proliferation of writing about aspects of Indian culture does not offer the only evidence of this fascination. Indian literary works, both ancient and modern, also received attention, a situation boosted by the award of the 1913 Nobel Prize for Literature to Bengali poet and religious philosopher Rabindranath Tagore, who visited the United States in 1916. At the same time, American concert halls began to feature Indian music; indeed, Coomaraswamy's first visit to the United States, in 1916, coincided with the concert tour of musician Ratan Devi, his first wife.[15]

Perhaps the most popular expression of Indian culture in the West was dance, not the least because the predominantly Western performers effectively mediated its strangeness. During the early twentieth century, interest in dance as an art form increased significantly, owing largely to the efforts of such pioneer modern dancers as Loie Fuller, Isadora Duncan, Maud Allan, and Ruth St. Denis.[16] All of these performers emerged from the background of vaudeville and show dancing, which inevitably (and necessarily, if they were to attract audiences) tempered their early efforts at serious theatrical dance. So, for example, Ruth St. Denis based the cycle of East Indian dances on which she made her reputation—*Cobras, Incense, Radha, The Yogi,* and *Nautch,* of 1906 and 1908—in part on the exotic dancers and snake charmers she observed in the "East Indian" village at Coney Island Amusement Park (fig. 56).[17] St. Denis never claimed to have resurrected authentic Oriental dance, but whether audiences recognized her performances as hybrids filtered through the American popular theatre is questionable. Opportunities to see authentic Indian dance in the West hardly

existed, and even in India the dominant dance style—the "nautch" (a term deriving from the Sanskrit *nātya,* meaning dance)—bore little resemblance to the historical, religiously based Indian dance. Indeed, as nautch dancing, which developed in the Muslim courts of North India, gained an association with prostitution, dancing lost favor as a respectable art in India. By the early twentieth century, the seductive nautch, perhaps not so different from show dancing after all, had become the representative form of Indian dance.[18] Thus, ironically, St. Denis's efforts to create a religious mood in many of her dances, if sometimes misguided, may have resulted in dance more faithful to ancient Indian art in its spiritual intent than the nautch, which had in fact evolved from the ancient forms.[19] The study and revival of indigenous Indian dance forms owes much to the interest awakened by St. Denis and other Western performers of Indian dance.[20]

At the same time Indian culture and art came into the public eye—that is, during the second decade of the century—it also emerged as an element in Manship's sculpture. Among the earliest of his works to suggest this interest is the *Infant Hercules Fountain* (M54), conceived during the summer of 1914 on the occasion of Manship's first return visit to the Academy, which had just moved into the impressive new quarters designed by the firm of McKim, Mead, and White. Three years earlier, anticipating the need to embellish that building's spacious courtyard, Manship had offered the Academy a cast of his *Duck Girl* fountain. On this brief stop in Rome, however, he took over one of the fine new sculpture studios and worked there at modeling the figure that became the centerpiece of his eventual gift to the Academy.[21] Although the intervention of the war postponed its dedication until October 1921, the *Infant Hercules Fountain* was substantially complete by 1915 and exhibited widely in that year.

It represented the child Hercules in heroic size, atop a small pedestal decorated with six panels illustrating Hercules's labors, below which are six small grotesques, placed at right angles to the base (fig. 57). Water issuing from the mouths of these grotesques and spraying upward from the jaws of the strangled serpent falls into a deep red granite basin ornamented with six lion-head water spouts. Standing erect, Manship's Hercules casually crosses his left leg over the right. In the upraised right hand, toward which he gazes placidly, he grasps the serpent just below the head; its body twines around his arm, behind his back, and down around the large club on which he leans. The left hand rests on the club, just by the hip. The body is fleshy, befitting a child, but the proportions are not particularly childlike. Assuming an attribute of his maturity, Hercules wears the skin of the Nemean lion; its head covers his, while the claws are knotted over his chest and the pelt falls over his left arm.[22]

Manship's presentation of this classical subject is something of an anomaly. In Greek, Roman, and Etruscan depictions, the adult Hercules stands with

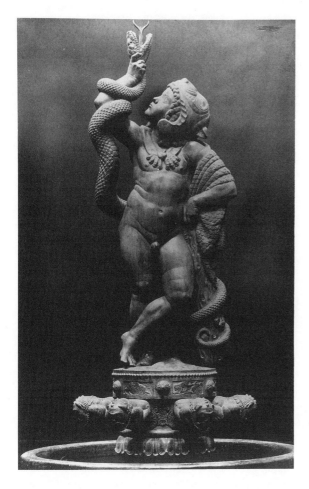

Fig. 57. Paul Manship,
INFANT HERCULES FOUNTAIN,
1914. Bronze, heroic size.
American Academy in Rome.
Peter A. Juley & Son
Collection, National
Museum of American Art,
Smithsonian Institution.

upraised arm, lion skin, and club, but the infant Hercules strangling the serpent lacks the attributes and sits as a baby would.[23] Manship's figure jars memories of the famous Farnese Hercules, an immense, muscle-bound oddity as peculiar anatomically as Manship's. Since Manship had a lively sense of humor and inclined occasionally to irreverence, it is possible that he intended his sculpture as a parody of the ancient one. But no matter what he had in mind, he must have been amused by the range of sources that critics proposed for the *Infant Hercules Fountain,* including Assyrian, Egyptian, Etruscan, Persian, Saracenic, and Italian Renaissance art.[24] Their recognition of something essentially Eastern in the *Infant Hercules Fountain* points the way to a more compelling source, and the one that went undetected: Indian art.

Fig. 58. Yakṣī from
Tadpatri Temple, Madras,
sixteenth century. Plate XIII
in E. B. Havell, THE IDEALS
OF INDIAN ART, 1911;
photographer Messrs.
Nicholas & Co., Madras.
Photo, Library of Congress.

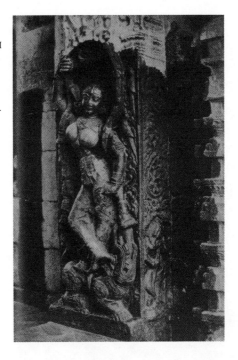

The figure of Hercules has much in common with the sculptural type of
the *Yakṣa* or *Yakṣī,* male and female nature deities found in conjunction
with shrines and temples. Although they vary in form and meaning, the
most common type was the *śālabhañjikā* (woman and tree); Coomaraswamy,
for one, declared "no motif more fundamentally characteristic of Indian
art from first to last."[25] In the *śālabhañjikā* configuration, the *Yakṣī* crosses
one leg over the other, placing the sole of her foot against the trunk of the
tree while grasping a branch overhead with one hand and resting the op-
posite hand on her hip. Manship's Hercules assumes the same stance, with
the snake substituting for the tree. Early books on Indian art reproduced
śālabhañjikās and Manship may have used the type as a model. The associa-
tion is less arbitrary than it might seem. The example most like Manship's
Hercules, from Havell's *The Ideals of Indian Art* (1911) (fig. 58), represents
the river goddess Gaṅgā, so identifiable because she stands on a croco-
dile—a relationship mimicked in the subordinate placement of Manship's
grotesque waterspouts.[26] Since Manship's work is a fountain, he may have
felt justified in adapting the Indian model.

This possibility increases with awareness that the legend of the youthful
Greek hero had an Indian counterpart in the story of the young Krishna's
physical battle with the evil serpent King Kāliya, who inhabited a whirl-

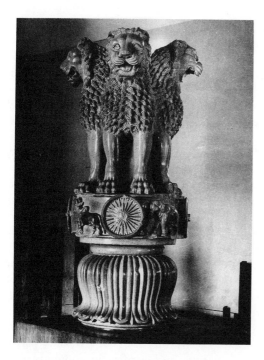

Fig. 59. Sarnath, Lion
Capital, third century B.C.
Chunar sandstone,
84 in. high.
Sarnath Museum.
Photo, American Institute
of Indian Studies.

pool in the River Yamunā. When Krishna (Kṛṣṇa) jumped into the whirl-
pool, Kāliya coiled around the young god, who overcame his adversary by
jumping upon the multi-headed serpent's hoods. In response, Kāliya put
forth his tongues and blood poured from his mouths. This story (the *kāli-
yadamana*) was related in Coomaraswamy's March 1912 *Burlington Maga-
zine* article on Rājput painting, featuring a brilliantly colored illustration of
this tale, and in his popular collection of Indian myths published a year
later.[27] Manship, with his awakening interest in Indian art, may have noted
similarities in the legends of Hercules and Krishna—whom the Greek
writer Megasthenes called "the Indian Hercules."[28] His fountain conflates
the stories of the infant Hercules battling the serpent and the *kāliyadamana,*
with its aquatic setting. At the same time, the rarity of sculptural rendi-
tions of the latter subject in Indian art left Manship free to seek formal
inspiration for his fountain in thematically unrelated Indian works such as
the *śālabhañjikā.*[29]

Indian sources for the *Infant Hercules Fountain* are not limited to the prin-
cipal figure. The alternating figurative reliefs and wheels of the plinth and
the lotiform, or bell-shaped, capital may well be based on the famous Lion
Capital from the column of Aśoka at Sarnath, discovered in 1905 (fig. 59).
Furthermore, the face of the lion crouching atop the Indian column re-

sembles the animal heads that serve as waterspouts on the basin of Manship's fountain. Scholars have noted strong stylistic similarities between the Aśoka columns and the Achaemenian art of Persia; if the Aśoka column did inspire Manship, it may help to explain a critic's suggestion of Persian influence for the *Infant Hercules Fountain*.[30]

The case for Indian influence on the *Infant Hercules Fountain* may never be settled conclusively, but the possibility cannot be ruled out in view of Manship's other works from this period that announce this source without hesitation. The most blatant example is a *Sundial* of 1916 (M86), a "rather heavy-handed dream in the sun," in which one critic (with reference to Havell) found "easily discoverable" prototypes in Indian sculptures of bodhisattvas.[31] "Collecting Buddhas is now a fad with many important members of exclusive society," observed a writer for the *New York Herald*.[32] Perhaps that explains the proliferation of the "tea party Buddhism" that Jacob Epstein—who identified Manship's art as an "extreme example" thereof—considered such a "deplorable influence" on American art.[33] The popularity of the Buddha, the *Herald* writer continued, comes from its "suggestion of placid calm, the lofty imperturbability to things of the moment, which is declared by all who visit our shores to be more than anything else lacking in the American make-up." Manship's Indian-inspired *Sundial* offered a panacea for the worldly stress of a wealthy patron; created expressly for a garden setting, it objectifies the contemplative mood sought by the visitor to the garden.

It seems likely that Manship's dealer, Martin Birnbaum, encouraged his interest in Indian art. Birnbaum both sold and collected Asian art and prodded the sculptors he represented to "keep the public guessing."[34] An early member of the India Society, Birnbaum may have met Coomaraswamy through their mutual friend Mary Mowbray-Clarke, a founder (with her husband, sculptor John Mowbray-Clarke, and Madge Jenison) of New York's unconventional Sunwise Turn Book Shop.[35] In addition to books, the Sunwise Turn displayed the eclectic mix of objects that form a virtual catalogue of the decade's artistic passions, including "three ancient Rajput miniatures, a Greek archaic mask, some batik hangings, sculpture ancient and ultra-modern, paintings by a half dozen men, a drawing of somebody's grandmother in a wiggley scrawl, a Hopi bowl, some African tiles, some of Mrs. Zorach's embroidery, and a large Inness."[36]

In 1918 the Sunwise Turn published Coomaraswamy's *The Dance of Śiva,* a collection of essays on Indian subjects. If Manship did not know Coomaraswamy personally, he at least knew of him for, by 1917, Manship had joined Birnbaum as one of only seventeen American members of the India Society (along with Arthur B. Davies, Barry Faulkner, and Charles Lang Freer).[37] One privilege of membership in the Society was receipt of

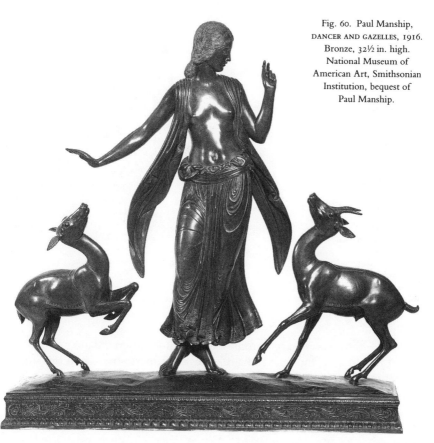

Fig. 60. Paul Manship,
DANCER AND GAZELLES, 1916.
Bronze, 32½ in. high.
National Museum of
American Art, Smithsonian
Institution, bequest of
Paul Manship.

the annual publications it sponsored; in 1917, the selection was A. Foucher's *The Beginnings of Buddhist Art, and Other Essays in Indian and Central Asian-Archaeology*. Previous offerings included two books on drawings by Coomaraswamy (1910, 1912), plates of Indian sculpture with text by Havell (1911), forty-two plates of the Ajanta frescoes (1914–1915), *The Music of Hindustan* (1913), and poems, plays, and songs (1912, 1913, 1914).[38] The bibliography on Asian art increased tremendously during the 1910s, a situation of which Manship evidently availed himself, judging from Barry Faulkner's recollection that the sculptor often spent evenings making designs for works "while his wife, Isabel, read to him from ponderous books on the art of India, Cambodia, and China."[39]

Among Manship's works, critics most frequently associated the *Dancer and Gazelles* (1916; M84, M85; fig. 60) with the art of India. It reminded A. E. Gallatin, for one, of "the significance that the Indian artist attaches to gesture, as well as the symbolism of hands."[40] A complex code of hand

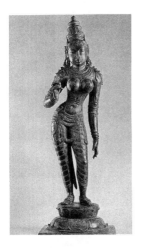

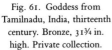

Fig. 61. Goddess from
Tamilnadu, India, thirteenth
century. Bronze, 31¾ in.
high. Private collection.

Fig. 62. Jacques Lipchitz, WOMAN AND GAZELLES,
1911–1912. Bronze, 46 in. long.
Courtesy, Marlborough Gallery, New York.

gestures—the *mudrās*—are central to the religion, drama, dance, and fine
arts of Hindu and Buddhist India. Coomaraswamy underscored this unify-
ing factor, as well as the wide applicability and importance of gesture, in
the introduction to *The Mirror of Gesture* (1917), his translation of the an-
cient Sanskrit treatise by Nandikeśvara. He pointed out that the Indian
drama had an elaborate dancelike gesture language and noted that the same
word, *nātya,* indicated acting and dancing. A close connection existed as
well between dancing and religion: historically, dance played an integral
part in religious festivals, temples featured sculpted dancing figures (and
occasionally pavilions to accommodate living dancers), and the gods were
said to have initiated cosmic events through the dance, as did Shiva (Śiva)
in his incarnation as Naṭarāja (Lord of the Dance). After publication of
Coomaraswamy's *Dance of Śiva* in 1918, the image of *Śiva Naṭarāja,* en-
circled by a ring of fire, came to embody Indian art for Western audi-
ences.[41] Such figures exhibit an ease and grace that finds few parallels else-
where, but Manship's best archaistic works, and most especially the *Dancer
and Gazelles,* rank among their closest modern equivalents.

Some aspects of Manship's statuette indeed seem borrowed from Indian
art. The undulating floral motif of the base, in particular, has striking
counterparts on the railings and posts of Buddhist stūpas and in painted
decorative details appearing at Ajanta, the widely famous sixth-century
A.D. frescoed rock temples.[42] In his 1914 article "Some Ancient Elements
in Indian Decorative Art," Coomaraswamy argued that Asiatic and Medi-

terranean civilizations shared common descent from a "world-culture" of 1500–500 B.C.; this "Early Asiatic" root had supplied the "alphabet" for all decorative art after that time.[43] Almost nothing remained of Indian art before 500 B.C., however, so Coomaraswamy turned to "the seemingly archaic motifs in modern Indian decorative and folk art"—which he believed preserved the older traditions—to establish the parallels between earlier Indian and Aegean art.[44] "A portion of that ancient world," he asserted, ". . . survives before our eyes in the folk traditions of modern India; they have preserved for us . . . an aspect of history which has almost everywhere else disappeared forever."[45] To a modern artist fascinated with preclassical culture, this possibility must have seemed tantalizing. Given his interests and professional connections, Manship may well have been aware of this theory of "world-culture," which gave his eclectic borrowings not only license but meaning.

The Indian qualities of the *Dancer and Gazelles,* however, have less to do with the copying of specific motifs than with an approach to design. Gallatin observed that Manship's gazelles "possess a smoothness and vitality one very rarely finds outside of Indian art," whereas, in David Finley's opinion, Manship learned from India "the concept of movement in space and the use of the silhouette to achieve a sharply defined outline," as well as "how to create complicated decorative patterns in stone and bronze without loss of form."[46] Manship appreciated the frequent lyricism, fluent rhythmic grace, and abundant detail of Indian sculpture (fig. 61) and the same qualities appear in his own work. These aspects of the *Dancer and Gazelles* become especially evident by comparison with Jacques Lipchitz's *Woman and Gazelles* of 1912 (fig. 62).[47] Unlike Manship's swaying dancer, whose pose recalls the Eastern tribhaṅga (the standard mode for suggesting movement in Indian sculpture) more so than Western contrapposto, Lipchitz's woman is earthbound, her slight contrapposto offset by firmly planted feet and symmetrically placed arms. Her arms above the elbow are held close to the body, whereas below they extend sideward (in the same vertical plane), ending in somewhat enlarged hands, cupped and facing palm outward; they link her with the still, alert gazelles. The pose is unnatural and formalized but, for that reason, expressive, somewhat in the manner of an early medieval orant figure. By contrast, everything about the *Dancer and Gazelles* suggests motion: the tiptoe stance of the dancer, her swinging drapery, the prancing gazelles, and the smooth, sinuous contours, which define a vibrant negative space.

Most commentators seem to have had Indian sculpture in mind when considering sources for the *Dancer and Gazelles,* but striking thematic parallels exist in Rājput painting (the sixteenth- to nineteenth-century Hindu painting of northwestern India), an art virtually unknown before Coomaraswamy identified and publicized it in 1912.[48] In 1916, the date of

Manship's *Dancer and Gazelles,* Coomaraswamy published a major study of Rājput painting in which he defined the qualities that distinguish it from the better-known art of the Mughal courts. Whereas Mughal art was worldly, secular, aristocratic, and professional—Coomaraswamy also says "academic"—Rājput painting was religious, vernacular, anonymous, and timeless (in that its consistency made it difficult to date).[49] Despite its production under princely patronage, Coomaraswamy described Rājput painting as a folk art expressing "the culture of the whole race, equally shared by kings and peasants."[50] Its principal formal characteristics— emphatic rhythmic outlines, flatness, and brilliant color—are certainly qualities that modern viewers would have identified with folk art and approved for their contrast to Western academic traditions. Manship's attraction to such a source would hardly be surprising, given the emphasis on contour in his own work, his prior interest in Greek vase painting, and his comprehensive belief that art, "to be truly great, must be the art of the common people."[51]

In particular, Manship's *Dancer and Gazelles* recalls selected motifs in rāgamālā painting, the pictorial expression of Indian musical modes that are associated with particular moods and emotions. Toḍī Rāgiṇī, for example, is a young woman with gazelles (in some instances, they flank her) attracted by her beauty and music.[52] The woman and faun or gazelle appear frequently in Rājput painting. Coomaraswamy reproduced several examples in his 1916 study (for example, fig. 63) and, on the basis of an inscription on another such image, interpreted them as expressions of the soul entangled in *māyā,* or illusion.[53] This reading would have held special appeal for the modernist artist who sought to cast aside artistic illusionism and imitative naturalism. Commentators on Indian art writing during the 1910s indeed repeatedly mention the poverty of Western realism by comparison with the powerful abstract language of form found in Indian and other primitive or archaic art.[54] The fact that Manship's artistic aims were less radical than some of his contemporaries' does not preclude his attraction to the spiritual allusiveness of Indian art.

At a less metaphysical level, the equation between female and animal grace and gentleness had a long history in artistic representation, though it hardly suffices to explain the popularity of the woman and gazelle motif among modern sculptors, particularly those such as Lipchitz, who deemphasized grace.[55] From a purely thematic point of view, it is tempting to associate these various modern sculptures of women and gazelles with Śakuntalā, the heroine of the eponymous Indian drama by Kālidāsa, an ancient masterwork well known in the West since the late eighteenth century.[56] Kālidāsa highlights Śakuntalā's gentle innocence by describing her happy coexistence with creatures of the forest, among them an orphaned

Fig. 63. Nāyikā with Deer, Punjab Hills, Guler, 1750–1775. Opaque watercolor on paper, 6½ × 4⁷⁄₁₆ in. Worcester Art Museum, Worcester, Massachusetts; museum purchase from Ananda K. Coomaraswamy, 1926.4.

faun, nourished in its infancy from Śakuntalā's own hand. Manship's dancer communes with gazelles, animals native to Africa and Asia; could she be Śakuntalā? Kālidāsa's play was sufficiently well known for Alice Morgan Wright, a Smith College senior (and later a successful sculptor), to develop a dramatic version for the school's senior play in 1904; a stage version also played in New York in 1905, with Ruth St. Denis in a minor dance part.[57] Manship's familiarity with it cannot be proven and, yet, awareness of the interpretive possibility enhances the Indian aura of the *Dancer and Gazelles*.[58]

Aesthetic kin to the *Dancer and Gazelles* include Greek vase painting, the fine tooling of Greek bronzes, and even Romanesque sculpture, since the dancer's skirt evokes the "platefold" drapery configuration of Romanesque sculpture such as that of Moissac, which Manship later praised "for the imaginative beauty of its carving. . . . at once pictorial and decorative, as well as sculpturally solid."[59] Ultimately, however, the strength of Manship's sculpture lies in its free interpretation of sources, exquisite craftsmanship, and graceful animation. Manship's success with the *Dancer and Gazelles,* as in his best work generally, lay in his ability to evoke, rather than imitate: the artistic past resonates in his sculpture, but its precise components are, finally, elusive. In the *Dancer and Gazelles,* Manship emerges as a sensitive and receptive observer of art and an artist of independent vision.

There can be little doubt that Indian art interested Manship or that its formal richness did not amply repay his study. His admiration for the art of India went beyond its fine craftsmanship. He considered Indian art (along with that of Buddhist China, Greece, Egypt, and thirteenth-century Europe) great because it was born of "the exaltation of spiritual or religious inspiration"; only when "technical facility replaces inner spiritual significance," as Manship believed had occurred in sixteenth- and seventeenth-century Hindu art, had decadence resulted.[60] (There is a certain irony in the fact that Manship's definition of artistic decadence closely matches charges critics repeatedly levied at his own art.) Manship genuinely respected the cultural climate that gave rise to Indian art, and yet the values he assigned to it reveal less about the complexities of Indian culture than about his feelings for his own. Indian art attracted him because he associated it, erroneously, with a simple and spiritually pure society, so unlike that of the materialistic modern West. Eric Gill's similar understanding of Indian art had led him to defend the "awakening of interest in the work of the so-called 'archaic' periods" as not having been "merely the result of a fashion for the quaint and barbaric."[61] Manship bears some responsibility for creating such a fashion, from which he undoubtedly also profited; but this does not render him artistically insincere. His borrowings from Indian art bespeak a rather poignant respect for cultural conditions that he, as a member of modern Western society, idealized but could never really know.

"The dance and sculpture are the two arts most closely united," declared Isadora Duncan around 1905.[62] During the first part of this century, theatrical dance underwent radical revision that in many ways parallels changes occurring in the contemporary visual arts. Dance professionals, critics, and artists recognized mutual concern and benefit in this situation. "The present-day revival of dancing as an art is not without its significance in its relation to the plastic and pictorial arts of our time," wrote Charles Caffin in his review of Manship's studio exhibition in late 1913; he praised the young sculptor for daring to formalize anatomy "for the purposes of design, as in the perfect dancing that one dreams of the movements of the body are symbols for emotion, not mere prosaic statements of it."[63]

The desire to capture expressive movement, if nothing new to sculptors, was certainly nourished in this period of fascination with dance performances and personalities. The whirling dynamism of pioneer modern dancer Loie Fuller challenged a host of decorative artists in the 1890s; Anna Pavlova, the Russian ballerina, so intrigued sculptor Malvina Hoffman that she pursued the dancer, won her friendship, and produced a series of reliefs showing Pavlova and a partner dancing; and Isadora Duncan

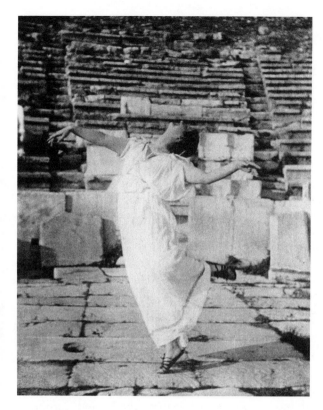

Fig. 64. Isadora Duncan dancing in ancient Athenian theater, in a photograph by her brother Raymond Duncan, ca. 1903. Photo courtesy of J. A. Hastings.

fascinated Rodin, Bourdelle, and Denis, among many others.[64] For the modern sculptor, these dancers' exploration of the human body's emotive range helped point the way to a new and richly suggestive formal vocabulary; like modern visual artists, dancers allowed new techniques to emerge in response to expressive needs. "Modern dance" (as the new form became known) prized spontaneity and individualism, qualities unthinkable in the classical ballet, though even its traditions faced serious challenge. Early-twentieth-century choreographers—having few models in the world of dance—sought alternatives to traditional forms and subject matter in the visual arts, and they joined modern sculptors in mining the preclassical and non-Western worlds.

To audiences, critics, and perhaps even the artist herself, no pioneer of the new modern dance breathed the spirit of ancient Greece more deeply than Isadora Duncan (fig. 64). Duncan's Greece was a passionate one; wearing diaphanous, flowing tunics that barely concealed her nudity and moving with Dionysian abandon, she epitomized the modern revolt

against convention. Greek dance, a lost art, offered no guidance, but Duncan found much fertile material for study in the classical collections of European museums and, eventually, in Greece, to which she made her first pilgrimage in 1903.[65] Some contemporary scholars analyzed Greek art in an attempt to reconstruct ancient dance.[66] For Duncan, ancient art served as an important model in her efforts to restore spirituality to dance, but her purpose excluded imitation or revival. She disavowed copying figures from Greek vases, friezes, or paintings, claiming instead to have "learned from them how to study Nature."[67] "I studied them so long to steep myself in the spirit underlying them, in order to discover the secret of ecstasy in them, putting myself into touch with the feelings that their gestures symbolized. Thus, in taking my soul back to the mystic sources of their rapture, I have, on my own part, found again the secret of Beauty."[68]

Duncan's reference to "finding"—and her further statement that "true movements . . . are not invented; they are discovered"—echoes the modernist artist's emphasis on intuition and spontaneity in creation, on finding as opposed to academic making.[69] Duncan believed that classical art offered a conduit to nature and the self. In counseling the dancer on this matter, she invoked Rodin's words: "it is not necessary to copy the works of antiquity. One must rather observe the works of Nature first, and then see in the works of the ancient sculptors only the way in which Nature has been interpreted."[70] The result—and a worthy goal—would be a modern classicism; in Cézanne's famous formulation: "One must be classical again by way of nature, that is, by way of sensation."[71] For American dance enthusiasts unfamiliar with modern French art theory, Charles and Caroline Caffin concisely articulated Duncan's position: "it was the confirmation of her own instinct that she discovered in Greek art. She was drawn to the latter by her natural impulses, and found herself most akin to the Greek when she was most natural herself."[72]

Duncan felt a particular affinity with modern sculptors, as they did with her: "She is not the Tenth Muse but all nine muses in one," gushed Lorado Taft, "and painting and sculpture as well."[73] Agreeing with Rodin, Duncan warned sculptors not to regard Greek art as the ultimate source of inspiration but, privileging her own art, she suggested that the sculptor might probe the Greek spirit by studying modern dance. Antoine Bourdelle agreed. Capturing Duncan's appeal for a generation of sculptors, he likened the dancer to "an antique marble throbbing with eternity," who infused with life a classical spirit all but snuffed out by stale academicism.[74]

Bourdelle first saw Duncan perform in 1909, and in 1911 he saw her again. These experiences profoundly affected his decorative reliefs for the Théâtre des Champs-Elysées, on which he worked from 1910 to 1913. Imagining Duncan a sculptural frieze come alive, Bourdelle made numerous sketches during her performances and from memory, hoping to cap-

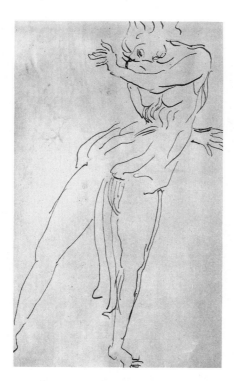

Fig. 65. Antoine Bourdelle,
Sketch of Isadora Duncan
dancing, 1911. Pen and ink
on paper, 8⅝ × 4⁵⁄₁₆ in.
Musée Bourdelle, Paris.

ture that vivacity for his reliefs.[75] But the wiry elegance of his line in the initial sketches (fig. 65) stiffened as he developed the composition—fictionally pairing Duncan with Nijinsky, principal dancer for the Ballets Russes—and adapted it for sculpture (fig. 36). The eventual placement of the relief high above the entrance to the theater demanded translation of the crisp, unshaded line of the drawings into dense sculpted masses capable of holding light and shadow so as to be visible from the street. Critics found the effect stiff and archaistic, not in the least evocative of Duncan's free movements. Lorado Taft, the dancer's admirer, bluntly labeled Bourdelle's reliefs "petrified rag time."[76]

Appropriately, the inaugural season of the Théâtre des Champs-Elysées featured the choreographic triumph of archaism—*L'Après-midi d'un faune,* staged by the Ballets Russes. By then a major success, this radical assault on the classical ballet had premiered precisely a year earlier, in May 1912, at the Théâtre du Châtelet. Parisian audiences found the twelve-minute production entirely unlike the company's earlier Greek ballets—*Acis and Galatea* (1905), *Daphnis and Chloe* (1909), and *Narcisse* (1911). Inspired by Isadora Duncan's performances in Saint Petersburg in late 1904, these ballets modified traditional choreography with Greek movement as imagined by Sergei Diaghilev, Michel Fokine, and Léon Bakst (respectively, the

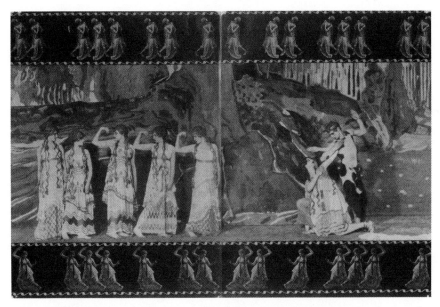

Fig. 66. Vaslav Nijinsky and the original cast of L'APRÈS-MIDI D'UN FAUNE, photographed on the stage of the Théâtre du Châtelet, Paris, May 1912. Dance Collection, The New York Public Library for the Performing Arts, Astor, Lenox and Tilden Foundations. Photo, Baron Adolfe de Meyer.

company's director, principal choreographer, and designer). For *L'Après-midi d'un faune,* Vaslav Nijinsky—the company's star dancer in his debut as choreographer—abandoned both the controlled fluidity of traditional technique and the looser plasticity that Duncan prompted in the company's earlier mythological ballets. In their place, Nijinsky substituted abrupt, earthbound, angular movements, enacted along an imaginary vertical plane at the front of the stage. His dancers turned their torsos to the audience and heads and limbs to the side, mimicking an archaic pictorial convention for representing the figure (fig. 66). The unhappy dancers complained to Nijinsky that they felt "carved out of stone"; indeed, to one critic, the dancers' highly stylized and "lapidary" appearance suggested nothing so much as a collection of archaic statues, or figures from a Greek vase, come to life.[77] *L'Après-midi d'un faune,* like much modern sculpture, was an experiment in pure form. Nijinsky himself claimed it had "no story really. It is simply a fragment drawn from a classic bas-relief."[78]

L'Après-midi d'un faune touched off a battle in the press between those shocked by the faun's autoerotic gesture, with which the ballet ended, and those who defended artistic freedom.[79] Rodin championed Nijinsky. His letter to the editor of *Le Matin* (30 May 1912), headed "The Rebirth of Dance," expresses the modernist esteem for those who "have set their instincts free, and rediscovered a tradition founded on a reverence for the natural." In *L'Après-midi d'un faune,* Rodin continued, Nijinsky's "beauty

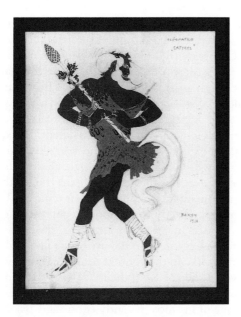

Fig. 67. Leon Bakst,
Costume design for a satyr
in CLÉOPÂTRE, 1910.
Watercolor on paper,
11 1/32 × 8 31/32 in.
Private collection;
photo courtesy of
Sotheby's, London.

is that of antique frescoes and sculptures . . . see him, and you will at once long to draw him or sculpt him. . . . We must not be surprised to see this eclogue by a contemporary poet [Mallarmé] set in ancient Greece; the transposition is a happy opportunity to inform archaic gesture with the strength of an expressive will."[80]

A contemporary writer suggested that Nijinsky's experience as dancer in Fokine's Indian-inspired ballet, *Le Dieu bleu,* prompted his "angular conventions"—a possibility that underscores the formal interchangeability between dissimilar cultures manifested also in Manship's art.[81] However, the critical stimulus for *L'Après-midi d'un faune* may have come from the company's principal designer, Léon Bakst, who was obsessed with archaic culture after extensive travel in Greece, and who guided Nijinsky through the galleries of ancient art in the Louvre.[82] Along with Maillol, Manship, and so many others, Bakst rejected the "polite forms" of the Hermes of Praxiteles, calling instead for a new classicism that would be rude, simple, and primitive.[83] The painting of the future, Bakst declared, must forsake atmospheric qualities—his mention of air, sun, and verdure clearly invokes impressionism—for a "lapidary style" having "man and stone" as its elements.[84] His call is less for a return to figuration as such than an appeal for the solid and substantial. The art of Egypt, Assyria, preclassical Greece, the early Renaissance, and of children seemed to Bakst the most worthy models. He perceived in all of them youthful innocence and sincerity, a healthy antidote to aestheticism and over-civilized modernity.

Bakst's reputation in the West grew independently of the Ballets Russes and found a masterful promoter in Martin Birnbaum, Manship's eventual

dealer. In 1913, Birnbaum introduced Bakst to America with an immensely successful and heavily publicized exhibition of theatrical designs at the Berlin Photographic Company (fig. 67).[85] "The detail is amazingly intricate, but he has learned the secret of subordinating it to the main lines of his design, just as an Eastern artist would have done," Birnbaum declared.[86] Another reviewer called Bakst "a great archaeologist, [who] uses, with entire freedom, the materials of past ages . . . but makes all the raw materials his own by the personal style with which he treats them. His style . . . is consistently frivolous and playful. Moreover, he is frankly artificial. . . . he is shallow in comparison with the greatest of masters; but he has applied a peculiar and highly original genius to the special purposes of the art of the theatre, and in his own domain he is unique and supreme."[87] These words sound remarkably similar to exactly contemporary comments on Manship's work, from the reserved assessment of the artist's originality and position vis-à-vis the masters to observations on the use of the past and the light-hearted character of the work. In the context of international interest in the "primitive" ancient world and the East, the two artists were indeed kindred spirits: masters of absorption, adaptation, and transformation.

Manship's *Salome,* one of his most patently exotic and Bakstian works, may owe something to contemporary dance performances (1915; M73; fig. 68).[88] A subject of seemingly endless fascination in the late nineteenth and early twentieth centuries, Salome received ghastly tribute in Oscar Wilde's play and the Richard Strauss opera based on it, Aubrey Beardsley's illustrations, and paintings by artists as diverse as Franz von Stuck and Robert Henri. In New York, the Metropolitan Opera production of the scandalous Strauss opera, which closed after one performance in January 1907, invested Salome with a new life in vaudeville.[89] At the same time, the role proved irresistible to pioneer modern dancer Maud Allan, whose Salome established her fame. Pictured as Salome in the Caffins' *Dancing and Dancers,* she strikes a vaguely Oriental pose (signified by the angular arms), although the exotic effect arises at least as much from her heavily beaded costume (fig. 69).[90] Manship's *Salome,* preceded in his own work by a *Vase with Oriental Dancer* of 1913 (M32), seems a sculpted Maud. Less successful than the *Dancer and Gazelles* in conveying movement, his *Salome* is all pose and little action, a crystallized choreographic moment with its meticulously arranged folds of drapery, beads that would have to be glued to stay in place, and stiff elaborate coiffure.[91] The sumptuous jewelry, costume, and hairstyle evoke exotic barbarism, but do not make for successful sculpture. Detail seems much less *of* the form than overwhelmingly *on* it—and in this respect, Manship failed precisely where Indian sculptors so often brilliantly succeeded. Viewing this work, one is acutely aware of minutiae, at the expense of the whole.

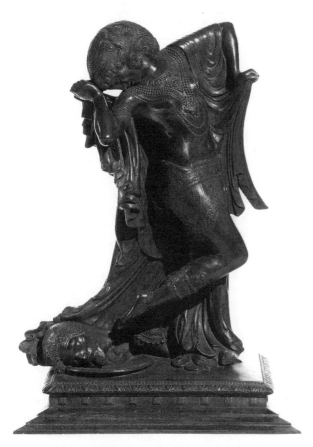

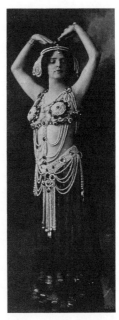

Fig. 69. Maud Allan as
Salome, ca. 1908. Dance
Collection, The New York
Public Library for the
Performing Arts,
Astor, Lenox and
Tilden Foundations.

Fig. 68. Paul Manship, SALOME, 1915. Bronze, 19 in. high.
National Museum of American Art, Smithsonian
Institution, bequest of Paul Manship.

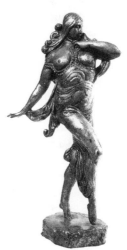

Fig. 70. Gaston Lachaise,
DANCING WOMAN, ca. 1915.
Bronze, 10⅞ in. high.
Courtesy of the
Lachaise Foundation.

The expressive limitations of Manship's *Salome* as an evocation of the dance become obvious by comparison with an exactly contemporary statuette of a dancing woman by Gaston Lachaise, Manship's studio assistant at the time (fig. 70). Although one of Lachaise's fussier works, the sculpture does not sacrifice volume to detail. Instead it creates an impression of vigorous, almost abandoned, movement: drapery swirls around the opulent body; one arm is flung to the rear, while the other hand clutches the dancing beads that have slid from the figure's shoulders; the hair curls up impossibly, but provocatively. Repeated round shapes—curls, beads, breasts, belly, and even the small disk-shaped base—express a weight and volume that the dancing, tiptoe posture belies. In contrast, Manship's figure appears angular, flat, and, although less corporeal, static and earthbound.

Lachaise's interest in dancing figures developed in late 1909 or early 1910, soon after he met Ruth St. Denis, who had recently returned from several years in Europe.[92] He made studies of St. Denis performing her Indian dances and showed a resulting sculpture, *Hindoo Dance—Ruth St. Denis,* at the National Academy of Design's winter 1912 exhibition. Ironically, Lachaise captured a sense of movement in his various sculpted dancers that critics thought St. Denis's art lacked; one called her dancing "static, an affair of postures and poses . . . more learned than beautiful," a criticism echoed in later writings on Manship.[93] St. Denis's style exhibited a strong archaism in its choreographic simplicity, symmetry, and planar orientation—prompted in *Egypta* (1910), for example, by her study of Egyptian reliefs—and she argued for priority in creating the two-dimensional dance style that Nijinsky made famous in *L'Après-midi d'un faune.*[94] In St. Denis's oeuvre, Egypt and India joined Byzantium (for *Theodora*), Babylon (in dances choreographed for D. W. Griffith's 1916 film *Intolerance*), and Greece; one critic described St. Denis as "the living image of Greek sculpture" after a 1907 performance in Berlin staged by Mariano Fortuny, who had recently introduced his chitonlike, "Delphos" dresses.[95] Her repertoire of the mid-1910s included a dance titled *From a Grecian Vase,* and the announcement of "Ruth St. Denis Ted Shawn and Company in Dance Pageant of Egypt Greece and India" on a 1916 poster appeared as the inscription on a Greek black-figure vase.[96]

By the mid-1910s, archaism was everywhere. If, up to that time, it had remained a viably modern expressive mode, its subsequent absorption into the mainstream of fashionable modernity robbed archaism of all power to challenge academic tradition. It became, in effect, a new academic manner, with readily identifiable stylistic components that could be—and were—widely and indiscriminately imitated. For craftsmen and manufacturers, archaism made good business sense; as "art deco," it sold furniture, jew-

elry, clocks, and other goods. But the marketability of archaism may have been no less a factor for sculptors, who saw in Manship's prominence, popularity, and growing personal wealth a door open to success. As early as February 1915, critics pronounced Manship's influence dominant in exhibitions at the Architectural League and the Pennsylvania Academy of the Fine Arts. According to one writer: "The wave of pseudo-Roman revival, which Paul Manship introduced into our exhibitions last winter, has spread like wildfire in the department of sculpture."[97] Not surprisingly, archaism gained particular currency among fellows of the American Academy. At least in part through these men, cultivated to collaborative endeavor, archaism emerged as an important style in architectural sculpture. During the 1920s and into the 1930s, artists and designers—whether fully intending to or not—transformed archaism into an enormously popular monumental and decorative style. In its new context, archaism's sleek lines and exotic references signified both future and past, change and stability—a heady and yet reassuring combination for the inhabitants of a dramatically changing modern world.

6

Archaism during the 1920s and 1930s: Decorative and Monumental

In America of the 1920s and 1930s, archaism emerged from the relative privacy of the studio or gallery to high visibility in the public sphere. The change in context signaled a fundamental shift in the meaning of archaism, but this shift was a cause no less than an effect of the transformation. For modernists of the prewar decade on both sides of the Atlantic, archaism had played an important formative role, allowing them to liberate sculpture from the complex academic practices that distanced the artist not only from artwork, but from a self that might be revealed in the creative process. A technical archaism such as direct carving compelled artists to find their own way, and for some (Brancusi offers one example) the path led to forms or techniques bearing little relationship to anything from the past. Other sculptors (such as Bourdelle) hesitated, unwilling or unable to effect so radical a transformation, although their own sense of vital engagement with the present may not have lessened. But for a third group, archaism represented something altogether different. These sculptors not only respected academic methods, materials, and subjects, but—rightly viewing them as embattled— sought to safeguard the traditions of sculpture. They employed archaizing stylizations as ends in themselves and with the intent of evoking the foundations of a classical art diminished in potency by its ubiquity and obsolescence. Such stylistic archaism, if superficial in a literal sense, was not an empty formal exercise but an urgent affirmation of traditional values under siege.

This second-generation archaism was unquestionably an academic phenomenon, although not so narrowly conceived as some writers would have it. Manship's standing as the most visible and successful exponent of archaism and the popularity of the style with later sculpture fellows of the American Academy

prompted critics to identify archaism with that conservative institution. In time, the Academy came to be seen as the very source of archaistic style. It is well to remember, however, that the Academy never sponsored a program of instruction and, at least in the early days, exercised little influence over the fellows. Manship's uncanonical style had taken the Academy's defenders somewhat by surprise, but in the face of immediate and widespread critical acceptance of his work, the Academy warmly embraced and avidly promoted its first outstanding success.[1] During a period in which academics felt their stature slipping dangerously, the Academy's advocates took the opportunity to assert that Manship's sculptures, "with their rich inventions of rainbow-winged fancy, are here to prove that the Academy is not an ogre, whose chief delight is to crush personal genius."[2]

Manship arrived at his style independently, but the potency of his example effectively made archaism the representative style of American Academy sculptors. Manship's appointment as annual professor in the Academy's School of Fine Arts for the years 1922–1923 and 1923–1924 encouraged this development. Although the office entailed no formal instructional duties, the Academy's leaders considered the presence of a sculptor with Manship's reputation "of great value" and regarded with approval his frequent visits to the fellows' studios and participation in Academy trips.[3] One certainly suspects Manship's influence in the "pronounced tendency of the Fine Arts Fellows to follow the excursions of the Classical School in their field work," noted in the Annual Report for 1922–1923—particularly given the complementary remarks about Manship made elsewhere in the report by Classical professor Tenney Frank, who retained doubts about the partnership between the two schools. The fine arts fellows were similarly impressed. "I remember Paul Manship taking me by the arm and saying, 'Come on, I want to show you the art of Rome,'" recalled Gaetano Cecere; "[he] was a godsend to me, because he was a very intelligent man and [had] a very keen appreciation."[4] Not surprisingly, each of the sculpture fellows in Rome during Manship's tenure as professor— Cecere (1920–1923), Edmund Amateis (1921–1924), Lawrence Tenney Stevens (1922–1925), and Alvin Meyer (1923–1926)—employed elements of archaism in their work.[5]

By the mid-1920s, the association between archaism and the Academy had become so strong that Walker Hancock, a fellow from 1925 to 1928, recalled that Charles Grafly (his teacher as well as Manship's) would not give him a letter of recommendation to the Academy "because he was so afraid that [Hancock] would be infected by this stylization. . . . Grafly felt that Manship had betrayed the cause because he was a stylist."[6] Hancock did not recall ever being urged "to work archaistically," but he conceded that "it was in the air to some extent and you felt a little more comfortable if you were doing it."[7] Thus, "those renowned young playboys of the

Fig. 71. John Gregory, VENUS AND HER ATTENDANT NYMPHS, ca. 1917.
From "John Gregory, Sculptor," *Arts and Decoration* 12 (15 November 1919):8.
Photo, Library of Congress.

classic spirit"—fellows of the American Academy in Rome—became, in
the popular view, the apostles of archaism.[8] A few examples will suffice to
illustrate the point.

One of the first fellows to follow Manship's lead in fact preceded him at
the Academy. Furthermore, Sherry Edmundson Fry began his fellowship
in 1908 a considerably more experienced sculptor than Manship was when
his fellowship began, having studied in Paris at the Académie Julien and
the Ecole des Beaux-Arts, and at Giverny with MacMonnies. As early as
1902, he received an honorable mention at the Salon in Paris. Fry's
Academy work reveals no trace of archaism; at the time, Lorado Taft ob-
served, "the archaistic revival was not yet in full swing."[9] Within a year of
Manship's critically acclaimed debut, however, Fry began to draw upon
preclassical sources: his Major Clarence Burrett memorial fountain of
about 1914 transplanted to Staten Island the Apollo from the Temple of
Zeus at Olympia, whereas *Maidenhood* (1914) juxtaposed a naturalistic
nude with a kore's pose and highly stylized drapery—an effect one re-
viewer dubbed "Manshipized."[10]

Before John Gregory went to Rome in 1912, he felt "swallowed" by
"Paris and Rodin and the naturalistic school," but the sojourn at the
Academy converted Gregory to the manner he called "Playful Classic."[11]
Later in the decade, Gregory created a group of three reliefs frankly evok-
ing in style and configuration the so-called Ludovisi Throne, actually an
altar dating to the fifth century B.C., in Rome's Terme Museum (fig. 71).[12]
A photograph of Gregory's triptych shows the left panel in an unfinished
state: one portion of the figure has been roughed out whereas the other,
not yet started, is indicated by an outline drawing, presumably on the
smooth surface of stone, but evidently retraced on the photographic image

for publication. This evidence suggests that the sculptor (or his assistant) was working directly in stone—an approach that contradicts Gregory's almost exclusive reliance on modeling and that cannot easily be explained, except as an experiment in technical archaism.[13] As is true of his severe style source, Gregory confined stylization to details, such as the hair, and to formalized gesture. Much of his subsequent sculpture continues this manner, evident in his freestanding works in clarity of design and silhouette, frontally oriented but twisting forms, and sparing use of archaistic detail.

Gregory's archaism drew him into a more scholarly engagement with Greek art in 1925, when he joined Paul Jennewein (an Academy fellow between 1916 and 1920) in creating sculpture for the new Philadelphia Museum of Art. Architect Charles Borie had designed a massive building incorporating three pavilions in the form of Greek temples, to which he wished to impart archaeological authority. Sometime after construction began in 1919, he therefore decided to color the pedimental sculptures and architectural details. In 1924, Jennewein accompanied Borie to the American Academy "to gather data" for the project, and they continued to Greece with A. W. Van Buren, the archaeology professor who had proved so helpful to fellows of the Academy prior to its consolidation with the School.[14] Van Buren's report that the two men conducted "important studies of technical problems" suggests the seriousness with which Jennewein and Borie applied themselves to their investigations.[15]

Back in the United States, Jennewein and Gregory worked closely with Leon Solon, an active proponent of polychromy and, by his own account, an important influence on the architect's decision to employ it at the museum.[16] Solon reported that the sculptors had been chosen because their work "was of such formal character that it would lend itself to color decoration"; that essential formal quality can only have been the archaizing simplification that both men adopted while at the Academy.[17] As executed, the pediments owe their stylized effect to the polychromy more than to any archaizing details, which could not have been seen from the ground below.[18] Gregory's pediment, on the theme "The East: Pursuit of Wisdom," appears, however, considerably more archaistic than Jennewein's "The West: Sacred and Profane Love" (fig. 72). Gregory deliberately engineered that effect, the result of a static design that he found expressive of the iconographic program. "The passage of time is a matter of no consideration to the Oriental mind," he explained; thus, "there exists none of the energy and animation so characteristic of Western civilization."[19] Furthermore, he claimed: "The essence of eastern mysticism is the complete abandonment of all individuality or personality, the ultimate state of perfection being absolute nullity or absorption with the Infinite."[20] The effort to find

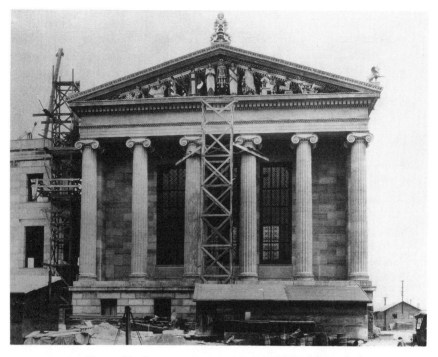

Fig. 72. John Gregory, THE EAST—PURSUIT OF WISDOM, pediment for the
Philadelphia Museum of Art (C. L. Borie, Jr., Horace Trumbauer, and C. C. Zantzinger,
architects), begun 1925. Peter A. Juley & Son Collection, National Museum of American Art,
Smithsonian Institution.

a visual form expressive of self-effacement and the association of such per-
sonal negation with Eastern culture—Gregory's allegorical figures include
India and Egypt—had a decidedly archaistic counterpart in German sculp-
ture of the preceding two decades; but I will return to this issue.

From 1913 to 1916, Leo Friedlander held the Academy's sculpture fel-
lowship, and his works from this period exhibit many of the decorative
stylizations associated with archaism. In *Mother and Infant Hercules,* of
1916, obviously archaistic features include the treatment of drapery and
formalized pose, reminiscent of the sixth-century convention for running
figures (fig. 73).[21] The statuette represents the moment when Hercules's
mother, Alcmena, discovers the two snakes strangled by her son. Friedlan-
der may have intended the work as a postscript to the episode Manship
captured in his *Infant Hercules Fountain,* modeled at the Academy during
the summer of 1914 (although not installed until after World War I). The
distinctively heroic and masculine character of Friedlander's archaism, so

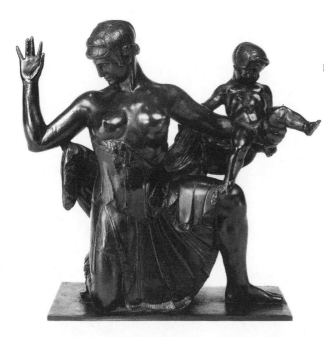

Fig. 73. Leo Friedlander,
MOTHER AND INFANT
HERCULES, 1916.
Bronze, 11⅛ in. high.
Private collection; courtesy
of Conner-Rosenkranz,
New York.
Photo, Scott Bowron,
New York.

unlike Manship's work, is fully apparent in this early sculpture, with its muscular female anatomy, bold poses, and unyielding silhouette. If Manship's sculptures often give the impression of "a statuette magnified," Friedlander's statuettes have the character of monuments.[22]

A thirty-inch model for a "monument to volunteers of a national war" that Friedlander made as an Academy project in 1915 predicts his talent for large-scale public sculpture (fig. 74). A brawny man, with the simplified head of an Aeginaten warrior, rides an enormous, muscular horse while an Amazonian female with helmet and shield strides alongside. Comparison with Saint-Gaudens's similarly configured *Sherman Memorial* (1903) highlights the distinctive character of Friedlander's art and exposes significant changes in the style of monumental sculpture over the first quarter of the twentieth century. Sherman and his spirited mount, led by a personification of Victory that Lorado Taft called "the most ethereal of all sculpted figures," approach battle like proud participants in a military parade, the general's cape fluttering like a flag in the breeze (fig. 75).[23] A lively silhouette contributes to the festive appearance of the group. Friedlander's figures, by contrast, are compact and Herculean; their gestures are bold, their forms large and simplified, and their pace deliberate. Taft considered Friedlander's work too foreign to be acceptable as an American military

Fig. 74. Leo Friedlander,
MONUMENT TO THE
VOLUNTEERS OF A NATIONAL
WAR, ca. 1916.
Catalogue and Yearbook
of the Architectural League
of New York, 1917.
Photo, Library of Congress.

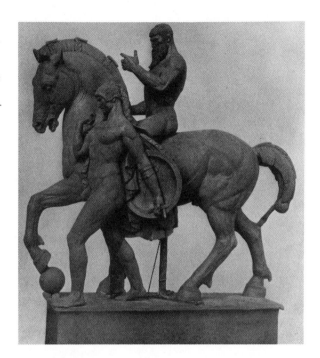

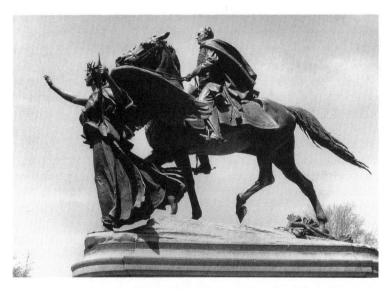

Fig. 75. Augustus Saint-Gaudens, GENERAL WILLIAM TECUMSEH SHERMAN MONUMENT, 1903,
Grand Army Plaza, New York. Overlife-size bronze equestrian statue on granite pedestal.
Photo, David Finn.

monument. He recoiled from the attempt "to crystallize patriotism into such alien forms as these," exclaiming: "For Germany or Austria yes, but for America not quite yet, please!"[24]

Taft identified Friedlander's heroic archaism with Germany for good reason (and not only because of the sculptor's German parentage).[25] Over the two preceding decades—a period of aggressive *Weltmachtpolitik* for Germany—a series of colossal political monuments featuring blunt, stylized figures had been erected in that country. More than their themes, the formal language of these monuments seemed to will the unified effort and sacrifice of individualism that German leaders regarded as necessary to the country's quest for political dominance. Contemporary German writers on art concurred: "If art is to help us overcome disorder, it must give us something simplified, as well as firm and distinct forms. All powerful art is characterized by such simplification."[26] A heroic German art could symbolize the triumph of the German *geist* over the troublesome divisiveness of formerly independent German states.

Sculpture, by virtue of its emphatic physical presence—the very quality that had troubled Baudelaire—was accorded a particularly important role.[27] In an unstable political climate, public monuments, in particular, fostered the image of an all-powerful and enduring German nation resistant to foes from without and weakness within. They offered, according to one commentator on Hugo Lederer and Ernst Schaudt's *Bismarck Monument,* "a symbol of the new German spirit, which stretches its mighty wings across the seas and senses its calling to be the world power and world culture."[28] Characteristically, these monuments fused sculpture and architecture in the form of a massive tower, suggesting concentrated energy, endurance, and power. Overwhelming in size and scale, they intruded aggressively on the viewer's consciousness, demanding a psychological self-effacement that might be equated with willing self-sacrifice for the greater glory of Germany.[29]

The *Völkerschlacht Monument,* designed by architect Bruno Schmitz and erected in Leipzig between 1905 and 1913, stood as the outstanding example of this type (fig. 76). Though commemorating the victory of German forces over Napoleon's troops near Leipzig in 1813, this "frowning pile" (as Taft dubbed it) belonged emphatically to the present and, if realized as planned, would have included a stadium for the physical training of the nation's youth, thus taking the form of a modern sanctuary *à l'antique.*[30] Schmitz engaged Franz Metzner to carry out the monument's sculptural decoration, which figured most prominently in the tripartite, domed space of its interior (fig. 77). A crypt, dedicated to Germany's fallen soldiers, contained eight monumental piers faced with masks of fate, before which armor-clad soldiers stood as if in eternal death watch. The uppermost section, featuring a repeated rider motif, honored homecoming war-

riors and, between these zones, four colossal seated figures represented Courage, Self-Sacrifice, Religious Faith, and National Strength.

To express the timelessness of these virtues, Metzner looked to art that not only had survived the ages but that had been associated with long-lasting civilizations. Egypt and Assyria offered the best models, for the sheer size and colossal scale of ancient Near Eastern monuments and sculptures suggested the qualities of power, solidity, strength, and endurance desired for the only recently consolidated German state. Contemporary critics were quick to explain the new development as quite apart from imitation. Richard Muther, in Vienna's *Die Zeit,* wrote in 1908: "We think of the Parthenon, Assyria, of Egypt and feel at the same time that the apparent archaism of this art is not an artificial imitation of primitive effects, but, rather, a creation arising from the original source of all art, a return to the principles of those times when the individual disciplines were not distinct from one another, but when architecture dictated the style for all arts."[31] German archaistic sculpture indeed has an architectonic quality, and Taft evidently perceived the same in Friedlander's work, which likewise exhibits a studied impersonality. In Metzner's idol-like Virtues, stylization in effect cancels individuality—of the figures represented, of the artist who made them, and, by extension, of the person who sees them.

Taft's distaste for Friedlander's model for a monument, expressed in a 1917 lecture at the Art Institute of Chicago, undoubtedly reflected his dislike of anything evocative of Germany's militarism.[32] And yet he foresaw a time when the archaism practiced by a rapidly growing corps of sculptors from the Academy in Rome might come to dominate American sculpture. Indeed, in 1929, when Friedlander received a commission to translate his statuette into monumental form—as a nineteen-foot-high anchor for the Washington, D.C., end of Arlington Memorial Bridge—its appearance was anything but unusual.[33] This heroic, impersonal style had become the new official classicism.

More massive and muscular than the classical styles of the nineteenth century, this archaizing classicism married elements of stylistic archaism to the aesthetic of direct carving, which I have characterized as a technical archaism important to modernist sculptors. These archaisms acted as a kind of highlighting, reempowering the classicism that post-Renaissance ubiquity had stripped of signifying power.[34] In referring to the foundations of classical art, they called forth the very roots of civilization. Direct carving, widely popular by the 1920s, made its mark in the glyptic mass and weightiness of the new classicism. The actual technique, however, could not practicably be used for monumental public sculpture executed by hired workers; indeed, in such a context, direct carving would have forfeited its significance as an approach that facilitated an artist's private exploration. But the

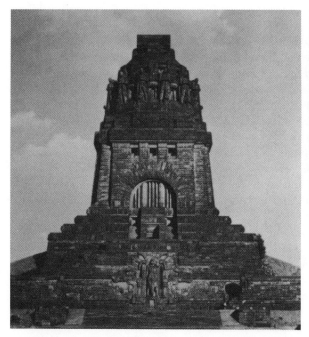

Fig. 77. Bruno Schmitz,
architect, and
Franz Metzner, sculptor,
interior of
VÖLKERSCHLACHT MONUMENT,
Leipzig, 1905–1913
(destroyed). From
Maria Pötzl-Malikova,
Franz Metzner. Photo,
Library of Congress.

Fig. 76. Bruno Schmitz, architect, and Franz Metzner, sculptor,
VÖLKERSCHLACHT MONUMENT, Leipzig, 1905–1913 (destroyed).
From Maria Pötzl-Malikova, *Franz Metzner*. Photo, Library of Congress.

look of direct carving communicated stability and permanence, qualities desired by both newly established political regimes—Nazism, fascism, communism—and relatively older ones, such as America's democratic government.[35] As an official style, or a style employed for official projects, this archaizing classicism served competing ideologies equally well.

Friedlander did not introduce this Germanic style to America.[36] Earlier in the century, Austrian-born Karl Bitter's pronounced tendency to archaism in his architectural and monumental sculpture made him the first serious practitioner of the style in this country. Bitter's prominence in the American artistic community—he served as president of the National Sculpture Society from 1906 to 1908 and from 1914 to 1915, acted as director of sculpture for the world's fairs of 1901, 1904, and 1915, and actively participated in numerous civic and professional organizations—endowed these efforts with especial importance. I have previously considered the impact of Greek archaic sculpture on Bitter's style and technique, but it remains to investigate the initial encouragement that German sculpture provided for that direction in his work.

Bitter's sculpted reliefs for the First National Bank in Cleveland, Ohio (1908), are among his most Germanic—and first strikingly "modern"—sculptures, fulfilling an aim he self-consciously declared in 1902.[37] Over the bank's three doorways, Bitter paired male or female figures, seating them bolt upright on the lintel and firmly delimiting their space by the oversized pictorial keystones that connected each doorway to the mezzanine windowsills above (figs. 78, 79). Allowing the architectural framework to determine the disposition of the figures, Bitter compressed the torsos within a square and below their bent knees let their legs disappear into drapery and seemingly dissolve. His device of isolating the angular, masklike faces and decorative headgear, stylistically and spatially, from the essentially naturalistic and more deeply recessed torsos heightened the disconcerting effect. Such liberties with the human figure were almost unthinkable in American sculpture at the time and no doubt startled those who saw the bank sculptures in photographs at the Architectural League exhibition of 1909. Certainly, the architecture of the bank building did not suggest Bitter's approach. In private correspondence, he characterized the architect, J. Milton Dyer, as a "typical Beaux-Arts man," by which he did not intend a compliment, having expressed dissatisfaction with Beaux-Arts design a few years earlier.[38] He very likely found the ponderous proportions of Beaux-Arts classicism incompatible with the controlled and planar architectural sculpture he wished increasingly to create. As few observers can have realized, Bitter's figures were strongly indebted to the work of Metzner.

Through regular contact with artists in his native Vienna, Bitter undoubtedly knew of Metzner, who lived in that city between 1903 and 1906 and maintained close affiliation with the Secession through the end of the decade.[39] In 1906, Metzner returned to Germany, prompted in part by his employment by German architect Bruno Schmitz on two monumental projects: the Haus Rheingold Restaurant in Berlin and the *Völkerschlacht Monument*. His work in these contexts reveals an emphatically architectonic approach to figuration, such as Bitter also sought (fig. 80). Indeed, in 1917, Lorado Taft described Metzner's Haus Rheingold sculptures in terms that apply equally to Bitter's treatment of the Cleveland bank figures: "He uses the human body as others employ plant forms, conventionalizing the figure, amplifying it, and now and then compressing it into unwonted spaces, but always with a pattern so essentially decorative and a touch so sure that one is compelled to recognize his authority."[40] Art historian C. R. Post likewise termed Metzner's approach an "arbitrary treatment of the human form in order to bestow upon it architectural lines and to force it into given architectural spaces."[41] Metzner's willingness to distort nature in his first major commission for architectural sculpture had led him to a

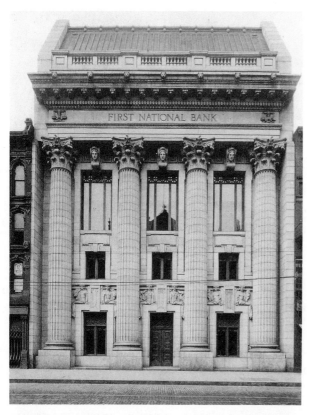

Fig. 78. J. Milton Dyer, First National Bank, Cleveland, Ohio, 1908 (demolished 1920). Photo, Peter A. Juley; courtesy of James M. Dennis.

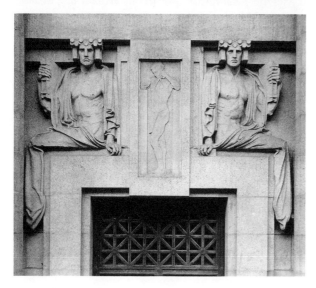

Fig. 79. Karl Bitter, KNOWLEDGE, eastern relief panel, First National Bank, Cleveland, Ohio, 1908; (demolished 1920). Granite, approx. 96 in. high. Photo, Peter A. Juley; courtesy of James M. Dennis.

Fig. 80. Franz Metzner, plaster models for facade reliefs, Haus Rheingold Restaurant Berlin, 1906; demolished. From Maria Pötzl-Malikova, *Franz Metzner*. Photo, Library of Congress.

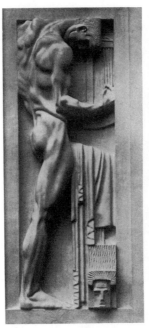 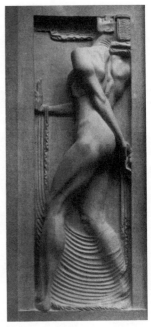

new language of form, in which accommodation of the figure to a geometric space took precedence over naturalism. Bitter followed a similar path and achieved a strikingly similar result. Although at that point, he had not personally seen Metzner's sculpture, numerous articles in European periodicals after 1900 could have familiarized him with Metzner's work, including a profusely illustrated, forty-three-page essay on Haus Rheingold in the April 1907 issue of *Deutsche Kunst und Dekoration*.[42] The Cleveland bank reliefs are less insistently stylized than the German sculptures, but their complete dissimilarity to other American work points to a source of inspiration in Metzner's work for the Haus Rheingold.[43]

When Bitter finally saw Metzner's work, while traveling in Europe in 1909, he reacted with the controlled disillusionment of a former admirer, declaring Metzner's sculptures at Haus Rheingold "rather disappointing" and noncommittally pronouncing the *Völkerschlacht Monument* (then under construction) "a very imposing structure."[44] But Bitter's experiences on this trip raised his doubts about modern European sculpture in general; his dominant impression of the Internationale Kunstschau exhibition in Vienna was of "talent wedded to coarseness" and "vulgarity and degeneracy."[45] Early Greek art offered the remedy—a purer example of the architectonic treatment Bitter sought—and, as previously demonstrated, deeply affected his work on the *Schurz Monument*.

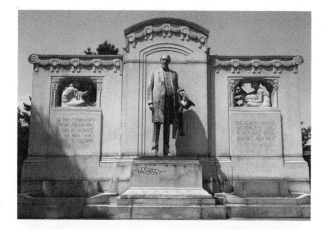

Fig. 81. Karl Bitter,
THOMAS LOWRY MONUMENT,
Minneapolis, 1911–1915.
Granite. Photo,
Alexandra McGee.

Fig. 82. Karl Bitter, *Planting*,
left relief panel (detail),
THOMAS LOWRY MONUMENT.
Photo, Alexandra McGee.

Fig. 83. Karl Bitter, *Vintage*,
right relief panel (detail),
THOMAS LOWRY MONUMENT.
Photo, Alexandra McGee.

In 1915, Bitter returned to a more Germanic archaism in his design of allegorical figures for the *Lowry Monument* in Minneapolis (fig. 81). As part of the granite screen behind Bitter's sober bronze statue of local businessman Thomas Lowry, the nude man and woman symbolize Planting and Vintage, somewhat forced references to Lowry's role in municipal growth (figs. 82, 83). These figures exhibit strong, angular stylizations that recall Bitter's earlier attraction to Metzner and Secessionist art. However, in a radical departure from the approach that he took to relief sculpture in the *Schurz Monument,* Bitter cut completely through the two-foot-thick granite wall of the exedra so that the figures remain attached only at the point of their heads, hands, and lower bodies (seated on the ground).[46] The figures thus occupy a position contained within the block, a creative interpretation of Adolf von Hildebrand's prescription for unified works of

sculpture. Hildebrand believed that sculpture in the round had evolved from reliefs carved through the block, and in the *Lowry Monument* the process seems still to be under way: although the male figure is ostensibly tying up grapevines, he may also be read as hewing his own form from the stone, thus, a surrogate for the sculptor himself.[47] The iconographic program can therefore be understood on two levels, and the second is one that refers to the working of the medium. However unintentional this may have been, that interpretive possibility contributes to our sense of the work as a modernist achievement.

Sculptor Walker Hancock remembered Bitter's Lowry reliefs as "one of the first two attempts (both made by Bitter) to give monumental sculpture a truly glyptic treatment" and he called them "the forerunner of much of the best architectural work" in America.[48] During the 1920s and 1930s, this type of architectural sculpture gained supporters in many camps. Walter Agard, a professor of Greek better known as a commentator on modern architectural sculpture, called for the frank expression of material and the integration of building and decoration. Architectural sculptors should never, he wrote (paraphrasing critic James Gibbon Huneker on Rodin), "shiver the syntax of stone" to make it appear like flesh; their work "must, instead, emphasize rather than suppress the fact that it is stone, as frankly as does the building itself."[49] For this reason, Agard found Metzner's work for the *Völkerschlacht Monument* "heroically modern in stamp": Metzner "respected the integrity of stone, realized its power, and expressed through broad modeling the permanence of the virtues which it records."[50] Significantly, Agard did not insist that sculpture actually be cut directly in stone, but allowed that "a sculptor who knows stone can model his figure in clay without sacrificing the character that its final form is to have."[51] Thus, he had no hesitation in naming Bitter the pioneer modern architectural sculptor, in particular for the flat-surfaced, sharply recessed reliefs of the *Carl Schurz Monument*—although these had been modeled and pointed.[52] Agard and other commentators found the fulfillment of this treatment in Lee Lawrie's sculpture for the Nebraska State Capitol, the outstanding example of the stylized, glyptic architectural sculpture popular between the world wars.

Lawrie owed his selection for this vast undertaking to his sympathy with the ideas and methods of architect Bertram Grosvenor Goodhue, who won the Nebraska capitol competition in 1920.[53] Goodhue firmly believed in the importance of ornament to architecture and in close collaboration between sculptor and architect. Lawrie had proved his mettle with sculpture for Goodhue's neo-Gothic Saint Thomas' Church in New York City. In the wake of such historicizing projects, however, Goodhue became committed to the search for an architectural idiom at once more modern, more American, and linked to the roots of Western culture.[54]

A changed political climate contributed to that effort. As Goodhue wrote in 1922: "Before the war I thought of myself as an internationalist, without giving the word any socialistic or radical meaning, but now everything is so changed that I like to hold tight to what I have in the way of heritage The common heritage of our western civilization is, it seems to me, perfectly clear and came to us through a direct line, starting, if you want to go so far back, with the very beginnings of Aryan civilization."[55] Thus, he continued, he designed the Nebraska capitol in "a very loose sort" of classical style, albeit "too loose" for some of his professional friends. Most strikingly, Goodhue abandoned the Greek and Roman precedent set by a majority of American state capitol buildings.[56] The most prominent feature of the Nebraska capitol is a skyscraperlike tower, centrally positioned to low, counterbalancing wings, which rises high above the midwestern plain (fig. 84). The effect is monumental, spare, stripped down, precise; and from a distance sculpture hardly appears to have a place. Initially, the viewer misses the usual clues as to its location because the building lacks the classical architectural features of pediment and entablature; even more critical to this effect is the fact that Lawrie's sculpture—incorporated into Goodhue's designs from the inception of the project—is so well integrated as to seem a part of the structure itself.[57]

Flanking the arched portal above the building's main entrance, four colossal human figures symbolizing the guardians of the law seem to emerge from the very fabric of the building, the emphatic joints of the masonry continuing into the figures themselves (fig. 85). Lawrie and Goodhue debated this treatment, used consistently throughout the exterior, with the sculptor arguing for the coarser, more visible joints as important to the desired effect.[58] Precedent for this approach existed in Hugo Lederer's *Bismarck Monument* at Hamburg, but if the German-born Lawrie had that work in mind, he omitted to mention it—a wise course in view of the negative associations such a monument would certainly have aroused in the wake of World War I.[59] In seeming to be cut from the wall itself (though they were not), Lawrie's sculptures express the essence of direct carving, with its attendant associations of honesty and strength.

In formal terms, the sculpture at the capitol thus supported the iconographic program of the building's exterior—the history of law—developed by Hartley Burr Alexander, a professor of philosophy at the University of Nebraska, in collaboration with Goodhue. Alexander, even more than Goodhue, was consumed by the desire to make the capitol uniquely expressive of American ideals and accessible to the people. In a rambling letter to Goodhue, Alexander expounded his ideas for a "rejuvenated provincialism" as "the one promising guide out of the present chaos of European and world ideals."[60] Closing ranks with Goodhue against an unstable modern world, Alexander looked to Nebraska's past and found in it some-

Fig. 84. Bertram Grosvenor Goodhue, Nebraska State Capitol, Lincoln, 1920–1932. Photo, Nebraska State Historical Society.

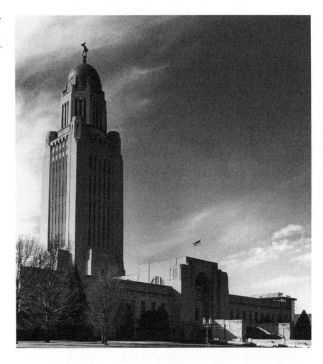

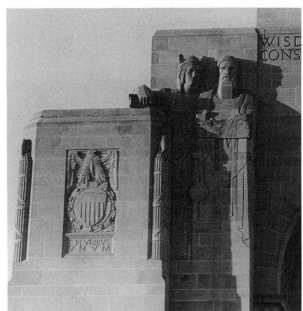

Fig. 85. Lee Lawrie, WISDOM and JUSTICE, east portal of the Nebraska State Capitol, Lincoln. Photo, Nebraska State Historical Society.

thing classical. He compared American Indian and ancient Greek culture, even to the point of arguing that "the student of Greek culture can get his best comprehension of it, on the aesthetic side, from an intimate study of [American] Indian rituals"—a statement reminiscent of Coomaraswamy's assertion that portions of the ancient world had survived in the modern folk traditions of India.[61]

Alexander, however, did not mean to advocate historical borrowing and objected to the winged buffalo Lawrie designed to flank the stairs at the building's main entrance, complaining that they would "fairly bellow from the portal, not in the sense of the passing of the bison, as you [Goodhue] mean it, but as a dead thing out of Ninevah or Persepolis."[62] Evidently unconvinced by Goodhue that Lawrie's sculptures would not look too Assyrian, Alexander later publicly rationalized the similarity as "due to a growing feeling for affinities, which led [Goodhue] to seek, for his own great plains, inspiration from the plains and plateaux of the Orient."[63] Lawrie, for his part, frankly acknowledged borrowing from Assyrian models and, in the opinion of at least one reviewer, did not sacrifice modernity in so doing: "The flat, simple treatment [of Lawrie's sculptural reliefs] is both ancient and modern, reminiscent of the Assyrian and the Egyptian yet essentially of our own time."[64]

Alexander's concerns received validation from a surprising source, a published reference by one of the project's champions, Charles Harris Whitaker, to claims by unnamed critics that the "archaic symbological treatment is not understandable to more than a handful of people in the United States."[65] Alexander was certainly overly optimistic concerning both the accessibility of the iconographic program he designed and the overall form of the building; in what must strike us as unintentionally humorous praise of "a design the plainsman would understand," he declared: "The whole structure is like a gnomon of the plainsman's hours, or perhaps like that Polos with which Anaximander is said first to have explained earth and sky to the Greeks."[66] Alexander's allegorical turn of mind, undoubtedly lost on the average Nebraskan, nevertheless earned him an invitation from the Rockefeller Center Corporation to develop a theme for the decorative program of the office complex under construction in New York.

Consideration of either Rockefeller Center or the last gasp of public allegorical sculpture must remain outside this study.[67] The story of archaism and Paul Manship, however, resumes at the main plaza of Rockefeller Center with Manship's *Prometheus* (1934; M338), one of the best-known public sculptures in America. The distinction arises solely from its prominent location, for the *Prometheus* fails miserably as monumental sculpture. Manship and his patrons recognized as much and attempted to save face by

acknowledging the shortcoming publicly in the center's own organ, *Rocke-feller Center Weekly;* as Manship conceded, his work was out of scale with its surroundings.[68] This miscalculation certainly encouraged humor. Several weeks earlier, the same magazine published a cartoon showing two men in front of the *Prometheus,* one saying conspiratorially to the other: "Let's tie up the rights to radiator caps."[69] With its bright gilding, sleek lines, and unstable pose—a poor attempt to express the titan's flight to earth—Manship's *Prometheus* indeed resembles a gaudy hood ornament.[70] Such an association hardly seems extraordinary taken in context with one of New York's most famous skyscrapers, the Chrysler Building (1930) and its ornament of sculpted automobile hubcaps, mudguards, radiator caps, and fins. But the joke on Manship's *Prometheus* required more than popularization of the automobile; it depended on the assimilation of the aesthetic of archaism into a commercial context—as the style known to posterity as art deco.

The term "art deco" was coined in the 1960s as a shorthand reference to the elaborately ornamental, eclectic French style that reached its apotheosis at the Exposition Internationale des Arts Décoratifs et Industriels Modernes, an impressive display of the latest consumer fashions held in Paris in 1925.[71] In later applications, art deco has designated a modern design movement having roots early in the twentieth century and flourishing during the 1920s or, alternately, during the entire interwar period—notwithstanding the fact that a pronounced stylistic shift toward simplified, machine-reproducible forms marks passage into the 1930s. I will use the term "art deco" in reference to design of the 1920s and 1930s as a matter of convenience only, without intent to endorse any particular position on more specific chronological implications of this label.

As its name announced, the 1925 exposition celebrated modern decorative and industrial art, with a line of pavilions extending from the Pont Alexandre to Les Invalides in central Paris (fig. 86). For Henry-Russell Hitchcock, the exposition proclaimed "the conquest of Europe by the New Traditionalists," architects and designers whom he described as "retrospective in their tendency to borrow freely from the past" and "modern in that they feel free to use and combine without regard for archaeological properties the elements thus borrowed." He continued: "The essential principle which governs both their retrospection and their modernity is the belief that not any one period of the past but the works of the past as a whole offer the surest guide. The manner is therefore completely eclectic since there exists no objection to mixing features from different and even opposed styles of the past; rather there is an obligation to do so as the price of our knowledge of the whole past."[72]

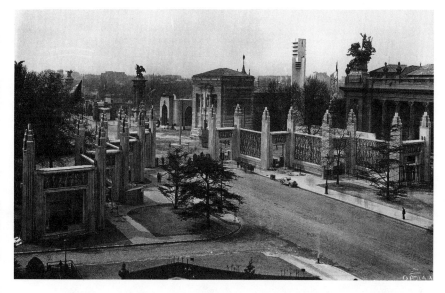

Fig. 86. André Ventre and Henry Favier, Porte d'Honneur, Exposition Internationale des Arts Décoratifs et Industriels Modernes, Paris, 1925 (destroyed). Metalwork by Edgar Brandt, glass reliefs by René Lalique. Photo, Musée des Arts Décoratifs, Fonds Lévy, Paris.

Hitchcock defined the "New Tradition" internationally and principally in terms of architecture, but the stars at the exposition in Paris, not surprisingly, were French designers; they included the metalworker Edgar Brandt, glass artist René Lalique, and cabinetmaker Jacques-Emile Ruhlmann, whom Hitchcock named a major representative of the New Tradition in decoration.[73] Ruhlmann's pavilion—the "Townhouse of a Rich Collector" (modeled on his own house, designed by Pierre Patout)—enshrined the acquisitive urge that the exhibition's backers, including four large Parisian department stores, hoped to stimulate (fig. 87). Arthur B. Davies, the primary organizer of the Armory Show twelve years earlier, somewhat equivocally pronounced the exposition "a great success for the modern movement in a sort of commercialized cubism—with restrictions toward archaism."[74] Although few of the displays could be called artistically revolutionary—they cannot have been and still have held the kind of commercial appeal that guided the event—modernity was the exposition's rallying cry.

In fact, the United States declined to participate because Secretary of Commerce Herbert Hoover believed designers in his country could not

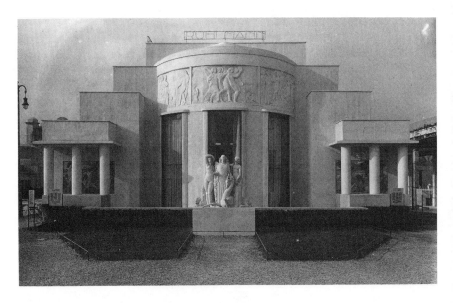

Fig. 87. Hotel d'un Riche Collectionneur (Ruhlmann pavilion), Pierre Patout, architect.
Exposition Internationale des Arts Décoratifs et Industriels Modernes, Paris, 1925 (destroyed).
Photo, Musée des Arts Décoratifs, Fonds Lévy, Paris.

meet the exposition's official requirement that submissions show "new in-
spiration and real originality" or avoid its strict prohibition on "repro-
ductions, imitations, and counterfeits of ancient styles."[75] In the realm of
design, Hoover concluded, the United States had nothing modern to con-
tribute. However, the government sent a committee to investigate, com-
prising 108 members of American trade organizations and art guilds. Many
of these observers, and other American visitors, were taken aback by what
they saw; one decried the "bastard offspring of anaemic artisanship and ef-
ficient salesmanship The dictatorship of ornament."[76] But the dis-
play impressed Charles R. Richards, head of the governmental delegation
and director of the American Association of Museums; his committee's
official report stated bluntly that America lived "artistically largely on
warmed-over dishes" and recommended that American industry cultivate
innovative design as a way to encourage buyers and to gain a competitive
edge in the marketplace.[77]
 To acquaint Americans with the new design, a selection of some four
hundred items from the exposition traveled to eight American museums,
a tour facilitated by Richards. This exhibition opened in 1926 at the Met-

ropolitan Museum of Art, of which the original charter of 1870 stipulated the museum's responsibility to aid "the application of arts to manufacture and practical life."[78] The president of the Metropolitan, Robert W. de Forest, went a step further when he collaborated with R. H. Macy and Company, the department store, on its "Art-in-Trade Exposition" (modeled after the Paris show) in 1927. Over the next three years, three dozen more exhibitions touting modern design took place, some quite small, others not. In 1928, for example, the Lord and Taylor department store showed an astounding 477 works by more than twenty of the major French designers. Accompanying lecture series invested these store exhibitions with academic authority—all to the end of promoting modern design and its acquisition.

The exposition in Paris created a popular image of modern design and, by the end of the decade, French-inspired art deco was everywhere. Attention to surface, the use of exotic materials, textural variety, strong color contrasts, and a preference for simple geometric or stylized form identify 1920s art deco (fig. 88). Its promoters encouraged the coordination of architecture and interior design as critical to the effect, but sculpture, too, had an important role to play.[79] As Roger Gilman, reporting on the Paris exposition in *Art Bulletin,* observed: "sculpture seems to be everywhere."[80]

Not all champions of sculpture approved of the new developments. "You will not find as much sculptural modernism in the marketplace as in the boudoir," declared Adeline Adams, a frequent essayist on sculpture, in 1929; "the boudoir is the transitory asylum for novelties."[81] As Adams surely intended, a lady's private chamber (especially as called by its French name) evokes indecision, frivolousness, luxury, perhaps even a certain decadence—qualities far removed from the (masculine) intellectualism and seriousness of purpose that academic and vanguard sculptors claimed in equal measure. By "sculptural modernism," Adams did not intend anything that her more radical contemporaries (or later writers) would have identified as modern in this period; her essay makes this clear. "Modernism, that ambiguous word of many meanings, is on every tongue, and on many pens. Open at random a sheaf of American publications [she mentions *House Beautiful*] Modernism rustles from their leaves."[82] Even the secretary of the Metropolitan Museum of Art, she wrote with evident dismay, "tells us of the modernism of the department store, as daily offered to the home-maker in her choice of furnishings."[83] In Adams's formulation, fashion and "the chicanery of modernism" went hand-in-hand.

More than a half century later, Reinhold Hohl disdainfully tagged the fashionable sculpture of this period (which he did not otherwise call modern) *"la haute sculpture,"* a clever phrase intended to evoke *haute coiffure* or *haute couture,* in other words, sculpture that is chic and commercially vi-

Fig. 88. René Chambellan, in
collaboration with Jacques
Delamarre, ENDURANCE.
Bronze plaque and radiator
grille, Chanin Building,
New York, 1927–1929.
Illustrated in *The Metal Arts* 2
(February 1929), pl. XI. Photo,
Library of Congress.

able, but not aesthetically valid.[84] What did this sculpture look like? Hohl named Archipenko, Brancusi, and Nadelman, reminding the reader that in 1912 Brancusi sold his *Maiastra* to *couturier* Paul Poiret, who placed it in the showroom, while cosmetics executive Helena Rubenstein bought out one of Nadelman's shows in 1911. Gilman, unspecific about artists, indicated that the sculptures he found so "entirely one with their surroundings" at the exposition were (like Brancusi's, Nadelman's, and Manship's) "simplified to the last degree, whether by polished surfaces or by archaic or even geometrical treatment of the details."[85] Adams gives the reader only the fashionable consumer and her boudoir. Significantly, contemporaries Adams and Gilman—although disagreeing in their estimation of "modern" sculpture—shared a reference point. Their formulations of the modern reveal a blurring of divisions between fine and decorative or utilitarian objects and the assimilation of artistic modernism to the realm of popular culture.[86] By the late 1920s, the word *modern* had indeed become an important signifier of fashionability.

"Modernistic" emerged as the contemporary term of derision—"born out of the hysteria created by the Paris Exposition," in designer Donald Deskey's phrase—for the fashionable decorative and fine arts.[87] Duncan Phillips and Charles Law Watkins defined "modernistic" as "a critical term of reproach" and its practitioners as academically sanctioned imitators, popularizers, or "normalizers" of a modernist manner.[88] "*Modernistic*," another brief essay on terminology concurred in 1938, ". . . should apply to works which imitate superficially the forms of *modern* art, reducing them to decorative mannerism."[89] Similarly, Alfred Barr, director of the Museum of Modern Art, declared: "The modernistic has become merely another way of decorating surfaces."[90] In a quite literal sense, something modernistic is *superficially* modern.

By the 1920s, many critics had come to view archaism and Manship's sculpture in precisely this way, a matter I will explore at length in the next chapter. Nevertheless, Manship's popularity remained high; not until the late 1930s, coincident with the end of the design movement now known as art deco, did his reputation enter serious decline. And with the rediscovery and naming of art deco, soon after the sculptor's death in 1966, interest in Manship's art again revived. It placed him in a niche that would have made him uncomfortable. Manship deplored the popular, commercially fabricated statuettes now so often associated with his work and mistrusted some of the impulses behind art deco, particularly as it developed in the 1930s.[91] It remains here to situate him with regard to this design movement, of which he has been called the "patron saint."[92]

Within the context of 1920s art deco—the French-inspired style—and its delight in sleek surfaces, rich color, and stylized natural form, Manship's art fits quite easily (fig. 89). This perception arises from both his indi-

Fig. 89. Paul Manship, AIR,
relief for American
Telephone and Telegraph
Building, New York, 1914.
Plaster. Photo courtesy of
John Manship.

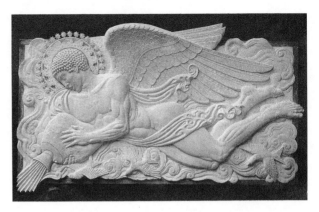

vidual sculptures and their compounded effect at exhibition. The richly colorful, carefully arranged ensemble that so struck a reviewer of Manship's show at the Art Institute of Chicago in 1915 would have seemed right at home a decade later:

> The fountain in the middle of the room was in the green of ancient bronze with a bowl of deep red, as of some rare species of marble, while in each corner of the room was a bust in classic white, representing a hero or god of Greek mythology. About the walls were panels representing the elements, these in beautiful stone or terra cotta reds, shaded or powdered with tracings of greenish grey, small panels in celadon blues and against this background were set the little figures and vases in plaster and bronze.[93]

Manship's penchant for archaeological exotica (Indian art, for example) also had a corresponding tendency in art deco, as in the craze for objects incorporating Egyptian styles and motifs touched off by Howard Carter's discovery of the tomb of Tutankhamen in 1922. And although he clearly considered himself a practitioner of the fine arts, Manship regularly undertook projects of an essentially decorative nature; during the 1910s and 1920s, he fashioned candelabra, ashtrays, planters and urns, a water fountain, even a door knocker (as would Maillol for a pavilion at the 1925 exposition). Not surprisingly, Manship lavished particular decorative attention on the New York City townhouse he remodeled for his family after 1925; some of its rooms are outfitted in what seems exemplary art deco style (fig. 90).[94]

At the time of that renovation, Manship had ample exposure to French modern design, having just returned from several years in Paris. In fact, he had participated in the 1925 exposition (the only American sculptor other than Janet Scudder to do so), showing an armillary sphere in the section

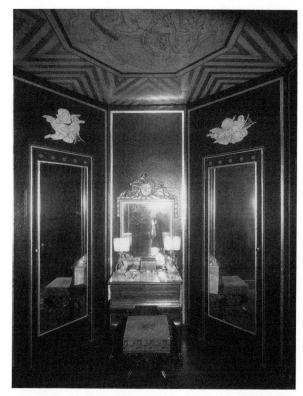

Fig. 90. Bedroom, Paul
Manship residence,
East 72nd Street,
New York City (destroyed).
Peter A. Juley & Son
Collection, National
Museum of American Art,
Smithsonian Institution.

Fig. 91. Paul Manship,
Paul J. Rainey Memorial
Gateway, 1926–1934.
Bronze, 36 × 42 feet. New
York Zoological Park,
Bronx. Peter A. Juley & Son
Collection, National
Museum of American Art,
Smithsonian Institution.

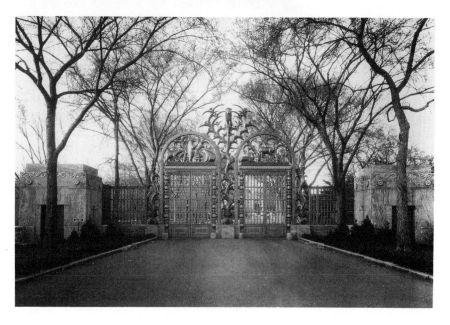

Fig. 92. Paul Manship,
EUROPA AND THE BULL, 1924.
Bronze on marble base,
10¼ in. high. National
Museum of American Art,
Smithsonian Institution,
bequest of Paul Manship.

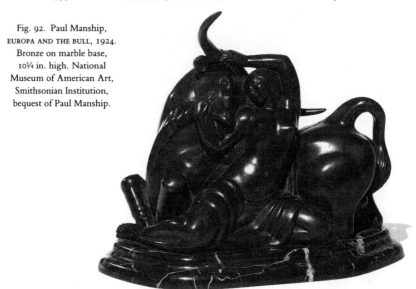

reserved for garden sculpture. Manship reportedly visited the exposition many times and found it "more than interesting, full of ideas." [95] He clearly paid attention to the creations of Edgar Brandt, the great French metalworker who collaborated in the production of the Porte d'Honneur, the imposing entryway to the fair (fig. 86). Brandt's example resonates in Manship's Paul J. Rainey Memorial Gateway for the Bronx Zoo (1926–1934; M344), one of the American sculptor's most complex and successful large-scale projects (fig. 91). But the "art deco" tendencies in Manship's work—in stylistic terms, his archaism—had appeared well before the 1920s, concurrent with the first steps in that direction by Brandt and other French designers. Manship's relationship to French art deco was not passive, but active; he undoubtedly absorbed ideas from his modern Parisian surroundings, just as the French surely found in his work confirmation of their own modern arts of design. Significantly, the year 1927 saw publication in French of the most substantive study of Manship to that date, by Louvre curator Paul Vitry.

Manship had moved to Paris in 1921 seeking escape from the demand for constant productivity brought by the extraordinary success of his archaistic statuettes. As he told a reporter in Paris: "I am here to work and to study and to make things and to destroy them if they don't please me, to be free of every pressure but my own wish." [96] During this period, Manship turned away from the miniaturism and decorative linearity of his early archaism toward greater solidity and mass, exemplified by *Europa and the Bull* (1924; M169; fig. 92). Europa, luxuriating against the reclining bull,

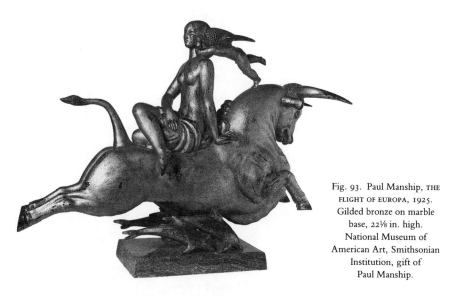

Fig. 93. Paul Manship, THE
FLIGHT OF EUROPA, 1925.
Gilded bronze on marble
base, 22⅛ in. high.
National Museum of
American Art, Smithsonian
Institution, gift of
Paul Manship.

embraces him, creating a tight, x-shaped composition that may have been inspired by a metope from the Temple of Zeus at Olympia in the Louvre collection, showing Herakles wrestling the Cretan Bull (fig. 29). Manship had long admired this metope and carefully analyzed its taut composition in his Academy lecture of 1912; in evoking this ancient depiction of struggle, Manship added a suggestive element of tension to the amorous coupling of Europa and her soon-to-be abductor. Manship issued *Europa and the Bull* in several sizes and it is among his few sculptures equally, if not more, effective as a larger work, undoubtedly because it relies more on volume than it does on line.

At the same time, Manship continued to explore the challenges of capturing motion and flight, with which he had flirted in *Flight of Night* of 1916. In contrast to the swooping elegance of that sculpture, flight in *The Flight of Europa* (1925; M77; fig. 93) seems deliberately calculated to appear an implausible and humorous affair. Manship chose to emphasize the weightiness of the bull through its horizontality and bulk, a quality he accentuated by positioning the animal on the backs of four tiny, leaping dolphins—the agents of flight. A decidedly unperturbed Europa sits erect and with crossed legs on her abductor's broad back, while a winged Eros, perched on the bull's shoulder, whispers in her ear. The fact that Europa and her amorous attendant face away from the bull checks the sense of forward motion, as does the stable vertical-horizontal intersection of the principal pair and the opposing arcs of the bull's horns and forelegs and the putto's wings and legs against the bull's rear legs and the dolphins' tails.

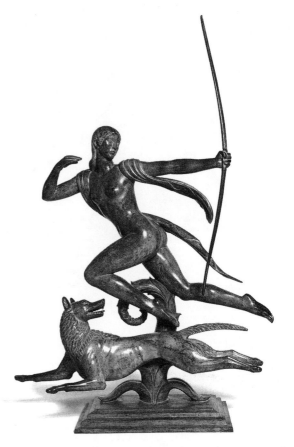

Fig. 94. Paul Manship,
DIANA, 1925. Bronze,
49 in. high. National
Museum of American Art,
Smithsonian Institution,
gift of Paul Manship.

Together with the lighthearted humor of this work, its immediate anteced-
ent in a gilded ashtray (1917; M96) that Manship gave Isabella Stewart
Gardner (owner of the famous Titian painting *The Flight of Europa*) high-
lights his disposition to undertake distinctly frivolous projects—the sort
of work that cemented Manship's association with art deco.[97] This two-
dimensional version also hints at an ultimate source of inspiration for *The
Flight of Europa* in the hammered gold Vapheio cups from Mycenae.[98] The
gold patina Manship applied to all three editions of *The Flight of Europa*
(M96, M177—M179) fulfilled a function similar to the linear details on his
earlier archaistic sculptures: it focused attention on surface, and did so in a
manner consistent with the contemporary designer's love of glossy metallic
and exotic veneers.

Manship's archaism culminated in the paired *Diana* (fig. 94) and *Actaeon*
(fig. 95), of which he made several variations, the last dated 1925 (M183–
M184).[99] These works successfully united the decorative emphasis of his
early archaistic style with his new concern for mass and continued his ex-
ploration of the floating figure. The expressive silhouette of each figure

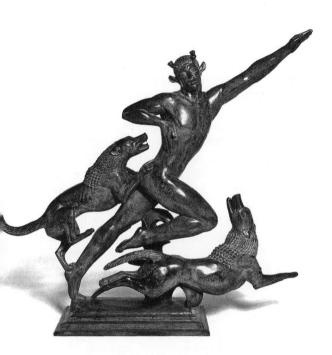

Fig. 95. Paul Manship,
ACTAEON, 1925. Bronze,
48 in. high. National
Museum of American Art,
Smithsonian Institution,
gift of Paul Manship.

makes the first impression. Emphasis on outline had always been a Manship signature, but in these sculptures he abandoned the languorous, elegant line and balanced composition of earlier works, such as the *Dancer and Gazelles* (fig. 60). Diana's movements are the more graceful; surprised at her bath by Actaeon, the chaste Diana bounds weightlessly away from him, sure of her mark. Actaeon lunges heavily in the opposite direction, the straight lines and forceful diagonal orientation of his body signifying speed and urgency. At the same time, the rigidity of Actaeon's limbs suggest the futility of his flight; as willed by the vindictive huntress, he is already metamorphosing into the deer that his own hounds will devour.[100]

The streamlined form and evocation of speed in *Diana* and *Actaeon* anticipate some of the directions modern design would take in the 1930s. By that time, the functionalist credo of the European design groups associated with the rising International Style had begun to sweep away the lavish decorativeness of 1920s art deco. Members of the Bauhaus, the French architect and designer Le Corbusier, and many others argued that luxury objects were socially irresponsible. Believing that an object should express

its purposes, materials, and manufacturing processes, they shunned nonessential or historically derived ornament in favor of simplified forms suited to inexpensive mass production. On a popular level, these ideas contributed to the rise of what has sometimes been called the Machine Style, owing to the ubiquity of machine imagery and machine production.[101] The elimination of surface decoration left the overall, stripped-down form as the ornament itself. Designers and their public found in these simplified forms an antidote to the complexity of life in the machine age and an appropriate expression of modernity; "simplicity," Paul Frankl declared in 1928, "is the keynote of modernism."[102] With the onset of the depression, manufacturers discovered persuasive economic reason to simplify their products, but the austere packaging seemed appropriate to hard times. Even more compelling, streamlining projected a reassuring image of efficiency and speed; it suggested smooth coordination that could soothe the psychological effects of abrupt changes in the business cycle and seemed to hold the promise that America could surge out of its economic stagnation.

Tempting though it may be to see Manship's *Diana* and *Actaeon* in this context, as an artist his feelings about the machine age were ambivalent at best. In a 1939 encyclopedia entry, he acknowledged the influence on modern sculpture of "the fleet lines brought into being by the swift moving automobile and the aeroplane lines of speed" and recognized them as "the reflection of the spirit of our day in the language of our day . . . ever changing and always fundamentally optimistic."[103] But in verbal communication to an audience of his peers, Manship decried the decline of sculpture in an increasingly technological age: "We may admire the perfection and functional beauty of a piece of mechanism, of the form and line of the automobile. We admire its simplicity and expression of speed, but let us not confuse it with art. . . . The spirit back of the mechanical age may be *useful* [to] art, but under its present direction, it is killing its *best friend*."[104] An artist who celebrated fine hand-craftsmanship, Manship could never sympathize with the call for a reconciliation between art and industry. Ironically, critic Henry McBride, in an unflattering review, attributed the success of Manship's sculptures to "mechanically exact" workmanship: "They seem to have been created by machines and finished by machines. This, too, fits in with our modern system of living."[105]

In the catalogue of the Machine Age exhibition at the Brooklyn Museum in 1986, Dianne Pilgrim suggests that "the machine's rise to prominence was accompanied by a growing conservatism, a fear of the loss of individualism."[106] There seems little doubt that Manship had that fear. Sometimes he expressed it quite directly, as when he referred to the modern sculptor as "the victim of our times confronted by the dislocation of the product of his profession in the modern world of machinery, utility, and science."[107] In a less combative moment, Manship seems al-

most tragic; he once told a newspaper interviewer that "work done with hands in a machine age is no expression of the age."[108] If Manship truly believed this, then he had to understand that it spelled the death of art as he knew it.

It is one of the ironies of Manship's career that he gained a certain popularity as a modern-looking sculptor while holding to a profoundly conservative understanding of his own practice. He intended no deception, nor was the public insulated from his traditional views, for which contemporary critics were only too willing to reproach him. But the veneer of stylish modernity appears to have satisfied Manship's patrons perfectly well. His art, like so much art deco design, reached back into the past while seeming to look ahead to the future; the duality helped to locate contemporary culture on a historical continuum.[109] In a world of flux and uncertainty, Manship's sculpture offered reassurance, mediation, and synthesis.

7

Archaism and the Critics: Disenchantment

By the 1930s, Manship had become the country's most visible sculptor—productive, materially successful, popular, and outspoken. His *Prometheus Fountain* at Rockefeller Center, gates for the Bronx Zoo, and five large sculpture groups adjacent to the central Trylon and Perisphere at the 1939 World's Fair kept his work squarely in the public eye. At the same time, Manship assumed increasing professional responsibility; a longtime member of the National Sculpture Society, National Academy of Design, and American Academy of Arts and Letters, between 1939 and 1954 he served each in succession as an elected leader. If, as one of his close friends alleged, he had "a positive aversion to the discussion of theories about art," then it was only in the narrowest terms of his own production.[1] In an official capacity and in public lectures and writings, Manship promoted ideas that can only have been his own. He believed in the usefulness of the past, valued fine craftsmanship and technical expertise, emphasized the importance of collaboration among artists, and stressed the artist's obligation to create works the general public could understand. In short, he considered the artist a guardian of tradition, a missionary on behalf of beauty, and a public servant. Paul Manship represented everything that the modernists loved to hate, and his reputation plummeted with the rise of the American avant-garde by the 1940s.

When Manship first exhibited his archaistic sculptures in New York in 1913, however, critics of varying allegiances responded with enthusiasm, as I showed in chapter 4. If his archaism was a "spell," as Herbert Adams incorrectly predicted, then it most often enchanted observers during those early years.[2] Using words like *unerring, invariable,* and *flawless,* they praised Manship's sense of design,

knowledge of form and construction, high standard of craftsmanship, and so on. Initially, this absolute vocabulary signaled approval of Manship's work, its perceived qualities of clarity, control, and discipline; however a shift toward the more negative connotations of inflexibility and limitation soon followed. Still the critics vacillated. Some presented Manship as an artist who might mediate between a salvageable tradition and the vital, but undisciplined, forces of modernity; possibly Manship saw it this way himself. For others who embraced those forces, Manship could only figure as a sacrificial academic. Reading the commentary on his art, one often feels that Manship was only a pawn in a series of critical maneuvers by representatives of the academy, the avant-garde, and those somewhere in between; to the extent that the discourse of modernism seemed fluid, they had something to debate. Among the hundreds of pages written on Manship's art during the 1910s and 1920s, a significant number issued from well-known critics.[3] Their essays make clear that in Manship they recognized much at stake.

Kenyon Cox, representing the academic— he would have said "classic"—point of view, found Manship a classicist in the best sense of the word, as he understood it: keenly observant of nature and yet respectful of artistic tradition. Classicism, Cox had earlier avowed, did not deny originality and individuality, and he called Manship's *Duck Girl* "original work of true classic inspiration."[4] Cox denied the claim of originality for radically modern practice, believing any exercise of individuality not restrained by "law" or tradition to merit little consideration as art.[5] But Cox was not blind to the shortcomings of academic art that applied the lessons of the past too narrowly, and from that "mechanically constructed pseudo-classic ideal" he approvingly pronounced Manship's distance.[6] Cox backed his words of praise with action when he nominated the young sculptor for associate status in the academic artist's pantheon, the National Academy of Design.[7]

Royal Cortissoz, writing for the *New York Tribune*, expressed a similar view of Manship's work. "No routine emulation of the antique" could have produced the *Duck Girl*, he claimed; rather, the sculptor had used "the idiom of an earlier day" because it was "simply natural" for him to do so. Thus, Manship was "classical in spirit," but "at bottom an intense realist" because, we infer, he had been true to nature (a point Cox also emphasized) and to himself.[8] Notwithstanding Cortissoz's conservative orientation, these words echo a modernist position, one that appears with greater clarity in the commentary on Manship by Charles Caffin, a critic more open to modernism and less tolerant of classicism than either Cox or Cortissoz.

In early 1913, Caffin remarked favorably on the quality of emotional expressiveness that he perceived in the *Centaur and Dryad* and on the ab-

stract—that is, archaistic—treatment of details. Neither had, in Caffin's view, anything to do with Manship's classical subjects, from which he hoped the sculptor might soon liberate himself. But when these features proved no less evident in an exhibition that Caffin reviewed later the same year, the critic was correspondingly less persuaded of Manship's modernist mettle; the same details that once anticipated abstraction now seemed to him appropriations of "the unessentials of classic sculpture." Caffin counseled Manship to rely more on his own observation and experience—to emulate the practice of classical artists rather than to imitate their works. Still, he held out hope, allowing that the sculptor was "trying to adjust to the classic style his own feeling for nature."[9] In the modernist discourse, it was an achievement at once classic and modern to strike a balance between nature and art, although authority rested ultimately with nature and the self. Thus, in 1903, Cézanne invoked Couture's advice to pupils: "Go to the Louvre. But after having seen the great masters who repose there, we must hasten out and by contact with nature revive within ourselves the instincts, the artistic sensations which live in us."[10] The classic (modern) artist must "remake the antique after nature."[11] Caffin's syntax—though he intended approval—implies that Manship did the opposite; such was indeed the case: during his student years in Rome, Manship sought inspiration in the galleries when he thought nature failed him.[12]

Manship's unorthodox choice of a source in archaic art, while disconcerting to more conservative critics, seems initially to have spared him the charge of academicism from Caffin.[13] But Caffin recognized a problem: Manship's distinction derived in part from his participation in "the modern recognition of the value of tempering naturalism with some degree of technical convention," and yet the artist undermined his modernity by excessive reliance on past traditions.[14] The older art Manship so freely imitated "grew out of living experience with natural forms," Caffin declared, while lamenting how little Manship himself had "dipped below the surface and sought to discover the tradition which he imitates." And he pointedly added: "Conventionalization, unless it grows out of a man's living sense of creativeness, adapted to some real purpose of the spirit, is but dead bones, snatched from the charnel house of what was once alive."[15] Conventionalization—in this case, formal stylization—can be understood in a positive sense only if it arises honestly, as from some intense inner pressure. Caffin's suggestion that it might serve some "real purpose of the spirit" thus evokes Wilhelm Worringer's thesis, articulated in *Abstraction and Empathy,* that formal abstraction visually embodies a quest for spiritual fulfillment.[16] In Manship's case, continued adherence to archaic stylizations opened him to charges of servile imitation; he seemed, at times quite mechanically, to reproduce art—perhaps even his own art—rather than drawing from the well of nature.

Fig. 96. Paul Manship,
PAULINE FRANCES, 1914.
Marble and polychromed
bronze, 27 in. high.
Metropolitan Museum
of Art, gift of
Mrs. Edward F. Dwight,
1916.

But Caffin revised his dire view in 1916, after seeing a portrait in high relief of Manship's infant daughter completed two years earlier (fig. 96). In a detailed account of this work, Caffin began by surveying possible proto-types—an exercise Manship's art always seemed to demand; however, he found the key to the work's success in the artist's transcendence of these sources (most conspicuous in fifteenth-century Florentine sculpture) and in the "mingling of significant abstraction with sensitive concreteness" and emotional depth.

> It is the first work, so far as I know, in which Manship has lost his self-consciousness in the presence of his art experience. He ceases to be, if one may say so, art-conscious; he is not deliberately adapting some motive de-rived from the past, but in the fullness of liberty that his knowledge of the past has given him is working creatively in the expression of his own reac-tions to the present. . . . The past, which he has studied so searchingly and with so brilliant an adaptiveness is now receding into proper perspective with his own personal experiences of life. It is taking its place as a rich and resourceful foundation for the growth of his own individual creativeness.[17]

Caffin's approval of the sculpture may reflect his preference for subjects that American artists drew from their own surroundings. *Pauline Frances* (M35) elicited equally effusive praise from other critics. George Humber, writing for the *New Republic,* declared the work a "masterpiece" for its

fusion of naturalism and abstraction, and Mariana Griswold Van Rensselaer made it the subject of an essay for *Scribner's Magazine* in which she, too, lauded Manship's ability to balance naturalism with "aesthetic interest."[18]

The admirers of *Pauline Frances,* a later critic believed, had been seduced by its subject matter.[19] Such suspicion of sentimentality undoubtedly accounts for the fact that the sculpture is one of the works least commented upon in more recent accounts of Manship's career. Van Rensselaer had openly acknowledged the potential pitfall, but found that Manship succeeded in expressing personal feeling without succumbing to sentimentality. Her defensiveness perhaps betrays a concern that readers' preconceptions about gender might undercut the seriousness of her art criticism; evidently, Manship's male critics felt no embarrassment in praising his sculpture of an infant. We would do well to take these writers on their own terms; in Van Rensselaer's succinct phrase: *Pauline Frances* "is an artist's *vision and version* of facts."[20] Manship looked closely at his subject, observed the peculiar undirected gestures and smooth elastic flesh of a newborn, and captured them in marble. But then, by setting the sculpture (realized as a half figure only) upright in its bronze niche, he denied a naturalistic or anecdotal reading. The same cannot be said of Manship's portrait of his third daughter, Sarah Janet (1929; M259), the complete figure of a recumbent infant made without a base. A photograph of Manship holding the real baby in one arm and the sculpture in the other frankly acknowledges his blurring of the boundaries between art and life in this later work.[21] In *Pauline Frances,* however, critics found the striking combination of naturalism and abstraction that initially attracted their attention to Manship's work and encouraged them to call it modern.

Even the most enthusiastic commentators had difficulty deciding whether Manship's art deserved their full support. Again and again, praise and doubt alternate in successive essays by the same critic or share space within a single review. One writer who thought that Manship followed the ancients "with a fidelity more facile than inspired" conceded: "His taste, however, is exquisite."[22] "It is almost as if he were obsessed by a multitude of the spirits of ancient sculptors," ventured another, who decried Manship's indiscriminate combination of stylistic elements, an effect he deemed "ludicrous," adding sardonically: "If you have a taste for artistic ragout made with perfect skill and seasoned with something like the esthetic paprika of assurance you may have a pleasant time with Mr. Manship."[23] The culinary analogy was particularly appropriate for Manship, who frequently likened the techniques of sculpture to "a lot of recipes" best studied in museums.[24] In the opinion of many writers, Manship followed those recipes a bit too closely. The commentator just quoted, for one, thought Manship would benefit by adding "a soupçon of originality" to his "artistic ragout,"

but he acknowledged a dilemma in wishing for another way to express the deficiency in Manship's work, "since of course the idea of mixing things so obviously and completely is original in the full sense of the word."[25] At least one writer found the quandary amusing: "While we are talking . . . about being original and ourselves, [Manship] has opened the doors into many traditions, looked appraisingly at the riches in each, and walked off with whatever he needed for his own originality."[26]

Manship's originality was very much at issue in critical writings of the 1910s. Faced with the unerring technical perfection of Manship's sculptures, some critics seemed willing to suspend judgment; in fact, in the aftermath of the Armory Show, many would have agreed with A. E. Gallatin's statement (in an essay on Manship's work) that "too much stress is to-day put upon the virtue of originality."[27] Indeed, according to C. R. Post: "It would be almost enough if he did no more than imitate the achievements of the former ages that interest him, for he brings to this task an understanding, as complete as it apparently is instinctive, of the epoch in question, a spring-like freshness sufficient to vitalize even an imitation, and a perfection and facility of craftsmanship in reproducing the style desired that afford the same justifiable pleasure as the pyrotechnics of a Caruso." The assumption that Manship acted instinctively spared him charges of pedantry; still, Post was troubled: "We must demand of Manship a real message as well as further technical originality if he is to fulfill his great promise."[28] The increasing unwillingness of critics to accept either brilliance of execution or eclectic style—the twin pillars of Manship's art—as sufficient criteria for excellence is summed up in Gallatin's wish that Manship, "having perfected himself in the technique of his art, and learned its traditions, would now strive to produce works even more creative and original and rather more modern in feeling."[29]

Manship's dealer, Martin Birnbaum, acknowledged such critical misgivings in his catalogue for the sculptor's first major solo exhibition in 1916. However, Birnbaum's response to the skeptics reveals little understanding of their concerns and could not have placated them. Those who doubted the sculptor's genius would not do so if they could observe Manship's working process, he claimed, adding however that "only his intimates know what deep thought and study go to the making of these facile looking, captivating little figures, and it is characteristic of the artist that no marks of the painful effort are left."[30] From the modernist perspective, evidence of the artist's intense psychic and physical engagement with his work—the "marks of the painful effort"—were precisely to be desired; but what form would this take? Birnbaum's own statement points to the answer (suggesting the pervasiveness of the modernist discourse in this period): it is the "mark"—the indexical sign of the artist's presence—that guarantees the artist's involvement in the work. Directly carved sculpture in stone or wood

(neither of which Manship produced) registers touch, as does worked clay. But here we reencounter a familiar problem: the clay model merely inaugurates a long process in which the artist rarely played a part, a process usually culminating in stone or metal—hard materials that present false indexes of the artist's original. Manship, we have seen, self-consciously abandoned expressive modeling for an aesthetic of hardness, produced by combining smooth surfaces with crisply incised linear detail. In chapters 3 and 4, I argued that the suppression of the autograph mark was a characteristic of modernity in bronze sculpture; but perhaps it must occur in conjunction with a relatively abstract vehicle, the non-figurative or partially figured sculpture, in order to be viewed as an aspect of "modernism." In the context of Manship's narrative, often mythological, subjects, his polished handling appeared to critics as overrefined, academic fussiness.

The polished—or as Birnbaum himself put it, "facile"—appearance of Manship's work, though contributing measurably to his popularity among conservative viewers, constituted for others a fatal flaw. Manship's works at first astounded by their brilliance of design and execution, but they failed ultimately to engage the viewer emotionally. Thus, an unsigned review compared Manship's "empty perfection" to that of the nineteenth-century French academic painter Bouguereau, noting that although Manship "is a capable, an extremely capable, an even sincere craftsman . . . that is not much. Art requires more than craftsmanship when it requires a soul. . . . he is without emotional power, and . . . must build form solely through intellectual processes. This is exactly as he does. And since his intellectual processes are not interrupted by emotional vagaries . . . he arrives at the coldest, the most detestable of virtues in art, perfection—if, indeed, perfection could be called a virtue."[31]

Manship's concern for fine craftsmanship was central to his self-identification as an artist and he would probably have been the first to admit perfection as a goal. That, at least, was Royal Cortissoz's impression; in 1933, he imagined Manship responding to criticism of his work as "hard" by saying "'I like to have things right.' And 'right' in Mr. Manship's own sense his work indubitably is. It is implacably 'right,' relentlessly 'right,' so extraordinarily 'right' that sensitive and frail human beings get scared when they see it. After they get over their first fright they are usually able to take pleasure in an art that is so exactly fitted to the requirements of the nation that produced it."[32] The final sentence insinuates that the nation, and not Manship, produced the sculpture. Cortissoz clearly intended to equate Manship and his public, for he continued:

> The times and the people are hard too. The average man when he wishes to boast will say: "I'm hard boiled, I am." . . . They simply mean by it that they

"know what's what," that they are well aware of the values of the commodities they traffic in, and they also mean that they can't be bothered with inconsequential things, with idle vagaries, with soul probings and things of that kind.

The elite of this generation almost instantly recognized Mr. Manship to be their sculptor. . . . The American elite did not wait for European approbation before adopting Mr. Manship. They joined forces with him the moment he swam into their ken. It was a case of instinct, and instinct is always swifter and more unerring than intellect.[33]

Perhaps the display of European modernism at the Armory Show made Americans leery of "European approbation" and prompted the American elite to join forces with Manship precisely against a radical, foreign artistic incursion. As Henry McBride, who found Manship's archaism insufferably anachronistic, observed: "best sellers . . . always indicate something."[34] But what did Manship's sculpture represent to Americans of the 1910s and 1920s? McBride, like Cortissoz after him, suspected that Manship's public unwittingly saw in his art their mirror image—"hard, unimaginative and lacking in subtlety"—and he believed the exactitude of Manship's work appealed to people obsessed with "getting their money's worth."[35] Thus, one of the Rockefeller Center architects explained why Manship had been chosen to design the sculpture for the Plaza: "We know that he'll turn out a 100% professional job, capably modeled, brilliantly cast, in scale, and with waterworks that work. And furthermore, on the opening day Manship will be there with the cord in his hand all ready to unveil."[36]

Manship, as Cortissoz had suggested, was one of the commodities Americans trafficked in (leading one recent writer to speculate that Manship sacrificed his development as an artist to client expectations based on the success of his early works).[37] Certainly the trustees of the American Academy, having quite literally invested in Manship, had an interest in promoting him, as the young sculptor clearly understood from his first days at the Academy.[38] And the Academy offered more than a network of patrons: it provided the socialization, the training in deference, without which a young man of relatively modest background could not successfully have dealt with—or been dealt with by—the social and economic elite who commissioned his work.[39] Although at times Manship expressed aggravation with the demands on his productivity, he presented himself, at the height of his career, as in control of his own commodification; according to a *New Yorker* profile, he dressed "like the floor partner of a Stock Exchange house, and his clipped moustache, strong jaw, and somewhat imperative blue eyes recall the regular army officer rather than the sculptor."[40]

As one of the most prominent sculptors of the day, Manship made an easy target, one struck with no greater force or dispatch than by E. E. Cum-

mings in an essay on Gaston Lachaise for *The Dial* of February 1920.[41] Manship, Cummings declared, "is neither a sincere alternative to thinking, nor an appeal to the pure intelligence, but a very ingenious titillation of that well-known element, the highly sophisticated unintelligence."[42] Case closed. Curiously, Cummings failed to mention that Lachaise served as Manship's principal assistant from about 1914 to 1920.[43] We might explain the omission by noting that Cummings shunned biographical detail in his essay (though he does not entirely exclude it) and that his comments on Manship deny the possibility of any benefit to Lachaise from the association (clearly he did not think it improved Manship). Certainly, it seems unlikely that Cummings sought to contain the affront to Manship by avoiding direct comparison—that would require taking Manship more seriously than he intended to.[44] Cummings, in short, had a point to make; it required him to introduce Manship as a type and then to isolate Lachaise from that type, an objective accomplished with considerable rhetorical skill. We may come to a better understanding of Manship's disqualification from the modernist arena if we examine the terms for artistic excellence that, for Cummings, Lachaise exemplified and Manship failed to meet. We should also consider Lachaise's work during the period of his employment with Manship and soon after. The evidence suggests a critical effort—not unique to Cummings—to draw a more decisive line between academic and modern than may in fact have existed.

Cummings met Lachaise through his Harvard classmate Edward Nagle, Lachaise's stepson, and a strong friendship soon developed between the sculptor and the young man who at the time considered himself "primarily a painter."[45] That calling decisively informed Cummings's piece on Lachaise, his first published critical essay. The article opens with a passage from Willard Huntington Wright's *Modern Painting* that, in effect, proclaims the death of sculpture: Cézanne (Cummings quotes Wright) "made us see that painting can present a more solid vision than that of any stone image. Against modern statues we can only bump our heads: in the contemplation of modern painting we can exhaust our intelligences."[46] Cummings identifies Manship as one of those sculptors whom Wright's words "wipe off the earth's face," but in Lachaise he finds a sculptor-equivalent to Cézanne.

This comparison drives his essay. Just as Cézanne's "hate of contemporary facility and superficiality drove him to a recreation of nature which was at once new and fundamental," so too Lachaise, whose "two greatest hates are the hate of insincerity and the hate of superficiality," sought to express "the truths of nature as against the facts of existence." Cummings elaborates his point by analogy with "the child's vision," which he characterizes in linguistic terms as the ability to depict things "not as nouns but

as verbs . . . to liberate the actual crisp organic squirm—the IS." Unlike
academic art—a mere "prepositional connective . . . between two nouns:
an artist and a sitter" ("Mr. Sargent's portrait OF Some One")—the child's
work "IS" itself, a site where self and subject converge.[47] The adult artist
in a developed Western society may recover the intensity of immediate ex-
perience that belongs to the child (or the "primitive") only by abandoning
the academy; Cézanne and Lachaise, for their parts, go "not beyond but
under conventional art." Paradoxically, this demands "an intelligent pro-
cess of the highest order, namely the negation . . . by thinking, of think-
ing." Thus, "Cézanne became truly naif—not by superficially contemplat-
ing and admiring the art of primitive peoples, but by carefully misbelieving
and violently disunderstanding a second-hand world." Lachaise, for his
part, was at once "inherently naif, fearlessly intelligent, utterly sincere"—
these are the first things Cummings tells us about Lachaise and they flag
both author and artist as modernists.

To the art of children, primitive peoples, and modern artists who suc-
ceed in expressing themselves "in spite of all schools," Cummings opposes
the "self consciously attempted naivete" and "deliberate unthought" of the
"would-be primitives." In this instance, he singles out William Zorach,
identifying him, oddly enough, only as a painter and making no mention
of Zorach's activity as a sculptor. Nor does Cummings offer any indica-
tion of what kind of work he has in mind when describing the dynamics
of viewing Zorach's art. We learn only that "shapes" "imitate" or "dupli-
cate the early simple compositions of mankind" and, by some mysteri-
ous "emotional appeal" (arising from a primitive formal configuration?),
"numb" our minds "into inactivity." But the effect is short-lived: "The
spell wears off, intelligence rushes in, the work is annihilated." The cheated
viewer is left with nothing but a "'fakey' feeling." How can we not be
confused when, after all this, Cummings tells us that Zorach is "unques-
tionably sincere"? For Manship, on the other hand, there can be no shred
of hope. Cummings states at the outset that Manship fails even to present
the "sincere alternative to thinking" that emotional appeal seems to offer
in Zorach's work. All of the negative words in this essay—sophisticated,
superficial, second-hand, insincere, "fakey," dead—apply to Manship's art.
Their positive counterparts (stated or implied)—naïve, searching, immedi-
ate, sincere, authentic, alive—are the attributes of Lachaise as a modernist.

The modernist paradigm privileged directness and spontaneity, qualities
more difficult to identify with the practice of sculpture than with painting.
Significantly, Cummings did not frame his presentation of Lachaise in
terms specific to sculpture; the persistent comparison is with Cézanne.
References to touch at several points in the essay might equally serve a
modernist painting: Lachaise's work "tactilises the beholder, as in the case

of an electric machine which, being grasped, will not let the hand go";
Elevation is "a complete tactile self-orchestration." The sculptor's medium
enters the discussion only on the final page of the essay, when Cummings
praises a stone edition of the voluptuous reclining female nude known as
The Mountain. The first version of this sculpture, of patinated plaster cast
from a clay model, figured earlier as an example of "perfectly knit enor-
mousness."[48] But for Cummings, the stone *Mountain* alone "actualizes the
original conception of its creator" and does so because Lachaise worked
directly in his medium: "He has enjoyed it as his contemporaries to whom
stone is not a tactile dream, but a disagreeable everyday nuisance to be
handled by paid subordinates, can never enjoy it."

Cummings might have had any number of Lachaise's contemporaries in
mind—though Zorach, a more dedicated direct carver than Lachaise, can-
not have been among them; however, the remark may be more pointed. In
1920, as Manship's "paid subordinate," Lachaise had nearly finished carv-
ing into limestone a massive memorial tablet to John Pierpont Morgan,
commissioned from Manship by the Metropolitan Museum of Art five
years earlier (M122). In written response to a question regarding his role in
this work, Lachaise told A. E. Gallatin that he not only executed the carv-
ing, but also composed the ornamentation and allegorical figures, "Man-
ship *introducing his manner in a final tracing* over same."[49] Though Gallatin
did not exploit this intelligence in his book on Lachaise published in 1924,
it must surely have ended any respect he had for Manship.[50] Cummings,
as an intimate of Lachaise's, very likely had the same information. From a
modernist point of view, the evidence was damning. Lachaise's statement,
if circulated, would have confirmed the worst that Manship's critics thought
of him by exposing a (literally) graphic example of superficiality in Man-
ship's art. The sculptor had conspired to "fling" over the foundation pro-
vided by another artist "an eclectic garment of style," and this act bespoke
complete disassociation between self and work; as one writer charged,
"the pieces are all outsides."[51] Lachaise, for his part, executed the job
as Manship directed, and the resulting plaque appeared to one observer
"an unintentional caricature . . . an anthology of all the styles with which
Mr. Manship was familiar."[52]

Such chameleonlike ability in an assistant might be surprising, but La-
chaise joined Manship's studio a far more experienced artist than his em-
ployer. Indeed, when he arrived in America from Paris in 1906—in pursuit
of his muse and future wife, Isabel Nagle—Lachaise had a decade of train-
ing and work behind him. For fourteen more years, however, financial
need bound him to the service of others. Lachaise's highly personal inter-
pretation of the female form undoubtedly limited the market for his work,
but the artist was less than aggressive in testing it. In modernist circles,

such hesitance (read as refusal) to engage commercial culture enhanced the artist's standing. As Cummings approvingly noted: "Lachaise's personality profoundly negates the possibility of self-advertising."[53] Manship exhibited no such restraint, and his commercial success undoubtedly stimulated Cummings's venom.

As of 1913, Lachaise's highly tactile and expressively modeled nudes could not have resembled Manship's contemporaneous work less. He wrung from them a quality of sculptural drama that links him more nearly to his countryman Henri Matisse than to any American sculptor of the period. But after about 1915, vigorous handling began to give way to the smoother, more polished treatment evoked by Cummings when he wrote of Lachaise's "perfectly sensuous exquisitely modulated vaselike nudes."[54] The sculptures of Brancusi and Nadelman—exhibited at the Armory Show in 1913 and at 291, Alfred Stieglitz's Fifth Avenue gallery, in 1914 and 1915—have often been presented as the catalysts for this new attention to finish and to controlled volume and contour in Lachaise's work; however, the same properties mark Manship's sculpture, with which Lachaise was then intimately involved.[55]

Formal rapprochement appears in the comparison of Manship's *Dancer and Gazelles* and Lachaise's *Standing Woman (Elevation),* begun in 1912 and realized in plaster by 1918, the year of Lachaise's first one-man show (figs. 60, 97). In significant departure from his earlier, twisting figures, Lachaise aligns his subject frontally, as does Manship. Although this might militate against the expression of movement, each sculptor denies stasis in balancing the figures delicately on the toes of arched feet and by the firm fluid contours, a hallmark of Manship's work though not previously of Lachaise's. But Lachaise never sacrifices volume, as Manship's critics charged that he did; the viewer wants to move around his pneumatic *Standing Woman.* The sculptor creates an expressive tension by thwarting this desire—his woman makes a graceful and elusive gesture that compels attention to her mysterious face, its expression of somnolence belied by the commanding pose. Manship's dancer makes a similar gesture, bidding the gazelles' attention, but such anecdotal engagement excludes the viewer and denies the magnetic power that the gesture, abstracted from narrative, acquires with Lachaise. Lachaise's sculpture commands, imposing and idol-like. By contrast, Manship's work seems delicate, insubstantial. The difference cannot be ascribed to size, since the large version of the *Dancer and Gazelles* (as Cortissoz rightly thought) lacks monumentality.[56] Manship possessed the sensibility of a miniaturist, but Lachaise—whose gift for refined detail benefited Manship in many instances—excelled in the realm of monumental form.[57]

But when he wanted (or needed) to, Lachaise could and did produce

Fig. 97. Gaston Lachaise,
STANDING WOMAN
(ELEVATION), 1912–1927.
Bronze, 70 in. high.
Courtesy of the
Lachaise Foundation.

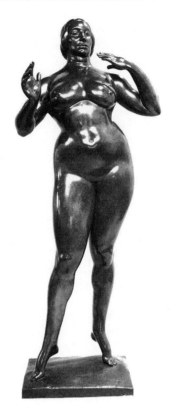

marketable decorative sculpture of miniaturistic refinement; he even de-
signed automobile radiator caps. Not surprisingly, such works bore much
in common with those of Manship, who on several occasions recommended
his assistant to prospective clients.[58] A trio of bronze peacocks that Lachaise
made in 1918, for example, exhibit the same hieratic arrangement, sleek
linearity, and emphasis on silhouette as the *Dancer and Gazelles*. Two years
later, Lachaise designed peacocks for the Miami house of Chicago million-
aire James Deering, a commission secured through Manship.[59] Around the
same time, and soon after Manship's departure for Europe, Lachaise cre-
ated a decorative marble frieze for the lobby of the American Telephone
and Telegraph Building in New York; his frieze joined earlier work by
Manship in the same space. He also submitted a plaster model (now lost)
in competition for a heroic statue to adorn the building's lobby (fig. 98).
Effortlessly holding the globe of the world in one hand and skyscrapers
symbolic of New York in the other, the female figure appears serene, self-
possessed, and sexless—a surprising desertion of the distinctive representa-
tion of woman that Isabel Nagle inspired in Lachaise. Nature and tempera-

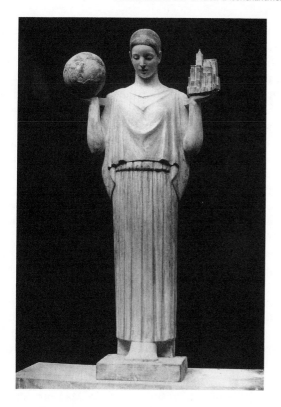

Fig. 98. Gaston Lachaise,
AMERICAN TELEPHONE
AND TELEGRAPH FIGURE,
1921–1923. Plaster,
size unknown.
Courtesy of the
Lachaise Foundation.

ment did not fuel the artist in this case; rather, he looked to severe-style Greek sculpture, such as the figure of Hippodameia (or Sterope) from the east pediment of the Temple of Zeus at Olympia. With compelling financial reason to suppress his personal vision, Lachaise selected the style he thought most likely to win him the competition. By 1920, that style was archaism. But Lachaise did not succeed in gaining the commission and the work lacks authority; indeed, the figure is virtually indistinguishable from the most pedestrian creations of any number of young, academic archaists.[60]

Neither Cummings's essay for *The Dial* nor his later piece on Lachaise for *Creative Art* mention such works.[61] The omission or marginalization of Lachaise's commercially viable and commissioned sculpture in this and other accounts—and insistent demonstration of the thickheadedness of critics ("The Dealers in Second-Hand Ideas") by Cummings in *The Dial*— encourages the reader to regard Lachaise as a victim of commercial culture, compelled by economic need to prostitute his talents to an art of "easy aesthetic currency."[62] Cummings's essays were hardly comprehen-

sive and certainly impressionistic; nevertheless, they present a vision of the artist as nonconforming outsider that cannot easily be reconciled with Lachaise's calculated production of sculpture palatable to the consuming public.

The importance of Cummings's essay to the study of Manship and archaism may be summarized as follows. First, few radical modernists had addressed Manship's art in print, and Cummings, writing from this perspective, unequivocally presents Manship's art and mode of operation as antithetical to modernist practice. Among critics of all persuasions, the possibility for compromise or conciliation with modernity had begun to wane by 1920. Second, Cummings reveals the problematic position of sculpture and the privileged status of painting in the modernist discourse; he does so explicitly at the beginning of his essay with the quotation from Wright's *Modern Painting* and implicitly by his election not to consider in any detail the sculptor's medium.

Some twenty years after Cummings's essay for *The Dial,* another young spokesman for the avant-garde drove the decisive wedge between the modernist work of art and the product of commercial culture. The now-landmark essay, "Avant-Garde and Kitsch," published in the fall 1939 issue of *Partisan Review,* launched the career of critic Clement Greenberg at the moment of Manship's decline. Greenberg, of course, did not mention Manship, but he might well have targeted the sculptor as a high priest of kitsch. Kitsch, according to Greenberg, "draws its life blood" from the "reservoir of accumulated experience" of "a fully matured cultural tradition," resulting in "ersatz culture," market-bound art for a consumer society. Manship, we have seen, drew from that reservoir both thematically and stylistically, and his art enjoyed enormous commercial and popular success. Greenberg identified kitsch with "vicarious experience and faked sensations"—recalling Cummings's detection of "a something 'fakey'" in Manship's work, Caffin's concern that "living experience with natural forms" did not lie behind Manship's art, and the complaints of numerous others over the sculptor's imitativeness. Finally, Greenberg defined kitsch as the culture of the masses and therefore as a tool for their manipulation by government. Here, too, his essay implicates Manship, who by the 1930s had become increasingly engaged in the production of large-scale public sculpture. In 1939, the year of Greenberg's essay, Manship's work could be seen on prominent outdoor display at the very heart of the New York World's Fair—despite its nominal claim to internationalism, a jingoistic set piece for American commerce. As damningly, Manship embraced an aesthetic that found echoes in the official art of Germany, Italy, and the Soviet Union (each of which Greenberg mentions), an archaizing classicism that many believed Manship himself had inaugurated in America.[63]

As the antithesis to kitsch, the avant-garde belonged to a different, "superior" realm of culture. Unlike kitsch, which seems "natural" and trans-

parent, avant-garde art was for Greenberg emphatically artificial; it "imitates the processes of art" and is "the imitation of imitating."[64] This idea is central to Greenberg's definition of the avant-garde, and he expanded upon it in "Towards a Newer Laocoon," an essay published in 1940.[65] The medium, Greenberg asserted, is the avant-garde artist's primary concern: the artist willingly accepts the limitations of a particular medium and "surrenders" to its resistance, while calling attention to the act of doing so. Avant-garde art, accordingly, rejects narrative and all external referents to focus on expression. "Pure" modern poetry, freed from grammatical logic, offered an analogy; in a passage reminiscent of Cummings's insistence on the "IS" of Lachaise's sculpture, Greenberg states: "The content of the poem is what it does to the reader, not what it communicates." The visual artist's medium has physical presence; "hence pure painting and pure sculpture seek above all else to affect the spectator physically." Cummings, who wrote that Lachaise's sculpture "tactilises the beholder," would certainly have agreed.

Modern sculpture, Greenberg continues, will highlight the material's resistance to the artist's efforts "to ply it into shapes uncharacteristic of stone, metal, wood, etc."; thus, "the stone figure appears to be relapsing into the original monolith."[66] But what shapes are characteristic of bronze, an alloy of tin and copper? Greenberg suggests that modern attitudes to this material are at work when "the cast seems to narrow and smooth itself back into the original molten stream from which it was poured, or tries to remember the texture and plasticity of the clay in which it was first worked out." But when bronze "tries to remember" the texture and plasticity of the clay, is not the artist behind this remembering allowing one material to imitate another? And is the thin stream the "shape" of bronze? Is its molten state—to which a sculpture can only refer through solid form (as perhaps in Brancusi's birds)—more natural than hardened bronze?

I have argued in this book for the modernity of an aesthetic of hardness as a reaction to the indexical expressiveness conventional in bronze sculpture by around 1900. Manship elected to make his work in bronze look hard in opposition to what he called the "impressionism" of so much early-twentieth-century sculpture. The stylized, linear passages he adapted from archaic art serve this end; by contradicting the academic legacy conjured by more naturalistic portions of Manship's sculpture, they force the viewer to acknowledge his work as artifice. Thus, although recognizable and banal subjects offer an easy point of entry to Manship's sculpture, their means of expression is not equally transparent. The viewer is turned back out, as it were, compelled to confront the work's opacity, its material, its essence as artistic creation. Manship's archaistic style was a highly self-conscious representational mode and, in that sense, modern.

But Greenberg's view prevailed; in defining the avant-garde, he played a

critical part in relegating major aspects of cultural expression to the nether-world of kitsch.[67] Of course, we cannot blame the collapse of Manship's reputation around 1940 on this or any other piece of critical writing. The most frequently offered explanation charges that Manship's art failed to address the profound and disturbing aspects of human nature that events culminating in World War II threw into high relief; while this undoubtedly contains some truth, it remains unsatisfactory. We are left to wonder, at the very least, how abstract art came to be seen as a more direct form of address.[68] But perhaps instead we should ask why Manship's reputation held up for as long as it did. Manship offered an answer to this question in 1952, by which time he had been almost forgotten: "I had no great talent . . . I was the right man at the right time."[69] The first part of this comment gains poignancy for suggesting Manship's resignation to some of the charges levied against him; but the second part reveals an assessment of his place in twentieth-century art that is not fundamentally in conflict with the opinions of some of his harshest critics.

In many respects, Manship ought to be the measure of the early modernist age, for his fame and reputation, despite qualifications, were nearly unshakable throughout the whole period—from his artistic debut in the New York of 1913 to the 1930s, when his prominently situated public sculptures made him the most visible sculptor in America. He was also held in high regard abroad: his solo exhibition at the Tate Gallery in 1935 united Manship with Rodin as the only non-Britons to be so honored during their lifetimes. Manship's archaism represented something of a compromise, which for many people demonstrated that it was possible to create a modern style that had recognizable ties to tradition. This was Manship's original achievement, his invention. In this respect, it could be argued that he was alone among the American practitioners of archaism, since many of those who followed his example were imitating *him* and not archaic models.

Manship's own archaism was not founded upon a deeply inculcated academic classicism, which the artist "modernized" in a superficial and calculated way with the stylized details that mark his archaistic style. His training as a sculptor had been neither institutionally nor classically oriented. His first teachers exposed him to the vigorously modeled French manner, and Manship went to Rome more or less a disciple of Rodin. Once there he changed his mind, in perhaps surprising validation of the Academy's mission to turn young artists away from the corrupting influence of modern French art and toward the Renaissance and antiquity—surprising because of the chaos under which the Academy so often operated during those early years. Working almost entirely on his own, without fixed notions of what sculpture should be, Manship was free to respond to anything he encountered while at the same time sheltered from encounters of certain kinds. In 1912, Manship discovered archaic art. Within the year,

he exhibited before the public a personal style of figuration—combining naturalistic anatomy with an abstract treatment of details and stylized gestures informed by archaic art—that critics dubbed "archaism."

Manship's interest in archaic art placed him in company with a diverse and international group of artists who, during the first decades of the twentieth century, sought to reinvigorate the tired traditions of Western art. Many later abandoned moderation and opted for a more radical break with the past. Accordingly, they discarded archaism as an answer to the questions of modern art. Manship, however, remained faithful to the archaism that inspired his success. That gesture determined his critical fate.

"The Decorative
Value
of Greek
Sculpture"
by Paul Manship,
American
Academy
in Rome,
May 1912

It may seem to you that the subject which I have chosen for today's talk—the D.V. of G.S.—is rather broad to be handled in so short a time—and so it is. I might have specialized upon any one of the many branches of the general subject & found upon every hand material for indefinite study. In fact, the great possibilities of the subject are overwhelming!

As one travels in Greece & reviews the art at Athens, Olympia, Delphi & elsewhere one finds works of often widely different periods side by side and so comparisons are naturally & easily arrived at. Just in this way I have chosen to express what I have to say so the illustrations which I use will not necessarily follow one another in chronological order.

I was especially interested in the marvelous decorative qualities in all Greek Art but in that of the archaic period in particular. In works of that epoch more than in any other, one feels that decorative relationship between architecture, sculpture & painting whose bonds of traditional style unite them together in the closest affinity. They are guided and trained in the same broad spirit.

(*Lantern slide—two archaic girl statues from the Acropolis Museum Athens*).[1] What a pity it is that the remains of antiquity are so fragmentary! I would repeat that the sculpture of the 6th century before Christ is tied to the other arts of the time with most inseparable bonds. Statues seem drawn with the straight edge of the architect. Architectural details of the time are rendered with the same sensitive & decorative feeling for form that characterizes the sculpture. And the painter—we know him only by his vases (that is, outside of literature) and those vases are composed and painted with the same taste, the same drawing, the same fundamental ideas of composition that are the principles of the sister arts. So in these statues we feel that power of design—

that feeling for structure in line—that sense of the harmonious in the divisions of spaces & masses—here left simple as the flesh parts, here admirably contrasted by rich drapery every line of which is drawn with precision. It is the decorative value of the line that is considered first, its truth to nature is secondary. All nature is formalized to conform with the artist's idea of Beauty. Just as the sculptor in modeling foliated forms to be used in architectural decoration reduced nature to its decorative essence, considering rather the relationship of lines & masses than reality, so here the artist subordinates all to his idea of composition. The whole statue may be considered as a decorative form upon which all detail is drawn rather than modeled (in the strict sense of the word). We feel that the outlining of folds might have been designed by the same hand that drew upon the vase so sharp is the drawing upon the otherwise plain broad surfaces. And in these archaic statues they displayed greatest ingenuity in the variety of the border designs painting them in red and other rich colors, just as the vase painter did on his draperies to contrast with the white of the female flesh.

(*Picture of painting from large cup*). Athena in this illustration is not really falling over backwards—it is really the film is not reproduced straight upon the slide. In this painting the treatment in line of the figure of Athena seems almost identical to that which was characteristic of the statues just shown. As the painter here enriched the borders of the garments with bands of decoration & colored the hair—painted design upon the helmet, etc., so too was the treatment upon sculpture.

(*Picture of border designs*). These are a few of the designs which I recorded in Athens. The hair of the early statue was painted dark red and red was also applied to the iris of the eyes and to the lips, while the use of other rich colors in the border designs and scattered ornament, such as the corona in the hair, necklace, ear ornaments, and so on, made the effect exceedingly rich & harmonious—and the texture of the marble was not obscured but rather enhanced. The necklace & ear ornaments were sometimes done in gold & gilt bronze, and marble statues were often gilded. Praxiteles is said to have valued most highly those of his statues which had had the advantage of the finishing touch from the brush of the great painter *Nicias*.

In architectural friezes the background was usually painted blue or red and accessories were often added in color. In these designs here before you those on the left, which are taken from the stele of Aristion, found near Marathon, contrast admirably with the others, which were taken from female statues of the same period. The former in their severity are suited to the spirit of the warrior, whereas the latter, which are more graceful, are adapted to the dress decoration of a statue of a girl.

(*Three stele reliefs*). How admirably do these three stele reliefs go together & yet how different they are in design. In each case a space of simi-

lar shape is filled. The figure on the right leaning upon his staff is carved in grey Boeotian marble & is probably one of the finest of the reliefs of this sort we have from that Period of the Persian Wars. The figure from the stele of Aristion, from which I took some of the designs shown in the preceding slide, is very calm & dignified & the workmanship is excellent. The careful modeling in parts shows quite an advance from the earlier work.

(*Picture of girls with flowers*). Here, in this charming relief now in the Louvre, the sculptor draws freely & with great grace. We feel the delicacy of the detail, the lovely expression in the faces & the harmonious effect generally. The folds of the chiton serve at once in their beautiful elaboration to explain most plainly the form beneath & to serve as a combination of beautiful decorative lines. The arrangement of the hands could not be done with more grace & effect. And so we here forget the mannerisms of the Archaic art. We do not feel so much the stiffness of the earlier works but we are impressed by the vigorous directness & charming expression of the ensemble. Here, as in so many of the sculptures of an archaic nature, we meet with that quality of Design, that handling of line that brings the work in closest affinity to the vase paintings of the period. The drawing of the eye in front view, notwithstanding that the head is in profile, and the sharp precise lining of the folds of the chiton are mannerisms which are characteristic of the works of the painter. And the relief only lacks that color which it undoubtedly originally had to give us a similar impression to that which we get from the vase paintings.

(*Slide from Birth of Venus, Ludovisi*). These admirable reliefs which we all know so well serve perfectly to show the great skill in composition of the artist of the Fifth Century B.C. in which the human figure was considered as ornament, a combination of lines & masses going to decorate the required surface with great directness & simplicity. However, that which appeals to us most of all is the naïve charm and girlish Beauty of the figures.

To the next slide we skip over a great space of time and from the considerations of work of the severe & formal school to the production of a time when unconventional & realistic qualities were at their height; that is, to Praxiteles & the consideration of his Hermes. (*Picture of Hermes*).

The Hermes of Praxiteles, which is considered by many to be the most beautiful marble from ancient times, was to me not all that I had expected. Why was it? For surely in that wonderfully modeled figure one cannot find in any art its superior for ideal reality; in the harmony of the graceful lines which compose it one cannot find a more superb example. The way in which the beautifully curved forms flow into one another from every point of view mark it as perfection in Art. The marble itself in its nearly perfect state of preservation seems to have lost nothing since that day when it was dedicated (to be sure, the lower legs are here restored in plaster & part of the right arm is missing) but the surface of that which re-

mains is as perfect as when it left the sculptor's studio. And in the glow of
the warm patina, which ages beneath the soft earth have given to it, it now
seems fairly to be flesh! The representation of the drapery which hangs
from the tree trunk upon which the god leans & supports the infant Dio-
nysus is perfect in its natural modeling. The spirit & the proportions of the
whole group are such as must please & in the head of the Hermes espe-
cially we appreciate the most ideal expression. What more could be said to
extol this masterpiece of masterpieces. Yet withal I *was* disappointed, for I
had been wrapt in appreciation for those sculptures from the pediments &
from the metopes of the Temple of Zeus at Olympia, which are set in the
Hall next to it. (*Picture of Pediment group*).

In them the expression is quite different. One can easily find fault with
the construction of the figures. One sees at once the difficulties under
which the sculptor labored in that age which was just emerging from the
Archaic and which was to bloom forth into the most beautiful flower of all
Art only a few years later in the Parthenon. Here one sees the immature
attempt at realism, which the sculptor trained in the severe forms of the
Early Art does not know how to grasp, that realism which in Praxiteles
is second nature. The shape of the crude stone seems here to predict the
composition of the group. With Praxiteles the stone is as soft material
under the wand of his genius.

Criticism is so easy & to appreciate fully is sometimes so hard. The very
grace & beauty which Prax. put into his work become soft & effeminate
beside these vigorously severe figures of the Zeus temple. (*Slide to illustrate
two reclining figures from pediments.*)

The upper figure is from the East Pediment & represents the River
God Cladeus. The other is from the West Pediment and is a lapith who
struggles with a centaur. The very facility of Praxiteles seems to count
against him for his soft flowing forms are lacking in the energy of the
cruder expressions of the Early Fifth Century. We feel that the effect of
the Hermes is dependent to a large extent upon the delicacy of finish,
whereas here the impression is one of bold simplicity & vigor. There is a
force which gives real life to the marble & could these figures move &
speak how vital in masculine qualities they would be. Compared to them
the personality of the beautiful Hermes is sweet and sentimental. As a *God*
he has not the superb power exemplified in the earlier creations.

(*Slide of central figures from Pediment*). The figures on the left—Oinomaos
& his consort Sterope, from the East pediment (which represents the prepa-
rations for his chariot race with Pelops)—and the figure on the right—of
Apollo, from the West Pediment (representing the fight of the Lapiths
with the Centaurs)—are statues which cannot be appreciated sufficiently in
words. One must see them! What I have said in estimation of the other
figures of these pediment groups applies particularly to these impressive

statues. To see these groups alone is worthwhile a trip across the world. And as pedimental composition they were never excelled in any time. I am sorry that I cannot show you a better view of these splendid works, one that would illustrate the admirable way in which the figures in the center of the tympanum that stand erect side by side seem almost to be supporting members in the architectural design. In the East pediment in particular the severe & straight grooving of the drapery seems to combine the effect of the fluting of the columns & the grooving of the triglyphs. The number of figures in the two pediments exactly correspond.

(*Metope—Hercules—Bull*). This metope from the temple of Zeus, Hercules subduing the Cretan Bull, could not be excelled as a vigorous expression of the scene. The tenseness of the struggle is perfectly shown in every line & muscle. The composition is ideal in its X form. The main lines of the figures are diagonals from the corner and if one were to express the idea of struggle of two forces in opposite direction in two simple lines, it could not be more diagrammatically realized than in their crossing at right angles just as they do here. And yet this strain of contrasting forces keeps them firmly within the bounds of the frame. Its composition is therefore solid and structural & adapted to architectural decoration.

(*Slide of acanthus column with dancers*). From fragments excavated at Delphi they have reconstructed this acanthus column surmounted by three so-called dancing girls. Whether or not the reconstruction be correct does not concern us at this moment. It serves admirably as illustration of the harmonious use of the human figure and forms from vegetable nature combined into a dignified & artistic architectural unit forming a beautiful pedestal for a tripod or votive offering. The girls have been identified as dancers from Caryae. Interesting, is it not, that it must have been on some rich monument as this that similar graceful figures were used as architectonic supports for the first time and so brought into popular use the name caryatidae to describe all female figures employed for a similar purpose. Beautiful as these figures are (they are over life size) they are but a part of a monument on whose every detail the same careful decorative treatment was bestowed.

(*Picture of bronze Charioteer*). He comes last in my illustrations but he is by no means the least—the bronze Charioteer of Delphi! He is part of a quadriga group erected as a votive offering after a victory at the Pythian Games in 462 B.C., and according to some authorities may be the work of Amphion of Knossos. Such questions we leave to the archaeologists. The appreciation of its artistic qualities interests us now. The wonderful bronze treatment of this statue marks it as the finest extant example of bronze sculpture. It is unsurpassed in its decorative beauty as well as in the naturalistic modeling of the head, arm, hand & feet. How big and dignified is its ensemble! It has yet a perfection of detail that makes us marvel! Plaster

casts can give but a faint notion of the beauty of the original. The hair is executed in most minute detail. The bronze worker was an engraver who guided his tool with the precision of a goldsmith, and with a taste for the appropriate in decoration, which makes it a jewel of sculpture. And yet, to show the wealth of sculpture in ancient times, Pausanias makes no mention of it in his selection of the treasures of Delphi. The treatment of the flesh is simple, even severe in its refinement of plain surfaces, harmoniously contrasting with the texture of the drapery & hair. Each eyelash is a separate hair of bronze. The eyes are executed in color & are most natural & beautiful, the fillet around his head was decorated with a meander inlaid in silver. All this perfection & delicacy of detail is but secondary to the simplicity & the spontaneity, the aristocratic dignity & distinction of the type!

The sculpture which I have been considering has been almost entirely of that period before the building of the Parthenon, which was begun in 447 B.C., and within barely ten years probably the most beautiful building the world has known was opened to the public. And so the archaic age, as we call it, was ended. This perfection of proportion & technical skill was arrived at because the ages preceding endeavored ever towards a fuller expression in those very things and in the end created what shall ever stand as a marvel of beauty because Beauty had ever been their goal. Then with the mastery of the materials of their art came new ambition. The Artists sought new modes of expression and as they could not excel in design they strove to surpass in the representation of human emotion, of anatomical correctness & in the showing of the human body in every possible movement. Grandeur in Hellenistic days was accomplished rather through physical size than nobility & dignity of pose and in those lines of their endeavour they achieved their purposes. Their purposes were not of decorative perfection.

That balance of conservatism which is felt in the early statues in every regard, from expression to the composition of drapery where severity & conventionalizing of form gave dignity & restfulness to the figures. In the more florid art of the Hellenistic age there was no expression which they could not carve in marble; in their complete mastery over their material they knew not what restraint was. They delight in creation & power. We behold their works with astonishment for they are the very culmination of skill. But their art is oftentimes a restless Art and after the first sensation has passed they often tire us and we return to the reposeful beauty of the early works, which sometimes do not at first appeal to us—they may be stiff in pose & expression; the forms are often curiously & unrealistically rendered. Their appeal is not to our dramatic sense nor is it superficial. It is a deeper chord that is struck & a tone to which we can respond. And so we harken unto their simple music.

As Art must appeal to our inner senses through our eyes, so first of all

must the sense of sight be satisfied. The ear that knows what beautiful music is, is shocked by discord. And so the eye, when trained to harmony of proportion & beauty of line & color is shocked when discord occurs in them. The misfortune is that too few people have that sense developed.

The architect considered his building as a problem in the shaping of spaces, in the proportion of his columns to the intercolumniation to the entablature, and so on. He considered every detail in its relationship to the whole. Just in that same way the sculptor of the archaic age created his statue. He considered the relationship of each fold to its neighbor, of each mass of drapery to the others, of every feature of the statue with every other in its harmony of shape & size. And with Phidias, the Sculptor-Director of the building of the Parthenon, as I have said, the decorative art reached the highest expression & perfection that our world has known. Slowly the wheel turned and the ideas & ideals of Art tended in other directions. Advance was made in certain expression but the beauty of the first bloom was never surpassed.

So here in Italy, the early masters of the Renaissance strove for beauty of form & composition and reached their summit before Michelangelo. Then came new ideas & new expressions with advances in many directions, but he who loves beauty for beauty's sake will ever [go] back to those early works of the primitives.

Notes

Abbreviations

AAA Archives of American Art
AAR American Academy in Rome
AFA American Federation of the Arts
LC Library of Congress
NAD National Academy of Design
NMAA National Museum of American
 Art
NSS National Sculpture Society
NYPL New York Public Library
PAFA Pennsylvania Academy of the Fine
 Arts

Introduction

1. *Webster's New Collegiate Dictionary,* 1977 ed., s.v. "archaic."

2. *Webster's New International Dictionary of the English Language,* 1935 ed., s.v. "archaic."

3. In an interview with John D. Morse, 18 February 1959 (AAA), Manship commented: "Each new generation, I'm sure, looks upon classical antiquity with new eyes. I was more interested in the older styles of the ancients. Whereas a man like [Daniel Chester] French was involved with the highly developed and mature work of the classical periods. . . . You'll find that each decade goes further back into the primitive and in the studies of primitive art. With the result that now it is gone practically as far as it can go with the art of the Cyclades, the art of the Negro, the primitive art of the Pacific Islands, too. So that we have gained and gone the full turn to the beginning."

4. "African and Oceanic Sculptures," *Les Arts à Paris* (15 July 1918), in

Leroy C. Breunig, ed., *Apollinaire on Art: Essays and Reviews, 1902–1918,* p. 470. For the same relationship as articulated by André Salmon, see William Rubin, ed., *"Primitivism" in 20th Century Art* 1:243.

5. For an overview of Western attitudes toward primitive cultures during the eighteenth and nineteenth centuries, see Frances Susan Connelly, "The Origins and Development of Primitivism in Eighteenth and Nineteenth-Century European Art and Aesthetics" (Ph.D. diss., University of Pittsburgh, 1987).

6. Duncan Phillips and Charles Law Watkins, "Terms We Use in Art Criticism," *Art and Understanding* 1 (March 1930):166–167 (my emphasis).

7. Ibid., p. 166.

8. Robert Goldwater, *Primitivism in Modern Art* (1967), p. 261 (the revised version of *Primitivism in Modern Painting*). Nazarene and Pre-Raphaelite painting serve Goldwater as examples of archaism, as opposed to, say, Gauguin or Picasso as primitivists.

9. Ibid., p. 262. According to this definition, archaism must be considered an affectation, a possibility that Phillips and Watkins also admit: "The pseudo-primitive or pseudo-savage imitators put on an archaic manner as they would put on a costume in a masquerade," whereas "the genuinely archaic modernists are those who aspire to classic finalities and seek to attain to these with the language of their own period" ("Terms," p. 168). Compare the negative characterization of archaism in Richard G. Carrott, "Revivals and Archaisms," in *In Search of Modern Archi-*

tecture: A Tribute to Henry-Russell Hitchcock, pp. 16–30. Seymour Howard cast archaism in a more positive light in "Definitions and Values of Archaism and the Archaic Style," *Leonardo* 14 (Winter 1981):pp. 41–44.

10. Goldwater, *Primitivism* (1967), p. 262.

11. Goldwater, *Primitivism* (1938), p. xvii.

12. Rubin, *"Primitivism,"* p. 11.

13. See Thomas McEvilley, "Doctor Lawyer Indian Chief: ' "Primitivism" in 20th Century Art' at the Museum of Modern Art in 1984," *Artforum* 23 (November 1984):54–61, with a response by William Rubin and Kirk Varnedoe, *Artforum* 23 (February 1985):42–51; James Clifford, "Histories of the Tribal and the Modern," *Art in America* 73 (April 1985):164–177; and Yve-Alain Bois, "La Pensée sauvage," *Art in America* 73 (April 1985):178–189, with a response by Kirk Varnedoe, "On the Claims and Critics of the 'Primitivism' Show," *Art in America* 73 (May 1985): 11–21.

14. Rubin, *"Primitivism,"* p. 74.

15. Ibid., pp. 5, 41. Goldwater also excluded the art of the Americas from the category of the primitive, on the basis of its "relative formal complication" and because the older American civilizations had vanished and were thus "no longer living symbols of primitive simplicity subject to aesthetic idealization and imperial conquest" (*Primitivism* [1967], pp. 266–267).

16. Rubin, *"Primitivism,"* p. 74.

17. Bois, "La Pensée sauvage," p. 180. Bois suggests that the curators of the primitivism show screened out pre-Columbian art because the modern artist's interest in that art was more conceptual than formal—and presumably therefore less suited to visual demonstration in an exhibition.

18. John Manship, *Paul Manship;* Harry Rand, *Paul Manship.* Recent exhibition catalogues include *Paul Manship: Changing Taste in America,* with essays by various authors, and Frederick D. Leach, *Paul Howard Manship: An Intimate View,* the first scholarly study of the artist. See also Susan Rather, "The Past Made Modern: Archaism in American Sculpture," *Arts Magazine* 59 (November 1984):111–119.

1. The American Academy in Rome and the Formation of Manship's Archaism

1. The basic study of Borglum is A. Mervyn Davies, *Solon H. Borglum: "A Man Who Stands Alone."*

2. Manship's entry in the National Academy of Design's 82nd Annual Exhibition (16 March–20 April 1907), a plaster group entitled *Pulling,* represented horses pulling a sand scoop. Photographs of the work (since destroyed) appeared in the *Western Architect* 10(February 1907):23, and the *St. Paul Pioneer Press* (clipping of uncertain date in possession of John and Margaret Manship), the latter reproduced in Rand, *Manship,* p. 14.

3. The long-accepted, and widely published, dates of Manship's study at the PAFA, 1906–1907, probably followed the artist's own recollection, since the inscription "Paul Manship—Phila.—1906–7 by himself—age 21 [?] years" appears in his hand on a self-portrait in the collection of the NMAA. However, Manship's student card (PAFA Archives) indicates his registration for the 1907–1908 term only, dates further supported by Manship's correspondence (e.g., a letter to Mrs. Borglum dated 6 March 1908 detailing activities at the PAFA; Solon H. Borglum Papers, Library of Congress

[LC]); contemporary articles (including the one in the *Western Architect* 10 [February 1907] that refers to Manship as Borglum's pupil); and exhibition catalogues (the PAFA is listed as Manship's address in the 1908 *Catalogue of the Exhibition of the National Sculpture Society under the Auspices of the Municipal Art Society of Baltimore*). The artist must have inscribed the NMAA self-portrait many years after it was made; this would explain the inaccuracy, as well as changes in the last digit of his age (from twenty-three to twenty-one or twenty-two).

4. Information from Manship's student card, PAFA Archives.

5. Edwin Murtha, Manship's son-in-law, catalogued 576 sculptures (some with brief commentary) in his monograph *Paul Manship*. Although not always reliable, the listing remains useful as the closest approximation to a catalogue raisonné available. Murtha's catalogue numbers are given parenthetical notation in the text when I refer to sculptures included in his list.

6. "The Reminiscences of Paul Manship," 1958, Oral History Collection, Columbia University. Toward this end, Manship studied French with Solon Borglum's Parisian wife, laboring to translate a treatise he remembered as "L'Anatomie comparative des animaux domestiques" (Manship to Monica Davies, Borglum's daughter, 20 November 1953, Borglum Papers, LC).

7. "Another Heine Chapter," *New York Times*, 26 January 1896, as quoted in Michele H. Bogart, *Public Sculpture and the Civic Ideal in New York City, 1890–1930*, p. 65 (a full account of the controversy appears on her pp. 61–66).

8. Charles Caffin, *American Masters of Sculpture*, pp. 205, 207. For other contemporary commentary see *Philadelphia Inquirer*, 4 April and 8 April

1908, scrapbook, Pennsylvania Academy of the Fine Arts Papers, AAA; and "American Sculpture as Seen at Baltimore," *New York Times*, 12 April 1908, scrapbook for 1908, National Sculpture Society Papers, AAA. The principal modern study is the exhibition catalogue by Mary Jean Smith Madigan, *The Sculpture of Isidore Konti, 1862–1938*.

9. From Europe, Manship wrote Konti: "I was indeed disappointed in some of Rodin's work, just as you said I would be" (21 October 1909, Isidore Konti Papers, AAA).

10. Details of the Rome prize competition for 1909 are to be found in the American Academy in Rome Papers (AAR), AAA.

11. "City News. Youngest American Ever Taking Prize," *Saint Paul Dispatch*, 15 September 1909.

12. Paper given at the Art Students League, New York, 1915, Manship Papers, AAA. In fact, Manship did not really change his mind about this, as witness his letter to fellow artist Barry Faulkner from Paris, written 30 December 1921: "Paris is the center of the world—and while I am not in the center of the whirlpool I feel the motion of it." Rome, by contrast, "would have none of the pep which is part of the atmosphere of this town" (quoted in John Manship, *Paul Manship*, p. 97).

13. A considerable body of literature exists on American artists in Italy in the nineteenth century. Books of a general nature include E. P. Richardson and Otto Wittmann, Jr., *Travelers in Arcadia: American Artists in Italy, 1830–1875*; Van Wyck Brooks, *The Dream of Arcadia: American Writers and Artists in Italy, 1760–1915*; and Paul R. Baker, *The Fortunate Pilgrims: Americans in Italy, 1800–1860*. For the most recent and exhaustive study, comprehending the

twentieth century, see William L. Vance, *America's Rome*. Among those dealing more specifically with Rome and sculptors are Margaret Farrand Thorp, *The Literary Sculptors;* William Wetmore Story, *Conversations in the Studio;* and Henry James, *William Wetmore Story and His Friends*.

14. Timothy Cole to W. Lewis Fraser, 27 June 1887, Timothy Cole Papers, AAA. "Hart" may be the sculptor Joel Tanner Hart (1810–1877), who worked in Italy between 1849 and 1877. Recent studies of American artists in France include Lois Marie Fink, *American Art at the Nineteenth-Century Paris Salons,* and H. Barbara Weinberg, *The Lure of Paris: Nineteenth-Century American Painters and Their French Teachers*.

15. Caffin, *American Masters of Sculpture,* p. ix.

16. Comment by an unnamed artist related by Carl N. Werntz, president, the Chicago Academy of Fine Arts, 9 November 1912, AAR Papers, AAA. Not surprisingly, French artists and writers had already expressed similar sentiments; see Anne Middleton Wagner, *Jean-Baptiste Carpeaux, Sculptor of the Second Empire,* chap. 4, esp. pp. 111–115.

17. For a discussion of the hurdles a mid-nineteenth-century French art student had to negotiate to gain the Prix de Rome, and of life at the Villa Medici, see Wagner, *Carpeaux,* chaps. 3, 4. Wagner's scrutiny of the Académie de France yields a different picture of the institution from the idealized conception of the American Academy's founders.

18. The American Academy began its existence in November 1894 as the American School of Architecture in Rome. Despite this name, the institution included sculpture and painting from an early date and, in 1897, in-

corporated under New York State law as the American Academy in Rome; it achieved legal recognition by the United States government in March 1905. For a general history of the Academy, see Lucia Valentine and Alan Valentine, *The American Academy in Rome, 1894–1969,* which includes particularly useful appendices: a Dramatis Personae and lists of Academy Fellows, Artists and Scholars in Residence, and Trustees.

19. McKim to John Mead Howells, 23 October 1894, quoted in Charles Moore, *The Life and Times of Charles Follen McKim,* p. 138.

20. "The American Academy in Rome," general circular, 1907, AAR Papers, AAA. The extent to which the fellows should be guided sparked debate among the founders, particularly McKim and William Ware, then a professor of architecture at Columbia University. McKim initially referred to the School of Architecture as an "atelier," in which the men would receive guidance from a "competent instructor," and he complained of his colleague: "The trouble with Mr. Ware is that he believes in allowing every student who presents himself in Rome to have a foothold and take part in the proceedings as much or as little as he pleases" (McKim to Robert Peabody, and to Edwards J. Gale, April 1894; quoted in Moore, *McKim,* pp. 144, 132).

21. "The American Academy in Rome," general circular, 1907, AAR Papers, AAA.

22. Among the Charles Follen McKim Papers, Library of Congress, is a copy of the "Règlement de L'Academie de France à Rome," annotated with reference to the American Academy, from the 1891 "Statuts et Règlements" of the Académie des Beaux-Arts. On the French Prix de Rome in painting, see

Philippe Grunchec and Jacques Thuillier, *Le Grand Prix de Peinture: Les concours des Prix de Rome de 1797 à 1863*. For the French academic system as a whole, see Albert Boime, *The Academy and French Painting in the Nineteenth Century*.

23. The award of Academy monies to John Russell Pope in 1896 was the sole exception. The Academy also extended its hospitality to holders of other fellowships, including the Rotch and Stewardson, although generally for much shorter periods.

24. Samuel A. B. Abbott, director from 1897 to 1900, to McKim, 9 April 1903, AAR Papers, AAA.

25. F. W. Chandler, trustee, to McKim, 20 February 1905, AAR Papers, AAA. He suggested that the Academy enlist the aid of a Beaux-Arts student in Rome, a recipient of the Prix de Rome, to provide guidance for the fellows; French architectural fellow Ernest Hébrard briefly filled this role.

26. Because the Academy's ability to administer stipends depended on its financial stability, a drive to raise a one-million-dollar endowment began around 1905. The Academy's officers hoped that enlightened self-interest would stimulate generosity: "The graduates of the Academy will be particularly useful to men who have the means and desire to erect beautiful and appropriate buildings" (Theodore Ely [?], trustee and vice-president, to Stanford White, 13 December 1905, AAR Papers, AAA). The early "founders" (as donors of $100,000 were called) included Henry Walters, J. P. Morgan, and W. K. Vanderbilt. The endowment was not completed until some ten years later.

27. Breck to Francis Davis Millet, Academy trustee, executive secretary, and chief administrator, 5 May 1906, AAR Papers, AAA. The lure of Paris had hardly decreased five years later

when Millet lamented: "There were no candidates for the Lazarus at all. The Mooney Scholarship gets all it wants, because the winners are free to go where they like and study what and when and how they like, and live in the Latin quarter, and become artists through keeping mistresses" (letter to director Frederic Crowninshield, 20 May 1911, AAR Papers, AAA).

28. Breck to Millet, 18 August 1908, AAR Papers, AAA; Barry Faulkner, *Barry Faulkner: Sketches from an Artist's Life,* pp. 60–61.

29. Crowninshield to Millet, 22 December 1909, AAR Papers, AAA. Faulkner particularly aroused the ire of the Academy's officers by spending a full year studying in Florence with American painter George de Forest Brush; see ibid., p. 71.

30. Discussion of the competition in Paris appears in a letter from Breck to Millet, 17 June 1907, AAR Papers, AAA.

31. Frank Miles Day, trustee, to the Committee on Coordination of the American Academy in Rome, 28 December 1908, and Report of the Executive Committee to the Board of Trustees, 1909, AAR Papers, AAA.

32. Manship had made a walking tour of Spain during the summer of 1908 with Hunt Diederich, a friend from the PAFA; he recounted the circumstances in "The Reminiscences of Paul Manship," 1958, Oral History Collection, Columbia University. The incorrect 1907 date for this trip that appears repeatedly in the Manship literature arose from the confusion surrounding the dates of Manship's study at the PAFA, which the trip followed (see n. 3).

33. Manship to Isidore Konti, 21 October [1909], "on a train from Paris to Lucerne," Konti Papers, AAA. Manship's letters to his mentor constitute

the best source of information about his activities during the period of his fellowship. In the case of successive citations from the same letter, I cite the item only once, following the first instance.

34. For example, Charles Ricketts, "Constantin Meunier: His Aim and Place in the Art of the Nineteenth Century," *Burlington* 7 (June 1905):181–187; and Christian Brinton, "A Sculptor of the Laborer: Constantin Meunier," *Century* 71 (April 1906):845–855.

35. Manship's *End of Day* also recalls Solon Borglum's *Evening* of 1909; reproduced in the exhibition catalogue *Paul Manship: Changing Taste in America*, p. 17.

36. Millet to trustee William Kendall, 15 September 1908, AAR Papers, AAA.

37. Kendall [?] to Millet, 27 November 1909, AAR Papers, AAA.

38. Millet to Daniel Chester French, 18 October [1909], AAR Papers, AAA.

39. Crowninshield to Academy treasurer William Boring, 28 October 1909, AAR Papers, AAA.

40. Millet to Kendall, 15 September 1908, AAR Papers, AAA.

41. The sculptor's studio measured approximately twenty-six feet square and sixteen feet high, with a full-height window (Breck to Millet, 3 February 1909, AAR Papers, AAA); even so, Millet found the studios "not what they should be" (letter to Day, 22 October 1909, AAR Papers, AAA).

42. Manship to Konti, 12 November 1909, Konti Papers, AAA.

43. Manship to Konti (early 1910), Konti Papers, AAA. Ironically, the studio Manship used probably belonged to Barry Faulkner, the painting fellow who immediately preceded him at the Academy and who had recently been reprimanded for defying Academy regu-

lations against working on commissions. Indeed, Faulkner spent his entire fellowship period making studies for a mural for the E. H. Harriman house at Arden, New York. He also ignored the Academy's residency requirement and lived for one year in Florence, working under the tutelage of George de Forest Brush (Faulkner, *Barry Faulkner,* pp. 60–74).

44. Letter to Konti, 3 January 1910, Konti Papers, AAA. Throughout this study, I have corrected Manship's irregular orthography (as also for other unpublished documents quoted here); even so, Manship's awkward syntax stands as a reminder of his minimal formal education.

45. "Made a Death-Mask of Governor Johnson," *St. Paul Dispatch,* 30 September 1909; see also " Johnson Statue May be Made by Manship. St. Paul Sculptor Eager to Build Heroic Monument," *St. Paul Dispatch,* 28 November 1909.

46. Letter from George P. Tweed, 15 April 1910, Borglum Papers, LC. As the secretary of the Johnson Commission informed Manship, the artist chosen must belong to "sculptors of the first rank, those of an established international reputation," to which he bluntly added: "I do not see how I could well include your name in this short list as your reputation is still to be made" (Charles W. Ames to Manship, 20 January 1910, Governor John A. Johnson Memorial Commission, Minnesota Historical Society, Saint Paul). The prominent sculptors considered for the commission included Bitter, Solon Borglum, French, Grafly, and Konti, in whose company Manship indeed appears decidedly underqualified. The finished work, by Andrew J. O'Connor, Jr., Bitter later condemned as "an unpardonable performance, slovenly and

cheap. . . . The influence of modern Paris is plainly visible, no sincerity or nobility, just a few cheap effects in theatrical pose and dashy modeling" (Letter to Mrs. Bitter, 20 July 1913, Bitter Papers, AAA).

47. Academy vice-president Ely to Millet, AAR Papers, AAA.

48. Day, report of his visit to Rome, 20 March 1910, AAR Papers, AAA.

49. Photographs record two slightly different versions of *Wood Nymph's Dance*. The one among the Konti Papers almost certainly captures an early stage of the relief, since Manship regularly sent his former teacher photographs of work in progress (and did so with this relief, according to a letter of 31 October 1911) and since the composition is somewhat awkward. Another version, presumably completed, appears in *Metropolitan Magazine* 39(February 1914):39; see also John Manship, *Paul Manship*, p. 35.

50. See, for example, south metope 27 (a Lapith youth and centaur in combat) from the Parthenon.

51. Undated letter, Konti Papers, AAA.

52. Manship sketched the projected fountain in an undated letter to Konti, to whom he also reported the visits of American sculptors Frederick MacMonnies and Daniel Chester French; French "seemed to like my relief," he related, but MacMonnies had little to say (26 June 1910, Konti Papers, AAA).

53. Manship to Konti, 11 September 1910; Konti Papers, AAA.

54. Manship to Konti, (autumn) 1910, Konti Papers, AAA.

55. Manship to Konti, 4 March 1910, Konti Papers, AAA. Another sculpture fellow, Albin Polasek, also spoke glowingly of an energetic young model named Caterina, whose "abounding strength made her scorn to step to or from the model's stand; no matter how long she had posed, she always jumped" (quoted in Ruth Sherwood, *Carving His Own Destiny: The Story of Albin Polasek*, p. 225). According to Polasek, this model inspired his *Maiden of the Roman Campagna* (1911), whose physical type is similar to that of the *Duck Girl*.

56. On the "Narcissus," now thought to represent Dionysus, see Francis Haskell and Nicholas Penny, *Taste and the Antique: The Lure of Classical Sculpture, 1500–1900*, pp. 271–272.

57. The sculpture appears, for example, in the comfortable, bourgeois *Parlor on Brooklyn Heights of Mr. and Mrs. John Bullard* in a painting by Edward Lamson Henry (1872; Manoogian Collection). Manship mentions the "Narcissus from Pompeii" in his entry on "Decorative Sculpture" for *Encyclopaedia Britannica*, 14th ed., s.v. "Sculpture."

58. Stanley Casson, *XXth Century Sculptors*, pp. 45, 47. Likewise, Paul Vitry recognized "cette absence presque complète de l'intermédiaire du classique scolaire, cette prise de contact directe avec les grands modèles grecs aperçus tout de suite, et non après la fatigue et l'ennui scolaire de toutes les redites acadèmiques" (*Paul Manship, sculpteur américain*, p. 9).

59. Manship Papers, AAA. Manship's son confirmed his father's approach in a conversation with me, 26 April 1984.

60. Manship to Konti, letters from early spring 1912 and summer 1911, Konti Papers, AAA.

61. During both of the previous summers, Manship had traveled with his fiancée, Isabel McIlwaine, and a friend from the Academy, Frank Fairbanks. In 1911, they visited Brussels, Antwerp, the Hague, Amsterdam, Ber-

lin, Dresden, and Vienna. In Italy, they went to Venice, Ravenna, Padua, Florence, Siena, Orvieto, and Naples (itinerary from letter, Isabel McIlwaine to Konti, 2 August 1911, Konti Papers, AAA).

62. Esposizione Internationale di Roma, *Catalogo della mostra archeologica nelle Terme di Diocleziano*. Works from Greek museums included in the exhibition (Section XI) also received separate publication as *Marbres des Musées de Grèce; catalogue de la collection des moulages exposés à Rome en 1911*. The 1908 *Catalogue of the Collection of Casts* of the Metropolitan Museum of Art stated that the Acropolis korai could not be cast "owing to the remnant of paint on these statues" (p. 36), but the risks were either overlooked or overcome, since the catalogue of the archaeological exhibition in Rome notes that the korai were cast for the first time expressly for display there (Esposizione Internationale di Roma, *Mostra archeologica*, p. 121).

63. Hildebrand, *The Problem of Form in Painting and Sculpture*, p. 124; see, in general, his final chapter, "Sculpture in Stone." I discuss Hildebrand at greater length in chapter 3.

64. On Metzner, see the studies by Maria Pötzl-Malikova: "Franz Metzner und die Wiener Secession," *Alte und moderne Kunst* 21 (1976):pp. 30–39, and idem, *Franz Metzner: Ein Bildhauer der Jahrhundertwende in Berlin-Wien-Prag-Leipzig*. For a discussion of the influence of both Metzner and Hildebrand on early-twentieth-century American sculpture, see Susan Rather, "Toward a New Language of Form: Karl Bitter and the Beginnings of Archaism in American Sculpture," *Winterthur Portfolio* 25 (Spring 1990):1–19.

65. Charles Aitken, "Notes—Ivan Meštrović," *Burlington Magazine* 26 (March 1915):260.

66. A statement by Meštrović regarding his purpose in creating this monument appears in Laurence Schmeckebier, *Ivan Meštrović, Sculptor and Patriot*, pp. 21–22. An extensive early bibliography on Meštrović follows the collection of essays edited by M. Ćurčin, *Ivan Meštrović: A Monograph*.

67. As its first political action, the London-based Yugoslav Committee for National Liberation mounted an exhibition of Meštrović's work at the Victoria and Albert Museum in 1915 (Schmeckebier, *Meštrović*, p. 27); John Singer Sargent was on the organizing committee (Ćurčin, ed., *Meštrović*, p. 90). Ernest H. R. Collings's essay "Meštrović in England," pp. 48–54 in Ćurčin's book, offers useful insights into the history of the artist's reception in that country; for the same volume, Collings also compiled a bibliography of writings on Meštrović to 1918, numbering 234 items (most in English).

68. Meštrović gained intimate familiarity with ancient Greek sculpture while an art student in Vienna, supporting himself by making copies for sale (Milan Ćurčin, "Ivan Meštrović in Wien," *Festschrift Julius Franz Schütz*, pp. 168–178).

69. Manship to Konti, undated, Konti Papers, AAA.

70. Manship to Konti, 31 October 1911, Konti Papers, AAA. According to the author of "American Art at the Roman Exposition," *Philadelphia Public Ledger* (4 June 1911): "The pavilion was intended to present to Europe an architectural ideal well recognized in this country but only slightly known abroad. A modern suburban house, such as is occupied by many families near large cities, was the model, which necessarily suffered many modifications in adapting it for galleries." Another

newspaper article, "Foreign Critics Praise Our Art" (13 February 1912, source unidentified) somewhat equivocally mentions the "home for American art which was conspicuous for the attention it attracted throughout the entire exposition" (PAFA scrapbooks, AAA).

71. Esposizione Internationale di Roma, *Catalogo della mostra di belle arti.* The Italian government purchased two of Konti's exhibited works, *Illusion: Pursuit of Happiness* and *Genius of Immortality.* Sherwood states that the American Academy was represented by a single work—a plaster portrait bust of Manship by Albin Polasek, present location unknown (*Polasek,* p. 214); however, no such listing appears in the official catalogue.

72. For a photograph of Manship working on an early version of his third-year project, not yet featuring the mask, see John Manship, *Paul Manship,* p. 41, pl. 30.

73. E. Douglas Van Buren illustrates several such antefixes in *Figurative Terra-cotta Revetments in Etruria and Latium,* for example, pl. 4. Manship might have been aware of Elizabeth Van Buren's research through her husband, A. W. Van Buren, a professor at the American School of Classical Studies, with whom the American Academy fellows bound for Greece consulted during the spring of 1912. He also had ample opportunity to see such antefixes in the Palazzo dei Conservatori and other Roman collections.

74. Martin Birnbaum, *Catalogue of an Exhibition of Sculpture by Paul Manship,* p. 7.

75. Manship to Konti, undated, ca. 1912, Konti Papers, AAA.

76. Semi-Annual Report of the Executive Committee, November 1895, McKim Papers, LC.

77. Lord to Kendall, 7 February 1896, AAR Papers, AAA.

78. Millet to Day, then acting president, 16 February 1909, AAR Papers, AAA.

79. Millet to Mead, 24 May 1910, AAR Papers, AAA.

80. Blashfield to Mead, 27 September 1911, AAR Papers, AAA.

81. Crowninshield to Millet, 26 January 1911, AAR Papers, AAA. A year earlier he had complained that "the British and American archaeological schools have been very civil in the way of extending their privileges to our men, who, I regret to say, don't care to avail themselves of them" (28 January 1910, AAR Papers, AAA).

82. Blashfield to Mead, 27 September 1911, AAR Papers, AAA.

83. Gorham Phillips Stevens, director (1912, 1917–1932), to Mead, 29 December 1912, AAR Papers, AAA. In the same vein, Millet wrote Mead: "Funny that everybody is afraid that the Archaeological Institute might absorb the Academy! Might as well fear that Barnard College would absorb Columbia" (24 May 1910, AAR Papers, AAA). The consolidation agreement of 21 January 1911 reported endowments of $100,000 for the School and $900,000 for the Academy.

84. See, for example, Mead [?] to French, 18 May 1912, AAR Papers, AAA.

85. For information on activities at the School of Classical Studies, see its Annual Reports, AAR Papers, AAA.

86. Stevens to Millet, 20 January 1912, AAR Papers, AAA. Stevens presumably meant to write Minoan, rather than Mycenaean, as the work appeared with the title *Minoan Poetry* at the 1915 Architectural League exhibition. It featured architecture, frescoes, and costumes clearly informed by the discover-

ies of Sir Arthur Evans at Knossos, where both Stevens and Stahr made drawings (Stevens to La Farge, 13 November 1914, AAR Papers, AAA). Evans's definitive publication, *The Palace of Minos at Knossos,* appeared in four volumes between 1921 and 1935. For an earlier, popular account, see Ronald M. Burrows, *The Discoveries on Crete and Their Bearing on the History of Ancient Civilisation.*

87. Manship to Konti, early spring 1912, Konti Papers, AAA.

88. Report of the Director of the School of Fine Arts, Annual Report, 1912–1913, AAR Papers, AAA.

89. Manship, "The History of Sculpture," *Encyclopaedia Britannica,* 1952 ed., s.v. "Sculpture." Manship's comment that the caryatids were "not completely liberated from Asiatic traditions" refers to his comparison (earlier in the essay) between the style and technical procedures of early Greek artists and those from Egypt and the Near East. The Siphnian Treasury frieze exhibits two distinct styles: conservative in the south and west (location of the caryatid porch and original entrance) and more advanced in the north and east (the approach from the Sacred Way and chief entrance after the early fifth century B.C.); which Manship had in mind is unclear.

90. Manship, "The Decorative Value of Greek Sculpture," lecture at the American Academy, May 1912; for the full text, see Appendix. Manship later defined decorative sculpture as "all sculpture made primarily as decoration or part of an architectural scheme, or which is so designed as to fit into an architectural setting, or which, though not designed for any particular place, is yet so considered in its form relationships and harmonies of line and mass,

that it becomes an abstraction in form of the object or subject represented" ("Sculpture," *Encyclopaedia Britannica,* 1952). Jeffrey M. Hurwit discusses the community of the arts in the late archaic period, with specific reference to the interrelationship between the Siphnian Treasury frieze and red-figure vase painting, in *The Art and Culture of Early Greece, 1100–480 B.C.,* pp. 292–307.

91. "It was then that I first became interested in mouldings and architectural details, and began to make notes, sketches and measured drawings of bases for statues" (paper given at the Art Students League, 1915, Manship Papers, AAA). See Manship, "The Sculptor at the American Academy in Rome," *Art and Archaeology* 19 (February 1925):89–92.

92. Stevens to La Farge, 3 October 1922, AAR Papers, AAA.

93. The fame of the Hermes, found in 1877 in the Heraion at Olympia (exactly where Pausanias had seen it in the second century A.D.), rested not only on its beauty but on its status as the only original statue to survive by a first-rank, known Greek sculptor. Scholars of the 1930s, however, challenged its attribution to Praxiteles—or at least to the fourth-century sculptor of that name; more recently, Sheila Adam has argued that the Hermes is a Greek copy of ca. 100 B.C. (*The Technique of Greek Sculpture in the Archaic and Classical Periods,* pp. 124–128).

94. Manship, "Decorative Value" (see Appendix, pp. 185–186).

95. Ibid. (Appendix, pp. 186–187).

96. Manship's drawing, marked "Acropolis Museum, Athens, April 26, 1912" (Coll. John Manship) identifies the korai as Acropolis nos. 594, 679, 680, and 682. Partial color blindness notwithstanding, Manship's description

of the painted korai reveals his sensitivity to the importance of coloring to their effect.

97. Manship, "Decorative Value" (Appendix, p. 188).

98. Russell Sturgis, *The Appreciation of Sculpture*, pp. 18–19. Among writers who addressed the subject of preclassical sculpture at any length, Ernest A. Gardner was one of the most appreciative, devoting a full chapter to "Early Masterpieces" in his *Six Greek Sculptors*, pp. 28–55; I discuss his conclusions in chapter 2.

99. The term "severe style," as applied to sculpture of the period 480–450 B.C., only gained currency with the publication of Vagn Poulsen's *Der strenge Stil* (1937). However, Manship's lecture makes clear that he recognized a shift from the more decorative, archaic approach to the greater simplicity and severity of form that appeared around 480 B.C.

100. Manship, "Decorative Value" (Appendix, pp. 188–189).

101. Mead, memorandum of a visit to Rome, early fall 1912, AAR Papers, AAA.

102. Report of the Director of the School of Fine Arts, Annual Report, 1912–1913, AAR Papers, AAA.

103. On 27 August 1912, for example, French inquired of Henry Wolfe, assistant secretary of the Academy, when Manship would be returning: "If he is coming soon, I may have a job to put in his hands." This may have been the *Soldier of the Revolutionary War*, listed by Murtha as a commission gained "because of the influence of Daniel Chester French" (*Paul Manship*, p. 150, no. 30). According to the same source, "the painter John La Farge" helped Manship obtain his first commission after returning, a

St. Joseph (p. 150, no. 29). John La Farge died in 1910; his son, architect C. Grant La Farge, a trustee and secretary to the Board of the Academy, provided the assistance.

104. The social demands of life at the Academy must have been constant. Less than two weeks after his arrival in Rome, Manship wrote to Konti: "I am a sport now. I have a new dress suit & Tuxedo & carry a cane! *Zut!*" (14 November 1909, Konti Papers, AAA). Two years later, he reported having gone to a ball with "eight princesses, five duchesses, numerous baronesses & marquise. . . . There was certainly some class to that dance" (letter to William Manship, 15 February 1911, courtesy of William Manship, Jr.). John Manship's *Paul Manship* does an excellent job of establishing Manship's social milieu during his heyday.

105. Adams to C. Grant La Farge, 8 December 1913, Files of the American Academy in Rome (AAR), New York.

106. Konti said that Manship's work was "like himself, joyous and faun-like. As a boy in the studio, for all his hard work, he was full of vitality, laughing and singing, sometimes from the rafters above, and the next minute grabbing you and dancing you around the studio. A lovely, simple nature, that boy" (related by Herbert Adams in ibid.).

2. The Archaeological Background

1. For the first history of archaeology, focusing especially on Greece, see Adolf Michaelis, *Die archäologischen Entdeckungen des neunzehnten Jahrhunderts* (Leipzig: E. A. Seeman, 1906); English ed.: *A Century of Archaeological Discoveries*. See also Glyn E. Daniel, *The Origins and Growth of Archaeology*

and, for prehistoric archaeology, idem, *A Hundred and Fifty Years of Archaeology*.

2. Throughout the text, I have referred to studies by their English titles, except where the original language publication is especially familiar. In all cases, however, I have dated publications according to their original edition.

3. Johann Joachim Winckelmann, *Reflections on the Imitation of Greek Works in Painting and Sculpture*, p. 33.

4. Ibid., pp. 33, 35.

5. Gotthold Ephraim Lessing, *Laocoon: An Essay upon the Limits of Painting and Poetry*. See also Margarete Bieber, *Laocoon: The Influence of the Group since Its Rediscovery*.

6. For a descriptive catalogue of ninety-five of the most celebrated ancient sculptures known before 1900, see Haskell and Penny, *Taste and the Antique*.

7. See Fani-Maria Tsigakou, *The Rediscovery of Greece: Travellers and Painters of the Romantic Era*. Until well into the nineteenth century, few viewers recognized that ancient copies littered the field; but see Haskell and Penney, *Taste and the Antique*, p. 106.

8. According to Gisela Richter: "Ancient writers give some general information about the beginnings of Greek sculpture. . . . They also mention a few sculptors by name and even assign specific works to them. . . . Rarely, however, has it been possible to associate extant works with these names. A few names are known from signatures; but again only in a few instances can these signatures be connected with specific works" (*Sculpture and Sculptors of the Greeks*, p. 151).

9. The two Jonathan Richardsons ranked among the few early commentators on classical art to acknowledge this bias and to recognize how few ancient masterworks had survived

antiquity (*Traité de la peinture et de la sculpture par Mrs. Richardson, père et fils* 3: book 1, pp. 100–101, 205–206, 218–220; book 2, pp. 581–582.

10. Rhys Carpenter, *The Humanistic Value of Archaeology*, p. 103.

11. Ibid., p. 36.

12. Prehistoric archaeology gained added impetus from Charles Darwin's *On the Origin of Species* (1859) and Sir Charles Lyell's *The Geological Evidence of the Antiquity of Man* (1863).

13. Schliemann's reports to the *Times* (London) are listed and selectively reprinted in *Myth, Scandal, and History: The Heinrich Schliemann Controversy and a First Edition of the Mycenaean Diary*, ed. William M. Calder III and David A. Trail, pp. 240–260. The first major account in English of Schliemann's career appeared soon after his death: C. Schuchhardt, *Schliemann's Excavations: An Archaeological and Historical Study*.

14. Michaelis, *A Century of Archaeological Discoveries*, p. 217. Recent researchers have levied more serious charges. Calder, for example, argues that Schliemann fabricated his great discovery of the "Treasure of Priam" at Troy in May 1873; this treasure, he contends, comprised numerous small finds made over a three-year period of excavation, perhaps even augmented by purchases (Calder, "A New Picture of Heinrich Schliemann," in Calder and Trail, eds., *Myth, Scandal, and History*, pp. 33–34). In Calder's estimation, Schliemann's scholarly contemporaries generally refrained from criticizing him because they thought Schliemann "a thorough rogue, not deserving refutation"; in private, however, they were less circumspect (pp. 34–35).

15. See, for example, Alexander Conze, Alois Hauser, and George Niemann, *Archäologische Untersuchungen auf*

Samothrake (1875–1880); and Ernst
Curtius and Friedrich Adler, *Olympia:
Die Ergebnisse der von dem Deutschen
Reich Veranstalteten Ausgrabung* (1890–
1897). Hauser, Niemann, and Adler
were architects.

16. Michaelis, *A Century of Archaeo-
logical Discoveries*, p. 126. With this pre-
cedent, all finds made on Greek soil af-
ter 1875 were officially required to
remain in Greece (pp. ix–x).

17. Archaeological institutes were
established in Athens by the French
(1846), the Germans (1874), the Ameri-
cans (1881), and the British (1885),
and in Rome by the French (1874),
the Americans (1895), and the British
(1900).

18. For a concise discussion of these
and other characteristics of archaic
style, see Hurwit, *The Art and Culture
of Early Greece*, pp. 15–32.

19. See Winckelmann's Book VIII,
chap. 1, "The More Ancient Style of
Art," in *History of Ancient Art* 2:115–
129. As E. H. Gombrich pointed out,
Winckelmann based his characterization
of preclassical Greek art not on actual
examples but on early Italian painting,
which Vasari (reading ancient authors)
had compared to the early stages of
Greek art (*The Ideas of Progress and
Their Impact on Art*, pp. 30–34).

20. The British Museum purchased
sculpture from the Temple of Apollo at
Bassae in 1812 and, in 1818, acquired
the famous Parthenon marbles, which
Lord Elgin had brought to England in
1803. In Paris the Louvre housed a few
fragments from the Temple of Zeus at
Olympia. Adolf Furtwängler's investi-
gations at Aegina in 1901 proved Thor-
waldsen's arrangement of the pedimen-
tal sculpture and the temple's presumed
dedication to Athena incorrect; his re-
construction (also now superseded)
appeared in one of the most lavish

archaeological publications to that
date: *Aegina: Das Heiligtum der Aphaia*
(1906). Thorwaldsen's restorations to
the figures, removed in the 1960s, are
preserved in photographs, for which
see Christiane Grunwald, "Die Aegine-
ten Ergänzungen." See also Raimund
Wünsche, " 'Come nessuno, dai tempi
fiorenti dell'Elladi.' Thorvaldsen,
Ludovico di Baviera e il restauro dei
marmi di Egina," in Elena di Majo et
al., *Bertel Thorvaldsen, 1770–1844, scul-
tore danese a Roma*, pp. 80–102.

21. The first influential published
analysis of the Aegina sculptures was
Johann Martin Wagner's *Bericht über die
Äginetischen Bildwerke etc., mit kunst-
geschichtlichen Anmerkungen von Friedrich
Schelling* (1817). For other nineteenth-
century evaluations of the Aegina sculp-
tures, see Lars Olof Larsson, "Thor-
valdsens Restaurierung der Aegina-
Skulpturen im Lichte zeitgenössischer
Kunstkritik und Antikenauffassung,"
Konsthistorisk Tidskrift 38 (1969):23–46,
esp. pp. 36–40. As Larsson points out
(p. 37), Wagner did not distinguish be-
tween the stylistic treatment of the two
pediments, which later scholars find
quite marked.

22. On Thorwaldsen and the an-
tique, see Jørgen Birkedal Hartmann,
*Antike Motive bei Thorwaldsen: Studien
zur Antikenrezeption des Klassizismus*,
in which the *Hope* is discussed on
pp. 64–74. Hartmann identifies a statue
of Dionysus owned by Thorwaldsen's
early patron Thomas Hope as the
model for the overall configuration of
Thorwaldsen's 1838 self-portrait (p. 73).
See also H. W. Janson, *19th-Century
Sculpture*, pp. 71, 73.

23. Reinhard Kekulé von Stradonitz,
"Ancient Art," in Karl Baedecker,
Southern Italy and Sicily, p. xxxiv. The
"discovery" of Greek Doric architec-
ture in the 1760s (above all in Sicily)

and the ensuing debate over the meaning of this "primitive" order and its relationship to the more graceful Ionic offers an interesting precedent for the terms of the later debate over archaic sculpture. Both Doric architecture and archaic sculpture (which coincides chronologically with the earlier stages of the Greek Doric) came to be celebrated as "modern." For the seminal modern study of the Doric Revival, see Nikolaus Pevsner and S. Lang's "Apollo or Baboon," *Architectural Review* 104 (December 1948): 271–279, reprinted in Pevsner, *Studies in Art, Architecture and Design,* 1:197–211, 243–245. See also Joselita Raspi Serra, ed., *Paestum and the Doric Revival 1750–1830.*

24. For an early discussion of the Acropolis excavations and the free-standing archaic works found there, see Guy Dickins, *Archaic Sculpture* (1912). Kouroi received their own exhaustive study in Waldemar Deonna, *Les "Apollons archaïques"* (1909). See also the major study by Henri Lechat, *La Sculpture attique avant Phidias* (1904).

25. For an overview of earlier travel to Greece, see Tsigakou, *The Rediscovery of Greece.* Architects, more frequently than other artists, made the journey; see *Paris-Rome-Athens: Travels in Greece by French Architects in the Nineteenth and Twentieth Centuries.* The possibilities for the study of original art of preclassical date, limited in Europe (that is, outside of Greece), were practically nonexistent in America of the early twentieth century. For an overview of the Metropolitan Museum of Art's classical collection as of that time, see Gisela M. A. Richter, *Handbook of the Greek Collection,* p. 1.

26. Ernest A. Gardner, *A Handbook of Greek Sculpture,* pp. 89–213, and idem, *Six Greek Sculptors,* pp. 1–55.

27. Gardner, *Six Greek Sculptors,* p. 14.

28. Ibid., p. 11.

29. *Die Naturwiedergabe in der älteren griechischen Kunst;* the first English edition appeared in 1907.

30. For a different understanding of the conceptual nature of archaic art, see Hurwit, *The Art and Culture of Early Greece,* pp. 27–29.

31. Meyer Schapiro, "The Romanesque Sculpture of Moissac: Part I (1)," *Art Bulletin* 13 (September 1931):251.

32. Publications of photographs exclusively included G. F. Hill's *One Hundred Masterpieces of Sculpture* (1909) and Ernst Von Mach's *Handbook of Greek and Roman Sculpture* (1905).

33. In 1908, the Metropolitan Museum of Art owned 2,607 sculptural and architectural casts of Egyptian, Oriental (i.e., Near Eastern), Greek and Roman, Early Christian, Byzantine, Romanesque, Scandinavian, Saracenic, Gothic, Renaissance, and modern works. The largest number—1,045—reproduced classical works, though only 223 of Greek art prior to 450 B.C. The entries include a brief description of the object, its probable date and present location, a bibliographic reference, and a statement about any restorations to the work (Metropolitan Museum of Art, *Catalogue of the Collection of Casts*).

34. Charlotte Leon Mayerson, ed., *Shadow and Light: The Life, Friends and Opinions of Maurice Sterne,* p. 66.

35. J. Fenimore Cooper, *Excursions in Italy,* p. 89.

36. Stanley Casson, *Some Modern Sculptors,* p. 17.

3. Archaism As Modernism: Content and Technique

1. Among European cities, I have singled out Paris for its artistic preemi-

nence and importance to American artists. Photographs of many of the elaborate public monuments erected in Paris during the latter part of the nineteenth century appear in Galeries Nationales du Grand Palais, *La Sculpture française au XIXe siècle*, pp. 242–251, the most comprehensive published gathering of nineteenth-century French sculpture. Léonce Bénédite's narrative of an ordinary viewer's horror at a typical sculpture display sets the tone for his condemnation of modern sculpture in "Les Salons de 1899: La sculpture," *La revue de l'art* 5 (1899):410–418, 473–484. That viewer, Bénédite relates, "ne pouvait mettre les pieds dans un musée et surtout dans une exposition, sans être bouleversé par toutes les incroyables histoires qu'on prétendait lui raconter. . . . Mais où ce cauchemar devenait obsédant, c'est lorsqu'il avait le malheur de s'asseoir sur un banc, dans une exposition de sculpture. Il en partait suggestionné par tous ces marbres ou tous ces plâtres contournés, tordus, exaspérés, avec une envie folle, lui aussi, de danser sur un pied, d'agiter ses bras en tous sens, de rouler des yeux comme un nègre de foire. Il n'échappait, qu'en sortant vite, à ce vertige de folie" (p. 410).

2. Charles Baudelaire, "The Salon of 1846" ("Why Sculpture Is Tiresome"), in *Art in Paris, 1845–1862*, p. 111. Over a half century later, Edmond Claris solicited responses to Baudelaire's critique of sculpture from twenty-two sculptors (most notably Rodin and Medardo Rosso), critics (including Gustave Geffroy and Camille de Sainte-Croix), and painters. Some of these were published in *La Nouvelle Revue* for June 1901 and more completely in Claris, *De l'Impressionisme en sculpture*.

3. Jean-Léon Gérôme, the most ex-

treme representative of such imitation, modeled his sculptures (regardless of the projected size of the finished work) in plaster at life size, working with calipers to measure and compare life model and plaster, often arranging for them to be photographed together in testament to his accuracy; see Gerald Ackerman in Peter Fusco and H. W. Janson, eds., *The Romantics to Rodin: French Nineteenth-Century Sculpture from North American Collections*, p. 286.

4. Maurice Denis, " A Definition of Neo-Traditionism," translation in Linda Nochlin, *Impressionism and Post-Impressionism, 1874–1904, Sources and Documents*, p. 190. Similarly, American artist Max Weber spoke of the "plastic spiritual principles" embodied in "the Parthenon, in archaic sculpture, in the Assyrian and the Egyptian, and in the color and design of Minoan and Persian, Chinese and Indian porcelains, rugs, and paintings" (*Essays on Art*, p. 12). On archaism as a salient feature of Weber's own art, compare the comments of Elizabeth Luther Cary, who criticized Weber for just that quality, in a review reprinted in *Camera Work* 36(October 1911):45.

5. Jeffrey Hurwit counters such a reading, asserting that "concessions to nature were made almost grudgingly. . . . Archaic art headed toward the naturalistic *despite* an obstinate struggle to maintain the rule of schema and pattern" (*The Art and Culture of Early Greece*, p. 22; also pp. 255–259).

6. See Emile Zola, "Proudhon et Courbet" (1866), *Mes Haines* (Paris, 1879), p. 25.

7. Roger Fry, "The Sculptures of Maillol," *Burlington Magazine* 17 (April 1910):32.

8. Ibid., p. 31. In 1904, Julius Meier-Graefe had referred to an "archaistic" quality in Maillol's work, which he ex-

plained as "an effect of [Maillol's] immaturity" (*Modern Art; Being a Contribution to a New System of Aesthetics* 2:77).

9. Fry criticizes archaic art in "Bushman Paintings," *Burlington Magazine* 16 (March 1910):334–338, contrasting the intellectualized, conceptual vision of archaic artists with art that expresses (or seeks a return to) "ultraprimitive directness of vision" (p. 338). For Fry's mockery of the modern reverence for early Greek art, see also "Greek Art," in his *Last Lectures*, pp. 170–216, esp. p. 173—a posthumous, anonymously edited reconstruction of Fry's academic lectures.

10. Fry, "The Sculptures of Maillol," pp. 26, 31. André Gide praised Maillol's *Méditerranée* in similar terms in the exhibition review "Promenade au Salon d'Automne," *Gazette des Beaux-Arts,* ser. 3, 34 (1905):475–487, esp. pp. 478–479.

11. Fry, "The Sculptures of Maillol," p. 32.

12. Maillol, as quoted in Judith Cladel, *Aristide Maillol: Sa vie, son oeuvre, ses idées,* p. 97. Maillol's explicit comparison between the Zeus temple sculptures and the Praxitelean Hermes in the same museum—he dubbed Praxiteles "le Bouguereau de la sculpture, le premier pompier de la Grèce" (p. 98)—recalls Manship's similar, if less contemptuous, response.

13. William Zorach, *Zorach Explains Sculpture,* p. 263.

14. As quoted in Judith Cladel, *Auguste Rodin: L'Oeuvre et l'homme,* p. 37.

15. Beaunier, *Le Sourire d'Athèna,* p. 255. For other characterizations of Aegina's "smiling" environs, see pp. 243–244.

16. "Quand on vient de visiter les salles où l'art de la décadence multiplie ses gestes ronds, ses fades coquetteries, ses grâces détestables, son éloquence

vaine, l'on aime infiniment cette rude simplicité d'un art antérieur aux stratagèmes. . . . dans sa rudesse, quel style noble, fier, puissant!" (ibid., p. 254). Although Beaunier acknowledged seeing the Aegina sculptures "dans leur exil bavarois" in Munich's Glyptothek, his narrative encourages the reader imaginatively to reinstate them to their island home. He discusses the temple site and its sculptures on pp. 244–256.

17. Ibid., p. 249.

18. Edward Storer, "Classicism and Modern Modes," *The Academy* 85 (6 September 1913):293–294. Storer's point of reference was Greek sculpture in the British Museum, presumably from the postarchaic period.

19. Manship, "Decorative Value" (Appendix, p. 188).

20. Hurwit, *The Art and Culture of Early Greece,* p. 197.

21. For early consideration of Egyptian influence on kouroi, see Deonna, *Les "Apollons archaïques"* (1909), pp. 21– 32.

22. Jacques Lipchitz, *My Life in Sculpture,* pp. 25, 11. Archipenko also found ancient Near Eastern and early Greek art attractive and once stated: "Meine wahre Schule war der Louvre, den ich während einiger Jahre jeden Tag besuchte. Dort studierte ich hauptsächlich die archaische Kunst und alle die grossen toten Stile" (quoted in Erich Wiese, *Alexander Archipenko,* p. 4).

23. Lipchitz, *My Life in Sculpture,* p. 25.

24. Derain, as quoted in Gelett Burgess, "The Wild Men of Paris," *Architectural Record* 27 (May 1910):p. 407.

25. The English translation of Wilhelm Worringer's *Abstraktion und Einfühlung* did not appear until 1953.

26. Harriet Hosmer, "The Process of Sculpture," *Atlantic Monthly* 14 (December 1864):736. "It is high time that some distinction should be made be-

tween the labor of the hand and the labor of the brain," declared Hosmer (p. 737). Her sense of mission was rooted in the need to defend herself, and other female sculptors, against the charge that they did not execute their own sculpture because they employed male workers. To those who believed that her male counterparts did otherwise, Hosmer's essay must have read as something of an exposé; but it is a sincere and informative account (enlivened by the author's justifiable sense of outrage) of the nineteenth-century theory and practice of sculpture in marble. See also Wagner, *Carpeaux,* chap. 1, esp. pp. 7–10.

27. Jouin, *Esthéthique du sculpteur* (Paris: Henri Laurens, 1888), p. 126, as quoted in Daniel Rosenfeld, "Rodin's Carved Sculpture," p. 94.

28. One technical manual characterized the pointing process as "nothing other than a succession of geometric problems that are solved in the process of execution" (Karl Robert, *Traité pratique du modelage et de la sculpture* [Paris: Henri Laurens, 1889], p. 15, as quoted in Rosenfeld, "Rodin's Carved Sculpture," p. 93).

29. For a clear presentation of both sand- and lost-wax casting, see Michael Edward Shapiro, "Sculptors and Founders: An Overview of Bronze Casting in America, 1850–1900," in *Cast and Recast: The Sculpture of Frederic Remington,* pp. 13–35. On nineteenth-century sculptural processes in general, see the essays by various authors in Galeries Nationales du Grand Palais, *La Sculpture française au XIXe siècle,* pp. 60–159; Jeanne L. Wasserman, ed., *Metamorphoses in Nineteenth-Century Sculpture;* and for America, Michele Helene Bogart, "Attitudes toward Sculpture Reproductions in America, 1850–1880" (Ph.D. diss., University of Chicago, 1979).

30. Taft, *The History of American Sculpture* (1903), p. 334. Taft called MacMonnies's art "essentially plastic rather than glyptic" (p. 333).

31. Truman H. Bartlett, "Auguste Rodin," *The American Architect and Building News* 25 (1 June 1889): 263.

32. Sadakichi Hartmann expressively characterized this aspect of Rodin's genius, while chastising Augustus Saint-Gaudens for excessive literalism, when he wrote, with respect to Saint-Gaudens's *Puritan:* "Imagine what a Rodin could have made of it if he had treated it like his Balzac, like an idea shimmering through matter" ("Puritanism: Its Grandeur and Shame," *Camera Work* 32 [October 1910]: 17).

33. Geffroy, "Chronique Rodin," *La Justice* (11 July 1886): 1, as quoted in Rosenfeld, "Rodin's Carved Sculpture," p. 89. Rainer Maria Rilke, "Auguste Rodin," quoted in Albert Elsen, ed., *Auguste Rodin: Readings on His Life and Work,* pp. 129–130.

34. Rodin, unlike most of his contemporaries, permitted evidence of the bronze casting process (unplugged air-pocket holes, and so on) to remain in a completed work. Rosalind Krauss has rightly argued that such documentation of the process of creation, "of the passage of the medium itself from one state to another," constitutes an important element of modernity (*Passages in Modern Sculpture,* p. 29).

35. Jouin, *Esthéthique du sculpteur,* p. 105, as quoted in Rosenfeld, "Rodin's Carved Sculpture," p. 82.

36. For the aspects of Rodin's sculpture that contradict naturalism and for his modernity in general, see Leo Steinberg, "Rodin," in *Other Criteria,* pp. 322–403.

37. Richard Shiff, *Cézanne and the End of Impressionism,* p. 72.

38. See, for example, Hildebrand's

negative characterization of Antonio Canova's tomb of the Archduchess Maria Christina (1798–1805) in Vienna (*Problem*, pp. 112–113).

39. Scholars have identified the technical shift from direct to indirect carving (pointing from a model) as one of the most important factors in the change from the archaic to the severe style of ca. 480–450 B.C.; see, for example, Brunilde Sismondo Ridgway, *The Severe Style in Greek Sculpture*, p. 19.

40. Hildebrand, *Problem*, pp. 135–136.

41. Ibid., pp. 132–133.

42. John Flannagan's "The Image in the Rock" (1941) best expresses the twentieth-century carver's credo; it appears in Dorothy Miller, ed., *The Sculpture of John B. Flannagan*, pp. 7–8.

43. Hildebrand, *Problem*, p. 136.

44. Adolf von Hildebrand, *Gesammelte Schriften zur Kunst* (Cologne: Westdeutscher Verlag, 1969), pp. 425–430, reprinted in English translation by Sabina Quitslund in Ruth Butler, *Rodin in Perspective*, pp. 139–143.

45. Quoted in ibid., p. 143.

46. Ibid., p. 140.

47. Löwy, *Rendering of Nature*, p. 105.

48. For an early-twentieth-century opinion on the unsuitability of Carpeaux's *The Dance* to its architectural setting, see the statement by sculptor Raymond Duchamp-Villon in George H. Hamilton and William C. Agee, *Raymond Duchamp-Villon, 1879–1918*, pp. 113–114. In America, Karl Bitter's work well illustrates the changing conception of architectural sculpture, from his "great lawless compositions" for the Administration Building at the World's Columbian Exposition of 1893 (Taft, *History of American Sculpture*, p. 457) to the highly controlled and abstracted reliefs he began to make in 1908; see also

Rather, "Toward a New Language of Form."

49. Quoted in Albert Elsen, *Pioneers of Modern Sculpture*, p. 84. Bourdelle worked for Rodin from 1893 to 1908 while concurrently pursuing his own career.

50. Casson, *Some Modern Sculptors*, p. 38. Although Bourdelle never went to Greece, his library and personal collections attest to his avid interest in Greek art and culture. See Marina Lambraki-Plaka, *Bourdelle et la Grèce: Les Sources antiques de l'oeuvre de Bourdelle*, pp. 151–156. Lambraki-Plaka's study suggests numerous specific, and reasonably convincing, ancient sources for works by Bourdelle; however, she does not address the broader question of motivation in sufficient depth to give shape to the wealth of observations she presents; her work remains an unsynthesized catalogue of sources.

51. Their flattened aspect led Elsen to liken Bourdelle's theater reliefs to "a steam-rollered early classical pediment" (*Pioneers*, p. 87).

52. Jean Chantavoine, "Au Théâtre des Champs-Elysées," *Femina* (15 June 1913), quoted in Lambraki-Plaka, *Bourdelle et la Grèce*, p. 86. A later commentator, Walter Agard, on the other hand, classed Bourdelle's work with Maillol's as a "profound expression of modern Hellenism" and praised the theater reliefs as "the first great architectural sculpture done in the modern spirit" (*The Greek Tradition in Sculpture*, p. 46; idem, *The New Architectural Sculpture*, p. 18).

53. *Fêtes* (15 September 1913), reprinted in Antoine Bourdelle, *Ecrits sur l'art et sur la vie*, pp. 66–67. For a selection of Bourdelle's statements on ancient art, see Lambraki-Plaka, *Bourdelle et la Grèce*, pp. 201–207.

54. Adolf Heilmeyer, *Adolf Hilde-*

brand, p. 15. If, in Meier-Graefe's estimation, Hildebrand had learned from the ancients how to relate his work to its setting, "he can hardly be said to have derived models for his sculpture directly from them. This preserves him from all danger of archaism" (*Modern Art* 2:139).

55. Hildebrand, *Problem,* pp. 13–14.

56. Ibid., p. 43.

57. Ibid., p. 45, and pp. 36–46, generally. The distinction between the impression and the effect is a subtle one; as characterized by Albert Boime, "the impression took place in the spectator-artist, while the effect was the external event" (*The Academy,* p. 170).

58. Hildebrand, *Problem,* p. 136.

59. Bitter to his Viennese correspondent Hans Kestranek, 10 February 1902, cited in James M. Dennis, *Karl Bitter, Architectural Sculptor, 1867–1915,* p. 94. Bitter expressed this wish to be more modern in connection with his efforts to design a grave memorial to railroad magnate Henry Villard (1902–1904).

60. Bitter's connections with Metzner figure in my chapter 6; but see also Rather, "Toward a New Language of Form."

61. Bitter to Marie Bitter, 16 May 1910, Bitter Papers, AAA. Early catalogues of the National Museum and Acropolis Museum offer a good idea of what Bitter probably saw; see especially Hans Schrader, *Archaische Marmor-skulpturen im Akropolis-museum zu Athen,* and J. N. Svoronos, *Das Athener Nationalmuseum.* Guy Dickins published the freestanding sculptures in *Archaic Sculpture,* the first important discussion in English of the Acropolis excavations.

62. Schurz had been an abolitionist and a general in the Civil War; later, as secretary of the interior under President Hayes, he had jurisdiction over Indian affairs.

63. The Egyptian costume visually communicated the content of the legend in the background of the sketch: "Slavery shall vanish. No remnant of ancient barbarism shall disgrace our civilisation." Note that the non-Caucasian figures exhibit considerably greater rigidity than the Greek types in both panels. Bitter evidently intended the rigidity to signal ethnic primitiveness.

64. Bitter's letter to Marie Bitter (16 May 1910, Bitter Papers, AAA) reveals that he indeed looked at archaic reliefs with the Schurz Memorial in mind.

65. Bitter expressed his intention to change materials in a letter to Kestranek, 11 March 1911, cited by Dennis, *Bitter,* p. 188.

66. Bitter to Kestranek, 2 January 1910, as quoted in Dennis, *Bitter,* p. 257. James Dennis kindly provided me with the text of this letter.

67. For the development of Riegl's theory of *Kunstwollen,* articulated first in his *Stilfragen* (1893) and most fully in *Die spätrömische Kunstindustrie* (1901), see Margaret Olin, "Alois Riegl and the Crisis of Representation in Art Theory, 1880–1905" (Ph.D. diss., University of Chicago, 1982), esp. chaps. 6 and 10.

68. Karl Gruppe, Bitter's last assistant, related the stages in the execution of the Schurz reliefs to James Dennis in an interview in April 1961 (as cited in Dennis, *Bitter,* p. 203).

69. Bitter, "Observations on Ancient and Modern Processes Employed in the Production of Monumental Sculpture," lecture for the Architectural League of New York, 28 February 1914, Karl H. Gruppe Papers, AAA.

70. On ancient relief sculpture, particularly as it relates to painting, see Hurwit, *The Art and Culture of Early Greece,* pp. 292–307. See also Richter, *Sculpture and Sculptors of the Greeks,* pp. 80–89; and Rhys Carpenter, *Greek*

Sculpture, a Critical Review, pp. 59–65. Bitter's repeated use of the profile head, even when the bodies are obliquely viewed, may have prompted Lorado Taft to call the reliefs "almost Egyptian" (*Modern Tendencies in Sculpture*, p. 122).

71. Hildebrand's *Problem* surely either stimulated or confirmed Bitter's concern for the relationship between technique and material. As a native speaker of German, Bitter could have read the original edition of 1893, but the appearance of an English translation in 1907 would have sparked discussion in American sculptural circles at a critical moment for Bitter's archaism.

72. Sidney Geist, *Brancusi: A Study of the Sculpture*, p. 161. Geist called *Crouching Figure* "the first direct carving in the modern tradition" (*Brancusi/ The Kiss*, pp. 30–32).

73. Disapproval of the division of labor in the studio certainly lay behind British calligrapher Eric Gill's ready embrace of direct carving when he first took up sculpture in 1909; see Fiona MacCarthy, *Eric Gill*, pp. 94–97.

74. Brancusi's aversion to formal crudity and his frustration in working the stone may have led him to mutilate and did cause him to disavow authorship of the directly carved *Ancient Figure* (Art Institute of Chicago); see Geist, *Brancusi: The Sculpture and Drawings*, p. 257.

75. Constantin Brancusi, in "Réponses de Brancusi sur la taille directe, le poli et la simplicité dans l'art," *This Quarter* 1 (Spring 1925):235. On the relationship between some of Brancusi's bronze and marble sculptures, see the partial text of a letter from Geist to Elsen in Albert Elsen, *Origins of Modern Sculpture: Pioneers and Premises*, p. 164, n. 94.

4. *Centaur and Dryad:* Manship's Art in Context

1. Bitter and Konti were particularly active in the Architectural League, serving as officers, jurors, and committee members, as well as exhibiting regularly. My information about the Architectural League derives from the combined yearbook-catalogues of its annual exhibitions.

2. The League exhibition for 1909 featured a retrospective showing of Academy work, including seventy-two drawings, sketches, paintings, and sculptures.

3. See John Manship, *Paul Manship*, pp. 31 (pl. 19), 36 (pl. 25). In their motif, both this maquette and the *Centaur and Dryad* relate to Isidore Konti's *Illusion: Pursuit of Happiness*, which Manship certainly saw at the International Exposition in Rome in 1911 and may have known earlier. Manship's frequent treatment of centaurs and satyrs in his first Roman works may have been his way of capitalizing on his previous experience in sculpting animals while minimizing his relative inexperience with human anatomy.

4. See also south metopes 10 and 29 from the Parthenon.

5. *Boston Herald*, 21 February 1915, sec. D, p. 3.

6. The frescoes from the Villa of the Cicero in Pompeii, transferred to panel for display in Naples, had long been known to artists. Delacroix copied one of them from a volume of engravings for his *Centauress and Bacchante;* see Walter Pach, *The Classical Tradition in Modern Art*, p. 35.

7. The pose and backswept drapery of the Nike of Paionius, another work Manship admired at Olympia, also resonates in Manship's dryad, though

with the same stylistic qualification; the Nike's billowing chiton, defying the marble's weight, becomes in the dryad an abstract pattern in hard bronze. Manship's detailed drawings of the Nike's base, dated 3 May 1912, are in the collection of John Manship.

8. John Manship recalled that whenever he and his father visited the Conservatori Museum, Manship would declare the Esquiline Venus "the cutest girl in Rome" (conversation with Susan Rather, 22 November 1985).

9. *Outlook* 112(8 March 1916):543.

10. Ernst Langlotz, *Ancient Greek Sculpture of South Italy and Sicily,* p. 261, no. 33. A. W. Van Buren of the American School of Classical Studies, whose wife, Elizabeth, studied figurative antefixes, perhaps drew Manship's attention to these works (see chap. 1, n. 73).

11. Address given at the University of Iowa, Iowa City, October 1937, Manship Papers, AAA; see also the text of a talk read at the Art Students League, New York, 4 December 1915, Manship Papers, AAA.

12. Walter Raymond Agard, *Classical Myths in Sculpture,* p. 155.

13. Royal Cortissoz, *American Artists,* p. 291. Manship was not alone in his interest in vase paintings; in 1916, Sherry Fry exhibited a sculpture in the round entitled *Figure on a Vase.* See *Catalogue of an Exhibition of Contemporary American Sculpture* (Buffalo Fine Arts Academy, Albright Art Gallery, Buffalo, New York, 17 June–2 October 1916).

14. "The Reminiscences of Paul Manship," Oral History Collection, Columbia University, 1958. Manship certainly placed great value on drawing in the creative process, but evidently did not regard his drawings as independent creations. His dealer, Martin Birn-

baum, claimed that Manship "refused to follow the prevailing fashion of preserving studio litter in the shape of inchoate scribbles, and calling them precious drawings" (Birnbaum, *Catalogue,* pp. 8–9).

15. Manship's essay "Decorative Sculpture" for *Encyclopaedia Britannica,* 14th ed. (s.v. "Sculpture"), included a reproduction of Stuck's *Mounted Amazon.* Stuck's horse exhibits the elongated neck and mane style characteristic of Greek archaic or archaistic examples; see, for example, Humfry Payne and Gerard Mackworth-Young, *Archaic Marble Sculpture from the Acropolis,* no. 700, pp. 137–138; or J. R. Mertens, *Greek Bronzes in the Metropolitan Museum of Art,* no. 42, pp. 62–63. For a slightly later example (ca. 470–460 B.C.), see the bronze statuette of a horse from Olympia in the museum, Olympia; reproduced in Gisela M. A. Richter, *A Handbook of Greek Art,* p. 199, fig. 280.

16. Art Institute of Chicago, *Exhibition of Contemporary German Art.* The exhibition traveled to Chicago, New York, and Boston. Stuck's *Wounded Centaur* (1890–1893) is another sculpture that seems strikingly like the *Centaur and Dryad* in design, although its rough modeling and extreme torsion, so unlike the later *Amazon,* are more Rodinesque than is Manship's sculpture.

17. *New York Times,* 10 January 1909, sec. 6, p. 6. A. E. Gallatin referred to Stuck ("the most amazing genius of modern Germany") as "a pagan of pagans," whose works were "the apotheosis of the *joie de vivre*" (*Modern Art at Venice,* p. 13).

18. Taft, *Modern Tendencies in Sculpture,* p. 144; and the *Boston Herald,* 21 February 1915, sec. D, p. 3. In theme, Stuck's painting *Listening Fauns* more

closely paralleled Manship's *Satyr and Sleeping Nymph* than did his exhibited sculpture.

19. *Boston Herald*, 21 February 1915, sec. D, p. 3.

20. "Manship's Figures of Women More Animal Than Human; Sculpture Seen at Detroit Museum of Art," *Detroit News*, 27 November 1915, p. 17.

21. *New York Tribune*, 21 January 1914, p. 5. An editorial titled "The Blushing Post-Office and the Fine Arts" in *Metropolitan Magazine* 39 (March 1914):6 attributed Morgan's attacks to the "Socialistic" policies of the magazine. Postmaster Morgan's action occurred in the climate of Anthony Comstock's reign of morality. A special agent for the Post Office Department and founder of the New York Society for the Suppression of Vice, Comstock engineered the arrest, on charges of indecency, of thirty-six hundred men, women, and children between 1872 and 1915 (Robert Bremner, ed., introduction to Anthony Comstock, *Traps for the Young*, pp. viii–ix).

22. Kenyon Cox, "Art: A New Sculptor," *The Nation* 96 (13 February 1913):162–163.

23. Cox's praise of archaic statuary in an essay published two months after his review of Manship's work may have had a stimulus in Manship ("The Illusion of Progress," *Century Magazine* 86 [May 1913]:39–43, esp. p. 42, reprinted in Cox, *Artist and Public*).

24. Kenyon Cox, *The Classic Point of View*, pp. 3–4.

25. Ibid., pp. 149–150. On Cox and fellow "traditionalist" writers on art, see H. Wayne Morgan, *Keepers of Culture: The Art-Thought of Kenyon Cox, Royal Cortissoz, and Frank Jewett Mather, Jr.*

26. William Kendall to Glenn Brown, 25 August 1911, AAR Papers, AAA.

27. William Walton, *World's Columbian Exposition: Art and Architecture*, p. 10. Unfortunately, Walton does not elaborate on his use of the term "modern-archaic." According to Michele Bogart, Saint-Gaudens, rather than French, initially conceived the statue of *The Republic* (*Public Sculpture*, p. 45).

28. Julie C. Gauthier, *The Minnesota Capitol: Official Guide and History*, p. 9. For an opposing point of view, see Nelson R. Abbott, "Recent Work by Daniel Chester French," *Brush and Pencil* 8 (April 1901):43–48.

29. Gauthier, *The Minnesota Capitol*, p. 9.

30. Saint-Gaudens's caryatids were installed on the exterior of the Albright Art Gallery in Buffalo in 1933, almost two decades after its founding. They are reproduced as plates 214-1 and 214-2 (p. 302) in John H. Dryfout, *The Work of Augustus Saint-Gaudens*.

31. Homer Saint-Gaudens, ed., *The Reminiscences of Augustus Saint-Gaudens* 2:357.

32. Dennis, *Bitter*, pp. 136–137.

33. In sculptures for the Wisconsin State Capitol drum executed after his visit to Greece in 1910, Bitter's archaism is less rigid. His borrowings from the archaic (most obvious in hair and drapery stylizations) have new assurance, while greater freedom of pose and expression lends vigor and authority to his work. For a discussion of the Wisconsin sculptures, see ibid., pp. 139–148.

34. Charles Caffin, "Great Promise Shown in a Young Sculptor's Work," *New York American*, 17 February 1913, p. 8. On Caffin as a critic, see Sandra Lee Underwood, *Charles Caffin: A Voice for Modernism, 1897–1918*. Other studies of American art criticism during

this period include Morgan, *Keepers of Culture;* Arlene R. Olsen, *Art Critics and the Avant-Garde: New York, 1900–1913,* focusing on Royal Cortissoz, James Gibbons Huneker, and Elizabeth Luther Cary; and Virginia McCord Mecklenburg, "American Aesthetic Theory, 1908–1917: Issues in Conservative and Avant Garde Thought" (Ph.D. diss., University of Maryland, 1983).

35. Michele Bogart's *Public Sculpture* is the major study of this subject. Bogart's earlier "In Search of a United Front: American Architectural Sculpture at the Turn of the Century," *Winterthur Portfolio* 19(Summer-Fall 1984): 151–176, focuses specifically on the problems inherent in sculptors' dependence on architectural commissions.

36. For the controversy over the *Maine Memorial,* see Bogart, *Public Sculpture,* pp. 194–204.

37. See, for example, Daniel Robbins, "From Statues to Sculpture: From the Nineties to the Thirties," p. 133.

38. Charles Caffin regarded the increasing popularity of the statuette as a sign of the public's "improved taste"; see his review of the National Arts Club exhibition, "Public Taste in Sculpture Improved," *New York American,* 12 May 1913, p. 8.

39. *Philadelphia Public Ledger,* 14 February 1915, women's sec., p. 7.

40. Vitry, *Paul Manship,* p. 11.

41. In 1910, the prize had gone to Eberle for *Windy Doorstep* and, in 1912, to Edward McCartan for *Fountain.*

42. A. E. Gallatin, *Paul Manship: A Critical Essay on His Sculpture and an Iconography,* p. 8.

43. Cox, "A New Sculptor," p. 163. For Cox's estimation of Rodin, see *Painters and Sculptors,* pp. 127–154. Royal Cortissoz accused Rodin himself of being mannered in a largely uncom-

plimentary essay on the sculptor in *Art and Common Sense,* pp. 365–377, esp. 372–377.

44. Daniel Chester French's memorial to Martin Milmore (1889–1893) presents a similar fiction in depicting the sculptor, who died at a young age, being stopped *in the act of carving* by the Angel of Death; neither Milmore nor French executed their own carving, however, and French's finished work is bronze. The Metropolitan Museum of Art owns a later, marble copy of the Milmore Memorial.

45. On the "unintelligibility" of Rodin's sculpture, see Krauss, *Passages in Modern Sculpture,* pp. 15–32.

46. Caffin, "Sculpture by Manship Shown," *New York American,* 24 November 1913, p. 6.

47. Kenyon Cox, contrasting Augustus Saint-Gaudens and Rodin, described the American sculptor in a manner that applies equally well to Manship: "design is his affair, the pattern of the whole, its decorative effect and play of line, its beauty of masses and spaces. . . . the realisation of parts is rigidly subordinated to decorative effect and beauty of *ensemble*" (*Painters and Sculptors,* p. 142).

48. *Boston Herald,* 21 February 1915, sec. D, p. 3.

49. Manship to a Mr. Baldwin, 28 January 1914, courtesy of John Manship. Manship's identification of impressionism in sculpture with a style or technique differs from that of the French artists whose points of view are represented in Claris's *De l'Impressionisme en sculpture* (1902). For them, impressionism signified (as it did in painting) the artist's determination to follow nature and self, immediate sensation, rather than the schools of art (convention) in the creation of sculpture.

50. Roberta K. Tarbell, "Sculpture in America before the Armory Show," in Tarbell et al., *Vanguard American Sculpture, 1913–1939*, p. 5. George Gray Barnard personally carved his heroic *Struggle of Two Natures in Man* in the early 1890s, but the work had previously been modeled and cast in plaster.

51. Beach to Paul Wayland Bartlett, 11 January 1914, Paul Wayland Bartlett Papers, Library of Congress.

52. Chester Beach Papers, AAA. In an undated letter to Konti, Manship mentioned that Beach had been invited to Thanksgiving [1910] dinner at the Academy (Konti Papers, AAA).

53. Beach to William MacBeth, 26 May [1911], MacBeth Gallery Papers, AAA.

54. Ibid. Beach refers only to the sculpture of Serbia, but he certainly meant Meštrović.

55. Beach to MacBeth, 2 November 1911, MacBeth Papers, AAA.

56. Manship mentions Beach in correspondence to Konti, letters undated and of 29 January [1911?] and 31 October 1911 (Konti Papers, AAA). He described the six rediscovered Michelangelo marbles in the Museo Nazionale in Florence in an undated letter, also to Konti.

57. In a 1936 lecture to the American Federation of Arts, Manship made his position clear: "In our world of realism, when a sculptor struggles with ancient methods over a piece of diorite or porphyry, carving a figure from it, although admiring his tenacity and ability, one realizes that mechanical tools and the Carborundum wheel are more rapid consumers of hard material" (Manship Papers, AAA).

58. See Flannagan's "The Image in the Rock," the classic statement of the direct carver's voyage of discovery

(Miller, ed., *The Sculpture of John B. Flannagan*, pp. 7–8).

59. "The Reminiscences of Paul Manship," 1958, Oral History Collection, Columbia University.

60. Paper given at the Art Students League, New York, 1915, Manship Papers, AAA.

61. Ibid. See also chapter 1, pp. 26–27. A description of Manship's technique appears in Alec Miller, *Tradition in Sculpture*, p. 157. William Wetmore Story, the dean of American sculptors in Rome until his death in 1895, had a scholar's interest in the use of plaster. On the basis of a passage in Pliny, Story concluded that ancient sculptors did not cast in plaster, as one of his contemporaries had asserted, but that they did use it as a modeling material ("The Art of Casting in Plaster among the Ancient Greeks and Romans," in *Excursions in Art and Letters*, pp. 89–115). Mid-nineteenth-century American sculptor Hiram Powers abandoned modeling in clay for modeling in plaster, for which he devised special tools; see Donald Martin Reynolds, *Hiram Powers and His Ideal Sculpture*, pp. 247–251.

62. Walker Hancock, interview with Susan Rather, Lanesville, Mass., 25 August 1984.

63. For a synchronic study of the international visual, literary, and performing arts, see L. Brion-Guerry, ed., *L'Année 1913: Les formes esthéthiques du l'oeuvre d'art à la veille de la première guerre mondiale;* Jean Laude's "La Sculpture en 1913" (in Brion-Guerry 1:203–275) includes a brief section on archaism (pp. 220–225).

64. Keck's work is pictured in the Architectural League's catalogue-yearbook for 1913. In their nudity, Manship's figures are also rather un-

archaic; the female nude does not appear with any frequency in Greek sculpture before the fourth century B.C.

65. *New York Tribune,* 20 December 1913, p. 9; Caffin, "Great Promise Shown in a Young Sculptor's Work," *New York American,* 17 February 1913, p. 8.

66. Thirty-five American sculptors, selected by Arthur B. Davies, Gutzon Borglum, and John Mowbray-Clarke, exhibited at the Armory Show. As president of the Association of American Painters and Sculptors, sponsor of the show, Davies made the event an international showcase for modern art. In 1911, when he assumed the presidency, Davies had just returned from extensive travels in the Mediterranean, including Greece; he declared the paintings at Pompeii "so archaic—so great—so modern" (Davies to William MacBeth, 6 December 1910, MacBeth Gallery Papers, AAA, as quoted in Brooks Wright, *The Artist and the Unicorn: The Lives of Arthur B. Davies (1862–1928),* p. 54).

67. Photographs of selected American sculpture entries appear in Munson-Williams-Proctor Institute, *1913 Armory Show 50th Anniversary Exhibition, 1963,* pp. 146–154. This useful catalogue and Milton W. Brown's *The Story of the Armory Show* remain the standard works on the subject. In the wake of the Armory Show, Davidson expressed concern for what he saw as "an absence of true consciousness of the material" on the part of many sculptors (F[rederick] J. G[regg], "The Extremists: An Interview with Jo Davidson," *Arts and Decoration* 3[March 1913]:171).

68. Compare Rodin's conception of *la science du modelé* as related in Auguste Rodin, *L'Art, entretiens réunis par Paul Gsell,* pp. 63–64.

69. A year earlier, Alfred Stieglitz showed other of Matisse's sculptures at 291; he reprinted selected reviews in *Camera Work* 38(April 1912):45–46.

70. For Matisse's concept of expression, see his "Notes of Painter" (1908), reprinted in translation in Alfred H. Barr, Jr., *Matisse: His Art and His Public,* pp. 119–123.

71. Krauss terms this effect "contextual drawing" in her sensitive discussion of Brancusi in *Passages in Modern Sculpture,* pp. 84–103.

72. Manship, "Decorative Value" (Appendix p. 185).

73. As quoted in Agee and Hamilton, *Raymond Duchamp-Villon, 1879–1918,* p. 50.

74. Kenyon Cox, "The 'Modern' Spirit in Art," *Harper's Weekly* 57 (15 March 1913):10. Although Cox used the phrase "artistic anarchy" with reference to selected paintings in the exhibition, he undoubtedly would have included the more radically modern sculptures in that designation had he chosen to comment upon them. Few writers did; but for a positive, if not particularly detailed, review, see William Murrell Fisher, "Sculpture at the Exhibition," *Arts and Decoration* 3 (March 1913):168–169.

75. Cox, "A New Sculptor," p. 163.

76. Bulkeley Cable, "Three Special Exhibitions of Notable Works of Art Are on View at City Museum," *St. Louis Republic,* 11 April 1915, sec. 2, p. 5.

77. Herbert Adams to C. Grant La Farge, 8 December 1913, AAR Files, New York.

78. Ibid.

79. Frank Fairbanks (Fellow, American Academy in Rome, 1909–1912) to Gorham Phillips Stevens, 21 April 1913, AAR Papers, AAA.

80. Ibid. Academy alumnus Albin

Polasek likewise spoke of the difficulties in making a transition from the sheltered life of a fellow in Rome to the realities of earning a living as an artist in New York. In 1914, the Association of the Alumni of the Academy formed a committee to assist returning fellows on matters of employment and exhibition (Annual Report for 1913–1914, AAR Papers, AAA). Manship served on the Association's Council.

81. Panama-Pacific International Exposition, 1915, Department of Fine Arts, *Catalogue Deluxe of the Department of Fine Arts* 1:58. Michele Bogart explains archaism as an attempt by sculptors to make their work "stylistically more harmonious" with the more simplified, rectilinear architecture of the 1920s and 1930s. She suggests that the change from the Beaux-Arts style in sculpture reflects "the architect's triumph in defining the aesthetic discussions in formalist terms" ("In Search of a United Front," p. 176). This argument ignores the earlier international context for archaism, its appearance in a wide range of art forms, and the largely non-architectural archaistic sculpture of Manship.

82. Adams to C. Grant La Farge, 8 December 1913, AAR Files, New York. As published in *Art and Progress* 6(November 1914):20–21, this letter was mistakenly identified as a response to the National Academy of Design's winter 1913 exhibition, which did not open until 20 December 1913.

83. On garden sculpture see *Fauns and Fountains: American Garden Statuary, 1890–1930,* essays by Michele H. Bogart and Deborah Nevins.

84. On Roman herms, see Cornelius C. Vermeule III, *Greek Sculpture and Roman Taste: The Purpose and Setting of Graeco-Roman Art in Italy and the Greek Imperial East;* for Roman herms in the style of archaic korai, see also H. Stuart Jones, ed., *A Catalogue of the Ancient Sculptures Preserved in the Municipal Collections of Rome: The Sculptures of the Palazzo dei Conservatori* 2:pl. 55. Evelyn B. Harrison, *Archaic and Archaistic Sculpture,* pp. 108–176, discusses Greek herms.

85. "The Reminiscences of Paul Manship," 1958, Oral History Collection, Columbia University.

86. Royal Cortissoz, quoted in "A Modern Primitive in Art," *Literary Digest* 52(6 May 1916):1279. Cortissoz had Manship's *Dancer and Gazelles* in mind, a sculpture uncharacteristically conceived in the larger size. When Manship converted a work from one size to another, he did not simply abandon it to mechanical processes, but reworked it somewhat (as comparison of the two versions of *Dancer and Gazelles* reveals); even so, the results are often unsatisfactory. See Vitry, *Paul Manship,* p. 27. On the *Dancer and Gazelles,* see chap. 5, this volume.

87. Walker Hancock, interview with Susan Rather, 25 August 1984.

88. Martin Birnbaum, *The Last Romantic,* p. 85.

89. As quoted in Sherwood, *Polasek,* pp. 277–285.

90. Items about Manship's sculpture began to proliferate in the press at just about this time, although how much of this Birnbaum stimulated is difficult to say. For the frequent notices and photographs of Manship's work in *Vanity Fair,* the sculptor could probably thank the magazine's editor, Frank Crowninshield, director of the Academy during Manship's fellowship.

91. Birnbaum, *Last Romantic,* pp. 64–65. Birnbaum's *Catalogue of an Exhibition of Sculpture by Paul Manship* is reprinted in *Introductions,* a collection of Birnbaum's catalogue essays on

various artists shown under his aegis. Birnbaum represented Manship until about 1930, when he left Scott and Fowles (which he joined soon after Manship's 1916 exhibition) to become a private consultant; at that time, Manship elected not to retain a dealer (John Manship, conversation with Susan Rather, 26 April 1984).

92. L. S., "Art—The Winter Academy," *The Nation* 97(25 December 1913):627.

93. Royal Cortissoz, "Matters of Art," *New York Tribune,* 23 November 1913, sec. 5, p. 6.

94. See, for example, "A Survey of Sculpture through the Ages," lecture notes (ca. 1944), Manship Papers, AAA.

5. Archaism from Other Places and in Other Modes

1. The two publications are H. H. Cole's *Catalogue of the Objects of Indian Art Exhibited in the South Kensington Museum* (1874), which contains the first history of Indian art, and Ananda K. Coomaraswamy's *History of Indian and Indonesian Art* (1927).

2. V. A. Smith, "Graeco-Roman Influence on the Civilization of India," *Journal, Asiatic Society of Bengal* 58, pt. 1 (1889, no. 3):173. Scholars now believe that Gandharan art took its classicizing elements from Roman art of the late first and second centuries A.D.

3. E. B. Havell, *Indian Sculpture and Painting,* p. 6, n. 1. Smith is better represented by the monumental *A History of Fine Art in India and Ceylon.*

4. Havell, *Indian Sculpture and Painting,* pp. 6, 25, 23.

5. On the changing Western perceptions of Indian art, see Partha Mitter, *Much Maligned Monsters: History of European Reactions to Indian Art;* also Pramod Chandra, *On the Study of Indian Art.* The India Society, renamed the Royal India Society in the 1930s, should not be confused with the Indian Society of Oriental Art, a group supporting modern Indian art, with which Havell and Coomaraswamy also associated.

6. Roger Fry, "Oriental Art" [four book reviews], *Quarterly Review* 212 (1910):226. Indian art "is at once stranger and more familiar than the art of China and Japan," Fry wrote: "More familiar in that it treats the human figure with a certain structural completeness which . . . at least recalls the general European tradition. Stranger in . . . the religious symbolism of Brahmanism. . . . We stand aghast before certain many-armed and many-headed figures in which the ideas of Siva and Vishnu are visualized" (pp. 234–235). Chandra suggests that the study of Indian sculpture developed only slowly, owing to the distaste of nineteenth-century scholars for a presumed "heathenish idolatry" (*On the Study of Indian Art,* p. 41).

7. Fry, "Oriental Art," pp. 227, 226. In a later essay entitled "The History of Sculpture," Manship, too, remarked on the formal similarities between Indian and European medieval art (*Encyclopaedia Britannica,* 1952 ed., s.v. "Sculpture").

8. Fry, "Oriental Art," p. 239.

9. See MacCarthy, *Eric Gill,* pp. 97–100.

10. Gill defined Heaven as "the achievement of unalloyed contemplation of God in surroundings having no significances but those of form" (introduction to Ananda Coomaraswamy, *Viśvakarma: Examples of Indian Architecture, Sculpture, Painting, Handicraft, First Series: One Hundred Examples of Indian Sculpture,* p. 6).

11. For Gill, "the zenith of Greek art was reached long before the time of

Phidias," in the archaic period (ibid., p. 4).

12. Ibid. In this essay, Gill uses the terms "archaic" and "primitive" interchangeably.

13. *Mediaeval Sinhalese Art* was printed by hand on William Morris's Kelmscott Press (renamed the Essex House Press), which Coomaraswamy at that time managed and operated out of his home at Broad Campden, England. Morris's example deeply influenced Coomaraswamy's efforts to promote a modern revival of Indian arts and crafts; see "Coomaraswamy and William Morris: The Filiation," in Roger Lipsey, *Coomaraswamy* 3:258–264.

14. For a select bibliography of Coomaraswamy's writings, see Lipsey, *Coomaraswamy* 3:293–304.

15. Ibid., p. 93. Devi was the stage name for Alice Richardson, an Englishwoman.

16. Among the many accounts of the development of modern dance, see especially Elizabeth Kendall, *Where She Danced: American Dancing, 1880–1930.*

17. On St. Denis's Orientalism, see Suzanne Shelton, *Divine Dancer: A Biography of Ruth St. Denis,* pp. 37–65, 89–117. St. Denis's emergence as a respectable and serious artist owed much to her patronage by prominent women from social and artistic circles, including Mrs. Karl Bitter, Mrs. Edwin Blashfield, Mrs. Arthur Davies, Mrs. J. Alden Weir, among the twenty-five sponsors of her March 22, 1906, performance at New York's Hudson Theatre. See Ruth St. Denis, *An Unfinished Life,* p. 67; and Denishawn Collection scrapbooks, vol. 1: St. Denis, 1906–1909, Dance Collection, Library and Museum of the Performing Arts, New York Public Library at Lincoln Center.

18. Faubion Bowers, *The Dance in India,* p. 97.

19. The design for the set of *Radha* erroneously housed the Hindu goddess in a Jain temple (Shelton, *St. Denis,* p. 51). St. Denis's husband and partner, Ted Shawn, asserted that her Indian choreography in *Radha* represented "the first attempt in the Occidental world to preach a religious doctrine through the medium of dance" (Shawn, *Ruth St. Denis: Pioneer and Prophet* 1:33).

20. Roshanara, an English contemporary of St. Denis's who helped popularize Indian dance, learned her art while growing up in India; she also performed with some of the most notable Western companies of the day, including those of Loie Fuller, Diaghilev, and Pavlova (Nesta MacDonald, *Diaghilev Observed by Critics in England and the United States, 1911–1929,* p. 61). In January 1914, Roshanara danced at New York's Palace Theatre (for a photograph, see the *New York Tribune,* 4 January 1914, sec. 3, p. 7) and, in 1917, appeared with Ratan Devi (Mrs. Coomaraswamy), also in New York (see Coomaraswamy, "Oriental Dances in America," *Vanity Fair* 8[May 1917]:61; the facing page shows Ruth St. Denis performing one of her Indian dances).

21. For correspondence concerning Manship's gift of the Hercules Fountain to the Academy, see AAR Papers, AAA.

22. Although the caplike arrangement of the lion's skin is not uncommon, it more rarely appears as a mantle, twisted around the arm, as in Manship's *Hercules.* For a provincial Roman parallel to this treatment, see British Museum, *Select Bronzes: Greek, Roman, and Etruscan in the Department of Antiquities,* pl. LI.

23. For a well-known seated infant Hercules, see the example in the Capitoline Museum illustrated in Margarete Bieber, *The Sculpture of the Hellenistic Age,* fig. 536. A rare standing infant

Hercules, dated to the first century
B.C., is in the St. Louis Art Museum.
24. Renaissance sources were suggested by Vitry, *Paul Manship*, p. 12;
Casson, *XXth Century Sculptors*, p. 50;
and Beatrice Gilman Proske, *Brookgreen
Gardens Sculpture*, p. 307. The more exotic models were proposed by Charles
Caffin, *New York American*, 8 February
1915, p. 9; in the *Philadelphia Public
Ledger* (14 February 1915), women's
sec., p. 7; and "Exhibitions at the Art
Institute: Sculpture by Paul Manship—
Paintings by Robert Henri," *Fine Arts
Journal* 33(1915):429–430.
25. Ananda Coomaraswamy, *Yakṣas*,
p. 32. Vincent Smith had suggested a
Western origin for the motif (*A History*,
pp. 380–382). See also J. Ph. Vogel,
"The Woman and Tree or *śālabhañjikā*
in Indian Literature and Art," *Acta Orientalia* 7(1928):201–231.
26. Yakṣīs often stand on animals or
grotesques; see, for example, Sherman
E. Lee, *A History of Far Eastern Art*,
figs. 89, 104. As noted in chap. 1, Manship's grotesques surely derive from
Greek archaic antefixes.
27. Ananda K. Coomaraswamy and
Sister Nivedita [Margaret E. Noble],
Myths of the Hindus and Buddhists, chap. 4.
28. On the "indischen Herakles," see
Moriz Winternitz, *Geschichte der Indischen Literatur* [1908] 1:389; see also
the introductory sentence of K. E. Neumann, *Krishnas Weltengang* (1905), p. 5.
29. On the scarcity of sculptural
representations of the *kāliyadamana*, see
J. Ph. Vogel, *Indian Serpent-Lore or the
Nagas in Hindu Legend and Art*, p. 90;
but see the south Indian bronze in E. B.
Havell, *Eleven Plates Representing Works
of Indian Sculpture, Chiefly in English
Collections*, pl. 8.
30. "Exhibitions at the Art Institute:
Sculpture by Paul Manship—Paintings
by Robert Henri," *Fine Arts Journal*

33(1915):429–430. Reproductions of
the Lion Capital appeared in Coomaraswamy, *Viśvakarma*, pl. LXXX; and
Smith, *A History*, pl. XIII.
31. George Humber, "Paul Manship," *New Republic* 6(25 March 1916):
208; and "A Modern Primitive in Art,"
The Literary Digest 52(6 May 1916):1278.
The latter, unnamed reviewer was not
specific in the reference to Havell, but
seems to have had in mind pl. 7 in *Indian Sculpture and Painting* (1908); see
also pl. 13 from the same book.
32. *New York Herald*, 16 February
1913, magazine sec., p. 7.
33. Jacob Epstein, *The Sculptor
Speaks: Jacob Epstein to Arnold L. Haskell*, p. 155.
34. As quoted in Sherwood, *Polasek*,
p. 285.
35. Birnbaum documented his friendship with Mary Mowbray-Clarke in his
autobiography, *The Last Romantic*,
p. 66. Coomaraswamy offset his scholarly Boston life with a more Bohemian
New York existence centered around
the Sunwise Turn; its example inspired
him to join bookseller George M. L.
Brown in opening the New York bookshop Orientalia to deal exclusively in
works about the East (Lipsey, *Coomaraswamy* 3:147, 154).
36. Madge Jenison, *Sunwise Turn: A
Human Comedy of Bookselling*, p. 22. For
additional information on the Sunwise
Turn, those who frequented it, and
contemporary interest in Indian art, see
Roberta K. Tarbell, *Hugo Robus (1885–
1964)*, pp. 43–45.
37. According to Lipsey, "the only
well-known American artist whose
contact with Coomaraswamy has
been recorded—aside from Georgia
O'Keeffe, . . .—was Morris Graves"
(*Coomaraswamy* 3:223). It is hard to
imagine Coomaraswamy having much
interest in Manship's work, given his

statement that "the two things that matter least about a work of art are its charm and its technique"—in other words, the very qualities for which Manship was repeatedly praised (*A Catalogue of Sculptures by John Mowbray Clarke* [New York, 1919], as quoted in Lipsey, *Coomaraswamy* 3:149).

38. The list of members and publications derives from the India Society, *Report for the Year 1917.*

39. "A Tribute by Barry Faulkner read by Dr. Murphy at Grace Church," 8 February 1966 [memorial service for Manship], Hancock Papers, AAA. Faulkner was Manship's closest friend and, in the mid-1920s, moved into an apartment on the fourth floor of the Manships' residence at 319 East 72nd Street. For Faulkner's reminiscences of Manship, see Faulkner, *Barry Faulkner,* pp. 81–84, 133–137, 156–157.

40. Gallatin, *Paul Manship,* pp. 5–6.

41. See Rodin's praise of two bronze sculptures of Śiva Natarāja in the Madras Museum in Victor Goloubew et al., *Sculpture Civaites,* pp. 9–13. In his preface, Goloubew noted that Rodin wrote his commentary in 1913 on the basis of photographs deposited in the Musée Guimet (and published in Goloubew's volume).

42. Reproductions of the Ajanta motifs appeared in numerous publications, most lavishly in John Griffiths, *The Paintings in the Buddhist Cave-Temples of Ajanta* (1897), vol. 2: *Decorative Details,* pls. 116–132.

43. Ananda Coomaraswamy, "Some Ancient Elements in Indian Decorative Art," *Ostasiatische Zeitschrift* 2(January–March 1914):383–384.

44. Ibid., p. 392. Coomaraswamy suggested that the Greek egg and dart motif derived ultimately from the Indian lotus petal molding (p. 389).

45. Ibid., p. 388.

46. Gallatin, *Paul Manship,* pp. 5–6; and Finley, foreword to Murtha, *Paul Manship,* p. 9. For a more static, Roman counterpart to Manship's gazelles, see the bronze deer from Herculaneum illustrated in Vittorio Spinazzola, *Le arti decorative in Pompei e nel Museo Nazionale di Napoli,* p. 251.

47. Lipchitz's *Woman and Gazelles* began as a single gazelle to which the nude and, later, a second gazelle were added; see Henry R. Hope, *The Sculpture of Jacques Lipchitz* (1954), reprinted in Museum of Modern Art, *Five American Sculptors,* p. 9.

48. Coomaraswamy, "Rajput Paintings," *Burlington Magazine* 20(March 1912):314–325, and idem, "Rajput Painting," *Ostasiatische Zeitschrift* 1(July 1912):125–139.

49. Ananda Coomaraswamy, *Rajput Painting,* pp. 2, 6.

50. Ibid., p. 6.

51. Manship, interview with John D. Morse, 18 February 1959, AAA.

52. Coomaraswamy included the same Rajasthani picture of Toḍī Rāgiṇī in his *Selected Examples of Indian Art* (1910), pl. IV; *The Arts and Crafts of India and Ceylon* (1913), fig. 78; and *Rajput Painting,* pl. XII-B. The earliest of these publications also reproduced a modern Indian drawing of a dancing Apsara (celestial nymph) by Asit Kumar Haldar (pl. XIV) that strikingly evokes Manship's dancer.

53. "Who has escaped the net of nature, O bewildered deer? The more you warily run, the more you are tangled therein!" (Coomaraswamy, *Rajput Painting,* p. 69; see also pl. XII-B).

54. R. Petrucci, "Rajput Painting," *Burlington Magazine* 29(May 1916): 74–79, esp. p. 76; Gill, introduction to Coomaraswamy, *Viśvakarma.* See also Coomaraswamy, *Rajput Painting,* p. 14, n. 4.

55. Fritz Behn, Henri Bouchard, Albin Polasek, and Edward Sanford, among other contemporary sculptors, essayed the woman and gazelle motif. The Metropolitan Museum of Art acquired a marble version of Bouchard's *Girl with Gazelle* in 1910, and Bouchard (a fellow of the French academy in Rome from 1902 to 1906) showed the same sculpture in bronze at the International Exposition in Rome in 1911; for an early essay on this sculptor, see Henry Marcel, "Le statuaire Henri Bouchard et son oeuvre," *Gazette des Beaux Arts* ser. 4, 9(1913):236–252.

56. Arthur W. Ryder's authoritative English translation of *Śakuntalā* appeared in 1912, supplanting the version by Monier Monier-Williams, in its eighth edition in 1898. An extensive listing of Western-language editions appears in Sten Konow, *The Indian Drama*, pp. 109–112.

57. The playbill and printed script— "An English Version of Sakuntala, Based upon Monier Williams' Translation of the Sanskrit Drama by Kalidasa, by Alice Morgan Wright"—are among the Alice Morgan Wright Papers, Sophia Smith Collection, Smith College. On St. Denis, see Shelton, *Divine Dancer*, p. 50.

58. Paul Klee summarized an entire scene from *Śakuntalā* in his *Abenteuer eines Fräuleins* (1922), one of several creative adaptations from Indian literary and visual sources (including rāgamālā painting) in his work; see Peg Delamater, "Some Indian Sources in the Art of Paul Klee," *Art Bulletin* 66(December 1984):657–672.

59. Manship, "Sculpture," *Encyclopaedia Britannica*, 1952.

60. Ibid. Manship also labeled the late Hellenistic and Baroque periods decadent. Maurice Sterne offers a slightly backhanded appraisal of the formal

strengths of Hindu sculpture; see Mayerson, ed., *Shadow and Light*, p. 92.

61. Gill, introduction to Coomaraswamy, *Viśvakarma*, p. 5.

62. Isadora Duncan, *The Art of the Dance*, p. 72. This book, published soon after Duncan's accidental death in 1927 but planned by her in collaboration with Sheldon Cheney, collects the dancer's major writings on her art, including previously published essays and program notes, as well as manuscript material. In some instances, as Cheney explains in his introduction and notes, the dates are unknown or ambiguous; in such cases, I do not provide them.

63. Caffin, "Art Notes," *New York Evening Post*, 8 November 1913; see also his "Interpretations of Dance in Sculpture at MacBeth's," *New York American*, 15 March 1915, p. 9. A frequent commentator on dance, in 1912 Caffin co-authored, with his wife Caroline Caffin, *Dancing and Dancers of Today: The Modern Revival of Dancing As an Art.*

64. For Fuller, see Robert Schmutzler, *Art Nouveau*, figs. 35, 168, 169, 172. On Hoffman, see the exhibition catalogue by Janis C. Conner, *A Dancer in Relief: Works by Malvina Hoffman.*

65. For an account of her first trip to Greece, see Isadora Duncan, *My Life*, pp. 116–135.

66. See, for example, Maurice Emmanuel, *La Danse grecque antique d'après les monuments figurés* (1896); English ed.: *The Antique Greek Dance after Sculpted and Painted Figures.*

67. Duncan, *Art of the Dance*, p. 102. Duncan writes of studying Greek vases in a letter from Athens of November 1903, published in *Le Ménestral* 69(13 December 1903):399. The New York Public Library's Dance Collection owns fifty-four photographs that belonged to Duncan; those of Greek works include the Charioteer of Delphi, several red-

figure vases, and Hellenistic sculpture. On dancer Maud Allan's study of Greek vase painting, see Maud Allan, *My Life in Dancing*, pp. 74–76.

68. Duncan, ca. 1920, *Art of the Dance*, p. 139.

69. Ibid. I discuss direct carving as "finding" in chapter 3, p. 63.

70. Rodin as quoted by Duncan, *Art of the Dance*, p. 102. Rodin and Duncan, great admirers of one another's work, first met in 1901; Rodin called Duncan "the greatest woman I have ever known, and her art has influenced my work more than any other inspiration that has come to me" (Rodin to Mary Fanton Roberts, as related by her in "Isadora—the Dancer," *Denishawn Magazine* 1[Summer 1925]:9).

71. Cézanne, as quoted by Emile Bernard in "Paul Cézanne," *L'Occident* 6(July 1904):24, in Shiff, *Cézanne and the End of Impressionism*, p. 124; also pp. 180–184.

72. Caffin and Caffin, *Dancing and Dancers*, p. 52. On Duncan's apparent lack of technical system and spontaneity of expression, see H. T. P., "A Dancer Whose Art Is All Her Own," *Boston Evening Transcript* (28 November 1908), reprinted in Olive Holmes, ed., *Motion Arrested: Dance Reviews of H. T. Parker*, pp. 56–61.

73. As quoted in Cheney, introduction to Duncan, *Art of the Dance*, p. 9. See also H. T. P., "Sculptural Isadora," *Boston Evening Transcript*, 21 October 1922, reprinted in Holmes, ed., *Motion Arrested*, pp. 66–70.

74. As quoted in Walter Terry, *Isadora*, p. 116.

75. For documentation of the development of Bourdelle's reliefs, from initial sketches of Duncan dancing through completion, see Claude Aveline and Michel Dufet, *Bourdelle et la danse: Isadora et Nijinsky;* see also Denise Basde-

vant, *Bourdelle et le Théâtre des Champs-Elysées*. The many drawings of Duncan dancing by Bourdelle and his contemporaries have proven useful to the reconstruction of the dancer's movements because, according to Annabelle Gamson, "Duncan didn't deal in steps but forms and shapes" (quoted in Barry Laine, "In Her Footsteps," *Ballet News* 3[February 1982]:22). See also Abraham Walkowitz, *Isadora Duncan in Her Dances*.

76. Taft, *Modern Tendencies in Sculpture*, p. 41.

77. Bronislava Nijinska, *Bronislava Nijinska: Early Memoirs*, p. 428; André Levinson, *Ballet Old and New*, p. 61. Levinson, a Russian who became the premier dance critic in France after moving there in 1921, opposed such "archaeological" tendencies in the ballet; referring to *L'Après-midi d'un faune*, he declared it "an unartistic idea to stretch along the footlights the figures that decorate the circumference of a vase in a living wreath, as if they were traced from an archaeology textbook" (pp. 61–62). For possible sources among the Greek vases in the Louvre, see Jean-Michel Nectoux et al., *Afternoon of a Faun: Mallarmé, Debussy, Nijinsky*, pp. 20–23.

78. From the *Pall Mall Gazette*, 2 February 1913, as quoted in MacDonald, *Diaghilev Observed*, p. 79. Subsequent to *L'Après-midi d'un faune*, the Ballets Russes continued its sensational primitivism with the shocking barbarism of Nijinsky's *Le Sacre du printemps*. An imaginative evocation of Russian folk rituals, *Sacre*'s simplified and rigid movements prompted critical outrage at Nijinsky for "laboriously instructing a highly-accomplished *corps de ballet* in mimicry of the awkward poses exhibited in sculpture of pre-classical days, when the sculptor was not so much ex-

pressive as struggling for expression" (A. E. Johnson, *The Russian Ballet* [1913], p. 210). See also Millicent Hodson, "Ritual Design in the New Dance: Nijinsky's *Le Sacre du printemps,*" *Dance Research* 3(Summer 1985):35–45.

79. On this topic more generally, see Joan Ross Acocella, "The Reception of Diaghilev's Ballets Russes by Artists and Intellectuals in Paris and London, 1909–1914" (Ph.D. diss., Rutgers University, 1984).

80. Along with other contemporary "testaments," Rodin's letter is reprinted in Nectoux et al., *Afternoon of a Faun,* p. 47.

81. Johnson, *The Russian Ballet,* p. 181.

82. Romola Nijinsky, *Nijinsky,* p. 91. Igor Stravinsky reported that Bakst "dominated" the production of *L'Après-midi d'un faune.* "Besides creating the decorative setting and the beautiful costumes, he inspired the slightest gesture and choreographic movement," Stravinsky wrote in *An Autobiography,* p. 36. Nijinsky, not unexpectedly, suggested quite the opposite, claiming credit even for the set (*Le Journal de Nijinksy,* p. 212). For Bakst's contributions to the choreography of the Ballets Russes's various Greek ballets, see Charles S. Mayer, "The Influence of Léon Bakst on Choreography," *Dance Chronicle* 1:2(1978):127–142.

83. Léon Bakst, "Les Formes nouvelles du classicisme dans l'art," *La Grande Revue* 61(25 June 1910):770–800; first published in the Russian periodical *Apollon* in 1909. See also "Léon Bakst on the Revolutionary Aims of the Serge de Diaghilev Ballet," *Current Opinion* 59(October 1915):246.

84. Bakst, "Les Formes nouvelles," p. 800. Gauguin, Denis, and Matisse are among the few modern painters for whom Bakst has words of praise.

85. Birnbaum claimed that the Bakst exhibition "broke all records for attendance" at the gallery (*The Last Romantic,* p. 72). In 1916, Birnbaum devoted his first show at Scott and Fowles to Bakst, presumably to capitalize on the Ballets Russes's first American tour, which took place that year. For collected responses to this tour, see MacDonald, *Diaghilev Observed,* pp. 136–167. A flood of publicity preceded the Ballets Russes's opening at the Century Theatre in New York in January 1916 (see Diaghilev's "Scrapbook: Clippings and Announcements, 1915–16" in the Dance Collection, NYPL).

86. Birnbaum, *Léon Bakst,* p. 7.

87. "Fine Arts," *Boston Evening Transcript,* 8 December 1913, sec. 2, p. 16. See also Charles Caffin, "Leon Bakst's Wonderful Designs," *New York American,* 3 November 1913, p. 6.

88. Although Manship dated the *Salome* 1915, the work—or at any rate a very similar early version—appears in the background of a photograph of Manship's studio arranged for an exhibition in November 1913; see John Manship, *Paul Manship,* pl. 40.

89. Florenz Ziegfeld's Salome, a Mlle Dazié, enjoyed such success that she opened "a school for Salomés, two hours every morning. . . . By the summer of 1908 she was sending approximately 150 Salomés every month into the nation's vaudeville circuit" (Kendall, *Where She Danced,* pp. 74–75). Such "rampant vulgarity" prompted an editorial, "The Salome Pestilence," in the *New York Times,* 3 September 1908, p. 6.

90. On Allan, see Felix Cherniavsky's series in *Dance Chronicle* 6–8, esp., for Salome, "Maud Allan, Part III: Two Years of Triumph, 1908–1909," *Dance Chronicle* 7:2(1984):119–158.

91. For an Indian parallel to the

complicated necklaces Manship's *Salome* wears, see the Tara from Sarnath, in Coomaraswamy, *Selected Examples of Indian Art* (1910), pl. XVIII. Charles Caffin criticized modern sculptors of dance subjects for failing to communicate movement in their focus on "a close repetition of gesture [which] tends to make the action rigid" ("Interpretation of Dance in Sculpture at Mac-Beth's," *New York American*, 15 March 1915, p. 9); see also idem, "Sculpture in Academy Exhibit," *New York American*, 27 December 1915.

92. St. Denis, *An Unfinished Life*, p. 136.

93. J. E. Crawford Flitch on St. Denis's 1908 London season, as quoted in Shelton, *Divine Dancer*, pp. 83–84.

94. Ibid., p. 132. The Denishawn Collection—Visual Works in the Dance Collection, NYPL, includes hundreds of photographs of St. Denis dancing and also a few of sculpted interpretations of her performances.

95. "Fortuny's Veils," *Berliner Tageblatt*, 25 November 1907, p. 3, as quoted in ibid., p. 82.

96. "Trailblazers of Modern Dance," a videotape of 1977 in the Dance Collection, NYPL; for reproductions of Greek and Egyptian sculpture that St. Denis gathered around the same time, see Ruth St. Denis, scrapbooks: Clippings, 1915, vol. 2, Dance Collection, NYPL.

97. *Philadelphia Inquirer*, 7 February 1915, news sec., p. 2. Both Caffin (*New York American*, 8 February 1915, p. 9) and E. W. Powell (*Philadelphia Record*, 14 February 1915, mag. sec., p. 4) noted the dominance of Manship's influence in painting as well as sculpture at the Architectural League exhibition of that year. They may have had in mind the *Center Panel for an Adam Ceiling*, by Frank Fairbanks, featuring fig-

ures in quasi-Greek and Etruscan costume, or Frederick Stahr's *Minoan Poetry;* both men held fellowships at the Academy during Manship's tenure.

6. Archaism during the 1920s and 1930s: Decorative and Monumental

1. Director Stevens, for example, may have influenced one reviewer (who mentions him in the article) on the matter of Manship's exceptional receptivity to his Old World environs; see *Philadelphia Public Ledger*, 22 February 1914, mag. sec., p. 11.

2. Adeline Adams, "Garden Sculpture," *Art and Progress* 5(May 1914):250.

3. American Academy in Rome, Annual Report for 1922–1923, AAR Papers, AAA.

4. Cecere, interview with George Gurney, 22 March 1978, AAA.

5. Amateis remembered being fascinated with Metzner's sculpture during the period of his fellowship (interview with George Gurney, 21 February 1978, AAA). On these sculptors, see the individual entries in Proske, *Brookgreen Gardens Sculpture.*

6. Hancock, interview with Susan Rather, 25 August 1984.

7. Ibid.

8. Herbert Adams, "The Debt of Modern Sculpture to Ancient Greece," *Art and Archaeology* 12(July–December 1921):220.

9. Taft, *Modern Tendencies*, p. 142.

10. *Philadelphia Public Ledger*, 14 February 1915, women's sec., p. 7.

11. "John Gregory, Sculptor," *Arts and Decoration* 12(15 November 1919):8. Gregory's French-inspired style is well represented by the *Frog Girl* of ca. 1907, reproduced in the article.

12. Gregory exhibited the central

panel at the Architectural League of
New York in 1917. The Ludovisi
Throne attracted considerable attention
after the Museum of Fine Arts in Bos-
ton acquired three related panels around
1908. The museum's L. D. Caskey
summarized the scholarly debate over
the Ludovisi Throne and argued for the
relatedness of the Boston panels in
"The Ludovisi Relief and Its Compan-
ion Piece in Boston," *American Journal
of Archaeology* 2d ser., 22(1918):101–
145. In his conclusion, Caskey sug-
gested that "the singular charm of the
reliefs is due in great measure to the
happy blending of archaism with real-
ism in the rendering of the figures and
the draperies" (p. 145).

13. Steven Eric Bronson notes Greg-
ory's dedication to modeling in "John
Gregory: The Philadelphia Museum of
Art Pediment" (M.A. thesis, Univer-
sity of Delaware, 1977), p. 46.

14. American Academy in Rome,
Annual Report for 1924–1925, p. 28,
AAR Papers, AAA.

15. Ibid., p. 54.

16. In "The Philadelphia Museum of
Art, Fairmount Park, Philadelphia—A
Revival of Polychrome Architecture
and Sculpture," *Architectural Record*
60(August 1926):97–111, Solon cred-
ited his own first article on polychromy
with this influence; see also Leon V. So-
lon, "Principles of Polychrome in
Sculpture Based on Greek Practice,"
The Architectural Record 43(June 1918):
526–533. In the 1890s, the Museum of
Fine Arts in Boston had sponsored ef-
forts to rediscover the technique of an-
cient polychromy; see Joseph Lindon
Smith, *The Hermes of Praxiteles and the
Venus Genetrix: Experiments in Restoring
the Color of Greek Sculpture.* See also
Marie-Françoise Billot, "Research in the
Eighteenth and Nineteenth Centuries
on Polychromy in Greek Architecture,"

in *Paris-Rome-Athens,* pp. 61–126. In
her introduction to this catalogue,
Barbara Rose suggests that French re-
constructions of Greek architectural
polychromy influenced the designers of
the Philadelphia Museum of Art (pp.
xxii–xxiii).

17. Solon, "The Philadelphia Mu-
seum of Art," p. 101.

18. Owing to soaring costs, only
Jennewein's pediment was set in place;
Gregory's one-third-scale models re-
main in storage at the museum. See
Bronson, "John Gregory"; idem, "The
Forgotten Pediment of the Philadelphia
Museum of Art," *National Sculpture Re-
view* 25(Spring 1976):16–17; and Shir-
ley Reiff Howarth, *C. Paul Jennewein,*
pp. 150–167.

19. Gregory, correspondence with
the museum's architects, as quoted in
Bronson, "John Gregory," p. 40.

20. Ibid.

21. For running figures, see Richter,
Sculpture and Sculptors of the Greeks,
pp. 37–39 and figs. 81–100, esp. fig. 91.

22. Royal Cortissoz, as quoted in "A
Modern Primitive in Art," *The Literary
Digest* 52(6 May 1916):1279.

23. Taft, *Modern Tendencies,* p. 113.

24. Ibid., p. 145. "What an amazing
expression of national ideals," wrote
Taft of the archaistic sculpture being
produced in America during the later
1910s; "imagine mystified savants
gravely discussing these anachronisms a
few centuries hence" (p. 144).

25. Some identified the very begin-
nings of twentieth-century archaism
with Germany. See Ada Rainey, "A
New Note in Art: A Review of Modern
Sculpture," *Century Magazine* 90 (June
1915):195; C. R. Post, *A History of Eu-
ropean and American Sculpture* 2:263; and
H. Adams, "The Debt of Modern
Sculpture to Ancient Greece," p. 220.

26. Ernst Horneffer (1909), as

quoted in Richard Hamann and Jost Hermand, *Stilkunst um 1900,* p. 397; for discussion of monumentality in a variety of German artforms at the turn of the century, see esp. pp. 364–506.

27. See, for example, Wilhelm Radenberg, *Moderne Plastik* (1912), p. iv.

28. George Fuchs, *Deutsche Kunst und Dekoration* 10(1902):351, as quoted in Hamann and Hermand, *Stilkunst,* p. 414.

29. As Kuno Francke, curator of the Germanic Museum at Harvard, wrote of the Bismarck Monument: "this one colossal man seems to relegate into nothingness everything that surrounds him: the trees, the houses, the streets with their busy throngs" ("The Revival of Plastic Art in Germany," *Cosmopolitan Magazine* 45[September 1908]:342). Thomas Nipperdey considers the ideology of such monuments in "National-idee und Nationaldenkmal in Deutschland im 19. Jahrhundert," *Historische Zeitschrift* 206(June 1968):529–585, esp. pp. 573–582. For background, see Hans-Ernst Mittag and Volker Plagemann, *Denkmäler im 19. Jahrhundert, Deutung und Kritik.*

30. Taft, *Modern Tendencies,* p. 61.

31. Richard Muther, "Die Kunstschau," *Die Zeit* (Vienna) (6 June 1908), quoted in Pötzl-Malikova, *Franz Metzner,* p. 40.

32. Taft's *Modern Tendencies* was the publication of his Art Institute lectures. See his comments on the Völkerschlacht Monument in the same volume, p. 61.

33. Friedlander's *Valor* and its companion, *Sacrifice,* were not completed and positioned on the bridge until 1951; owing to the prohibitive expense of executing the works in stone, as originally planned, the sculptures were cast in bronze. See Joel Rosenkranz, *Sculp-*

ture on a Grand Scale: Works from the Studio of Leo Friedlander.

34. There is here an interesting parallel with ancient archaism, a historically self-aware phenomenon that may have begun as early as the mid–fifth century B.C. (that is, in the immediate postarchaic period) and that was at any rate well developed by Hellenistic times. See esp. Harrison, *Archaic and Archaistic Sculpture,* pp. 60–67.

35. The most recent study of this subject—Igor Golomstock's *Totalitarian Art in the Soviet Union, the Third Reich, Fascist Italy & the People's Republic of China*—was not available to me at the time of this writing; see also Hellmutt Lehmann-Haupt, *Art under a Dictatorship,* esp. pp. 96–105. On sculpture made for United States government buildings during the 1930s, see George Gurney, *Sculpture and the Federal Triangle.*

36. "The German Spirit in America," *Boston Evening Transcript,* 25 February 1914, p. 28.

37. See Bitter to Hans Kestranek, 10 February 1902, cited in Dennis, *Bitter,* p. 94.

38. Bitter to Marie Bitter, 6 May 1907, Bitter Papers, AAA; Bitter to Kestranek, 1 October 1905, as cited in Dennis, *Bitter,* p. 119.

39. See Pötzl-Malikova, "Franz Metzner und die Wiener Secession," *Alte und moderne Kunst* 21(1976):30–39.

40. Taft, *Modern Tendencies,* p. 60.

41. Post, *A History of European and American Sculpture* 2:182.

42. An opportunity to see Metzner's work at the St. Louis World's Fair of 1904 (at which Bitter served as director of sculpture) had been lost when the so-called Klimtgruppe, a faction of the Vienna Secession, withdrew from participation; see Eduard F. Sekler,

Josef Hoffmann: The Architectural Work, pp. 288–289; and Christian M. Nebehay, *Gustav Klimt: Dokumentation,* pp. 346–347. For citations to some of the many articles on Metzner that appeared in *Deutsche Kunst und Dekoration* and other German periodicals, see the bibliography in Pötzl-Malikova, *Metzner,* pp. 130–131.

43. Conventionalization of the figure as a means to integrate sculpture and architecture similarly concerned Frank Lloyd Wright in the wake of his European sojourn of 1909–1910, and Secession sculpture directly inspired the geometrized figures at Wright's Midway Gardens in Chicago (1913, executed by Alfonso Iannelli). In a rare admission, Wright acknowledged his debt to Metzner, whom he had met in Europe, for these figures (Wright to Iannelli, 26 May 1915, Alfonso Iannelli Collection, Chicago Historical Society; cited in Anthony Alofsin, "Frank Lloyd Wright: The Lessons of Europe, 1910–1922" [Ph.D. diss., Columbia University, 1987], p. 156). Metzner's Haus Rheingold sculptures likewise impressed Leo Friedlander, who visited Berlin in 1908 and 1909 (Friedlander, "The New Architecture and the Master Sculptor," *Architectural Forum* 46[January 1927]:4).

44. Journal entries for 30 and 28 June 1909, Bitter Papers, AAA.

45. Journal entry for 15 June 1909, Bitter Papers, AAA. The Kunstschau exhibitions of 1908 and 1909 were sponsored by the group of artists, led by Klimt and including Metzner, that had broken away from the Secession in 1905.

46. Dennis suggests that Bitter pierced the screen to avoid giving the monument, placed in the middle of its site, a negative side and to expose the allegorical figures to southern light

(*Bitter,* pp. 213, 218). However, the relative unusualness and power of the cut-through reliefs strike the viewer as transcending any such practical considerations. For discussion of the project as a whole, see Dennis, *Bitter,* pp. 204–220. A German parallel to Bitter's see-through reliefs—Ulfert Janssen's *Hundertjahrbrunnen,* in Essen— is illustrated in *Die Kunst: Monatsheft für Freie und Angewandte Kunst* 17(3 October 1908):48.

47. The female figure's more passive appearance and placement among ripe natural growth (the fruits of the man's tense labor) are consistent with prevailing constructions of gender. Indeed, in the absence of any overt physical characteristics of her sex—a breast is visible only from the rear of the monument— passivity and (association with) fecundity are the features that identify *Vintage* as female.

48. Walker Hancock to Herman Warner Williams, Jr., 26 May 1960, Hancock Papers, AAA.

49. Walter Raymond Agard, "American Architectural Sculpture," *American Magazine of Art* 24(March 1932):209.

50. Agard, *The New Architectural Sculpture,* p. 71.

51. Ibid., p. 4.

52. Ibid., p. 34. For the Schurz Monument, see my chapter 3, pp. 68–72.

53. Lawrie claimed that after years of working with Goodhue, the architect felt comfortable leaving him project drawings with blank spaces where sculpture was to go, saying: "You know what to do" (Charles Whitaker, ed., *Bertram Grosvenor Goodhue: Architect and Master of Many Arts,* p. 33). Although this publication honored the recently deceased Goodhue, the editor included a separate section of plates illustrating

Lawrie's work for Goodhue as exemplary of the architect's ideas.

54. For the debate over the form that nationalism might take in American architecture between the wars, see Lisa B. Reitzes, "Moderately Modern: Interpreting the Architecture of the Public Works Administration," (Ph.D. diss., University of Delaware, 1989) 1:96–109. Reitzes discusses public perception of the Nebraska state capitol as a building at once classical and modern (1:153–156, 159, 168) and identifies it as a primary model for the "sculptural mode" popular in architecture of the 1920s and 1930s (1:179–199).

55. Goodhue to Alexander, 1 December 1922, as transcribed by Goodhue's secretary Marie Whittlesey in a letter to Lee Lawrie, 2 December 1922, Lee Lawrie Papers, Manuscript Division, Library of Congress.

56. These are surveyed in Henry-Russell Hitchcock, Temples of Democracy: The State Capitols of the U.S.A.

57. The challenge of creating sculpture appropriate to steel-framed buildings such as skyscrapers intrigued French sculptor Raymond Duchamp-Villon, who exhibited a project for a facade at the Armory Show. Walter Pach explored the rationale behind the artist's planar stone ornament in an accompanying publication and, significantly, found in Duchamp-Villon's design a "quality of response to the needs of America" (A Sculptor's Architecture, p. 21).

58. Lawrie to Goodhue, 23 November 1922, Lawrie Papers, LC.

59. Taft specifically noted the jointing of the Bismarck Monument in Modern Tendencies, p. 57.

60. Alexander to Goodhue, undated, as transcribed by Goodhue's secretary Marie Whittlesey in a letter to Lee Lawrie, 2 December 1922, Lawrie Papers,

LC. For stimulating his interest in provincialism, Alexander credited the prolific French writer and politician Maurice Barrès (1862–1923), an ardent nationalist and champion of traditional authority.

61. Coomaraswamy, "Some Ancient Elements," p. 388; see my chapter 5, pp. 118–119.

62. Alexander to Goodhue, as transcribed in a letter to Lee Lawrie, 2 December 1922, Lawrie Papers, LC.

63. Alexander, in Whitaker, ed., Goodhue, p. 41. Lawrie made a model for the north portal entrance to the capitol showing two configurations for the buffalo balustrade, one a relief and the other an engaged figure; see H. B. Alexander, "Nebraska's Monumental Capitol at Lincoln," Western Architect 32(October 1923):114.

64. "Lee Lawrie's Sculpture for the Nebraska State Capitol," American Magazine of Art 19(January 1928):16. Lawrie referred to the "Assyrian-Babylonian touch" in his sculpture in a letter to Elmer Green of the World Book Company, 16 September 1924, Lawrie Papers, LC.

65. Charles Harris Whitaker, "The Nebraska State Capitol," American Architect 145(October 1934):9. Whitaker does not answer the charge.

66. Alexander, in Whitaker, ed., Goodhue, p. 42. A recent "handy guide" prepared to help visitors to the capitol negotiate its iconographic program concedes that the sculpture "is largely ignored" because it is "difficult to interpret without aid," requiring "some knowledge of the history of the Western tradition." The essay—paradoxically appearing in an academic journal—only serves to highlight the inaccessibility of any such iconographic program to twentieth-century viewers. See Orville H. Zabel, "History in Stone:

The Story in Sculpture on the Exterior of the Nebraska Capitol," *Nebraska History* 62(Fall 1981):285–367. Louis H. Sullivan parodied the public's inability to understand allegorical sculpture in *Kindergarten Chats,* p. 18.

67. None of Alexander's proposals ("Man the Builder," "Frontiers of Time") were adopted in full, although parts of the program ultimately approved ("New Frontiers and the March of Civilization") followed his guidelines. For Rockefeller Center, see Alan Balfour, *Rockefeller Center: Architecture as Theatre,* and Carol Herselle Krinsky, *Rockefeller Center.* On the shift away from the sort of public sculpture represented at Rockefeller Center, see John Wetenhall, "The Ascendency of Modern Public Sculpture in America" (Ph.D. diss., Stanford University, 1988), chap. 1.

68. Kenneth Andrews, "What Paul Manship Thinks of Prometheus," *Rockefeller Center Weekly* 2(17 January 1935):5, 22–23.

69. Cartoon by Abner Dean, *Rockefeller Center Weekly* 1(25 October 1934):6.

70. The longevity of this type of sculpture may be inferred from an address Aline Saarinen delivered before the Architectural League of New York in 1954. She cautioned the architects against working with sculptors who produced "art which substitutes stylization for style . . . the streamlined or slipcover stuff. . . . These are sculptures which sheer and shave that inevitable eagle to be as sleek as an automobile radiator cap or stylize the Macfadden musculature of a figure so that it looks like a streamlined version of those embarrassing photos of male models. These are sculptures that simply enlarge what would be unpretentiously acceptable at ash-tray scale" ("Art as Archi-

tectural Decoration," *Architectural Forum* 100[June 1954]:132).

71. The term "art deco" first appeared in the subtitle to the exhibition *Les Années 25* at the Musée des Arts Décoratifs in Paris in 1966. Two years later, Bevis Hillier applied the term more broadly in *Art Deco of the Twenties and Thirties* and this usage became firmly established with the exhibition *The World of Art Deco* that Hillier organized for the Minneapolis Institute of Arts in 1971. There have been many popular studies of art deco, though few of substance. For the American context, see especially Rosemarie Haag Bletter and Cervin Robinson, *Skyscraper Style: Art Deco New York;* and Karen Davies, *At Home in Manhattan: Modern Decorative Arts, 1925 to the Depression.*

72. Henry-Russell Hitchcock, "Modern Architecture," pt. 1: "The Traditionalists and the New Tradition," *Architectural Record* 63(April 1928):340–341; pt. 2: "The New Pioneers," *Architectural Record* 63(May 1928):454.

73. Although Frank Lloyd Wright qualified as his only American "New Traditionalist," Hitchcock praised Betram Grosvenor Goodhue as "the brilliant harmonizer of the Old and New Tradition"—the "old" tradition being a more "archaeologically reminiscent" manner (ibid., pt. 1, pp. 346, 348).

74. Davies to Virginia Meriwether Davies, 10 August [1925], as quoted in Brooks Wright, *The Artist and the Unicorn: The Lives of Arthur B. Davies (1862–1928),* p. 94 (where the date is given as 1927).

75. *Report of Commission Appointed by the Secretary of Commerce to Visit and Report upon the International Exposition of Modern Decorative and Industrial Art in Paris, 1925,* pp. 17–18. Twenty-six nations joined France in the exposition. Other than the United States, only Ger-

many among the major Western nations did not participate; France extended the invitation to its recent enemy too late to make Germany's participation feasible.

76. Ellow H. Hostache, "Reflections on the Exposition des Arts Decoratifs," *Architectural Forum* 44(January 1926):11.

77. *Report of Commission*, p. 22. Positive assessments of the exposition include Roger Gilman, "The Paris Exposition: A Glimpse into the Future," *Art Bulletin* 8(September 1925):33–42, and Helen Appleton Read, "The Exposition in Paris," *International Studio* 82(November 1925):93–97, (December 1925): 160–165.

78. As quoted in Davies, *At Home in Manhattan*, p. 88. On the Museum's role in the collection and promotion of modern decorative art between the wars, see Penelope Hunter, "Art Deco and the Metropolitan Museum of Art," *Connoisseur* 179(April 1972):273–281.

79. Helen Appleton Read touted the emergence of "an artist . . . who designs rooms," the *ensemblier* ("The Exposition in Paris," p. 163).

80. Gilman, "The Paris Exposition," p. 38.

81. Adeline Adams, *The Spirit of American Sculpture*, p. 168.

82. Ibid., pp. 166–167.

83. Ibid., p. 167.

84. Reinhold Hohl, in Jean-Luc Daval et al., *Sculpture: The Adventure of Modern Sculpture in the Nineteenth and Twentieth Centuries*, p. 139.

85. Gilman, "The Paris Exposition," p. 41. See also Henri Rapin, *La Sculpture décorative moderne*.

86. On the relation of modernist aesthetics, consumer culture, and advertising, see James Sloan Allen, *The Romance of Commerce and Culture*, esp. pp. 3–17.

87. Donald Deskey, "The Rise of American Architecture and Design,"

The Studio (London) 105(April 1933): 268. Use of the term "modernistic" in a positive sense appeared earlier and more rarely; see Paul T. Frankl, *New Dimensions: The Decorative Arts of Today in Words and Pictures* (1928), p. 28 ("sharp modernistic effects which are characteristic of our time"), and Leon V. Solon, "The Park Avenue Building, New York City," *Architectural Record* 63(April 1928):289–290. Richard Striner has revived the term "modernistic" in reference to the work of architects who were sympathetic to modernism but unwilling to abandon ornament, including William Van Alen and Raymond Hood ("Art Deco: Polemics and Synthesis," *Winterthur Portfolio* 25[Spring 1990]:27).

88. Phillips and Watkins, "Terms," p. 165.

89. John McAndrew, "'Modernistic' and 'Streamlined,'" *Museum of Modern Art Bulletin* 5(December 1938):2.

90. Alfred Barr, *Modern Architecture: International Exhibition*, p. 13.

91. John Manship, *Paul Manship*, p. 111. Precisely that association led Alastair Duncan to say that Manship's art could be "seen in retrospect as exemplary Art Deco" (*American Art Deco*, p. 139).

92. Harry Rand, *Manship*, p. 71.

93. "Exhibitions at the Art Institute: Sculpture by Paul Manship—Paintings by Robert Henri," *Fine Arts Journal* 33(October 1915):429.

94. Manship's East 72nd Street residence and the four adjacent tenements he also owned have been demolished.

95. Isabel Manship, the sculptor's wife, to Barry Faulkner, as related in John Manship, *Paul Manship*, p. 111.

96. *Paris Herald*, 1 January 1922.

97. Manship to Isabella Stewart Gardner, Christmas Day [19]17, Isabella Stewart Gardner Papers, AAA.

98. The Metropolitan Museum of

Art displayed reproductions of these works; see Gisela M. A. Richter, *Handbook of the Classical Collection* (1917). Manship may also have had in mind the metope of Europa and the Bull from Selinus, in which dolphins fill the space beneath the bull, or a small early-fifth-century terra-cotta of the same subject, acquired in 1923 by the Metropolitan Museum, showing Europa with her feet curled up (M. E. P., "Greek Terracottas," *Bulletin of the Metropolitan Museum of Art* 18[September 1923]: 212–215).

99. *Diana* and *Actaeon* exist in three sizes; just over two feet (M138, M155), heroic size (M166, M167), and slightly under life size (M182, M183).

100. Rand argues convincingly that Manship modeled *Actaeon* on the figure of Laocoon from the famous Hellenistic statuary group, pointing out that Manship imitated the baroque restoration of the priest's arm, shown outstretched. Following critical and archaeological studies during the 1950s, the arm was reset to a bent position in 1960 (*Manship*, pp. 80–81). Archaeological prescience, alas, cannot then explain the bent left arm on Manship's 1939 *Actaeon;* he made the alteration to fit the heroic-sized figure within a shallow niche on the exterior of the Norton Gallery in West Palm Beach, Florida.

101. For a comprehensive study of this subject, see Richard Guy Wilson, Dianne H. Pilgrim, and Dickran Tashjian, *The Machine Age in America, 1918–1941*. See also Jeffrey L. Meikle, *Twentieth Century Limited: Industrial Design in America, 1925–1939*.

102. Frankl, *New Dimensions*, pp. 16–18.

103. Manship, "Decorative Sculpture," *Encyclopaedia Britannica*, 1939 ed., s.v. "Sculpture."

104. Manship, lecture given at the American Federation of the Arts (AFA) convention, 14 May 1936, Manship Papers, AAA. See also Manship, "The Sculptor at the American Academy in Rome," *Art and Archaeology* 19(February 1925):89–92.

105. Henry McBride, "Manship's Sculpture," *New York Sun*, 7 February 1925, reprinted in *The Flow of Art: Essays and Criticisms of Henry McBride*, pp. 209–210.

106. Pilgrim, in Wilson et al., *Machine Age*, p. 303.

107. Manship, AFA lecture, 14 May 1936, Manship Papers, AAA.

108. *New York Herald Tribune,* 5 February 1933.

109. Timothy Garvey explores this theme and Manship's appeal during the 1920s in "Paul Manship, F. Scott Fitzgerald and a Monument to Echo the Jazz Age," *Journal of American Culture* 7(Fall 1984):2–18.

7. Archaism and the Critics: Disenchantment

1. Walker Hancock to John Manship, 25 January 1967, Hancock Papers, AAA.

2. Herbert Adams to C. Grant La Farge, 8 December 1913, AAR Files, New York. The language of bewitchment figures also in "A Modern Primitive in Art," *The Literary Digest* 52 (6 May 1916):1278–1279.

3. For an exhaustive bibliography, see Rand, *Manship*, pp. 198–208.

4. Cox, *The Classic Point of View*, p. 45, and idem, "A New Sculptor."

5. Cox, *The Classic Point of View*, pp. 3–4.

6. Cox, "A New Sculptor."

7. Cox to Manship, 13 December 1913, letter in scrapbook in possession of John Manship. An earlier effort, in the spring of 1913, had failed. Nomina-

tions for associate required an affirmative ballot from two-thirds of those voting (NAD, Constitution and By-Laws, Amended and Adopted 12 March 1913); of thirty-one names considered on 11 April 1913, only eight were not elected, including Manship by a vote of thirty-two in favor and twenty-seven opposed. On 8 April 1914, he succeeded in gaining associate status by an overwhelming margin of sixty-four to thirteen; on that occasion nineteen of the twenty-five artists considered were *not* elected. Manship became a full member of the NAD in 1916 (NAD, Minutes, vols. N, O, P).

8. Cortissoz, "Matters of Art," *New York Tribune,* 23 November 1913, sec. 5, p. 6.

9. Caffin, "Sculpture by Manship Shown," *New York American,* 24 November 1913, p. 6.

10. Cézanne to Charles Camoin, 13 September 1903, in Paul Cézanne, *Paul Cézanne: Letters,* pp. 297–298.

11. Shiff, *Cézanne and the End of Impressionism,* p. 182 (the words are Shiff's inversion of a phrase of Diderot's); see also pp. 125–132.

12. See p. 25.

13. Herbert Adams's reference to Manship's archaism as a "spell" implies a dangerous, but presumably also temporary, bewitchment (letter to La Farge, 8 December 1913, AAR Files, New York); see also Cox, "A New Sculptor."

14. Caffin, "Certain Reflections," *New York American,* 8 February 1915.

15. Ibid.

16. See p. 59.

17. Caffin, "Paul Manship's Latest Work Reveals Creative Genius," *New York American,* 21 February 1916, p. 6. Manship first exhibited this work at the NAD's 89th Annual Exhibition in spring 1914 (cat. no. 387).

18. George Humber, "Paul Manship," *New Republic* 6(25 March 1916):208; M. G. Van Rensselaer, "Pauline (Mr. Manship's Portrait of His Daughter at the Age of Three Weeks)," *Scribner's Magazine* 60(December 1916):776; see also *Boston Evening Transcript,* 19 February 1915, p. 11.

19. Jerome Mellquist, *The Emergence of an American Art,* p. 370.

20. Van Rensselaer, "Pauline," p. 776.

21. Reproduced in John Manship, *Paul Manship,* pp. 125, 128.

22. *Philadelphia Inquirer,* 15 February 1914, p. 8 (review of PAFA annual exhibition).

23. Joseph Bailey Ellis, *Chicago Tribune,* 21 August 1915.

24. Variations on this theme appear in Manship's lecture notes (Manship Papers, AAA) and published writings. See, for example, "The Preparation of a Sculptor," from "The Making of an Artist—A Symposium," *American Preferences* 2(January 1937):51–53; and Manship's foreword to Lincoln Rothschild, *Sculpture through the Ages,* p. v.

25. Ellis, *Chicago Tribune,* 21 August 1915.

26. Humber, "Paul Manship," p. 209.

27. Gallatin, *Paul Manship,* p. 6.

28. Post, *A History of European and American Sculpture* 2:264–265.

29. Gallatin, *Paul Manship,* p. 7.

30. Birnbaum, *Catalogue,* p. 8.

31. "The Greatness of Paul Manship?" *Arts and Decoration* 6(April 1916):291.

32. Cortissoz, "Paul Manship's Sculpture," *New York Herald,* 15 April 1933.

33. Ibid.

34. McBride, "Manship's Sculpture," *New York Sun,* 7 February 1925, reprinted in McBride, *The Flow of Art,*

p. 209. On Manship's anachronism, see also A. E. Gallatin, "An American Sculptor: Paul Manship," *The Studio* 82(October 1921):144.

35. McBride, *The Flow of Art,* p. 210.

36. Rosamund Frost, "Manship Ahoy!" *Art News* 44(June 1945):28.

37. Rand, *Manship,* p. 73. Roger Fry speculated on the deleterious effects of popularity on painters distinguished for their "handwriting" or craftsmanship in "Higher Commercialism in Art," *The Nation & Athenaeum* 42(19 November 1927):276–277.

38. See Manship's letter to Konti of 3 January 1910, quoted on p. 23.

39. See p. 39.

40. Cameron Rogers, "Profiles: The Compleat Sculptor," *New Yorker Magazine* 4(1 September 1928):23.

41. Under the editorial direction of Scofield Thayer during the 1920s, *The Dial* became one of America's leading literary and artistic reviews. For its history during that period, see Nicholas Joost, *Scofield Thayer and "The Dial."*

42. E. E. Cummings, "Gaston Lachaise," *The Dial* 68(February 1920):195.

43. Precisely when Manship hired Lachaise is unclear. Lachaise's letters to Isabel Nagle (his future wife) in which Manship's name appears bear no date. Lincoln Kirstein believed Lachaise applied for a job about the time Manship's assistant Beniamino Buffano left for San Francisco to work on sculptural decorations for the 1915 world's fair, presumably in 1914. But Manship turned Lachaise down, hiring him only at a later, unspecified date (Kirstein, *Gaston Lachaise,* p. 10). Kirstein noted that Lachaise worked on the pedestal of the *Centaur and Dryad* (1912–1913), which may explain Wayne Craven's assertion that Manship hired Lachaise

soon after the Armory Show of February 1913 (*Sculpture in America,* p. 599); however, the base was still uncast in November 1913 (see photograph in John Manship, *Paul Manship,* p. 49) and Lachaise may have worked on it at a later time. John Manship, in his book (p. 70), recorded a 1916 date for Lachaise's employment, but in correspondence with me revised that estimate to late 1914 or early 1915, dates I support.

44. According to Richard S. Kennedy, Lachaise was given the opportunity to soften the blow, but declined (*Dreams in the Mirror: A Biography of E. E. Cummings,* pp. 208–209).

45. Cummings, as quoted in Milton A. Cohen, *Poet and Painter: The Aesthetics of E. E. Cummings's Early Work,* p. 35.

46. This and quotations in the next three paragraphs are from Cummings, "Gaston Lachaise." Cummings's artistic and theoretical debt to Cézanne forms a recurrent theme in Cohen, *Poet and Painter.*

47. Cummings's understanding of children's art may have been informed by Roger Fry, "Children's Drawings," *Burlington Magazine* 30(June 1917): 225–231.

48. For the various versions of *The Mountain,* see Gerald Nordland, *Gaston Lachaise: The Man and His Work,* pp. 113–118.

49. Lachaise to A. E. Gallatin, 12 February 1924 (my emphasis), Gaston Lachaise Papers, Yale Collection of American Literature, Beinecke Rare Book and Manuscript Library, Yale University. Manship described the labor that he and three assistants put into the Morgan Memorial in "The Reminiscences of Paul Manship," 1958, Oral History Collection, Columbia University; several photographs in the Peter A. Juley and Son Photographic Collection, Na-

tional Museum of American Art, Smithsonian Institution, document changes in the design.

50. A. E. Gallatin, *Gaston Lachaise*, pp. 5–6; see also pp. 10–11, for Gallatin's emphasis on the importance of direct carving to Lachaise's art.

51. The clothing metaphor figures in an early, favorable review by Royal Cortissoz, *New York Tribune*, 23 November 1913, sec. 5, p. 6. See also A. M. Rindge, *Sculpture*, p. 148.

52. Mellquist, *The Emergence of an American Art*, p. 371.

53. Cummings, "Gaston Lachaise," p. 198.

54. Ibid., p. 197.

55. Nadelman thought himself the source of Lachaise's new vision; see Lincoln Kirstein, *Elie Nadelman*, p. 255, n. 9. Cummings classed Nadelman with Manship as an artist appealing to the "highly sophisticated unintelligence" ("Gaston Lachaise," p. 195).

56. Cortissoz, cited in "A Modern Primitive in Art," *The Literary Digest* 52(6 May 1916):1279.

57. Lachaise worked for jewelry designer René Lalique in Paris and made details for monuments by Boston sculptor Henry Hudson Kitson before entering Manship's studio.

58. Manship extended professional and personal support to Lachaise during and after the period of their association in his studio, as Lachaise's letters to Isabel reveal (see, e.g., Nordland, *Gaston Lachaise*, p. 16), and a warm personal relationship is attested by the fact that Manship hosted the wedding supper for Gaston and Isabel Lachaise in 1917. Reuben Nakian, an assistant to Manship from 1916 to 1920, shared his recollection of those years with Cynthia Joyce Jaffee, "Nakian" (M.A. thesis, Columbia University, [1967]), pp. 11–26.

59. Lincoln Kirstein, *Gaston Lachaise:*

Retrospective Exhibition, p. 12. *The Dial* (April 1921) illustrated one of the peacocks, also reproduced (in a photograph by Charles Sheeler) in Gallatin, *Lachaise*, pl. 13.

60. For a positive assessment of the ATT figure, see Gallatin, *Lachaise*, pp. 11–12.

61. Cummings's *Creative Art* essay of August 1928 is reprinted in Hilton Kramer et al., *The Sculpture of Gaston Lachaise*, pp. 25–26. In the biographical portion of his monograph on Lachaise, Gerald Nordland mentions the artist's commercial works (*Lachaise*, pp. 25–29); however, he excludes them from consideration in a separate, thematically organized section on the sculpture, which privileges "the body of work that is most deeply personal . . . [the] recurring themes to which [Lachaise] returned obsessively" (p. 59).

62. Cummings, "Gaston Lachaise," p. 196, see also 204; Nordland, *Lachaise*, p. 29. On the other hand, former editor of *The Dial* Gilbert Seldes explicitly noted the conservative and vanguard extremes among Lachaise's patrons in "Profiles: Hewer of Stone," *New Yorker* 7(4 April 1931):30.

63. "Avant-Garde and Kitsch," reprinted in Clement Greenberg, *The Collected Essays and Criticism* 1:5–22.

64. Greenberg's emphasis.

65. "Towards a Newer Laocoon," reprinted in ibid. 1:23–38.

66. In an essay for *Partisan Review* of June 1949, Greenberg announced the appearance of a "new sculpture," free from the limitations of adherence to the monolith and its connotations of representation—and potentially more expressive than modern painting. Still privileging painting, however, he considered this constructed sculpture—by David Smith, Theodore Roszak, David Hare, and others—"a product of cub-

ism" and "an art that sees in its products almost as much that is pictorial as sculptural" (*The Collected Essays and Criticism* 2:313–319).

67. On Greenberg as a strategist for the avant-garde, see Fred Orton and Griselda Pollock, "*Avant-Gardes* and Partisans Reviewed," *Art History* 4(September 1981):305–327.

68. Of course, many advocates of abstract art thought that it was indeed an answer to the social and political realities of the 1940s; see, for example, Barnett Newman's statement in Emile de Antonio and Mitch Tuchman, *Painters Painting,* pp. 41–44.

69. Quoted in Frederick D. Leach, *Paul Howard Manship: An Intimate View,*

p. 2. Cf. John Manship, *Paul Manship,* p. 203, n. 31.

Appendix. "The Decorative Value of Greek Sculpture"

Included by permission of John Manship. I have corrected Manship's frequent misspellings and idiosyncratic punctuation to facilitate the reading of this text; however, his capitalization of words such as *art* and *beauty* has been retained.

1. Parenthetic references to works of art appearing throughout this text are Manship's, intended to indicate slide changes.

Unpublished Sources

Manuscript Collections

American Academy in Rome (AAR). New York office. Files.
Archives of American Art (AAA), Smithsonian Institution. Papers:
 American Academy in Rome (AAR).
 Architectural League of New York.
 Chester Beach.
 Martin Birnbaum.
 Karl Bitter.
 Timothy Cole.
 Isabella Stewart Gardner.
 Karl H. Gruppe.
 Walker Hancock.
 Isidore Konti.
 MacBeth Gallery.
 Paul H. Manship.
 National Sculpture Society (NSS).
 Pennsylvania Academy of the Fine Arts (PAFA).
Collection of American Literature, Beinecke Rare Book and Manuscript
 Library, Yale University.
 Gaston Lachaise Papers.
Dance Collection, Library and Museum of the Performing Arts, New
 York Public Library (NYPL) at Lincoln Center.
 Denishawn Collection.
 Sergei Diaghilev, "Scrapbook: Clippings and Announcements,
 1915–16."
 Ruth St. Denis, scrapbooks.
Library of Congress (LC). Manuscript Division. Papers:
 Paul Wayland Bartlett.
 Solon H. Borglum.
 Lee Lawrie.
 Charles Follen McKim.
Minnesota Historical Society, Saint Paul. Papers:
 Governor John A. Johnson Memorial Commission.
 Paul Manship.
National Academy of Design (NAD). Minutes.

National Museum of American Art (NMAA), Smithsonian Institution.
 Peter A. Juley and Son Photographic Collection.
Pennsylvania Academy of the Fine Arts (PAFA). Archives.
Sophia Smith Collection, Smith College.
 Alice Morgan Wright Papers.

Interviews

Amateis, Edmund. Interview with George Gurney, 21 February 1978.
 Archives of American Art, Smithsonian Institution.
Cecere, Gaetano. Interview with George Gurney, 22 March 1978.
 Archives of American Art, Smithsonian Institution.
Hancock, Walker. Interview with Susan Rather, 25 August 1984.
Manship, Paul. Interview with John D. Morse, 18 February 1959.
 Archives of American Art, Smithsonian Institution.
"The Reminiscences of Paul Manship," 1958. Oral History Collection,
 Columbia University.

Theses and Dissertations

Acocella, Joan Ross. "The Reception of Diaghilev's Ballets Russes by Art-
 ists and Intellectuals in Paris and London, 1909–1914." Ph.D. disserta-
 tion, Rutgers University, 1984.
Alofsin, Anthony. "Frank Lloyd Wright: The Lessons of Europe,
 1910–1922." Ph.D. dissertation, Columbia University, 1987.
Bogart, Michele Helene. "Attitudes toward Sculpture Reproductions in
 America, 1850–1880." Ph.D. dissertation, University of Chicago, 1979.
Bronson, Steven Eric. "John Gregory: The Philadelphia Museum of Art
 Pediment." M.A. thesis, University of Delaware, 1977.
Connelly, Frances Susan. "The Origins and Development of Primitivism
 in Eighteenth and Nineteenth-Century European Art and Aesthetics."
 Ph.D. dissertation, University of Pittsburgh, 1987.
Jaffee, Cynthia Joyce. "Nakian." M.A. thesis, Columbia University,
 [1967].
Mecklenburg, Virginia McCord. "American Aesthetic Theory,
 1908–1917: Issues in Conservative and Avant Garde Thought." Ph.D.
 dissertation, University of Maryland, 1983.
Olin, Margaret. "Alois Riegl and the Crisis of Representation in Art
 Theory, 1880–1905." Ph.D. dissertation, University of Chicago, 1982.
Rather, Susan. "The Origins of Archaism and the Early Sculpture of Paul
 Manship." Ph.D. dissertation, University of Delaware, 1986.
Reitzes, Lisa B. "Moderately Modern: Interpreting the Architecture of the
 Public Works Administration." 3 vols. Ph.D. dissertation, University of
 Delaware, 1989.

Clifford, James. "Histories of the Tribal and the Modern." *Art in America* 73(April 1985):164–177.

Cohen, Milton A. *Poet and Painter: The Aesthetics of E. E. Cummings's Early Work*. Detroit: Wayne State University Press, 1987.

Cole, H. H. *Catalogue of the Objects of Indian Art Exhibited in the South Kensington Museum*. London, 1874.

Comstock, Anthony. *Traps for the Young*. 1883. Edited by Robert Bremner. Cambridge: Belknap Press of Harvard University Press, 1967.

Conner, Janis C. *A Dancer in Relief: Works by Malvina Hoffman*. Yonkers, N.Y.: Hudson River Museum, 1984.

Conze, Alexander, Alois Hauser, and George Niemann. *Archäologische Untersuchungen auf Samothrake*. 2 vols. Vienna: C. Gerold's Sohn, 1875–1880.

Coomaraswamy, Ananda. *The Arts and Crafts of India and Ceylon*. Edinburgh: Foulis, 1913.

———. *History of Indian and Indonesian Art*. New York: E. Weyhe, 1927. Reprint ed., New York: Dover, 1965.

———. "Oriental Dances in America." *Vanity Fair* 8(May 1917):61.

———. *Rajput Painting*. London: H. Milford, Oxford University Press, 1916.

———. "Rajput Painting." *Ostasiatische Zeitschrift* 1(July 1912):125–139.

———. "Rajput Paintings." *Burlington Magazine* 20(March 1912):314–325.

———. *Selected Examples of Indian Art*. Broad Campden: Essex House Press, 1910.

———. "Some Ancient Elements in Indian Decorative Art." *Ostasiatische Zeitschrift* 2(January–March 1914):383–392.

———. *Viśvakarma: Examples of Indian Architecture, Sculpture, Painting, Handicraft, First Series: One Hundred Examples of Indian Sculpture*. Introduction by Eric Gill. London: Luzac, 1912–1914.

———. *Yakṣas*. Smithsonian Miscellaneous Collections 80, no. 6. Washington, D.C.: Smithsonian Institution, 1928.

Coomaraswamy, Ananda K., and Sister Nivedita [Margaret E. Noble]. *Myths of the Hindus and Buddhists*. London: George G. Harrap & Co., 1913; New York: Holt, 1914.

Cooper, J. Fenimore. *Excursions in Italy*. Paris: Baudry's European Library, 1838.

Cortissoz, Royal. *American Artists*. New York: Scribner's, 1923.

———. *Art and Common Sense*. New York: Charles Scribner's Sons, 1913.

Cox, Kenyon. "Art: A New Sculptor." *The Nation* 96(13 February 1913):162–163.

———. *Artist and Public*. New York: Charles Scribner's Sons, 1914.

———. *The Classic Point of View.* New York: Charles Scribner's Sons, 1911.

———. "The 'Modern' Spirit in Art." *Harper's Weekly* 57(15 March 1913): 10.

———. *Painters and Sculptors.* New York: Duffield, 1907.

Craven, Wayne. *Sculpture in America.* New rev. ed. Newark: University of Delaware Press; New York and London: Cornwall Books, 1984.

Cummings, E. E. "Gaston Lachaise." *The Dial* 68(February 1920): 194–204.

Ćurčin, Milan, ed. *Ivan Meštrović: A Monograph.* London: Williams & Norgate, 1919.

———. "Ivan Meštrović in Wien." In *Festschrift Julius Franz Schütz,* pp. 168–178. Graz-Cologne: Hermann Böhlaus, 1954.

Curtius, Ernst, and Friedrich Adler. *Olympia: Die Ergebnisse der von dem Deutschen Reich Veranstalteten Ausgrabung.* 5 vols. Berlin: A. Asher & Co., 1890–1897.

Daniel, Glyn E. *A Hundred and Fifty Years of Archaeology.* London: Duckworth, 1975.

———. *The Origins and Growth of Archaeology.* New York: Thomas Y. Crowell, 1967.

Daval, Jean-Luc, et al. *Sculpture: The Adventure of Modern Sculpture in the Nineteenth and Twentieth Centuries.* New York: Rizzoli, 1986.

Davies, A. Mervyn. *Solon H. Borglum: "A Man Who Stands Alone."* Chester, Conn.: Pequot Press, 1974.

Davies, Karen. *At Home in Manhattan: Modern Decorative Arts, 1925 to the Depression.* New Haven: Yale University Art Gallery, 1983.

de Antonio, Emile, and Mitch Tuchman. *Painters Painting.* New York: Abbeville, 1984.

Delamater, Peg. "Some Indian Sources in the Art of Paul Klee." *Art Bulletin* 66(December 1984): 657–672.

Denis, Maurice. "A Definition of Neo-Traditionism," translated by Linda Nochlin. In *Impressionism and Post-Impressionism, 1874–1904, Sources and Documents,* edited by Linda Nochlin, pp. 187–191. Englewood Cliffs, N.J.: Prentice-Hall, 1966.

Dennis, James M. *Karl Bitter, Architectural Sculptor, 1867–1915.* Madison: University of Wisconsin Press, 1967.

Deonna, Waldemar. *Les "Apollons archaïques."* Geneva: Georg & Co., 1909.

Deskey, Donald. "The Rise of American Architecture and Design." *Studio* (London) 105(April 1933): 266–273.

Dickins, Guy. *Archaic Sculpture.* Catalogue of the Acropolis Museum, vol. 1. Cambridge: [Cambridge] University Press, 1912.

di Majo, Elena, et al. *Bertel Thorvaldsen, 1770–1844, scultore danese a Roma*. Rome: De Luca Edizioni d'Arte, 1989.

Dryfout, John H. *The Work of Augustus Saint-Gaudens*. Hanover, N.H., & London: University Press of New England, 1982.

Duncan, Alastair. *American Art Deco*. New York: Harry N. Abrams, 1986.

Duncan, Isadora. *The Art of the Dance*. Edited by Sheldon Cheney. 1928. Reprint, New York: Theatre Arts Books, 1969.

———. *My Life*. New York: Boni & Liveright, 1927.

Elsen, Albert. *Origins of Modern Sculpture: Pioneers and Premises*. New York: George Braziller, 1974.

———. *Pioneers of Modern Sculpture*. London: Arts Council of Great Britain, 1973.

Elsen, Albert, ed. *Auguste Rodin, Readings on His Life and Work*. Englewood Cliffs, N.J.: Prentice Hall, 1965.

Emmanuel, Maurice. *La Danse grecque antique d'après les monuments figurés*. Paris: Librairie Hachette, 1896. English edition: *The Antique Greek Dance after Sculpted and Painted Figures*. Translated by Harriet Jean Beauley. New York & London: John Lane, 1916.

Epstein, Jacob. *The Sculptor Speaks: Jacob Epstein to Arnold L. Haskell*. 1932. New York: Benjamin Blom, 1971.

Esposizione Internationale di Roma. *Catalogo della mostra archeologica nelle terme di Diocleziano*. Bergamo: Istituto Italiano d'Arti Grafiche, 1911.

———. *Catalogo della mostra di belle arti*. Bergamo: Istituto Italiano d'Arti Grafiche, 1911.

"Exhibitions at the Art Institute: Sculpture by Paul Manship—Paintings by Robert Henri." *Fine Arts Journal* 33(October 1915):429–434.

Faulkner, Barry. *Barry Faulkner: Sketches from an Artist's Life*. Dublin, N.H.: William L. Bauhan, 1973.

Fauns and Fountains: American Garden Statuary, 1890–1930. Essays by Michele H. Bogart and Deborah Nevins. Southampton, N.Y.: Parrish Art Museum, 1985.

Fink, Lois Marie. *American Art at the Nineteenth-Century Paris Salons*. New York: Cambridge University Press, 1990.

Fisher, William Murrell. "Sculpture at the Exhibition." *Arts and Decoration* 3(March 1913):168–169.

Francke, Kuno. "The Revival of Plastic Art in Germany." *Cosmopolitan Magazine* 45(September 1908):335–347.

Frankl, Paul T. *New Dimensions: The Decorative Arts of Today in Words and Pictures*. New York: Payson & Clarke, 1928.

Friedlander, Leo. "The New Architecture and the Master Sculptor." *Architectural Forum* 46(January 1927):1–8.

Frost, Rosamund. "Manship Ahoy!" *Art News* 44(June 1945):28.

Fry, Roger. "Bushman Paintings." *Burlington Magazine* 16(March 1910): 334–338.

———. "Children's Drawings." *Burlington Magazine* 30(June 1917):225–231.

———. "Higher Commercialism in Art." *Nation & Athenaeum* 42(19 November 1927):276–277.

———. *Last Lectures.* With an introduction by Kenneth Clark. New York: Macmillan; Cambridge: At the University Press, 1939.

———. "Oriental Art." *Quarterly Review* 212(January 1910):225–239.

———. "The Sculptures of Maillol." *Burlington Magazine* 17(April 1910):26–32.

Furtwängler, Adolf. *Aegina: Das Heiligtum der Aphaia.* 2 vols. Munich: K. B. Akademie der Wissenschaften, 1906.

Fusco, Peter, and H. W. Janson, eds. *The Romantics to Rodin: French Nineteenth-Century Sculpture from North American Collections.* Los Angeles & New York: Los Angeles County Museum of Art and George Braziller, 1980.

Galeries Nationales du Grand Palais. *La Sculpture française au XIXe siècle.* Paris: Editions de la Réunion des Musées Nationaux, 1986.

Gallatin, A. E. "An American Sculptor: Paul Manship." *Studio* 82(October 1921):137–144.

———. *Gaston Lachaise.* New York: E. P. Dutton, 1924.

———. *Modern Art at Venice.* New York: J. M. Bowles, 1910.

———. *Paul Manship: A Critical Essay on His Sculpture and an Iconography.* New York: John Lane, 1917.

Gardner, Ernest Arthur. *A Handbook of Greek Sculpture.* London & New York: Macmillan, 1895.

———. *Six Greek Sculptors.* London: Duckworth, 1910; New York: Charles Scribner's Sons, 1910. Reprint, Freeport, N.Y.: Books for Libraries Press, 1967.

Garvey, Timothy. "Paul Manship, F. Scott Fitzgerald and a Monument to Echo the Jazz Age." *Journal of American Culture* 7(Fall 1984):2–18.

Gauthier, Julie C. *The Minnesota Capitol: Official Guide and History.* Saint Paul, Minn.: Pioneer Press Manufacturing Department, 1907.

Geist, Sidney. *Brancusi: A Study of the Sculpture.* 1967. New rev. ed. New York: Hacker Art Books, 1983.

———. *Brancusi/The Kiss.* New York: Harper & Row, 1978.

———. *Brancusi: The Sculpture and Drawings.* New York: Harry N. Abrams, 1975.

Gide, André. "Promenade au Salon d'Automne." *Gazette des Beaux-Arts,* ser. 3, 34(1905):475–487.

Gilman, Roger. "The Paris Exposition: A Glimpse into the Future." *Art Bulletin* 8(September 1925):33–42.

Goldwater, Robert. *Primitivism in Modern Art*. Rev. ed. New York: Vintage Books, 1967.

———. *Primitivism in Modern Painting*. New York: Harper, 1938.

Golomstock, Igor. *Totalitarian Art in the Soviet Union, the Third Reich, Fascist Italy & the People's Republic of China*. New York: IconEditions, 1990.

Goloubew, Victor, Ananda Coomaraswamy, E. B. Havell, and Auguste Rodin. *Sculpture Civaites*. Ars Asiatica: Etudes et Documents Publiés sous la Direction de Victor Goloubew, vol. 3. Brussels & Paris: G. Van Oest, 1921.

Gombrich, E. H. *The Ideas of Progress and Their Impact on Art*. New York: Cooper Union School of Art and Architecture, 1971.

"The Greatness of Paul Manship?" *Arts and Decoration* 6(April 1916):291.

Greenberg, Clement. *The Collected Essays and Criticism*. Vol. 1: *Perceptions and Judgments, 1939–1944*. Vol. 2: *Arrogant Purpose, 1945–1949*. Edited by John O'Brien. Chicago: University of Chicago Press, 1986–.

G[regg], F[rederick] J. "The Extremists: An Interview with Jo Davidson." *Arts and Decoration* 3(March 1913):170–171, 180.

Griffiths, John. *The Paintings in the Buddhist Cave-Temples of Ajanta*. 2 vols. London: n.p., 1897.

Grunchec, Philippe, and Jacques Thuillier. *Le Grand Prix de Peinture: Les concours des Prix de Rome de 1797 à 1863*. Paris: Ecole Nationale Supérieure des Beaux-Arts, 1983.

Grunwald, Christiane. "Die Aegineten Ergänzungen." In *Bertel Thorwaldsen*, pp. 243–260. Cologne: Wallraf-Richartz-Museums, 1977.

Gurney, George. *Sculpture and the Federal Triangle*. Washington, D.C.: Smithsonian Institution Press, 1985.

Hamann, Richard, and Jost Hermand. *Stilkunst um 1900*. Deutsche Kunst und Kultur von der Grunderzeit bis zum Expressionismus, vol. 4. Berlin: Akademie-Verlag, 1967.

Hamilton, George H., and William C. Agee. *Raymond Duchamp-Villon, 1879–1918*. New York: Walker & Co., 1967.

Harrison, Evelyn B. *Archaic and Archaistic Sculpture*. The Athenian Agora, vol. 11. Princeton: American School of Classical Studies at Athens, 1965.

Hartmann, Jørgen Birkedal. *Antike Motive bei Thorwaldsen: Studien zur Antikenrezeption des Klassizismus*. Tübingen: Ernst Wasmuth, 1979.

Hartmann, Sadakichi. "Puritanism: Its Grandeur and Shame." *Camera Work* 32(October 1910):17–19.

Haskell, Francis, and Nicholas Penny. *Taste and the Antique: The Lure of*

Classical Sculpture, 1500–1900. New Haven & London: Yale University Press, 1981.

Havell, E. B. *Eleven Plates Representing Works of Indian Sculpture, Chiefly in English Collections.* London: Probsthain & Co., [1911].

———. *Indian Sculpture and Painting.* London: John Murray, 1908.

Heilmeyer, Adolf. *Adolf Hildebrand.* Bielefeld & Leipzig: Velhagen & Klafing, 1902.

Hildebrand, Adolf. *The Problem of Form in Painting and Sculpture.* Translated and revised with the author's cooperation by Max Meyer and Robert Morris Ogden. 2nd ed. New York: G. E. Stechert & Co., 1932.

Hill, G. F. *One Hundred Masterpieces of Sculpture.* London, 1909.

Hillier, Bevis. *Art Deco of the Twenties and Thirties.* London: Studio Vista, 1968.

———. *The World of Art Deco.* New York: E. P. Dutton, 1971.

Hitchcock, Henry-Russell. "Modern Architecture." Part 1: "The Traditionalists and the New Tradition." *Architectural Record* 63(April 1928): 337–349. Part 2: "The New Pioneers." *Architectural Record* 63(May 1928):453–460.

———. *Temples of Democracy: The State Capitols of the U.S.A.* New York & London: Harcourt Brace Jovanovich, 1976.

Hodson, Millicent. "Ritual Design in the New Dance: Nijinsky's *Le Sacre du Printemps.*" *Dance Research* 3(Summer 1985):35–45.

Holmes, Olive, ed. *Motion Arrested: Dance Reviews of H. T. Parker.* Middletown, Conn.: Wesleyan University Press, 1982.

Hosmer, Harriet. "The Process of Sculpture." *Atlantic Monthly* 14(December 1864):734–737.

Hostache, Ellow H. "Reflections on the Exposition des Arts Decoratifs." *Architectural Forum* 44(January 1926):11–16.

Howard, Seymour. "Definitions and Values of Archaism and the Archaic Style." *Leonardo* 14(Winter 1981):41–44.

Howarth, Shirley Reiff. *C. Paul Jennewein.* Tampa, Fla.: Tampa Museum, 1980.

Humber, George. "Paul Manship." *New Republic* 6(25 March 1916):207–209.

Hunter, Penelope. "Art Deco and the Metropolitan Museum of Art." *Connoisseur* 179(April 1972):273–281.

Hurwit, Jeffrey M. *The Art and Culture of Early Greece, 1100–480 B.C.* Ithaca & London: Cornell University Press, 1985.

India Society. *Report for the Year 1917.* London: Printed at the Chiswick Press, 1918.

James, Henry. *William Wetmore Story and His Friends*. 2 vols. Boston: Houghton Mifflin, 1903.

Janson, H. W. *19th-Century Sculpture*. New York: Abrams, 1985.

Jenison, Madge. *Sunwise Turn: A Human Comedy of Bookselling*. New York: E. P. Dutton, 1923.

"John Gregory, Sculptor." *Arts and Decoration* 12(15 November 1919):8.

Johnson, A. E. *The Russian Ballet*. London: Constable, 1913.

Jones, H. Stuart, ed. *A Catalogue of the Ancient Sculptures Preserved in the Municipal Collections of Rome: The Sculptures of the Palazzo dei Conservatori*. 2 vols. Oxford: Clarendon Press, 1926.

Joost, Nicholas. *Scofield Thayer and "The Dial."* Carbondale & Edwardsville: Southern Illinois University Press, 1964.

Kalidasa. *Sakoontala, or The Lost Ring*. 8th ed. Translated by Monier Monier-Williams. London: George Routledge; New York: E. P. Dutton, [1898].

———. *Shakuntala, and Other Works*. Translated by Arthur W. Ryder. London: J. M. Dent & Sons; New York: E. P. Dutton, [1912]. Reprint, New York: E. P. Dutton, 1959.

Kendall, Elizabeth. *Where She Danced: American Dancing, 1880–1930*. New York: Alfred A. Knopf, 1979.

Kennedy, Richard S. *Dreams in the Mirror: A Biography of E. E. Cummings*. New York: Liveright Publishing, 1980.

Kirstein, Lincoln. *Elie Nadelman*. New York: Eakins Press, 1973.

———. *Gaston Lachaise: Retrospective Exhibition*. New York: Museum of Modern Art, 1935.

Konow, Sten. *The Indian Drama*. Translated by S. N. Ghosal. 1920. Reprint, Calcutta: General Printers & Publishers, 1969.

Kramer, Hilton, et al. *The Sculpture of Gaston Lachaise*. New York: Eakins Press, 1967.

Krauss, Rosalind E. *Passages in Modern Sculpture*. New York: Viking Press, 1977.

Krinsky, Carol Herselle. *Rockefeller Center*. New York: Oxford University Press, 1978.

Laine, Barry. "In Her Footsteps." *Ballet News* 3(February 1982):22.

Lambraki-Plaka, Marina. *Bourdelle et la Grèce: Les sources antiques de l'oeuvre de Bourdelle*. Athens: N.p., 1985.

Langlotz, Ernst. *Ancient Greek Sculpture of South Italy and Sicily*. New York: Abrams, n.d.

Larsson, Lars Olof. "Thorvaldsens Restaurierung der Aegina-Skulpturen im Lichte zeitgenössischer Kunstkritik und Antikenauffassung." *Konsthistorisk Tidskrift* 38(1969):23–46.

Leach, Frederick D. *Paul Howard Manship: An Intimate View*. Saint Paul: Minnesota Museum of Art, 1972.

Lechat, Henri. *La Sculpture attique avant Phidias*. Paris: Albert Fontemoing, 1904.

Lee, Sherman E. *A History of Far Eastern Art*. Rev. ed. Englewood Cliffs, N.J.: Prentice Hall; New York: Harry N. Abrams, n.d.

"Lee Lawrie's Sculpture for the Nebraska State Capitol." *American Magazine of Art* 19(January 1928):13–16.

Lehmann-Haupt, Hellmutt. *Art under a Dictatorship*. New York: Oxford University Press, 1954.

"Léon Bakst on the Revolutionary Aims of the Serge de Diaghilev Ballet." *Current Opinion* 59(October 1915):246–247.

Lessing, Gotthold Ephraim. *Laocoon: An Essay upon the Limits of Painting and Poetry*. 1766. Translated by Ellen Frothingham. New York: Noonday Press, 1961.

Levinson, André. *Ballet Old and New*. Translated by Susan Cook Summer. New York: Dance Horizons, 1982.

Lipchitz, Jacques. *My Life in Sculpture*. With H. H. Arnason. New York: Viking Press, 1972.

Lipsey, Roger. *Coomaraswamy*. Vol. 3: *His Life and Work*. Princeton: Princeton University Press, 1977.

Löwy, Emmanuel. *The Rendering of Nature in Early Greek Art*. Translated by John Fothergill. London: Duckworth & Co., 1907.

McAndrew, John. "'Modernistic' and 'Streamlined.'" *Museum of Modern Art Bulletin* 5(December 1938):2–3.

McBride, Henry. *The Flow of Art: Essays and Criticisms of Henry McBride*. Edited by Daniel Catton Rich. New York: Atheneum Press, 1975.

MacCarthy, Fiona. *Eric Gill*. London & Boston: Faber & Faber, 1989.

MacDonald, Nesta. *Diaghilev Observed by Critics in England and the United States, 1911–1929*. London: Dance Books Ltd; New York: Dance Horizons, 1975.

McEvilley, Thomas. "Doctor Lawyer Indian Chief: '"Primitivism" in 20th Century Art' at the Museum of Modern Art in 1984." *Artforum* 23 (November 1984):54–61.

Madigan, Mary Jean Smith. *The Sculpture of Isidore Konti, 1862–1938*. Yonkers, N.Y.: Hudson River Museum, 1974.

Manship, John. *Paul Manship*. New York: Abbeville Press, 1989.

Manship, Paul. "Decorative Sculpture" and "Materials." *Encyclopaedia Britannica*. 14th ed. S.v. "Sculpture."

———. "The History of Sculpture." *Encyclopaedia Britannica*. 1952 ed. S.v. "Sculpture."

———. "The Preparation of a Sculptor." *American Preferences* 2(January 1937):51–53.

———. "The Sculptor at the American Academy in Rome." *Art and Archaeology* 19(February 1925):89–92.

Marbres des Musées de Grèce; catalogue de la collection des moulages exposés à Rome en 1911. Athens, 1911.

Marcel, Henry. "Le statuaire Henri Bouchard et son oeuvre." *Gazette des Beaux Arts* ser. 4, 9(1913):236–252.

Mayer, Charles S. The Influence of Léon Bakst on Choreography." *Dance Chronicle* 1:2(1978):127–142.

Mayerson, Charlotte Leon, ed. *Shadow and Light: The Life, Friends and Opinions of Maurice Sterne.* New York: Harcourt, Brace & World, 1965.

Meier-Graefe, Julius. *Modern Art; Being a Contribution to a New System of Aesthetics.* 1904. Translated by Florence Simmonds and George W. Chrystal. 2 vols. London: William Heinemann; New York: G. P. Putnam's Sons, 1908.

Meikle, Jeffrey L. *Twentieth Century Limited: Industrial Design in America, 1925–1939.* Philadelphia: Temple University Press, 1979.

Mellquist, Jerome. *The Emergence of an American Art.* New York: Scribner's, 1942.

Mertens, J. R. *Greek Bronzes in the Metropolitan Museum of Art.* New York: Metropolitan Museum of Art, 1985.

Metropolitan Museum of Art. *Catalogue of the Collection of Casts.* New York: Printed for the Museum, 1908.

Michaelis, Adolf. *A Century of Archaeological Discoveries.* Translated by Bettina Kahnweiler. London: John Murray; New York: E. P. Dutton, 1908.

Miller, Alec. *Tradition in Sculpture.* London & New York: Studio Publications, 1949.

Miller, Dorothy, ed. *The Sculpture of John B. Flannagan.* New York: Museum of Modern Art, 1942.

Mittag, Hans-Ernst, and Volker Plagemann. *Denkmäler im 19. Jahrhundert, Deutung und Kritik.* Munich: Prestel Verlag, 1972.

Mitter, Partha. *Much Maligned Monsters: History of European Reactions to Indian Art.* Oxford: Clarendon Press, 1977.

"A Modern Primitive in Art." *Literary Digest* 52(6 May 1916):1278–1279.

Moore, Charles. *The Life and Times of Charles Follen McKim.* Boston & New York: Houghton Mifflin Co., 1929.

Morgan, H. Wayne. *Keepers of Culture: The Art-Thought of Kenyon Cox, Royal Cortissoz, and Frank Jewett Mather, Jr.* Kent, Ohio & London: Kent State University Press, 1989.

Munson-Williams-Proctor Institute. *1913 Armory Show 50th Anniversary Exhibition, 1963.* Utica, N.Y.: Munson-Williams-Proctor Institute, 1963.

Murtha, Edwin. *Paul Manship*. New York: Macmillan, 1957.
Museum of Modern Art. *Five American Sculptors*. New York: Arno Press for the Museum of Modern Art, 1969.

Nandikeśvara. *The Mirror of Gesture: Being the Abhinaya Darpaṇa of Nandikeśvara*. Translated by A. K. Coomaraswamy with Gopala Kristnayya Duggirala. 1917. Reprint, New York: E. Weyhe, 1936.
Nebehay, Christian M. *Gustav Klimt: Dokumentation*. Vienna: Verlag der Galerie Christian Nebehay, 1969.
Nectoux, Jean-Michel, et al. *Afternoon of a Faun: Mallarmé, Debussy, Nijinsky*. New York: Vendome Press, 1987.
Neumann, K. E. *Krishnas Weltengang*. Munich: R. Piper, 1905.
Nijinska, Bronislava. *Bronislava Nijinska: Early Memoirs*. Translated and edited by Irina Nijinska and Jean Rawlinson. New York: Holt, Rinehart & Winston, 1981.
Nijinsky, Romola. *Nijinsky*. New York: Simon & Schuster, 1934.
Nijinsky, Vaslav. *Le Journal de Nijinsky*. Translated by G. Solpray. [Paris]: Gallimard, 1953.
Nipperdey, Thomas. "Nationalidee und Nationaldenkmal in Deutschland im 19. Jahrhundert." *Historische Zeitschrift* 206(June 1968):529–585.
Nordland, Gerald. *Gaston Lachaise: The Man and His Work*. New York: George Braziller, 1974.

Olsen, Arlene R. *Art Critics and the Avant-Garde: New York, 1900–1913*. Ann Arbor, Mich.: UMI Research Press, 1980.
Orton, Fred, and Griselda Pollock. "*Avant-Gardes* and Partisans Reviewed." *Art History* 4(September 1981):305–327.

P., M. E. "Greek Terracottas." *Bulletin of the Metropolitan Museum of Art* 18(September 1923):212–215.
Pach, Walter. *The Classical Tradition in Modern Art*. New York & London: Thomas Yoseloff, 1959.
———. *A Sculptor's Architecture*. New York: Association of American Painters and Sculptors, 1913.
Panama-Pacific International Exposition, 1915, Department of Fine Arts. *Catalogue Deluxe of the Department of Fine Arts*. 2 vols. San Francisco: Paul Elder & Co., 1915.
Paris-Rome-Athens: Travels in Greece by French Architects in the Nineteenth and Twentieth Centuries. Paris: Ecole Nationale Supérieure des Beaux-Arts; Houston: Museum of Fine Arts, 1982.
Paul Manship: Changing Taste in America. Saint Paul: Minnesota Museum of Art, 1985.

Payne, Humfry, and Gerard Mackworth-Young. *Archaic Marble Sculpture from the Acropolis*. New York: William Morrow, 1950.

Petrucci, R. "Rajput Painting." *Burlington Magazine* 29(May 1916):74–79.

Pevsner, Nikolaus, and S. Lang. "Apollo or Baboon." *Architectural Review* 104(December 1948):271–279. Reprinted in Nikolaus Pevsner, *Studies in Art, Architecture and Design*. Vol. 1: *From Mannerism to Romanticism*. New York: Walker & Co., 1968.

Phillips, Duncan, and Charles Law Watkins. "Terms We Use in Art Criticism." *Art and Understanding* 1(March 1930):160–174.

Post, Chandler Rathfon. *A History of European and American Sculpture from the Early Christian Period to the Present Day*. 2 vols. Cambridge: Harvard University Press, 1921.

Pötzl-Malikova, Maria. *Franz Metzner: Ein Bildhauer der Jahrhundertwende in Berlin-Wien-Prag-Leipzig*. Munich: Adalbert-Stifter Verein and Stuck-Jugendstil Verein, 1977.

———. "Franz Metzner und die Wiener Secession." *Alte und moderne Kunst* 21(1976):30–39.

Proske, Beatrice Gilman. *Brookgreen Gardens Sculpture*. Brookgreen Gardens, S.C.: Printed by Order of the Trustees, 1943.

Radenberg, Wilhelm. *Moderne Plastik*. Düsseldorf & Leipzig: Karl Robert Langewiesche Verlag, 1912.

Rainey, Ada. "A New Note in Art: A Review of Modern Sculpture." *Century Magazine* 90(June 1915):193–199.

Rand, Harry. *Paul Manship*. Washington, D.C. & London: Smithsonian Institution Press for the National Museum of American Art, 1989.

Rapin, Henri. *La Sculpture décorative moderne*. 3 vols. [Paris]: Ch. Moreau, [1925–1929].

Rather, Susan. "The Past Made Modern: Archaism in American Sculpture." *Arts Magazine* 59(November 1984):111–119.

———. "Toward a New Language of Form: Karl Bitter and the Beginnings of Archaism in American Sculpture." *Winterthur Portfolio* 25 (Spring 1990):1–19.

Read, Helen Appleton. "The Exposition in Paris." *International Studio* 82(November 1925):93–97; (December 1925):160–165.

Report of Commission Appointed by the Secretary of Commerce to Visit and Report upon the International Exposition of Modern Decorative and Industrial Art in Paris, 1925. Washington, D.C.: Department of Commerce, 1926.

Reynolds, Donald Martin. *Hiram Powers and His Ideal Sculpture*. New York & London: Garland Publishing, 1977.

Richardson, E. P., and Otto Wittmann, Jr. *Travelers in Arcadia: American Artists in Italy, 1830–1875*. Detroit & Toledo, 1951.

Richardson, Jonathan, Sr., and Jonathan Richardson, Jr. *Traité de la pein-*

ture et de la sculpture par Mrs. Richardson, père et fils. 3 vols. [Amsterdam, 1728].

Richter, Gisela M. A. *A Handbook of Greek Art.* 7th ed. London & New York: Phaidon, 1974.

———. *Handbook of the Classical Collection.* New York: Metropolitan Museum of Art, 1917.

———. *Handbook of the Greek Collection.* Cambridge: Harvard University Press for the Metropolitan Museum of Art, 1953.

———. *Sculpture and Sculptors of the Greeks.* 4th ed. New Haven & London: Yale University Press, 1970.

Ricketts, Charles. "Constantin Meunier: His Aim and Place in the Art of the Nineteenth Century." *Burlington* 7(June 1905):181–187.

Ridgway, Brunilde Sismondo. *The Severe Style in Greek Sculpture.* Princeton: Princeton University Press, 1970.

Rindge, A. M. *Sculpture.* New York: Payson & Clarke, 1929.

Robbins, Daniel. "From Statues to Sculpture: From the Nineties to the Thirties." In *Two Hundred Years of American Sculpture,* pp. 113–159. New York: Whitney Museum of American Art, 1976.

Roberts, Mary Fanton. "Isadora—the Dancer." *Denishawn Magazine* 1(Summer 1925):9–13.

Rockefeller Center Weekly 1(25 October 1934):6.

Rodin, Auguste. *L'Art, entretiens réunis par Paul Gsell.* Paris: Bernard Grasset, 1911.

Rogers, Cameron. "Profiles: The Compleat Sculptor." *New Yorker* 4(1 September 1928):21–23.

Rosenfeld, Daniel. "Rodin's Carved Sculpture." In *Rodin Rediscovered,* edited by Albert E. Elsen, pp. 81–102. Washington, D.C.: National Gallery of Art, 1981.

Rosenkranz, Joel. *Sculpture on a Grand Scale: Works from the Studio of Leo Friedlander.* Yonkers, N.Y.: Hudson River Museum, 1984.

Rothschild, Lincoln. *Sculpture through the Ages.* Foreword by Paul Manship. New York & London: Whittlesey House, McGraw-Hill, n.d.

Rubin, William, and Kirk Varnedoe. "On 'Doctor Lawyer Indian Chief: "'Primitivism' in 20th Century Art" at the Museum of Modern Art in 1984.'" *Artforum* 23(February 1985):42–51.

Rubin, William, ed. *"Primitivism" in 20th Century Art.* 2 vols. New York: Museum of Modern Art, 1984.

S., L. "Art—The Winter Academy." *Nation* 97(25 December 1913):627.

Saarinen, Aline B. "Art as Architectural Decoration." *Architectural Forum* 100(June 1954):132–135.

St. Denis, Ruth. *An Unfinished Life.* New York: Dance Horizons, 1971.

Saint-Gaudens, Homer, ed. *The Reminiscences of Augustus Saint-Gaudens.* 2 vols. New York: Century Co., 1913.

Schapiro, Meyer. "The Romanesque Sculpture of Moissac: Part I (1)." *Art Bulletin* 13(September 1931):249–351.

Schmeckebier, Laurence. *Ivan Meštrović, Sculptor and Patriot.* Syracuse, N.Y.: Syracuse University Press, 1959.

Schmutzler, Robert. *Art Nouveau.* New York: Harry N. Abrams, 1962.

Schrader, Hans. *Archaische Marmor-skulpturen im Akropolis-museum zu Athen.* Vienna: Alfred Hölder, 1909.

Schuchhardt, C. *Schliemann's Excavations: An Archaeological and Historical Study.* Translated by Eugénie Sellers. London & New York: Macmillan, 1891.

Sekler, Eduard F. *Josef Hoffmann: The Architectural Work.* Princeton: Princeton University Press, 1985.

Seldes, Gilbert. "Profiles: Hewer of Stone." *New Yorker* 7(4 April 1931): 28–31.

Serra, Joselita Raspi, ed. *Paestum and the Doric Revival 1750–1830.* Florence: Centro di, 1986.

Shapiro, Michael Edward. *Cast and Recast: The Sculpture of Frederic Remington.* Washington, D.C.: Smithsonian Institution Press, 1981.

Shawn, Ted. *Ruth St. Denis: Pioneer and Prophet.* 2 vols. San Francisco: Printed for John Howell by John Henry Nash, 1920.

Shelton, Suzanne. *Divine Dancer: A Biography of Ruth St. Denis.* Garden City, N.Y.: Doubleday & Co., 1981.

Sherwood, Ruth. *Carving His Own Destiny: The Story of Albin Polasek.* Chicago: R. F. Seymour, 1954.

Shiff, Richard. *Cézanne and the End of Impressionism.* Chicago: University of Chicago Press, 1984.

Smith, Carol Hynning. *Drawings by Paul Manship: The Minnesota Museum of Art Collection.* Saint Paul: Minnesota Museum of Art, 1987.

Smith, Joseph Lindon. *The Hermes of Praxiteles and the Venus Genetrix: Experiments in Restoring the Color of Greek Sculpture.* Described and explained by Edward Robinson. Boston: Alfred Mudge & Son for the Museum of Fine Arts, 1892.

Smith, V. A. "Graeco-Roman Influence on the Civilization of India." *Journal, Asiatic Society of Bengal* 58, pt. 1(1889, no. 3):107–198.

———. *A History of Fine Art in India and Ceylon.* Oxford: Clarendon Press, 1911.

Solon, Leon V. "The Park Avenue Building, New York City." *Architectural Record* 63(April 1928):289–297.

———. "The Philadelphia Museum of Art, Fairmount Park, Philadelphia—A Revival of Polychrome Architecture and Sculpture." *Architectural Record* 60(August 1926):97–111.

———. "Principles of Polychrome in Sculpture Based on Greek Practice." *Architectural Record* 43(June 1918): 526–533.

Spinazzola, Vittorio. *Le Arti decorative in Pompei e nel Museo Nazionale di Napoli*. Milan: Casa Editrice d'Arte Bestetti e Tumminelli, 1928.

Steinberg, Leo. *Other Criteria*. New York: Oxford University Press, 1972.

Storer, Edward. "Classicism and Modern Modes." *Academy* 85(6 September 1913): 293–294.

Story, William Wetmore. *Conversations in the Studio*. 2 vols. Boston, 1890.

———. *Excursions in Art and Letters*. Boston & New York: Houghton, Mifflin, 1891.

Stravinsky, Igor. *An Autobiography*. New York: Simon & Schuster, 1936.

Striner, Richard. "Art Deco: Polemics and Synthesis." *Winterthur Portfolio* 25(Spring 1990): 21–34.

Sturgis, Russell. *The Appreciation of Sculpture*. New York: Baker & Taylor Co., 1904.

Sullivan, Louis H. *Kindergarten Chats*. New York: Wittenborn, Schultz, 1947.

Svoronos, J. N. *Das Athener Nationalmuseum*. 4 vols. Athens: Barth & Barth, 1908.

Taft, Lorado. *The History of American Sculpture*. New York: Macmillan, 1903.

———. *Modern Tendencies in Sculpture*. Chicago: University of Chicago Press for the Art Institute of Chicago, 1921.

Tarbell, Roberta K. *Hugo Robus (1885–1964)*. Washington, D.C.: Smithsonian Institution Press for the National Collection of Fine Arts, 1980.

Tarbell, Roberta K., Joan M. Marter, and Jeffrey Wechsler. *Vanguard American Sculpture, 1913–1939*. Rutgers, N.J.: Rutgers University Art Gallery, 1979.

Terry, Walter. *Isadora*. New York: Dodd, Mead, 1984.

Thorp, Margaret Farrand. *The Literary Sculptors*. Durham, N.C.: Duke University Press, 1965.

Tsigakou, Fani-Maria. *The Rediscovery of Greece: Travellers and Painters of the Romantic Era*. New Rochelle, N.Y.: Caratzas Bros., 1981.

Underwood, Sandra Lee. *Charles Caffin: A Voice for Modernism, 1897–1918*. Ann Arbor, Mich.: UMI Research Press, 1984.

Valentine, Alan, and Lucia Valentine. *The American Academy in Rome, 1894–1969*. Charlottesville: University Press of Virginia, 1973.

Van Buren, E. Douglas. *Figurative Terra-cotta Revetments in Etruria and Latium*. London: John Murray, 1921.

Vance, William L. *America's Rome.* 2 vols. New Haven & London: Yale University Press, 1989.

Van Rensselaer, M. G. "Pauline (Mr. Manship's Portrait of his Daughter at the Age of Three Weeks)." *Scribner's Magazine* 60(December 1916): 772–776.

Varnedoe, Kirk. "On the Claims and Critics of the 'Primitivism' Show." *Art in America* 73(May 1985): 11–21.

Vermeule, Cornelius C., III. *Greek Sculpture and Roman Taste: The Purpose and Setting of Graeco-Roman Art in Italy and the Greek Imperial East.* Ann Arbor: University of Michigan Press, 1977.

Vitry, Paul. *Paul Manship, sculpteur américain.* Paris: Editions de la Gazette des Beaux-Arts, 1927.

Vogel, J. Ph. *Indian Serpent-Lore or the Nagas in Hindu Legend and Art.* London: Arthur Probsthain, 1926.

———. "The Woman and Tree or śālabhañjikā in Indian Literature and Art." *Acta Orientalia* 7(1928):201–231.

Von Mach, Ernst. *Handbook of Greek and Roman Sculpture.* Boston, 1905.

Wagner, Anne Middleton. *Jean-Baptiste Carpeaux, Sculptor of the Second Empire.* New Haven & London: Yale University Press, 1986.

Wagner, Johann Martin. *Bericht über die Äginetischen Bildwerke etc., mit kunstgeschichtlichen Anmerkungen von Friedrich Schelling.* Stuttgart & Tübingen, 1817.

Walkowitz, Abraham. *Isadora Duncan in Her Dances.* With essays by various authors. Girard, Kan.: E. Haldeman-Julius, 1945.

Walton, William. *World's Columbian Exposition: Art and Architecture.* Philadelphia: G. Barrie, 1893.

Wasserman, Jeanne L., ed. *Metamorphoses in Nineteenth-Century Sculpture.* [Cambridge]: Fogg Art Museum, Harvard University, 1975.

Weber, Max. *Essays on Art.* New York: William Rudge, 1916.

Weinberg, H. Barbara. *The Lure of Paris: Nineteenth-Century American Painters and Their French Teachers.* New York: Abbeville Press, 1991.

Western Architect 10(February 1907):23.

Whitaker, Charles, ed. *Bertram Grosvenor Goodhue: Architect and Master of Many Arts.* New York: Press of the American Institute of Architects, 1925.

Whitaker, Charles Harris. "The Nebraska State Capitol." *American Architect* 145(October 1934):5–10.

Wiese, Erich. *Alexander Archipenko.* Junge Kunst, band 40. Leipzig, 1923.

Wilson, Richard Guy, Dianne H. Pilgrim, and Dickran Tashjian. *The Machine Age in America, 1918–1941.* New York: Brooklyn Museum in association with Harry N. Abrams, 1986.

Winckelmann, Johann Joachim. *History of Ancient Art.* 2 vols. Translated by G. Henry Lodge (1856). New York: Frederick Ungar, 1968.

—————. *Reflections on the Imitation of Greek Works in Painting and Sculpture.* 1755. Complete German text, with a new English translation by Elfriede Heyer and Roger C. Norton. La Salle, Ill.: Open Court, 1987.

Winternitz, Moriz. *Geschichte der Indischen Literatur.* 3 vols. Leipzig: C. F. Amelangs Verlag, 1908–[1922].

Worringer, Wilhelm. *Abstraction and Empathy: A Contribution to the Psychology of Style.* Translated by Michael Bullock. London: Routledge & Kegan Paul, 1953.

Wright, Brooks. *The Artist and the Unicorn: The Lives of Arthur B. Davies (1862–1928).* New City, N.Y.: Historical Society of Rockland County, 1978.

Zabel, Orville H. "History in Stone: The Story in Sculpture on the Exterior of the Nebraska Capitol." *Nebraska History* 62(Fall 1981):285–367.

Zola, Emile. *Mes Haines.* Paris, 1879.

Zorach, William. *Zorach Explains Sculpture.* New York: American Artists Group, 1947.

abstraction, 53, 59, 110, 166
Académie de France, Rome (Villa Medici), 15, 16, 21
Adam, Sheila, 200n.93
Adams, Adeline, 153, 155
Adams, Herbert, 13, 39, 91, 102–103, 232n.13
Adler, Friedrich, 43
Aegina, Temple of Aphaia, 43–46, 44 (fig. 44), 58, 102, 203n.20
African art, 3–4
Agard, Walter Raymond, 146, 208n.52
Aitken, Robert, 92, 98
Alexander, Hartley Burr, 147, 149
Allan, Maud, 111, 128, 129 (fig. 69), 221–222n.67
Amateis, Edmund, 133
American Academy in Rome, 88, 90, 112, 171, 194n.18, 201n.104
 competitions for fellowships, 12–13, 17
 consolidation with American School of Classical Studies, 31–33
 endowment, 195n.26, 199n.83
 fellows, 16–18, 20 (fig. 8), 21 (fig. 9), 130, 133–135, 136–137
 mission of, 14–16, 24, 86, 194n.20
 relationship to Architectural League, 77
 requirements, 24, 35
 rivalry with French Academy, 15, 16
 studios at, 20, 21, 22 (figs. 10, 11)
 Villa Aurelia, 33
 Villa Mirafiori, 18, 19 (fig. 7)
American School of Classical Studies in Rome. See American Academy
Apollinaire, Guillaume, 4
archaeology, 32, 40–43, 50
archaic art
 characteristics of, 5, 7, 43, 49, 68

 and court cultures, 6
 and distortion, 59
 Fry's criticism of, 55, 206n.9
 and health, 56, 58
 modern characterizations of 36, 46–47, 48, 49
archaic sculpture
 authenticity of, 67–68
 publication of, 48–49
 technique of, 64
 youthfulness of, 56
 See also Greek sculpture
archaic smile, 44, 56, 58
archaism
 ancient, 226n.34
 associated with American Academy, 131, 132–134, 140
 in bronze sculpture, 72
 character of, 4, 5, 6, 56,58, 71–72, 75, 130–131, 140, 191n.9
 definitions of, 2, 75
 fashionability of, 130
 identified as Germanic, 139
 as official classicism, 140
 opposed to copying, 66
 and romanticism, 5
 technical, 28, 59, 135
 term applied to modern art, 55, 66, 67, 85, 86, 151, 205n.8, 208–209n.54, 215n.66
 and tradition, 5, 67, 132
Archipenko, Alexander, 1, 155, 206n.22
Architectural League of New York, 1, 39, 77, 91, 103, 142
Armory Show, 1, 7, 76, 97–102, 169, 171, 175, 228n.57
art deco, 130, 150, 153, 155, 158, 160
Art Students League, 26
Assyrian art, 29, 53, 55, 71, 127, 140, 149

Athens
 Acropolis excavations, 28, 47–48
 Acropolis Museum, 68
 Erechtheion, 34, 88
 Parthenon, 34, 71, 188, 189
authenticity, 50, 67–68, 95
avant-garde, 7, 178–179
awkwardness, 3

Bakst, Léon, 125, 127, (fig. 67), 128
Ballets Russes, 8, 125, 223n.85
 L'Après-midi d'un faune, 125–127, 126
 (fig. 66), 130, 223n.82
 Le Sacre du Printemps, 222n.78
Barbus, 3
Barnard, George Gray, 98
 Struggle of Two Natures in Man,
 214n.50
Barr, Alfred, 155
Barrès, Maurice, 228n.60
Bartlett, Paul Wayland, 91, 95
Bartlett, Truman Howe, 61
Bassae, Temple of Apollo, 203n.20
Baudelaire, Charles, 51, 53, 139
Beach, Chester, 92, 95–96
Beaunier, André, 56, 58, 206n.16
Beaux, Cecilia, 10
Beaux-Arts classicism, 142. See also
 subentry under sculpture
Behn, Fritz, 221n.55
Bénédite, Léonce, 204–205n.1
Berlin Photographic Company, 105,
 128
Birnbaum, Martin, 30, 105, 116, 127,
 169–170, 211n.14, 216–217n.91
Bismarck Monument, 139, 147, 226n.29
Bitter, Karl, 12, 13, 68, 70–72, 91, 141,
 144, 208n.48, 210n.71
 archaism of, 86, 88
 Carl Schurz Memorial, 68–72, 69
 (figs. 37, 38), 146
 First National Bank reliefs, 142, 143
 (fig. 79), 144
 Lowry Monument, 145 (figs. 81, 82,
 83), 146
 relationship to Metzner, 142, 144

technique of, 70, 88
Villard Memorial, 209n.59
Wisconsin Capitol pediment, 88, 89
 (fig. 48)
Blashfield, Edwin Howland, 13, 32–33
Bogart, Michele, 216n.81
Boime, Albert, 209n.57
Bois, Yve-Alain, 6, 192n.17
Borglum, Solon, 10, 11, 23, 29, 94
Borie, Charles, 135
Bosworth, Welles, 103
Bouchard, Henri, 221n.55
Bouguereau, William Adolf, 170,
 206n.12
Bourdelle, Antoine, 66, 124–125, 132,
 208n.50
 The Dance (Théâtre des Champs-
 Elysées), 66 (fig. 36)
 sketch of Isadora Duncan dancing,
 125 (fig. 65)
Brancusi, Constantin, 1, 72–74, 132,
 155, 175, 179
 Ancient Figure, 210n.74
 Double Caryatid, 73 (fig. 39)
 Kiss, 74, 100
 Maiastra, 155
 Mlle Poqany, 74 (fig. 40), 100
 Muse, 100
 Sleeping Muse, 100, 101 (fig. 53)
 Torso, 100, 101 (fig. 54)
Brandt, Edgar, 151, 158
Breck, George, 17
bronze
 Greek sculpture in, 48, 187–188
 hardness of, 72, 95
 properties of, 61–62, 179
Buffano, Beniamino, 233n.43
Burlington Magazine, 115

Caffin, Charles, 14, 124, 128, 213n.38,
 223–224n.91
 Dancing and Dancers of Today, 124,
 128
 on Manship, 88–90, 94, 97, 122,
 165–167, 178
Calder, David, 202n.14

Canova, Antonio, 207–208n.38
Capitoline Museum, 25
Carpeaux, Jean-Baptiste, *The Dance,* 65
 (fig. 35)
Carpenter, Rhys, 41
Carrier-Belleuse, Albert-Ernest, 24
Carter, Jesse Benedict, 33
carving
 indirect (pointing), 50, 60, 63, 70,
 207n.28, 208n.39
 in plaster, 27, 97–98
 See also direct carving; hardness
Casson, Stanley, 50
casts, 26, 28, 49–50, 204n.33
Cecere, Gaetano, 133
Cézanne, Paul, 5, 124, 166, 172, 173
Chanin Building, 154 (fig. 88)
Chandra, Pramod, 217n.6
Chase, William Merritt, 10
Chrysler Building, 150
City Beautiful movement, 90, 103
Cladel, Judith, 56
Claris, Edmond, 205n.2
classic, relation to primitive, 3
classicism
 archaizing, 140–141
 Cox's definition of, 85, 165
 models, 2
 modern, 124, 127
 and nature, 124, 166
 origins in archaic, 67
Clemen, Paul, 83
Clésinger, Auguste, 24
commercialism, 151, 177, 178
Comstock, Anthony, 213n.43
convention, 4, 5, 7, 49, 59, 166
 in Greek archaic art, 36, 48, 188
Coomaraswamy, Ananda, 109, 110–
 111, 114, 115, 118–119, 120, 149
 Dance of Śiva, 110, 116, 118
 Mediaeval Sinhalese Art, 110
 Mirror of Gesture, 117–118
 Rajput Painting, 120
Cooper, James Fenimore, 50
copies, inferiority of, 50
Cortissoz, Royal, 104, 165, 170–171, 175

Cox, Kenyon
 Classic Point of View, 85–86
 on Manship, 84–85, 93, 102, 165
Crowninshield, Frederic, 13, 17, 18, 20,
 23, 32, 216n.90
Cummings, E. E., 171–175, 177–178,
 179
 on Manship, 172

dance
 Indian, 111–112, 118, 218n.26
 modern, 123–124
 and sculpture, 122, 128, 130
 See also Allan; Ballets Russes; Dun-
 can; Fuller; Nijinsky; St. Denis
Darwin, Charles, 202n.12
Dasburg, Andrew
 Lucifer, 97
Davidson, Jo
 Torso, 98 (fig. 51)
Davies, Arthur B., 100, 116, 151,
 215n.66
Day, Frank Miles, 24
Delacroix, Eugène, 210n.5
Delphi, 34, 48, 187
 Treasury of the Siphnians, 34
 See also Greek sculpture: Charioteer
Denis, Maurice, 53, 223n.84
Dennis, James, 227n.46
Derain, André, 59
 Crouching Figure, 59, 60 (fig. 33), 72
Deskey, Donald, 155
Deutsche Kunst und Dekoration, 144
Dewey Arch, New York, 52 (fig. 28)
Diaghilev, Sergei, 125
Dial, The, 172
Diederich, Hunt, 195n.32
direct carving, 28, 67, 146
 in antiquity, 63–64, 70–71
 and authenticity, 67
 and origins, 67–68, 140
 modern practice of, 28, 63–64, 72–
 73, 95–96, 97, 174
 and political stability, 140–141
 See also hardness; non-finito
directness, 59, 173

Doric architecture, 203n.23
Duchamp-Villon, Raymond, 208n.48, 228n.57
Torso, 102
Duncan, Alastair, 230n.91
Duncan, Isadora, 111, 122, 123 (fig. 64), 124–125, 125 (fig. 65), 126, 222n.70
Dyer, J. Milton, 142
First National Bank, 143 (fig. 78)

Eberle, Abastenia
Windy Doorstep, 92
Ecole des Beaux-Arts, 14, 15, 16, 90
Egyptian art, 3, 6, 53, 55, 71, 127, 156
as model for Greek art, 4, 58
modern sculptors and, 29, 58–59, 140
Epstein, Jacob, 116
Etruscan art, 3
Evans, Sir Arthur, 199–200n.86
Exposition Internationale des Arts Décoratifs et Industriels Modernes, 150, 151 (fig. 86), 152 (fig. 87), 156
expression, 3, 59, 67, 215n.70

Fairbanks, Frank, 17, 103, 224n.97
Faulkner, Barry, 17, 116, 117, 195n.29, 196n.43, 220n.39
finding, 63, 124
Finley, David, 119
Flannagan, John, 95, 96
Fokine, Michel, 125, 127
Fortuny, Mariano, 130
Frankl, Paul, 162
Freer, Charles Lang, 116
French, Daniel Chester, 13, 28, 29, 38, 91, 95, 191n.3, 197n.52, 201n.103
archaism of, 86
Milmore Memorial, 213n.44
Republic, 86
Wisdom, 86, 87 (fig. 47)
Friedlander, Leo, 136–137, 139, 140, 141, 227n.43
Monument, 137, 138 (fig. 74), 140
Mother and Infant Hercules, 136–137 (fig. 73)

Fry, Roger, 55–56, 206n.9, 233n.37
on Indian art, 109, 217n.6
Fry, Sherry, 17, 134, 211n.13
Fuller, Loie, 111, 122
Furtwängler, Adolf, 203n.20

Gallatin, A. E., 93, 117–118, 119, 169, 174, 211n.17
Gardner, Ernest, 48–49, 160, 201n.98
Handbook of Greek Sculpture, 48–49
Six Greek Sculptors, 48
Gardner, Isabella Stewart, 160
Gauguin, Paul, 72, 191n.8, 223n.84
Geffroy, Gustave, 62
Geist, Sidney, 72
German art, 83, 139–140
Gérôme, Jean-Léon, 205n.3
Gide, André, 206n.10
Gill, Eric, 109–110, 122, 210n.73
Viśvakarma, 110
Gilman, Roger, 153, 155
Goldwater, Robert
Primitivism in Modern Painting, 5–6, 192n.15
Goodhue, Betram Grosvenor, 146–147, 229n.73
Nebraska State Capitol, 148 (figs. 84, 85)
Grafly, Charles, 10–11, 94, 133
Graves, Morris, 219n.37
Greek art
and modern dance, 124
vase painting, 3, 71, 81, 82 (fig. 45), 221n.67
Greek sculpture
antefixes, 30, 80, 81 (fig. 44)
Athena Parthenos, 86, 88
authenticity of, 36, 44, 48
caryatids, 88
Charioteer, 36, 38 (fig. 21), 48, 187–188, 221n.67
copies of, 41, 50, 67
Elgin marbles, 203n.20
Esquiline Venus, 79 (fig. 42), 211n.8
Farnese Hercules, 113
Hellenistic, 26, 188
Hera from Samos, 56, 57 (fig. 32)

Hermes (Praxiteles), 29, 36, 37 (fig. 37), 102, 127, 185–186, 200n.93, 206n.12
Kleobis and Biton, 47 (fig. 26)
korai, 28, 36, 38 (fig. 22), 48, 58, 68, 88, 198n.62, 200–201n.96
kouroi, 48, 58, 68
Laocoon, 41, 231n.100
literary evidence for, 41, 202n.8
Ludovisi Throne, 134, 185, 224–225n.12
metopes, 24, 53, 66, 187, 230–231n.98
"Narcissus" from Pompeii, 26, 27 (fig. 14), 197n.57
Nike of Paionius, 210n.7
Parthenon frieze, 71
severe style, 53, 177, 201n.99
Silenus with a Baby (Lysippos), 29
stelai, 184–185
Venus de Milo, 18
Victory of Samothrace, 18
See also Aegina; Athens; Bassae; Delphi; Mycenae; Olympia; Selinus
Greenberg, Clement, 234n.66
"Avant-Garde and Kitsch," 178–179
"Towards a Newer Laocoon," 179
Gregory, John, 134 (fig. 71), 135, 136 (fig. 72)
Griffith, D. W.
Intolerance, 130

Hahn, Hermann, 83
Hancock, Walter, 96, 104, 133, 146
hardness
aesthetic of, 70, 94–95, 96–97, 170, 179
characteristic of archaic art, 43
Hartmann, Sadakichi, 207n.32
Harvey, Charles, 17
Haus Rheingold Restaurant, Berlin, 142, 144
Havell, Ernest Binfield, 108–109, 116, 117
Ideals of Indian Art, 114
Indian Sculpture and Painting, 108
Heilmeyer, Adolf, 67

Herter, Ernst, 12
Hildebrand, Adolf von, 28, 63–64, 67, 83, 95, 145–146
and archaism, 67
Problem of Form, 28, 63
Hitchcock, Henry-Russell, 150–151, 229n.73
Hoffman, Malvina, 122
Hoffman, Josef, 28
Hohl, Reinhold, 153
Hosmer, Harriet, 60, 206–207n.26
Humber, George, 167
Huneker, James Gibbon, 146
Hunt, Richard H., 14
Hurwit, Jeffrey, 58, 200n.90, 205n.5

Ianelli, Alfonso, 227n.43
imitation, 166, 179, 205n.3
impressionism, in sculpture, 28, 95, 213n.49
Indian art, 53, 107, 118 (fig. 61)
Ajanta, 118
Aśoka column, 115 (fig. 59), 116
model for western artists, 109
modern, 108, 110
popularity with collectors, 116
relation to Western art, 108, 109, 110, 119
scholarly debate over, 108–109
spirituality of, 109–110, 120, 122
woman and gazelle motif, 120
Yakṣi (śālabhañjikā), 114 (fig. 58)
See also Coomaraswamy; dance, Indian; Fry; Gill; Havell; Rājput painting; Smith
Indian Society of Oriental Art, 217n.5
India Society, 109, 116, 117
International Exposition in Rome, 28–29, 96, 198n.70, 210n.3
Manship's opinion of, 29
International Style, 161–162

Jenison, Madge, 116
Jennewein, Paul, 135
Jouin, Henry, 60, 63

Kālidāsa, 120–121
Keck, Charles, 12, 97
Kekulé, Reinhard, 46–47
Kendall, William Sargeant, 10
Kestranek, Hans, 70
Kirstein, Lincoln, 233n.43
kitsch, 178
Klee, Paul, 221n.58
Konti, Isidore, 11–12, 13, 25, 29, 201n.106, 210n.1, 210n.3
korai, kouroi. *See* subentries under Greek sculpture
Krauss, Rosalind, 207n.34, 215n.71
Krishna, 114, 115
Kunstwollen. *See* Riegl, Alois

Lachaise, 97, 130, 172–177
 ATT figure, 176, 177 (fig. 98)
 Dancing Woman, 129 (fig. 70), 130
 employed by Manship, 172, 174, 233n.43, 234n.58
 Hindoo Dance, 130
 Mountain, 174
 Peacocks, 176
 Standing Woman (Elevation), 174, 175, 176 (fig. 97)
La Farge, C. Grant, 77
La Farge, John, 14
Lalique, René, 151, 234n.57
Lambraki-Plaka, Marina, 208n.50
Laurent, Robert, 95, 97
Lawrie, Lee, 146–147
 Nebraska State Capitol, 148 (fig. 85)
Lederer, Hugo, 83
 Bismarck Monument, 139, 147
Lessing, Gotthold Ephraim, 41
Levinson, André, 222n.77
Lipchitz, Jacques, 58, 120
 Woman and Gazelles, 118 (fig. 62), 119
Lipsey, Roger, 219n.37
Lord, Austin, 32
Louvre Museum, Paris
 ancient art in, 53, 56, 185
 Manship's visit to, 18
Löwy, Emmanuel, 49, 53, 59, 65, 68

The Rendering of Nature in Early Greek Art, 49
Lyell, Sir Charles, 202n.12

McBride, Henry, 162, 171
machine style, 162
McKim, Charles Follen, 14, 16, 194n.20
McKim, Mead, and White (firm), 33
MacMonnies, Frederick, 61, 134, 197n.52, 207n.30
MacNeil, Hermon Atkins, 12
Into the Unknown (Inspiration), 93, 94, (fig. 50)
Maillol, Aristide, 1, 53, 55–56, 100, 156, 206n.12, 207n.30
 Desire, 54 (fig. 30), 55
 Flora, 55 (fig. 31)
Manolo, 100
Manship, Isabel, 117
Manship, John, 7, 233n.43
Manship, Paul, 7, 9, 58, 76, 156, 163, 164, 165, 171, 174, 201n.106, 199n.71
 academic embrace of, 86, 102, 165
 on ancient art, 25, 31, 34, 36, 38, 58, 183–189
 and art deco, 155–156, 158, 160
 and Asian art, 116, 117, 119
 attitude toward bronze, 96, 179
 attitude toward technology, 162–163
 and Bakst, 128
 censorship of, 84
 classicism of, 85, 106, 165
 on collaboration, 35, 103
 compared with contemporaries, 92
 craftsmanship, 85, 102, 162, 169, 170
 "Decorative Value of Greek Sculpture," 34, 36, 183–189
 on direct carving, 96
 early training, 9–13, 192n.3
 election to NAD, 231–232n.7
 exhibitions, 10, 39, 77, 92, 104, 105, 169, 180, 192n.2
 experience of Paris, 11, 14, 18, 156, 158, 193n.12

first trip to Greece, 34
garden sculpture, 104
on hardness, 94–95
impact on contemporaries, 131
inspired by vase painting, 77, 81
Johnson memorial competition, 21,
 23, 196n.46
and Lachaise, 130
on Meunier, 18
modernity of, 85, 90, 97, 106, 166,
 168, 179
naturalism of, 97, 106, 166
originality of, 169, 180
professorship at Academy, 133
public profile, 164, 171
realism of, 165
reasons for early success, 105, 106
receptivity to Rome, 25
and Rodin, 11, 12, 18, 84, 93, 94,
 193n.9
on romanesque sculpture, 121
Roman studio, 21, 77
scale problems, 104
self-assessment, 180
silhouette, importance of, 81–82
on spiritual in art, 122
and Stuck, 83, 84
technique of carving in plaster, 26–27
tour of Spain, 195n.32
use of drawing, 82, 211n.14
Works:
 Actaeon, 160–161 (fig. 95), 162
 Air, 156 (fig. 89)
 bedroom of New York residence,
 157 (fig. 90)
 Briseis, 11
 Calypso, 104
 Centaur and Dryad, 77, 78 (fig. 41),
 79, 80 (fig. 43), 82, 83, 84, 85,
 90, 106, 165, 233n.43
 Dancer and Gazelles, 117 (fig. 60),
 118, 119, 120, 121, 128, 161,
 175, 216n.86
 Diana, 160 (fig. 94), 161, 162
 Duck Girl, 26, 27 (fig. 13), 39, 84,
 112, 165

End of Day, 18, 19 (fig. 5), 25, 94
Europa and the Bull, 158 (fig. 92)
Flight of Europa, 159 (fig. 93)
Flight of Night, 159
Frieze Detail from the Treasury of the
 Siphnians, 35 (fig. 18)
Greek Vase, 35 (fig. 17)
Indian Hunter, 104, 105 (fig. 55)
Infant Hercules Fountain, 81, 112,
 113 (fig. 57), 114, 115, 116, 136
Little Brother, 85, 92
Lyric Muse, 85
Mask of Silenus, 29, 31 (fig. 16), 80,
 85
Morgan Memorial, 174, 233n.49
Pauline Frances, 167 (fig. 96), 168
Paul J. Rainey Memorial Gateway,
 157 (fig. 91), 158
Playfulness, 85, 92, 93 (fig. 49)
Prometheus, 149, 150, 171
Pronghorn Antelope, 104, 105 (fig.
 55)
Pulling, 18, 25, 192n.2
Rest After Toil, 12, 13 (fig. 3), 25
Salome, 128, 129 (fig. 68)
Sarah Janet, 168
Satyr and Sleeping Nymph, 83, 211–
 212n.18
Self-Portrait, 192n.3
Sundial, 116
Vase with Oriental Dancer, 128
Wood Nymph's Dance, 25 (fig. 12),
 84, 197n.49
Wrestlers, 10 (fig. 1), 11, 25, 94
marble, 61, 62–63, 64, 186
mark, 169–170
See also touch
Matisse, Henri, 99, 175, 223n.84
 Back I, 99, 100
Mead, William Rutherford, 32, 38
medieval art, 49, 53, 110, 121
Meier-Graefe, Julius, 205n.8, 208–
 209n.54
Meštrović, Ivan, 28–29, 96, 198n.68,
 214n.54
 Caryatid, 29, 30, (fig. 15)

Metropolitan Magazine, 84
Metzner, Franz, 28, 68, 139–140, 142, 144, (fig. 80), 224n.5
Völkerschlacht Monument, 141 figs. 76, 77)
Meunier, Constantin, 18
Stevedore, 18, 19 (fig. 6)
Meyer, Alvin, 133
Michaelis, Adolf, 42
Michelangelo, 95–96, 214n.56
Millet, Francis Davis, 14, 17, 18, 20, 32, 33
Minnesota State Capitol, 86
modeling, 10–11, 61, 94
critique of, 64
in plaster, 26–27, 214n.61
modernism, 72, 76, 85–86, 165, 166, 178
defined by Cummings, 173
and fashion, 153, 155
and simplicity, 162
modernistic, 155
Morgan, Edward M., 84
Morgan, J. Pierpont, 33
Morris, William, 218n.13
Mowbray-Clarke, John, 116
Mowbray-Clarke, Mary, 116
Murtha, Edwin, 193n.5, 201n.103
Mycenae (Greece), 42, 160

Nadelman, Elie, 100, 155, 175, 234n.55
Nagle, Edward, 172
naïveté, 5
Nation, 84
National Academy of Design, 91, 92, 93, 104, 130
Manship's election to, 231–232n.7
Manship's exhibition with, 10, 104, 165
National Sculpture Society, 12, 68, 91, 103
naturalism, 3, 53, 59
and abstraction, 110, 168
modern, 97
nature, 53, 124, 166
Nazarenes, 3, 191n.8

Nebraska State Capitol, 146–147, 148 (figs. 84, 85), 228n.54
New Republic, 167
New Yorker, 171
New York World's Fair, 164, 178
Nijinsky, 125, 127
L'Après-midi d'un faune, 125–127, 126 (fig. 66), 130
Le Sacre du Printemps, 222n.78
non-finito, 96
Nordland, Gerald, 234n.61

Oceanic art, 3–4
O'Keeffe, Georgia, 219n.37
Olympia, 34, 36, 42–43
Temple of Zeus, 29, 36, 37 (fig. 20), 53, 54 (fig. 29), 55, 56, 77, 134, 159, 177, 186
originality
academic conception of, 20, 165
modernist conception of, 20, 106
of modern primitivism, 6
technique of, 63
See also Manship, Paul: originality of

Pach, Walter, 102, 228n.57
Paris, 14, 16, 17, 90, 156, 158, 195n.27, 196–197n.46
Monument à Guy de Maupassant, 52 (fig. 27)
See also Exposition Internationale; Manship, Paul: experience of Paris
partial figure, 11, 98
Partisan Review, 178
Pavlova, Anna, 122
Pennsylvania Academy of the Fine Arts, 10, 26
Philadelphia Museum of Art, 135, 136 (fig. 72)
Phillips, Duncan, 4–5, 155
Picasso, Pablo, 4, 191n.8
Woman's Head, 99
Piccirilli, Attilio
Maine Memorial, 91
Piccirilli Brothers (firm), 70

Pilgrim, Dianne, 162
Platt, Charles, 103, 104
pointing. *See* carving, indirect
Poiret, Paul, 155
Polasek, Albin, 105, 197n.55, 215–
 216n.80, 221n.55
polychromy, 36, 135, 184, 198n.62,
 201n.96, 225n.16
Post, C. R., 142, 169
Powers, Hiram, 214n.61
Pre-Raphaelites, 3, 191n.8
primitive art, 3–4, 110, 173, 191n.3
primitivism, 2–7, 84, 192n.17
Purists, 3

Rājput painting, 115, 119–120, 121
 (fig. 63)
Rand, Harry, 7, 231n.100
realism, 51, 85, 110, 165, 186
Reitzes, Lisa, 228n.54
relief sculpture, 24, 53, 55, 63, 65, 66,
 68, 70, 71
Renaissance art, 3, 53, 113, 127, 167,
 189
Richards, Charles R., 152
Richardson, Jonathan, senior and junior,
 202n.9
Richter, Gisela M. A., 202n.8
Riegl, Alois, 70
Rilke, Rainer Maria, 62
Rockefeller Center, 149, 171
Rodin, Auguste, 58, 61–62, 74, 93–94,
 146, 180, 215n.68, 222n.70
 Age of Bronze, 61
 on archaic art, 56
 Caryatid, 62 (fig. 34)
 criticism of, 64, 66
 Crouching Woman, 11 (fig. 2)
 on dance, 126–127
 Gates of Hell, 66
 impact on American sculptors, 93–
 94, 97, 98
 on Indian sculpture, 220n.41
 The Kiss (Le Baiser), 58
 Manship's interest in, 11
 Monument to Victor Hugo, 64

sculptural technique, 11, 63, 64, 72,
 207n.34
Rogers, John, 91
Rome, 12, 14, 15, 90
Rubenstein, Helena, 155
Rubin, William, 6
Ruckstull, Frederick, 12
Ruhlmann, Jacques Emile, 151

Saarinen, Aline, 229n.70
St. Denis, Ruth, 111 (fig. 56), 112, 121,
 130, 218n.17
Saint-Gaudens, Augustus, 14, 17, 29,
 207n.32, 212n.27, 213n.47
 archaism of, 86, 88
 Sherman Memorial, 137, 138 (fig. 75)
St. Louis World's Fair, 226n.42
Śakuntalā, 120–121
Salome, 128
Samothrace, 42
Sanford, Edward, 221n.55
Sargent, John Singer, 198n.67
Schapiro, Meyer, 49
Schliemann, Heinrich, 42, 202n.14
Schmitz, Bruno
 Völkerschlacht Monument, 139, 141
 (figs. 76, 77), 142
Scribner's Magazine, 168
Scudder, Janet, 156
sculpture
 allegorical, 90–91
 and architecture, 55, 65, 142, 146,
 208n.48, 208n.52, 228n.54
 art deco, 153
 Beaux-Arts, 90–91
 compared to painting, 51, 59, 72,
 172, 173, 234n.66
 garden, 103
 genre, 91–92
 Germanic element in, 12, 141, 144
 narrative absence, 59
 neoclassical, 61, 90
 physicality of, 53, 59, 62, 173–174
 public, 7, 91
 traditional processes of, 59–61
 See also relief sculpture

Secession (Vienna), 28, 68
Selinus, 46 (fig. 25), 47
Semper, Gottfried, 70
 Der Stil, 70
severity, 36, 43
Shawn, Ted, 218n.19
Shiff, Richard, 63
simplicity, 3, 5, 36, 53, 56, 58–59, 162,
 186, 188
sincerity, 3, 5, 127, 173
Śiva (Shiva) Naṭarāja, 118
Smith, Vincent, 108, 109, 219n.25
Solon, Leon V., 135
spontaneity, 95, 173, 188
Stahr, Frederick, 34, 224n.97
Sterne, Maurice, 50, 221n.60
Stevens, Gorham Phillips, 33, 34, 36,
 38, 133, 224n.1
Stieglitz, Alfred, 175, 215n.69
Storrs, John, 97
Story, William Wetmore, 214n.61
Stravinsky, Igor, 223n.82
streamlining, 161, 162
Striner, Richard, 230n.87
Stuck, Franz von, 28, 82, 128
 Mounted Amazon, 82–83 (fig. 46)
 Wounded Centaur, 211n.16
Sturgis, Russell, 36
SunwiseTurn Book Shop, 116
synthesis, 56, 66

Taft, Lorado, 61, 124, 125, 134, 137,
 139, 140, 142, 207n.30, 209–
 210n.70
Thorwaldsen, 43–46, 203n.20
 Hope, 45
 Self-Portrait, 45 (fig. 24), 46, 203n.22
touch, 61, 74, 173–174
 See also mark
tradition, 20, 49, 70
Tuaillon, Louis, 83

unity, 59

Van Buren, A. W., 34, 135, 199n.73,
 211n.10
Vanity Fair, 110
Van Rensselaer, Mariana Griswold, 168
Vitry, Paul, 92, 158, 197n.58
vivacity, 47
Völkerschlacht Monument, 139–140, 141
 (figs. 76, 77), 142, 144, 146,
 226n.32

Ward, John Quincy Adams, 29, 91
Ware, William, 194n.20
Warren, Harry, 17
Watkins, Charles Law, 5, 155
Weber, Max, 97, 205n.4
Whitaker, Charles Harris, 149
Williams, Ernest, 17
Winckelmann, Johann Joachim, 40–41,
 43, 203n.19
Wisconsin State Capitol, 88
World's Columbian Exposition, 15
 (fig. 4), 86, 103
Worringer, Wilhelm
 Abstraction and Empathy, 59, 166
Wright, Alice Morgan, 121
Wright, Frank Lloyd, 227n.43
Wright, Willard Huntington
 Modern Painting, 172, 178

Young, Mahonri
 Bovet Arthur, 92
youthfulness
 as a quality of archaic art, 56, 127

Zola, Emile, 53
Zorach, William, 56, 95, 173, 174